The Best American
Sports Writing
2015

The Best AMERICAN SPORTS WRITING™ 2015

Edited and with an Introduction
by Wright Thompson

Glenn Stout, *Series Editor*

A Mariner Original

HOUGHTON MIFFLIN HARCOURT

BOSTON • NEW YORK 2015

ISSN 1056-8034
ISBN 978-0-544-34005-3

Printed in the United States of America
DOC 10 9 8 7 6 5 4 3 2 1

Contents

Foreword

I WAS A SICK KID.

I was born with an enlarged heart, had virtually every childhood disease by the age of two, and thereafter was never well for long. My mother complained that at birth I didn't cry, I coughed, and she lost track of the number of times she put me on the school bus healthy, only to get a call an hour or so later that I had a fever of 103 or 104 and that she had to come get me immediately. Throw in an eye operation, a bone disease, unexplained searing headaches, five or six bouts with pneumonia, poking and probing by specialists, and all sorts of other unexplained afflictions and accidents—falling on a stick and having it pierce the roof of my mouth, crashing through a glass door, a coma after a tetanus shot, having my front teeth knocked out in a car accident, a broken arm, a torn rotator cuff, a crushed bladder, a half-dozen concussions, mysterious hives caused by cold water, chronic bronchitis, mononucleosis, and so on—well, I missed a lot of school. At the end of the year, when other kids bragged about their grades, I boasted about how many days I missed. I once set a personal record just shy of 50, and always, always missed at least 20.

It made for a strange life. I think I fell partway into myself at an early age and have never climbed completely out. I was ruled by my imagination, the only constant, escaping the hospital or sick-bed by embracing the fever dreams and fantasies and shadow plays on the wall of my room as I'd be woken up to take a breathing treatment or eat ice chips or take a pill or have my temperature

taken, a humidifier spitting in the background and mentholated oil percolating through quadruple layers of clothes.

Confined, too much, and cut off from anything much beyond the bedridden, mind-stripping wasteland of daytime TV, I was saved by words, the pages of paper I lowered over the bedrails to escape to another place. I didn't just read words, I consumed them and allowed them to lead me away, never questioning their value, having utter faith in whatever place they took me. I didn't learn to read books as much as occupy them, to wiggle into the crevices of language and characters and stories and then be swept away, or carried elsewhere. Those places often seemed more real to me than where I was, buried under quilts, and even today my dreams are not often of where I am but ongoing chapters of stories and scenes that unfold without end. I am not in my dreams as much as they are in me.

At a certain point, as I grew older, I began to realize that some of those words that captured me were more potent than others, the connections stronger, more immediate and emotional, making me feel in ways nothing else ever did. That words could do that seemed like some kind of magic, an utter mystery of invention.

How was it possible? How could writers do that? How could someone, with words alone, ink on paper, make me feel so much, so deeply? How could words teach what life had not, and articulate thoughts and feelings that I'd never before expressed but that now, once articulated, were unquestionably mine? How did they get in there? And then eventually came a question even more important for me to ask: how can I do that?

Unconscious of its near-impossibility, I followed the usual path of a young writer, one both completely common and entirely my own: voracious reading, writing for the school newspaper, and then off to college for creative writing, coupled with a headlong search for experience—sex and drugs and rock 'n' roll but also pouring concrete, driving cross-country, working one crap job after another, trying to get old fast, to get past the awkwardness of the young writer to become just the noun itself. I was aware enough to know that I had to jettison and write out all the bad sentences and pretentious ideas and rules-ridden construction and then, every once in a great while, I could see—actually hear it spoken from my own mouth when reading my own words—something I unques-

tionably wrote that worked. Then of course came the challenge: figuring out why and how to make it happen again, to do it more or less, if not on command, at least often enough to know it was no accident.

Twenty-five years ago, I was somewhere on that path, at the start, making the transition from young writer to writer, when steward-ship of this book improbably came to me. I've told the story be-fore—I had an agent who was asked to recommend another agent who might have a client to edit a proposed new annual sports writing anthology. Purely by luck, she recommended me. At the time I was writing sports features for *Boston* magazine, freelancing, working at the Boston Public Library, and trying to both write and work full-time. From the start, I could envision an entire shelf of editions of this book, my name sharing the spines, some small part of me realizing I was meant to do this.

What I did not anticipate was what was really important. Select-ing material for this book forced me, for the first time really, to take the why and how of writing seriously. I wasn't just fooling around anymore. Knowing what worked and what did not now mattered. My take on what was good or bad would be tested every single year, not just by the readers of this book but by my peers, other writers, all of whom, I was certain, were far smarter and more qualified than I.

To paraphrase the poet James Wright, fear is what quickened me. I believed from the start that even though the subject matter of this book would be "just sports," sports reach into so much of the world that the subject can include the full dimension of our experience; the writers would prove that, and all I had to do was uncover the evidence. The fear came from worrying, not that the work did not exist, but that I would not find it, or recognize it, that I would miss the essential and end up collecting the arbitrary. I feared that the subject would be seen as "just sports"—nothing more than an accounting of who recently won or lost.

The writers, of course, saved me. They did so not only with their words but with their competitiveness, the kind that makes us both share discoveries with others and curse ourselves for not writing it first, or doing it better. In this way the best writing forced its way into this book, and with each passing year I began to have a better idea not only of what writing works, but why.

A big part of that was due to the first decision made in regard to this series, and perhaps the most important one. When it was still in the talking stages, I suggested that we call it *The Best American Sports Writing*—two words, rather than the compound "sportswriting." From the start, I think, this term made the book larger, more inclusive. It wasn't "just sports." It was "just writing," and the influence of the adjective "sports" became not absolute and narrow but expansive, wide, and ever-searching.

I recently had a writer ask me how to find stories "that have that larger, human, beyond-sports resonance." I think the answer is in that first decision. Sportswriting tells you the score, the essentials, who won and who lost and why. The work represented in this book tells you everything else—why you care.

Unburdened by an exclusive definition, the series was able to evolve in ever more interesting directions. While there has always been room here for "sportswriting"—the columns, game stories, and shorter features of the daily press—over the past 25 years the media landscape has changed dramatically and profoundly. The daily press, rather than being essential and central to the genre, now shares that place not only with other print products but with digital media and an increasing number of online outlets.

Over these years, as the medium changed, so did the content. New formats freed writing from constraints of both time and space. Reporting and reaction need not wait, nor must they fit a predetermined hole. Over time the possibilities of what writers can do have expanded. And ever so slowly, after a transitional period of massive contraction in the print world, the outlets for such work have expanded as well.

This series has bridged perhaps the most volatile era in journalism. When I published my first magazine story in 1986 (also my first written story, period), I wrote it out longhand and then had to borrow an electric typewriter. The first edition of this book, published in 1991 and edited by David Halberstam (whose immense generosity I will never forget), included only print stories, nearly half of them from newspapers and newspaper magazines. Online journalism did not exist. Not until the 2000 edition did the book feature a story from an online source. (For the record, it was Pat Toomay's "Clotheslined" from Sportsjones.com.) The online behemoth of ESPN did not crack the pages until 2002 (Gene Wojciechowski's "Last Call" from ESPN.com).

This evolution has been a good thing. When I was that sick kid, most magazines were out of reach—our family budget did not allow for *Sports Illustrated,* much less *The New Yorker,* and I had access to only a single newspaper, the boosterish *Columbus Dispatch.* Sports writing from elsewhere lived on a single shelf at the local library, 796.M365 in the old Dewey decimal system, where the old *Best Sports Stories* series lived.

Now, of course, almost everything is available: most print sources also appear somewhere online, and the online world has proliferated and grown in the past few years at an astonishing rate. As a result, the nature of sports writing has inevitably changed, evolving in ways that were impossible to predict even a decade ago. But it has always been this way.

Sportswriting (the compound word) initially took shape as the score and the game report; it was soon supplemented by the notes columns, which gave birth to the true columnist. Features—at least the kind of work we recognize today as features—were exceedingly rare before the 1920s (the start of the age of the magazine) and really did not proliferate until after World War II. And there it sat for some time, sportswriting encompassed in but four forms: notes, columns, gamers, and features.

By the 1960s, the influence of writers like Gay Talese and the need to provide something the lumbering presence of television could not were changing the nature and character of sports features: they were becoming harder, more demanding and ambitious. When the stray issue of *Sport* or *SI* found its way into my hands, or into the old *Best Sports Stories,* I was mesmerized. Over the next day or two, I was not confined to bed but freed.

Over the next few decades this kind of work began to flourish, not just in *Sports Illustrated* and *Sport* but also in the daily press (as what became known as take-outs), newspaper Sunday supplements, magazines, and the late lamented *Inside Sports,* and the hybrid *National Sports Daily.* Eventually sports-themed features and profiles became ever more regular staples not just in men's magazines, like *GQ, Esquire,* and *Playboy,* but also in regional and general-interest magazines and even in more literary publications such as *The Atlantic Monthly, Harper's,* and *The New Yorker.* When this series launched, these were the places where sports writing lived and flourished.

Change, of course, is inevitable. As the online world began to

develop, the print world, through a combination of pure demographics, greed, and one misstep after another, began to shrink—as did, for a time, the amount and kind of writing the guest editors tend to select for this book. With fewer pages available in print sources, fewer stories were published, and those that did appear were often shorter and less ambitious. The Sunday supplement magazine all but died off (there were nearly 100 when this series started), and the 3,000-, 4,000-, or 5,000-word take-outs or serial features became both more rare and more predictable.

When work of any kind becomes predictable, produced by the same impulses and written and edited by the same people according to the same criteria, it suffers. Ambition can ossify into the formulaic. If writing has an enemy, it is predictability, and if there is one thing I decry after two and a half decades of wading through this bottomless word bog every day, it is work that is safe and smug and satisfied with itself, the "good enough" story that checks off all the boxes and then goes to lunch. That's one of the reasons this series features a guest editor—to ensure that it never stays the same.

If writing has a savior, however, it is the individual writer, usually unattached, hungry, ambitious, and necessarily more creative. As digital media began to flourish, unconfined by the material and economic restraints of print, the scope of the genre began to expand again. In the last decade—really, the last five years—another form has developed, filling the space left between the decline of the newspaper and the shrinkage of magazine advertising, on one side, and a similar contraction in the book world, on the other, when major publishers virtually abandoned the nonfiction midlist. In between was left an appetite unfulfilled.

Leave it to the writers to fill it. We all know it when we see it, but it goes by many names: narrative journalism, creative nonfiction, deep reads, longreads, or the handle that seems to raise so many hackles bound to the past, longform. (Let's just get this out of the way early—if the name bothers you, call it what you want.)

This type of writing was always there, only now there was a place designed to support it. If there is any material difference in this kind of work, it may be that traditional print features and book-length narratives tend to rely on the reader's preexisting interest in a subject. The best longer features overcome this, just as the

best poems and best fiction do; the "subject" does not matter and is secondary to the execution of the form, the creation of an interesting narrative and the development of characters. That is part of what makes longform so attractive to writers: the inherent challenge is to write something that's engaging regardless of a reader's preexisting interest, but that respects the reader who is already interested in the subject. This means you never dumb down; you write up. Longform is an exciting place to be. Once upon a time, I regularly heard from younger people who wanted to know, "How can I be a sports writer (or sportswriter)?" I don't get asked that question much anymore. They tell me, "I want to write longform."

Here's the thing. The skills and craft required to produce good work—good sports writing, of any length—have not changed. If I have realized anything over the last 25 years, it is this. Length is only a consequence of the time and care spent reporting, writing, and editing. As many stories are killed for being too short or underreported as for being too long. Every story in every circumstance can be told in any number of ways. That might mean a story of 1,500 or 3,000 words, but it might also mean a story of 15,000 or 30,000 words. Every story, regardless of length, must feel as if it is organic and just as long as it needs to be.

So what do I look for when seeking out "the best"? From my chair, after 25 years of professional reading, not to mention nearly 30 years as a professional writer, the best stories share a few qualities that never change and are as necessary today as in 1920, or when I was swaddled in my bed as a 10-year-old.

I believe the best work features thorough reporting and has a defined shape, a structure and a backbone, an architecture and a music, all its own. The stories I wish to read again are organic, written from within, from the material outward rather than plugged into some preexisting template or journalistic equivalent of verse, chorus, verse. They are confident from the first word, and certain—they sound as if they already know the end of the story, as if every word is predetermined from the first syllable. I once heard Bill Heinz talk about how important it was for him to find the opening chords, for they define all that can follow. The best stories allow the reader to identify characters by revealing something universal, something authentic we share. They unfold, they answer questions before the reader asks them, they create three-dimen-

sional pictures that play out over that fourth dimension, time, they let the reader create an internal movie of what is happening, they play to the senses, they involve the senses.

All the parts can be in place, but in the end I think it's the *sound* of a story that plants it in the reader's mind and makes it matter. By that I mean a literal, singular sound that, even if never uttered aloud, is distinctive, its pace and tone seductive, a rapt voice whispering in your ear. Just as one need not know the singer's language to appreciate the song, the sound of a story should be just as engaging. I don't read for the stories in this book as much as I listen for them.

The really good story provides an experience that approaches the book experience—it takes you from one place you've never been before and by the end leaves you in another place, changed. The lede is important, of course (why else continue?), but the end is no less so. Stories should not just stop: they should finish by leaving the reader unable to close the book, relishing the reading experience and wanting to share it. The best close makes the reader pause and allows the momentum of the story to wash over like a wave that runs up the sand and then sinks and disappears, leaving a trace behind. That sensation is what first carried me away from my sickbed and still does so today.

I believe that the goal of reading and writing is to change lives in ways large and small, that when the water recedes the reader must know something has changed. This is the payoff for time spent listening to words. This is why we bother. You emerge at the end of a story almost without breath, transformed, and you want to read it again.

This is what I listen for more than anything else: to want to read it again. After 25 years of editing this series, if that was not the case, I do not think I could read another word. The last thing I want is for this book to come out and to have no desire to read it again myself. This has not often happened. Amid all the false starts, the hundreds and thousands of stories I've started to read over the years and then put down because, well, I discover I don't even want to read them once, the rare story that demands to be read again and again keeps me at it.

That's the dirty little secret of this series. Many readers have already read some of the stories collected in these pages each year,

and it is easy enough to find virtually all of them online. Yet it is just that—the desire to read a story again, to reexperience its craft and drama—that provides the rationale for this series. Discovering work you've never encountered before is great and essential—but so is becoming reacquainted with work you might already know, this time stripped down to its core, just words on a page where the reader and the writer, not to mention the editor, can all share something saved.

And in the end that is the justification for bothering with any of this at all, whether as an editor, a writer, or a reader. We hope to be taken away—to share, through words, and to become more than we are. If you give yourself to something long enough and completely, it gives you something back.

So I have learned from the words in this book.

Each year I read every issue of hundreds of general-interest and sports magazines in search of writing that might merit inclusion in *The Best American Sports Writing*. I also write or email the editors of many newspapers and magazines and request submissions, and I make periodic requests through Twitter and Facebook. I search for writing all over the Internet and make regular stops at online sources such as Gangrey.com, Longreads.com, Longform.org, Sportsdesk.org, Nieman.org, and other sites where notable sports writing is highlighted or discussed. However, this is your book, not mine. I also encourage everyone—friends and family, readers and writers, editors and the edited—to send me stories they believe should appear in this series. Writers in particular are encouraged to submit—do not be shy about sending me either your own work or the work of those you admire.

All submissions to the upcoming edition must be made according to the following criteria. Each story

- must be column-length or longer.
- must have been published in 2015.
- must not be a reprint or book excerpt.
- must be published in the United States or Canada.
- must be received by February 1, 2016.

All submissions from either print or online publications must be made in hard copy and should include the name of the author,

date of publication, publication name, and address. Photocopies, tear sheets, or clean copies are fine. Readable reductions to 8½-by-11 are preferred. Newspaper submissions should be a hard copy of the story as originally published—not a printout of the Web version.

Individuals and publications should please use common sense when submitting multiple stories. Because of the volume of material I receive, no submissions can be returned or acknowledged, and it is inappropriate for me to comment on or critique any submission. Magazines that want to be absolutely certain their contributions are considered are advised to provide a complimentary subscription to the address listed below. Those that already do so should extend the subscription for another year.

All submissions must be made through the U.S. Postal Service—midwinter weather conditions at *BASW* headquarters often prevent the receipt of UPS or FedEx submissions. Electronic submissions—by email, Twitter, URLs, PDFs, or online documents of any kind—are not acceptable; please submit some form of hard copy only. The February 1 deadline is real, and work received after that date may not be considered.

Please submit an original or clear paper copy of each story, including publication name, author, and date the story appeared, to:

> Glenn Stout
> PO Box 549
> Alburgh, VT 05440

Those with questions or comments may contact me at basw editor@yahoo.com. Previous editions of this book can be ordered through most bookstores or online book dealers. An index of stories that have appeared in this series can be found at glennstout.net, as can full instructions on how to submit a story. One of the selections for this year's edition is from SB Nation Longform, for which I serve as editor, but like all other stories, it was submitted to the guest editor blindly, not identified by source or author, and was selected entirely on merit. For updated information, readers and writers are also encouraged to join *The Best American Sports Writing* group on Facebook or to follow me on Twitter @GlennStout.

I wish to extend my thanks to Wright Thompson for his hard

work, commitment, and support for this book, and to all those at Houghton Mifflin Harcourt who have helped with the production of this series for 25 years. My thanks also go to Siobhan and Saorla for bearing with my 25 years of distracted inattentiveness. And to all the writers who made it possible.

<div align="right">

GLENN STOUT
Alburgh, Vermont

</div>

Introduction

THE FIRST ENTRY in this book is a profile of an aging foot-
ball legend, Y. A. Tittle, written by my best and oldest friend, Seth
Wickersham. It's a story about time, and about what a young man
wants and what an older man gets, and about the relationship be-
tween the two. It's my favorite piece from last year, and reading it,
along with the other stories I chose, takes me back 15 years, when
Seth and I were both students at the University of Missouri, when
we could only dream of writing something as sophisticated and
nearly perfect as his story on Y.A. We had a tight group of friends,
and I often think about how much fun it would be to go back and
be with them again. We all covered sports for the *Columbia Mis-
sourian,* led by our mentor and guru Greg Mellen, and our lives
revolved around the stories we read.

I remember finding Gary Smith's "Shadow of a Nation" and
"Frank Sinatra Has a Cold" by Gay Talese. We recited openings:
*OK. Golf Joke . . . We begin way over there, out on the margin . . . Go
with him. Go out into the feed yards with Jack Hooker . . . Few men try
for best ever, and Ted Williams is one of those.* We searched out these
stories, to read and study, but also to hold, more of a talisman
than textbook. We dug through the archives of old *Sports Illustrat-
ed*s and *Esquire*s, and Willie Morris's *Harper's* and Clay Felker's *New
York.* We read stories online and in the school library, speaking the
names of the canon with a reverence that only college journalism
students really understand: Gary Smith, Tom Junod, Gay Talese,
Richard Ben Cramer, Charles P. Pierce, Rick Telander, Michael Pa-
terniti. We read all of their work, and we also waited for the *Best*

American Sports Writing to be released each year. We wanted to be in the book, yes, but more than that, we wanted to be part of the community of people trying to write the kind of stories that *might* end up in the book.

We formed an impossibly nerdy secular church with the classics of narrative nonfiction as our holy text. We'd sit around and argue: I remember a particularly intense fight at a bar called Harpo's with my friend Steve Walentik over Junod's profile of Michael Stipe. Steve and Seth, Justin Heckert, Daimon Eklund and Tony Rehagen, and so many others—we were a brotherhood who wanted something, and while that something seemed impossibly far away most of the time, the stories in *Best American Sports Writing* made it seem reachable.

We did bad Gary Smith impersonations and filed stories written in second person from the point of view of alcohol (uh, Seth) and game stories that began with imagining outfitting a food or drinks vendor with a tape recorder (ahem, Heckert). We wrote schmaltz and sap and saccharine, laced with over-the-top allusions to ancient literature—one defensive end was "a Grendel among the Danes" (sadly, me)—and we copied our heroes and tried to improve. We wrote awful stuff and one or two halfway decent things; the best story any of us did in college was Heckert's profile of Missouri football player Jamonte Robinson, which I remember reading with fear, because I wasn't capable of doing work like that, but now I had my target. That story inspired us to try to be as good as Justin. Seth got a job before any of us, at *ESPN The Magazine*. He soon began talking of "narrative arc," and he wrote a profile of Antwaan Randle El, the first one of us to actually have a national magazine byline, and suddenly there was a new target. We pushed each other that way, and when I look on my shelves and see my collection of the *Best American Sports Writing* books, I remember those friends and that time.

The publisher asked me to write an introduction to this book, which I know many sports fans buy because they cherish the stories. I think of the book as something to be treasured by the many young writers, in college and in their first jobs, who want to create stories that people read and remember.

The work collected here offers many specific lessons. See how Seth constructs the Tittle story, or how Chris Jones evokes the emp-

tiness of a house built for loud boys, a story about the Gronks but also about being left behind. Watch Dan Wetzel pull off deadline magic, or see Jeremy Collins channel Larry Brown or Raymond Chandler in his story about his best friend watching Greg Maddux. Wells Tower's piece is a kind of literature, as is Flinder Boyd's. Don Van Natta Jr. takes us inside the world of a famous and rarely understood man, which to me remains the most important skill in magazine writing: the profile. Rick Bass reminds us that a magazine story's highest aspiration is to be a short story that is true. I see so much in these pages to emulate in my own work, little hints for making it better. For instance, the best profiles are of people who are going through something you are going through in your own life. Also, find the central complication in someone's life and show through scenes how, on a daily basis, they solve it. (I stole that advice.)

When I first started reading *The Best American Sports Writing*, I imagined the book as sacrosanct, but now I see that it's just one person's opinions. For this edition, I picked what I liked. Here's exactly how it happened. Glenn sent me a pack of maybe 70 stories, which he'd culled from the hundreds of entries he gets and collects himself. They were all printed without byline or headline, cut-and-pasted into a Word document. I began reading. If I finished a story without ever wanting to stop, it went into the yes pile. If I didn't like all of a story, it went into the no pile. Everything else became a maybe. I was surprised by how many I'd never read before; my World Cup travel this past year evidently made me miss a lot of stories. I picked "Haverford Hoops," written by Chris Ballard, without any idea who wrote it or where it ran.

I wanted a specific kind of story. Years ago, at some conference, I heard someone say they wanted "the stench of journalism" off their work, which I took to mean all those canned phrases and boilerplates that break the spell a writer is casting. I wanted stories with a beginning, middle, and end, and stories that not only told of a character encountering an obstacle and being changed by it, but also evoked some larger human condition. I picked some stories outside that definition because they made me feel, or see, something.

These are not the "best" 21 stories of the past year—they are simply the ones I liked best out of a stack Glenn Stout mailed me. I

added three that were not in his selection, including Scott Eden's story on Yasiel Puig. A year ago, Scott's Tiger Woods story wasn't selected, just to show how the book really is compiled according to one person's whim. Since this essay is aimed at journalism students, here's a lesson on how to end a story. This is the last paragraph of Scott's Woods story, referencing the famous clip of Tiger as a young child on a television show:

> What you might not recall is the club. It is a sawed-off adult 3-wood with a stiff steel shaft, a standard-size persimmon-wood head and what appears to be a grip of adult gauge. The club would have likely weighed about 300 grams, not much less than an adult male's driver today. And it's only in rewinding this tape that you see that this foreshortened club, made by Earl, is clearly too heavy for the boy. So heavy that when he makes his backswing, the club goes far past parallel; for an instant, you think he might drop it. From that point, in order to get this ponderous thing square to the ball, the boy must uncork his hips with all the might available in his toddler body. And then he must whip his hands, also as hard as he can, so they'll catch up with his hips. Which they do. Pop. The ball launches into the net in the shadows of the stage's backdrop. Cheers erupt from the crowd. And when you rewind the clip and watch it again, and again, the moment reveals itself: Tiger Woods, at 2 years and 10 months, is making the very same move, containing the very same flaw, that the man version of this boy will spend his entire career striving to erase. Only a person with world-class coordination and kinesthetic sense could possibly swing a club like that as a toddler. The flaw, in other words, was grooved by his own talent.

The selected entries are both road map and compass, for those starting out and for those like me who are still trying to improve. I spend a lot of time trying to make sure that I don't stop working as hard as we worked all those years ago, and that I don't take any success for granted. Writing one good story doesn't buy you anything the next time out, except for maybe a little confidence, and even that has a half-life of nothing. I'm often wondering if I'll write a good story again, or wondering how I've written some of the good ones in the past, and over and over I find my way out of the darkness by reading a story I love, one that inspires me to be better and makes me afraid that I'll fail. If nothing else, I hope that you'll find that kind of North Star in this book.

*

Being asked to edit this book was an honor, but it also made me realize how fast time goes and how far away I am from the sports desk at the *Missourian*. When I speak at college journalism schools, students inevitably ask me how someone gets my job. The truth is, I'm not sure how I got it. Since I had to write this essay as part of the agreement—a piece certain to read as narcissistic and self-involved—I've been thinking about the past 15 years and wondering about that question. The best answer I can come up with is that I've always been surrounded by smart people who believed in me: Greg Mellen at the *Missourian*, Colleen McMillar at the *New Orleans Times-Picayune*, Mike Fannin at the *Kansas City Star*, and so many people at ESPN: Jay Lovinger, who changed my life; Jena Janovy, Michael Knisley and Kevin Jackson, Rob King and Patrick Stiegman, the Johns (Skipper and Walsh), Paul Kix, Chad Millman, J. B. Morris, Eric Neel.

Mostly, though, I've been surrounded by a group of friends. Without them, none of this would have happened. We fell in together, pushing, pulling, helping each other, and hurting each other too—being there to read stories, sure, but also for funerals and weddings. At the risk of reverting to the schmaltz of the *Missourian*, I find myself thinking about them right now. The other day it was announced that Shakespeare's Pizza, a block from the Mizzou J-School, was being torn down and rebuilt as part of some luxury apartment building, and while everything will be put back, nothing will be the same. Some spirit of the old place will be gone forever, another reminder of how fast things can disappear. God, I'm getting nostalgic and unbearable now, so I'll wrap it up. One last story, if that's okay.

I remember one night a long time ago, sitting with Seth at a bar in Columbia called Widman's. It was the low point of my quest to write the kind of stories included in this book; I couldn't get an internship or find a single person outside of my teachers and circle of friends who believed in me. I was desperate, and all these years later I realize that the stories I loved kept me going in the face of rejection.

I hope a story or two in this book does the same for you. I hope that in 15 years, when one of the people reading this book is suddenly its guest editor, you'll be able to pick your best friend's story, a masterpiece about the inevitable march of time. Maybe you'll

take a moment while writing a short essay to think about how fast it all goes, and how it feels like just yesterday you read Gary Smith or Gay Talese for the first time and wondered if you too would ever find a Jonathan Takes Enemy or get close to someone like Frank Sinatra. I hope you enjoy these stories, and I hope they help you write the stories you dream of being able to write.

Wright Thompson

The Best American
Sports Writing
2015

Awakening the Giant

FROM ESPN THE MAGAZINE

YOU REMEMBER THE picture. Y. A. Tittle is on his knees in the end zone after throwing an interception that was returned for a touchdown. Swollen hands on his thigh pads, eyes fixed on the grass, he is helmetless and bleeding from the head, one dark stream snaking down his face, another curling near his ear. His shoulder pads make him seem hunched over, resigned, broken down. The black-and-white photo was taken in 1964, the final year of Tittle's career. It hangs in a silver frame at his home in Atherton, California, not with the prominence befitting one of the most iconic pictures in sports history but lost among many mementos from a Hall of Fame career. The picture is now 50 years old, and Tittle is now 87. He does not remember much anymore, but that photo is seared in his mind. "The blood picture," he calls it. He hates it.

He remembers a place. It is in Texas.

On a December morning, he's sitting in his usual spot on his couch, flipping through a photo album. His breathing is labored. There is fluid in his lungs. Waistline aside, Tittle doesn't look much different now than he did in his playing days: bald head, high cheekbones, blue eyes that glow from deep sockets, ears that have yet to be grown into. His skin is raw and flaky, and when he scratches a patch on his head, a familiar line of blood sometimes trickles down. He shares his large house with his full-time helper, a saint of a woman named Anna. His daughter, Dianne de Laet, sits nearest him, leaning in as he touches each yellowed picture.

"That's at Marshall High School!" Y.A. says, pointing to a shot of himself in a football uniform worn long ago, long sleeves and a leather helmet. That takes Y.A. back to his tiny hometown of Marshall, Texas, near the Louisiana border. Friday nights in the town square, where "I'd neck with a girl, if I was lucky." Brown pig sandwiches at Neely's barbecue. And football, always football. In 1943, he says, Marshall High traveled 200 miles to play Waco, ranked second in the state. The Mavericks pulled off the upset, and on the couch he recites the beginning of the newspaper story: "From the piney woods of East Texas came the challenging roar of the Marshall Mavericks, led by a tall, lanky redhead with a magical name: Yelberton Abraham Tittle."

He is slightly embarrassed as he utters his full name. As a teen-ager he reduced it to initials, and it later became legend. Remembering his Texas days seems to bring a youthful spirit out of him, which is why Dianne gave him this album today. But then he flips to a photo of himself during his college days at Louisiana State, and something slips. "Where did you get these pictures?" he says to Dianne. "I haven't seen them."

She knows that he has seen these pictures many times, of course. Some even hang in his house. Dianne is 64 years old, with blue eyes shining from a face that she tries to keep out of the sun, and it is hard for her to watch each old photo bring the joy of a new discovery. She lives feeling a loss for her father, a loss that he doesn't feel for himself—until something stirs it up. That happens when Y.A. mentions that his phone has been strangely quiet, considering that Christmas is in a few days. He suddenly realizes that he hasn't heard from his best friend from high school. "I don't think Albert died, did he?" he says.

"He died," Dianne says, with the forced patience of having to repeat news over and over. "He died a couple months ago."

"Oh yeah, right. He was such a good friend."

"Jim Cason"—Y.A.'s best friend from the NFL—"also died about a month ago," Dianne says.

"You said Jim Cason died too?"

"He's gone."

"Damn," Y.A. says, closing the album.

"You're the last leaf on the tree," Dianne says.

*

She remembers her dad. It's not the person he is now. Some years back, doctors diagnosed dementia. Friends always ask Dianne if his condition is related to football. She can't know for sure but thinks he's simply getting older. In the past year, Y.A.'s memory loop has tightened like a noose. He repeats himself every minute or so. It has left a football legend, whose speaking engagements used to take him around the country, incapable of holding normal conversation and limited to a handful of topics: his late wife, Minnette; his four children, seven grandchildren, and five great-grandchildren; football; the hope of a vodka rocks each day at 5:00 p.m.; and, most of all, his hometown of Marshall, Texas.

Anyone familiar with Tittle's football career knows that it wasn't supposed to be this way. His body was supposed to crumble, not his mind. He was famous during his 17-year career—as a backup with the Colts, as a star with the 49ers, and as a legend with the Giants—for not only playing through pain but for retaining a wit in the face of crushing losses. But Dianne has watched her dad regress in inches, too small to notice during daily visits from her nearby house but devastating when considered in their totality. "I haven't lost him," she says. "But I'm losing him."

Still, she believes—hopes—that the dad she's known all her life resides somewhere inside, bound up and waiting to be freed. That person arrives in flashes, mostly when he talks about a party that he has hosted for 27 years in a row at his house on the shores of Caddo Lake, 20 minutes northeast of Marshall. What began as a way to give Tittle's former teammates a taste of East Texas evolved into an annual event, a rite of spring, with friends from every stage of his life sitting on the porch as the sun set, drinking beers and eating barbecue, strumming guitars and howling country songs, listening to the host's yarns grow more elaborate as the cooler emptied and night descended into morning. His golden rule of storytelling: "Lie to tell a truth." When folks would mercifully stumble to bed, Y.A. would issue an order: be at the dock to go fishing at 7:00 a.m. They would always be there, black coffee in hand. Y.A. would usually oversleep.

That party is never far from his mind, even now. In December, as if on cue, the anticipation of hosting for a 28th year creeps into Y.A.'s consciousness. "We have to do it," he says to Dianne.

She is wary. Most of his teammates are dead. The prospect of a

few widows surrounding her confused and crestfallen dad seems terrifying. But in California, he spends his days in the TV room of an oversized house as his memory evaporates. Maybe, she wonders, his memory can briefly be restored in Marshall. Maybe geography can somehow transcend disease.

"We're going," Dianne says.

Dianne hopes she can give her dad the kind of miracle he once gave her. On December 17, 1949, in Houston, Y.A. was playing in a charity football game when suddenly an eerie feeling told him to go home. He hitchhiked four hours to his house in Marshall, and early the next morning, Minnette, pregnant with their first child, awoke covered in blood. She had suffered a placental abruption and was hemorrhaging. Minnette was rushed to the hospital. Men weren't allowed in the delivery rooms back then, so Y.A. pounded on the door, desperate for any update. Minnette survived. Their child, a little girl, had gone so long with so little oxygen that doctors pronounced her dead on her birth certificate. But the doctors were wrong. Dianne was alive—four trembling pounds, cradled in her dad's hands.

So it's fitting and somewhat ironic that of all the Tittle kids, Dianne is the one whom Y.A. now calls "my quarterback. I do what she says." In a family of athletes, she suffered from exercise-induced anaphylaxis—potentially fatal allergic reactions brought on by physical activity. Still, she grew up trying hopelessly to connect with her dad. She watched all of his games, studying them for clues into what football revealed about him. Fans saw him as a star, larger than life. She saw him as human—a target on a field, a limping hero at home. Y.A. tried to bond with his daughter by ironing her clothes, but at heart he was the type of father who had no sympathy for splinters or stubbed toes and who wouldn't talk football without one of his sons present.

It was not easy for a country boy from Texas to raise a beautiful teenage daughter in the 1960s. He initially disapproved of her marrying her hippie boyfriend, Steve de Laet, whom she met at the University of Colorado. And he initially disapproved of her decision to become a poet and harpist too. "The only Sappho I ever knew played for the Green Bay Packers," he liked to say.

In 1981, Dianne ran a marathon, and when her allergy began to fight her from the inside, hardening her mouth and swelling her

skin, she thought about how her dad always played through pain—through blood, even—and she finished. At a family gathering a year later, Dianne said: "Dad, sit down. I'm going to do something for you on the harp."

She recited one of her original poems, and afterward Y.A. said, "What Greek was that?"

"Dad, it's called 'The Hero.' It's about you."

Dianne has tentatively planned the annual party for March, but Y.A.'s health might prevent him from flying. In January, Y.A.'s breathing was so bad he thought he was dying. "This is it," he told Dianne. He was placed on oxygen. But over months of daily conversations with his "little bitty brother" Don—he's 84—Y.A. asks hundreds of times when they're going to Caddo Lake. Finally, Dianne books the party for the last Friday in April, but days before they are due to leave, Y.A. comes down with bronchitis. They board the plane to Dallas anyway. On the flight, he collapses from lack of oxygen; passengers have to help him off the floor. The entire trip seems like a bad idea. But then Don picks up Dianne, Y.A., and Anna at the airport, and they drive three hours east, off I-20 and to the end of a long country road, where a white house emerges from the blooming dogwoods. A sign reads: TITTLE'S BAYOU COUNTRY EST.

"It's magical," Y.A. says.

They spend the afternoon on the back porch, staring at the lake. A breeze crosses through. Condensation from cold beer leaves rings on their table. Dianne studies her dad, hungry for flickers of memory, but he seems to be getting worse. Ten or so times each hour, he utters a version of this: "I grew up in Marshall, Texas. I went to Marshall High School—the Marshall Mavericks. I went to LSU to play football so that I could be closer to my older brother Jack, who played at Tulane. He was my hero."

He hollers at Anna to bring him a vodka rocks and makes a few crude jokes, as if returning home has transplanted him to his teenage years. It's all too much for Dianne. She walks to the dock and stares at the muddy water. It's clear that there won't be any magic on this trip. "His memory is gone," she says, as if she needs to confirm it to herself. The party seems like a looming disaster. One of his few living high school teammates can't make it. Her brothers are unable to attend. She's out of energy and patience, and she

feels guilty about both. Her eyes turn glassy. Something more than a party is at stake.

"You're witnessing a family tragedy," she says.

The lake seems to calm her, as it did the dozens of times she came here as a child. Soon she remembers today's tiny moments that made her smile. During lunch at Neely's barbecue—a Marshall staple almost as old as Y.A. is—everyone stopped and stared and pointed. Waitresses wanted a picture. Two teenagers approached him, calling him Mr. Tittle. Y.A. sat with them over brown pig sandwiches, talking about their football careers, not his. When it came time to leave, Y.A. reached for his wallet—he always pays—but the boys had already picked up the tab. It gave Y.A. a fleeting moment of honor, and it gave Dianne a fleeting moment of reassurance. She sometimes forgets that he is still a sports icon, even as she's more protective of him than ever.

It's dark now, and the mosquitoes are fierce. Dianne heads back to the house. Y.A. slowly lumbers inside from the porch. He sinks into a couch, panting so hard that it resembles a growl. It's been a long day.

"You still breathing?" Don asks.

"I'm still breathing," Y.A. says.

Y.A. coughs hard most of the night, and by morning he is exhausted and croaking, his voice a scratchy wisp. But he has enough energy to venture into Marshall for a glimpse of his childhood, maybe the last. In the passenger seat of an SUV, he seems more alert, guiding Dianne through the outskirts of town as if he'd never left. They drive a mile down a thin, sleepy road and over a hill—a stretch he used to walk in the dark after football practice—until they arrive at a grassy lot, barren except for the crumbled foundation of a brick house that burned down a few years ago. A NO TRESPASSING sign hangs on a tree.

"Here it is," Y.A. says. "I grew up here."

They park on the lawn. A man from a nearby porch looks over suspiciously, then turns away. "This brings back so many memories," Y.A. says. Dianne sits in the car, waiting to hear stories that she's heard many times. He used to tell her about the hundreds of bushes that filled the yard and how in 1936, at age 10, Y.A. would pretend to be Sammy Baugh, taking a snap, rolling right, throwing

to them. "They were my receivers," he would say. The ball would lodge in a bush and he'd run to it, then throw to another, then another, for hours—Complete! Twenty-five yards! Touchdown!— fighting through asthma, through an allergy to grass, dodging snakes, sick with himself if he missed two bushes in a row, fascinated with spinning a ball long and well. His father, Abe, would come home from his job at the post office and be furious, his yard decimated. But Y.A. couldn't stop. Nothing made him feel so alive.

It's quiet in the car.

"This is a bit sad for me," Y.A. says.

Seconds pass. "What are we going to do with this property, Dianne?" he says.

"Dad," she says, trying hard not to tear up, "a young woman owns it."

Again, silence. As Dianne slowly steers the car away, she says, "This might be our last trip out here." Soon after, Y.A.'s sadness seems to have cleared from his mind like a bad throw. He directs Dianne past the cemetery where his parents rest, past the old grocery store, past the Harrison County Courthouse, to a brick building. "This is the old Marshall Mavericks High School," Y.A. says.

Dianne slows down, but Y.A. doesn't want to stop. He tells her to turn right, then left, until she pulls up alongside a park, fenced up and unkempt.

"This is the old football field," he says.

Dianne hits the brakes. "Dad, I have to get out." She jumps from the SUV, past men sitting on their cars and drinking out of brown paper bags, past rusted gates with broken locks, up concrete stairs blanketed in shattered glass, and looks out onto a shaggy field that she's never seen before. "Wow," she says.

She takes off her shoes. She needs to run. She owes her life to this field. It wasn't where her parents first made eyes—that was in the town square—but it's where they fell in love. Before he graduated from high school, Y.A. gave Minnette a bracelet with their initials in hearts. He left for LSU, she for the University of Arkansas, putting their relationship on hold. As a senior, Y.A. was asked by a reporter what he planned to do after graduating. "Marry my high school sweetheart and play professional football," he said. Minnette's boyfriend at the time was not amused. Months later, she and Y.A. were married.

A train whistles by. Dianne reaches the end zone and raps her knuckles against the rusted goalpost. She stands with her hands on her hips, tears and sweat soaking her face . . .

Y.A. slams the horn, ready to leave. Dianne takes a final look and climbs into the car, adrenaline filling her chest. Before she can turn the keys, her dad does something rare: he begins to sing. *When those old Marshall Men all fall in line, we're going to win that game, another time. And for the dear old school we love so well, we're going to fight, fight, fight and give them all hell!*

She is in awe. Since she landed, she's been questioning why she made this trip. Is it for her dad? For her? Is it to cling to a fanciful dream? Finally, she's in a moment that beats the hell out of the alternative.

Two blocks later, Y.A. says, "Did we go by the old Marshall Mavericks High School?"

That afternoon, outside the house, an electrical worker approaches Y.A. as he gets out of the car. "I know who you are," he says. "Y. A. Tittle. New York Giants. You're a baaaaad boy!"

"Well, thank you," Y.A. says.

A few minutes later, on the couch, he opens a dusty commemorative book celebrating the Giants. He turns each page slowly, back to front, present to past. Legends pass on the way to the middle of last century, to the era of Gifford, Huff, and Tittle, a team of Hall of Famers known for losing championships as their peers on the Yankees—with whom they shared a stadium, a city, and many rounds of drinks—became renowned for winning them. Y.A. stops at a black-and-white shot of a man standing alone on the field, covered in mud.

"That's me," he says.

It's from 1963. The same year in which Y.A., at age 37, set an NFL record with 36 touchdown passes. But he injured his knee early in the NFL title game against Chicago and threw five interceptions. It was his third straight loss in a championship game, and it effectively marked the end of his career. For years, he was the rare quarterback in the Hall of Fame without a title. It hurt. He always covered it up by poking fun at himself, making jokes about the weather during the championship games. But that last loss to the Bears was the worst day of his career: cold, bitter, violent. It marks him, even today. That game, he will never forget.

He turns to a page dedicated to the best performance of his career, against the Redskins in 1962, a game when he set a record with seven touchdown passes.

"I didn't know I was that good," he says.

Y.A. often talks about how he misses football. He misses the camaraderie, misses raising a vodka and saying, "We did it." The game was, as Dianne likes to say, his "emotional home," and in retirement in Atherton, he "was homesick for it." Y.A. and Minnette fought a lot during those early empty years, struggling to adapt to a new reality; Dianne once screamed at them so loud to stop arguing that she lost her voice. Y.A. spent the next few decades running an insurance company, giving speeches, and informally advising quarterbacks. He developed real estate in the Bay Area and made a lot of money and traveled the world and bought houses around the country. He buried his older brother, his sister, his wife, and one of his sons. As the voids in his life piled up, the party at Caddo Lake became more important. Dianne considered it noble that her father strived to host it each year the way he had once strived for a championship. Each party was a win. That's why she hates the blood picture too. The image of defeat that the world associates with her father does not resemble the man she grew up idolizing, the man she desperately hopes is still inside the current one, pining for what she calls one last "moment of victory."

Y.A. closes the Giants book, and family members filter into the room. Tonight everyone wants to eat at the Longwood General Store, a roadside steakhouse. Back in the day, it was one of Y.A.'s favorite joints. Now he doesn't want to go. "We came 3,500 miles to see this," he says, pointing outside. "We got vodka and a meal and the lake. Why leave?"

Anna nudges him out the door. But then his memory circle restarts. Why leave? He refuses to get in the car. Family members buckle their seat belts, hoping the air of inevitability convinces him. But now he has to use the bathroom. Then his memory loop kicks in again, and he makes his old argument with the conviction of it being new. The family is exhausted. One of the most painful aspects of dementia is that it not only robs Y.A. of memory and identity, it robs him, as Dianne says, "of the capacity for joy."

Five minutes later, Y.A. relents. The restaurant is a shack of Americana, with a stuffed alligator and old signs offering baths for 25 cents, exactly the type of place that could stir some memories.

The family orders steaks and beers. Y.A. orders catfish and a glass of milk and barely utters a word all night.

It's Friday. Party time. Dianne is stressed, hustling to prepare. Y.A. is stressed too, aware that something he cares about deeply is out of his control. "Dianne," he says, "did you make a guest list?"

"No."

"What kind of party doesn't have a guest list?"

The truth is that she didn't want to. She still doesn't know who's coming. But one of Y.A.'s oldest friends, a 90-year-old woman named Peggy, helped spread the word. And at 5:00 p.m., on a sunny and warm evening, guests arrive in droves—mostly neighbors and friends of the family. Y.A., dressed sharp in a navy blazer, greets everyone at the kitchen table. It's hard to tell if he remembers any faces, if not names. The party swells to 50 or so people. Dianne leaves her dad's side to catch up with old friends, reliving memories of her own.

A white-haired man approaches Y.A. and says, "I know every game you ever played, what you did, and who you played with."

"Oh yeah?" Y.A. says.

He hands Y.A. a copy of the *Marshall News Messenger* from September 30, 1943. Y.A. opens the fragile paper and scans the Mavericks roster until he sees Yelberton Abraham Tittle. He shakes his head.

"I've got the worst name in the world," he says.

The party moves to the porch, and Y.A. sits in front of a guitar trio, tapping his feet. Every few minutes he repeats a thought as though it has just occurred to him. He requests "On the Road Again" over and over, and the band acquiesces most of the time. Between songs, his friends tell some of their favorite Y.A. stories. About how he used to fake injuries to keep from losing at tennis. How he was benched once because he refused to cede play-calling authority to the head coach. How he once persuaded a referee to eject his coach rather than throw a flag. Y.A. occasionally laughs but mostly stares at the lake.

Midnight nears. People leave one by one, kissing Y.A.'s head and saying, "God bless you." He gives a thumbs-up for the cameras, and he autographs the only photo people brought—the blood picture, of course—by signing his name neatly on the white of his

shoulder: Y. A. Tittle HOF '71. A palpable finality lingers, as if everyone knows this might be the last time they see him.

The musicians move inside to the living room. Y.A. gives his all to hobble closer to them, one foot barely shuffling in front of the other. He sits on the couch, coughing. It is past his bedtime. Only six or so people remain. Y.A. holds his watered-down vodka but doesn't drink, humming along to country songs.

Then someone plays the opening chords to "Amazing Grace."

"Oh God," Y.A. says.

His face reddens, like dye touching water. His eyes turn pink and wet. His breathing becomes deep and heavy. He brings his left fist to his eye, then puts down his drink, and soon both hands are pressed against his face. Memories are boiling up. Only he knows what, and soon they will be gone. The only thing that's clear is that Y. A. Tittle is finally whole. He opens his mouth but can't speak. He stares at the ground, his face glossy and damp, and begins to mouth the words, *I once was lost but now am found.*

Something feels different the next morning. Y.A. sits in a recliner with a blanket warming his legs, holding a coffee. Sun lights the room. Dianne and Anna lean on the counter; Don and Steve, Dianne's husband, sit on the couch. All are tired, their voices scratchy. But they're huddled in a sort of wonder. Y.A. is telling stories that have been told before but seem sweeter now.

"Tell the snake story, Dad," Dianne says.

"We saw a big snake," Y.A. begins. "This was 10, 15 years ago. Right out there. We were scared to death. I tell everyone to get back.

"I get a hoe. I sneak up behind it and hit it and hit it and hit it and hit it. I was protecting my family. Finally, it flipped over. I looked and it read, 'MADE IN JAPAN.'" Everyone laughs. Y.A. is on a roll. He is trying hard—too hard—to convince everyone that as a single man he rarely exploited his fame for any backseat pleasures. "I would sometimes get a kiss," he says. Just then, Anna brings a plate filled with Y.A.'s medicine, tethering him to his current reality. "Anna!" Y.A. says. "I'm telling a bunch of lies over here and getting away with it—until you brought these pills."

For a moment, at least, nobody is searching for a glimpse of what Y. A. Tittle used to be. They're enjoying what he is. A few

minutes later, Dianne watches with pride as he heads toward the door, waving off any help. "I can walk anywhere," he says. "I can run anywhere.

"I can still play football."

The next day, Dianne, Anna, and Y.A. board their 6:00 a.m. flight back to San Francisco. A tornado is destroying the region. Dianne is bracing for another rough trip. Y.A.'s cough seems to be worse, and Dianne knows that very soon her dad will forget about the party. Yesterday afternoon, discussion turned to the plans for the night. Y.A. said, "We're having people over for the party, right?" A bit of the color drained from Dianne's face when she heard it.

But the plane takes off smoothly, leaving the storm behind. In the air, Y.A. breathes easily. No oxygen is needed. When they land back in California, where time and memory stand still, he says to Dianne, "That was one of my best trips home."

CHRIS JONES

One Thousand Two Hundred and Fifty-Eight Pounds of Sons

FROM ESQUIRE

GORDY GRONKOWSKI, the patriarch of those very same Gronkowskis, America's First Family of Smashmouth Football, the man who somehow parlayed five orgasms into 1,258 pounds of relentless physical force—a first baseman, two tight ends, and two fullbacks—the first father in 20 years to see three of his sons play during a single NFL season, and the first father in nearly 30 years with an even-money chance to see a fourth, might have gone after it a little hard last night.

He spent the evening and a good chunk of this morning in downtown Buffalo, watching his alma mater, the Orange of Syracuse, lose by two points to Dayton in the NCAA tournament, and suddenly it's obvious how his sons learned to shake off disappointment by laying waste to themselves and one another and however many blocks of their battered hometown. It's Sunday afternoon, and Gordy's still moving a little more slowly than his usual terrifying pace, sipping from a bottle of water, shaking his head at himself and his hangover. "That was rough," he says. "I don't know why that kid didn't drive to the basket."

The kid in question, for once, is not one of his. His kids would have driven to the basket. He's referring to Syracuse guard Tyler Ennis, who in the dying seconds launched a long three for the win when he might have driven for the push, dooming the Orange to elimination rather than sending the game and their season into overtime. For most of the people in the arena last night, Ennis's

snap judgment was just a bad call made by a teenager under the clock's adult-sized pressure. But Gronkowski doesn't watch sports the way the rest of us watch sports. For him, games are not just games. "They are everything," he says. They are morality plays, tests of will and feats of strength, definers of men and boys and their good family names for generations. In sports, Gronkowski sees justice and beauty, companionship and teamwork, discipline and sacrifice. He sees blessings earned or squandered, and he sees fundamentals learned or forgotten. Most of all, he sees belief and the power of it, and he sees the terrible blackness that roosts in its absence. And when you see sports and therefore the world the way Gordy Gronkowski does, nothing makes less sense than a divinely talented kid launching a no-hoper when the lane and the universe were wide open to him. "You drive the basket," he says, and he says it as though he's expecting not only agreement in this particular instance but a lifelong conversion to the idea: in the dying seconds of every basketball game that remains to be played here on earth, every basket shall be driven.

It's easy for Gronkowski to be certain: look at his boys and what they have done. He built this house in 2002, in a Buffalo suburb called Amherst, and it is a physical manifestation of his faith in them, custom-built for giants and their dreams. The rooms are huge, the hallways are double-width, and the doors are as tall as the ceilings in more-mortal shacks. ("The movers loved it," Gordy says. "They could swing the furniture around no problem.") Every bed those movers moved was king-sized. One bedroom contains three of them alone; they were for the boys, but not for any specific boy. "They slept in any of 'em," Gordy says. "Wherever they crashed that night, they crashed." In the predictably massive backyard, there is a baseball field, 325 feet down the lines; a pool and a hot tub; a full tennis court with regulation-height basketball hoops and hockey nets too. It is child-jock nirvana.

But the basement is the true heart of this home. Gordy pads down the stairs and turns on the lights, suspended from 10-foot ceilings. The walls are bare studs. "I didn't want it plush," he says. "I wanted that hard-core feeling." He owns and operates G&G Fitness, a chain of 14 home and commercial gym-equipment stores across the Northeast, and his basement looks like an unfinished showroom. There is approximately $80,000 worth of gear down here, machines dedicated to every muscle group: a bench with a

safety rack, a leg press and calf lift, a punching bag, free weights, pull-up and chin-dip bars, a kind of elliptical—"That's an AMT," Gordy says; "Precor, top of the line"—a rowing machine, and a treadmill. He climbs onto each piece of equipment to demonstrate the very particular part of his body it is designed to improve, his fatigue visibly lifting with the weights. He is 54 years old, and he is six-foot-three and 235 pounds of Polish American muscle, and he still comes down here six days a week, working out with the enormous ghosts of his five absent sons.

Along one wall, he has built five trophy cabinets, black with glass fronts. Together they are about 20 feet long and six feet high. Unlike the beds upstairs, each cabinet has been assigned to a particular son, arranged in birth order: first Gordie Jr. (first baseman, drafted by the Angels in 2006), then Dan (tight end, drafted by the Lions in 2009), Chris (fullback, signed undrafted by the Cowboys in 2010), famous Rob (tight end, second-round pick by the Patriots in 2010), and finally Glenn, dubbed "Goose" by his family (fullback, Kansas State). Today they help Gordy remember, like photo albums, but that's a new, unintended purpose. Gordie Jr.'s cabinet is full, but it is the least full; Rob's is the most full. They are stuffed with trophies and medals of every possible sort, football and baseball MVPs and championships but also awards for basketball, hockey, and even bowling prowess. In Dan's cabinet, there's a size-16 shoe he wore when he played at Maryland; in Rob's, there's the football delivered to him by Tom Brady for his first NFL touchdown. There are nearly 500 trophies of various sizes in all, shining under the lights.

Gordy looks at the trophies, and he takes another sip of his water and he nods, because even though he knows in his heart that the way he raised his sons was right, such hard evidence makes it easier for him to believe. He mindfully kept the cabinets segregated by child because life is a competition and triumph is often singular, and he just as mindfully kept them in the basement, with the barbells and racks, because some products are better left on the factory floor. These trophies will always remain down here, where they were made, each one a mathematical proof, each one an article of faith, so that together they might multiply.

Gordy Gronkowski's favorite piece of basement equipment is something called a vibration plate. It looks almost like an industrial scale, with a square metal platform sturdy enough to handle

a careful elephant. He climbs onto it and he grabs hold of two handles on the ends of bands and kicks an invisible button. The machine comes buzzing to life, and now Gordy sounds like he's being mildly electrocuted. "This thing is awesome—you loosen right up, you gotta be on the balls of your feet, it hits everything," he says, his voice warbling, his entire body seized with tiny tremors.

Vibration plates are meant to shake out sore muscles, breaking up pockets of lactic acid and staving off cramps, and they may in fact perform such an essential service. But something about this artificial earthquake seems like quackery, like a scaled-up version of magnetic bracelets or miracle tonic—which makes it odd, at least at first, to learn of Gronkowski's allegiance to the benefits of full-body vibration. It runs counter to his more evident logical self, the man who has always subscribed so strongly to the efficacy of counting trophies.

He has an otherworldly capacity for figures. The numbers he cites are always exactly right, and he finds the truth in them in so many ways. "I'm always looking at the number," he says. "That's the only way I can really judge you." Gordy can claim to be successful in part because G&G Fitness has 69 employees. He didn't care especially which college each of his sons attended, so long as it offered a scholarship and had a good business school. At his physical peak, he could bench 225 pounds—the NFL combine standard—34 times. (Rob could manage only 23.) His sons weren't permitted to lift a particular weight unless they could do 15 reps with it; 15 reps was the standard that prevented injury. He is that rare father who even knows his children's weight to the pound. "Robby's 265, I think Danny's 260 right now, Gordie's close to 250, Chris is at 245, and Goose right now is about 238"—for that grand total of 1,258 pounds of Gronk. Gordy Gronkowski's family is bigger than yours, and that's a hard fact.

But there is also a mysticism in him that goes well beyond the countless hours he has spent down here vibrating the shit out of himself. In his own mathematical way, he holds an abiding faith in karma. "I always preached karma to my boys," he says. "Take my word, I did a lot of things wrong, and it always comes back to bite you three times. I always give 'em the three-to-one ratio."

Gordy is the son of a man named Ignatius Gronkowski. He has one brother, older, a comic-book character named Glenn. ("At his prime, he was six-foot-eight, 320, 24-inch arms on him," Gordy

says. "I'd say he's 290 now.") Ignatius Gronkowski was the son of an Olympian cyclist, and he was a big man and bodybuilder too. The Gronkowski family tree has only trunks. But Ignatius Gronkowski was deeply flawed, a heavy drinker and a largely absent father, giving his children little beyond their name and their mass. Glenn rebelled by retreating to his room, shutting the door, and escaping into books. Gordy hit the streets. "I was just a punk, beating people up all the time, stealing," he says. "My way of getting attention was to be an idiot, or to go beat the shit out of someone. I was an asshole, that's the bottom line."

Then he got to high school and one otherwise ordinary morning, he decided to make something more of himself. "I hate to say it, but I didn't want to become my father," he says. Driven by rage more than anything else, he hit the weights and played baseball and football with abandon—"The one thing I got was, I'll rip your throat out," he says, "I got that"—setting his sights on the college scholarship that would save him. When no offers came, he stole his game film from his football coach's office and bought a bus ticket to California (it cost him $240, he remembers), and he spent the spring of 1977 motoring up and down the state, visiting schools, trying to find one that would take him. Finally, Long Beach State offered him a spot, and he returned to Buffalo the prototypical self-made man.

Then something happened far beyond his scope. He was playing baseball back home with a friend named Dennis Hartman, who had been recruited by Syracuse. The Orange's defensive line coach was at the game, keeping tabs on Hartman, when he happened to notice this other big kid who could move his feet. Gordy Gronkowski attended a tryout and ended up signing with Syracuse instead of Long Beach, taking a short right rather than a long left, having earned his unlikely full ride at a school that he had never dreamed would take someone like him. His victory was hard won, the culmination of his step-by-step reformation, the product of his hate and his calculus and his effort. And yet it also seemed like a miracle to him, and all these years later it still does, how quickly and completely plans and futures can change, fate the vibration plate that sits just under the surface, beneath all of our feet.

He never meant to have five boys. One year, home from college, he met a girl in a bar. Her name was Diane. The next year he met

Diane in that same bar, and he met her in another bar the year after that. It seemed to Gordy as though they were supposed to be together, and he and Diane married shortly after his graduation. He tried to play pro ball in the United States Football League, but he had blown out his shoulder, knees, and ankles, and he ended up a somewhat intimidating sales executive for an oil company. ("I took that company from a million to $18 million," he says.) He and Diane started having children, not with any particular ambition and not with any particular final family in mind. They started having children because children are sometimes the consequence of a newly married man and woman having sexual intercourse. "They were all mistakes, if you want to put it that way," Gordy says, before he decides that he doesn't want to put it that way. "I shouldn't say mistakes. That sounds terrible. None of them was a mistake. God gifted us with them. *Unplanned*, let's use that."

The unplanned phase of the Gronkowski family climb continued long after the births of the children. In 1990, Gordy, still selling oil, opened his first gym-equipment store with his brother as his partner. Two jobs plus five boys equaled "total hell," he says. (Middle son Chris looks back on the chaos of those early years and says, "I have no idea how he did it.") On G&G Fitness's opening weekend, the Gronkowskis had plenty of browsers but sold none of their high-end equipment, and they began to panic. "We were just like, Oh God, we made the worst mistake of our life," Gordy says. By Sunday night, they were already plotting their escape, and on Monday morning Gordy called the store manager to tell him they were probably going to close up shop. The manager told Gordy they'd have to talk later—he was too busy. When they finally connected, the manager relayed to Gordy a number that still lights up something inside him: $9,000. He'd put $9,000 into the till when all those browsers came back to buy. The first of the family businesses was born. In 1996, Gordy quit selling oil, turning his full-time attention to the fitness empire that he'd nearly abandoned after 48 hours. He had learned perhaps his most important lesson: "You can never doubt yourself," he says. "As soon as you doubt yourself, that's when you're going to end up on your back."

The boys were all born with the confidence of true athletes, blessed with the same gifts that had been given to Gronk the Olympian nearly a century ago. But Gordie Jr., despite his size and his father's collegiate career, never played football. He was moti-

vated by love, not hate, and baseball had his heart. Gordy's heart followed. He coached his children's baseball teams for a dozen summers, winning championships 11 times. ("He got the most out of everyone," Dan says. "Any kid you ask, if they had my dad as a coach, they'd tell you that was their favorite year playing and he was their favorite coach.") Now method entered Gordy's madness. He emphasized two things: form and fearlessness. He rolled and tossed and finally popped up thousands of tennis balls to his children, hoping to improve their hand-eye coordination with an object that didn't leave either physical or mental scars when hands or eyes failed. Later, he moved on to baseballs, and his five boys lined up in the yard and together played a game they called Three Flies In. The first boy to catch three consecutive fly balls won, and perhaps not surprisingly the game evolved to include, just every so often, contact between something other than the bat and the ball. Football became the natural progression.

In some strange way, Gordy's having five sons might have made all the difference. Baseball is a game of fathers and sons, but football is a game of brothers. According to the Pro Football Hall of Fame, 364 sets have played the sport professionally. The built-in rivalries for dinner and affection, the alternating phases of admiration and envy, the physical and mental violence that brothers routinely visit upon each other — Rob once threw a fork so hard at Goose that it stuck in his elbow — whatever it is, the fraught alchemy of familial brotherhoods can lead to success within more metaphorical ones. Each successive Gronkowski — Dan, then Chris, then Rob — was arguably better than the last, either because he looked up to more brothers or because he had more brothers beating down on him. "That's what makes Rob great today," Gordy says. "He's got no fear. It started out from the get-go, the brawling. The kid just endured pain."

Dan, the first at many things, was also the first to take to the basement weight room; Gordie Jr., who had resisted, saw his little brother ballooning and soon joined him. "And then it was like a virus," Gordy says. The other boys just went downstairs as though by instinct, where they set about filling their jerseys and trophy cabinets. Gordy says Goose, entering his sophomore season at Kansas State, is the best pure athlete of the bunch. Is it an accident of genetics that he's the fastest of the Gronkowskis, or is his speed a product of his having to escape flying forks?

Gordy doesn't have a good answer. ESPN once determined that the odds of a family having three brothers play simultaneously in the NFL are one in 31 million. That number, perhaps more than any other, has stayed with him. It cements his sense of marvel, and he sometimes looks at his sons the way his lost teenage self would have looked at the man he has become. "It's unbelievable," he says. "It really is. I sit there sometimes and think, God, did this really all happen?"

Gordy's phone dings. Dan and Chris were both knocked out of the NFL last season—Dan was cut by the Cleveland Browns, and Chris hurt his ankle and took an injury settlement from the San Diego Chargers—but today both are in Florida at a combine for free agents, trying to get back into the league. Gordy thinks they have a good shot, so long as they think they do. Earlier, he had texted both of them: *Kick some ass today.*

Yeah baby, Dan wrote back.

Now Chris has chimed in. *I'm taking a dump. Almost weigh more than Dan so I have to get my weight down.*

Gordy reads the text and laughs to himself. "Knuckleheads," he says, and he shakes his head and smiles. Then he goes quiet for a moment. "That's good if his weight is up there, though," he says after he finishes another in his endless series of sums.

Gordy's only moments of doubt, the only cracks in his faith, come when he sees one of his children in pain. That's when everything falls apart. There was a time when he tried to coach his sons into refusing even to believe in it. One of his early house rules was: if you can get up, you get up. Dan set the standard during his first season of football in the eighth grade, when he ran off the field on a broken ankle. "I felt so bad," Gordy says. "I was sort of a hardass on that." Even today, whenever a Gronkowski looks hurt, he's really hurt, and except for young Goose, fingers crossed, Gordy has seen each of his boys go down and stay down.

Gordie Jr., drafted by the Angels, topped out in the minors when he blew up his back. Dan has injured his hamstring and, like Chris, his ankle. And Rob, Rob these last few cursed seasons, Rob has been the worst: ankle surgery, back surgery, two fractures in his arm, and last December's knee injury, which required surgery in January. When Rob was carted off the field, his father, watching from the stands—he goes to at least one son's game

each week—felt as though his broken heart was carted off with him.

"Helpless, helpless, helpless," Gordy says, and his eyes fill with tears. "And then you just say, Why, you know? Why him? When he's down on the field like that, everything runs through your head. Is he paralyzed? It just starts flying real fast. And you can't do anything about it. You're just stuck."

Gordy decides he's had enough of that particular strain of wondering. It's time to regain control. He retreats to his kitchen, and he begins fixing himself a soup. There are framed photographs of his children on the walls and on his counters—next to the bottles of salmon oil and milk thistle—including one of Rob scoring a touchdown. "There's nothing like that, on the other side of things," Gordy says. "That's my son. That's my boy right there."

Sometimes the house can feel quiet these days, even empty. The Gronkowskis used to go through $600 worth of groceries a week, two or three gallons of milk a day. The fridge was once covered with inspirational quotes. Now they're gone, like so much else. Now there's just Gordy, heating up his soup. He and Diane separated nine years ago; they divorced a year or two after that. "I couldn't have done it without her," he says, talking of raising the boys. "We had to be a team or it never would have worked." He's asked what eventually drove them apart. "Everything we did, I had to win," Gordy says. "The wife hated that. She couldn't stand that I had to win all the time. Even when we played coed volleyball or something, I had to win. She'd say it was just for fun, and I'd say, 'Yeah, isn't it fun winning?'" Gordy has a longtime girlfriend, but they don't live together. She has five children of her own, a boy and four girls. Gordy's not sure he could survive that again.

In the years since his boys moved out, he's fixed all the damage they did to the house he built for them. He's painted over the scuff marks on the kitchen ceiling, from footballs thrown across the room; he's patched the holes punched into the drywall and repaired the doors torn off their hinges; he's replaced the couches and beds that came with lifetime warranties but lasted two weeks; he's replaced the old hot tub too. "That hot tub could have told some stories," Gordy says. Only Dan still lives nearby. He'll drop by every so often, mostly to work out in the basement. It's been a while since a new trophy has been added to the cabinets down there. At the moment, only Rob and Goose are still in the competition.

At least the others have their educations from good business schools. Gordie Jr. works for G&G Fitness, living in Columbus, managing the Ohio stores. "He does a phenomenal job," Gordy says. Depending on how his comeback goes, Dan will be working for his father too, in marketing. Chris lives in Dallas; he and his girlfriend have opened an online engraving business. "They're killing it," Gordy says. "It's just something my girlfriend started up," Chris says. Gordy cowrote a book last year about raising his sons, *Growing Up Gronk*. There's been some talk of a cartoon starring the family, and a reality show called *Gronk Gyms* that would feature Gordy and his boys traveling across the country, installing dream factories. If those don't work out, Gordy's been thinking about taking a trip to Africa or building a home in Florida, a kind of family retreat where all of his boys might gather again, the way they did before.

Gordy's phone rings. He thinks it might be Dan or Chris with news from the combine—in the end, both will suffer injuries—but it's Gordie Jr. on the line. He's at a Costco in Pittsburgh, where he's set up a temporary display, selling equipment off the floor. Gordy answers the phone: "How much?"

It's been a good day. Gordie Jr. has pocketed $15,000. The kid can work a floor.

"Beautiful, sir," Gordy says. "Wow. Beautiful.

"Right. Right.

"Got it.

"Got it, sir.

"Wow. Beautiful. Beautiful.

"Got it. Got it, sir.

"What, oh, the Syracuse game?" Gordy says suddenly. "Yeah, it sucked. They blew it. I don't know why he didn't drive at the end. He took that shot at the end. I don't know why he didn't drive."

And then Gordy Gronkowski returns to his soup. He put in 60 hours at the store this week and wants to take it easy for the rest of the day. No workouts on Sundays. He's thinking he might go over to Dan's house and maybe give his wife a hand. Just six weeks ago, she gave birth to the first of the next generation of Gronkowskis—a boy, of course, named Jayce. "He's strong," Dan says. "Super-alert." Gordy says Dan has already asked him whether he might begin coaching his grandson a little. Nothing crazy. Nothing too serious. Maybe just get him holding a tennis ball, start him with something small like that.

JOEL ANDERSON

The Two Michael Sams

FROM BUZZFEED

IN A YELLOW-WALLED room in a Texas nursing home this July, a man in a wheelchair watched a flat-screen TV. He saw Michael Sam Jr. kiss his boyfriend and hug his small team of supporters—agents, coaches, and Pro Football Hall of Famer Jim Brown. The first out gay player drafted into the National Football League strode to the stage to receive ESPN's Arthur Ashe Award, an honor previously bestowed on Muhammad Ali, Pat Tillman, and Nelson Mandela. It was the climax of a star-studded evening in Los Angeles meant to announce Michael Jr.'s arrival as a national icon.

Michael Jr. thanked his agents, his publicist, the couple who welcomed him into their home in high school, supporters from the University of Missouri, and top officials with the St. Louis Rams, the team that had drafted him only two months earlier.

Finally, he gave a brief nod to his roots. "To my mother, a single mother who somehow raised eight kids. I love you dearly."

Back in his cramped room at the nursing home, Michael Sam Sr. picked up his battered, flip-style phone and found his son's number. He left a message.

"So that's what you're going to do?" he recalled telling his son. "After all I've done for you?"

Since Michael Jr. publicly announced he was gay in February—just days after he let his father know by text message—Michael Sr. has been vilified in the press. In the *New York Times*, Michael Sr. came off as a callous homophobe when he said, "I don't want my grandkids raised in that kind of environment . . . I'm old school. I'm a man-and-a-woman type of guy." When the ESPN documen-

tary declared that Michael Sr. had "abandoned the family" and left his mother to raise Michael Jr. and his seven siblings on her own, Michael Sr. seemed the archetype of the intolerant and absent black father.

In none of these accounts did Michael Jr. come to his father's defense. "I'm closer to my friends than I am to my family," Michael Jr. told the *Times*.

But the father-son story of Michael Sr. and Michael Jr. is more than a conflict over whether Michael Sr. loved and supported his son. It's the tale of a man who's been reduced to a caricature but whose actual life was shaped by the loss of child after child, some to death and some to crime. The rift between Michael Sr. and his youngest son started long before Michael Jr. came out and stems in no small part from those family tragedies.

Of course, those losses shaped Michael Jr. too, but he isn't saying how. Through his agent and publicist, he declined numerous requests for an interview. But it's not hard to see how, in order to succeed and perhaps just to survive, he might blame his father, fairly or not, for what happened to his family.

Michael Sr. spends most of his days at the DeSoto Nursing and Rehabilitation Center, about 15 miles southwest of Dallas. His electric hospital-style bed and almost all of his few belongings—a mini-fridge and a rolling dinner tray, mostly—are crammed into a corner of the room he shares with another patient. He locks his drawers because someone has been stealing his snacks.

He gets around in a wheelchair, having lost his ability to walk almost three years ago. He wears a gold chain around his broad neck, which bears a deep and long surgical scar that runs from the bottom of his hairline to somewhere past the neckline of his white undershirt. It's not clear he knows exactly what ailment has left him in a wheelchair. "I have a hole in my neck," he said. "But I ain't gonna die in this motherfucker. I'm getting out of here."

At 55, he's one of the youngest and most vibrant residents at the nursing home. He has a paunch and false teeth, but he still possesses the thickly muscled shoulders and arms of someone nicknamed "Hammer," a handle he got on the football field and in the streets. His hands still make large fists; kicking ass was a family pastime.

"Maaaannnn, I used to hit hard," he said. "I taught all my sons to play football."

He often rolls his wheelchair to a shaded patio, where he goes through Kool cigarettes like some people do cups of coffee. He banters with almost everyone. Especially the women. "Better quit bending that ass over like that," he tells one of the women staffers, a smile creasing his fleshy face. The woman smiles back. If she or other women staffers are offended by his behavior, they don't show it. At least a couple jokingly call him their boyfriend.

His phone rings throughout the day, bearing calls from his children or friends named "Frank Tha Cook" or "Little Leroy." The conversations usually cover his health, upcoming casino trips to Louisiana, and football, particularly the Cowboys, his favorite team since he was a boy.

One person who doesn't call is Michael Jr., who kept his distance as he ascended to fame and more recently when he tumbled out of big-time football.

After Michael Jr. publicly came out in February, even President Obama praised the announcement. On May 10, the St. Louis Rams drafted him, generating more praise. But despite the fact that he had been a star at the University of Missouri, where he became Co-Defensive Player of the Year in the powerful Southeastern Conference, he was chosen late. Only seven players were selected after him. He performed well during training camp and the pre-season—but was still cut from the final roster on August 30, touching off a debate about whether homophobia played a role in his release. The Cowboys signed him three days later to their practice squad, then dropped him on October 21. He is now a free agent.

For the nearly two months that Michael Jr. was with the Cowboys, he lived a half-hour away from his father. It was the closest they've lived to each other in about 15 years. A family friend, Sean Woods, hoped it would finally bring the men together. "Now," he said, Michael Jr. "has to deal with his daddy."

Yet the Michaels have exchanged only a few text messages and haven't spoken a word to each other, a quiet that has now lasted at least several months with no end in sight. Michael Sr. has mostly kept up with the vicissitudes of his son's career through updates on ESPN and phone calls from friends and family members.

Shortly after Michael Jr. was released from the Cowboys' practice squad, Michael Sr. sent a text to BuzzFeed News: *Hey they cut Mike.* Asked if he'd heard from his son recently, Michael Sr. texted back that Michael Jr. *wouldn't say a word to me honer* [sic] *thy father.*

"It's like he was looking for an excuse to separate from us," Michael Sr. said. "Now we're just letting him have his limelight. We're tired of begging him to stay in the family."

On the room's walls, Michael Sr. has pinned Father's Day cards, a corkboard with a calendar and pictures of his family, and, over his bed, a lengthy poem about angels. On a special spot on the wall—right over his flat-screen TV—are two pictures of Michael Jr. in his University of Missouri football uniform. Pointing at the pictures, Michael Sr. said he knew from the start that Michael Jr. would be special.

"That boy, he had some big nuts," Michael Sr. said. "He was big when he was born. That boy had some big-ass balls."

Wesley Sam, Michael Sr.'s father, was also pretty ballsy. In 1947, he was living in Opelousas, Louisiana, when he heard on the radio about what's generally considered the deadliest industrial accident in U.S. history, an explosion at the Monsanto plant near Galveston, Texas. He headed right to the scene, figuring he could get work there.

He loaded cotton at the Galveston wharves for a few months before landing a job at the Monsanto plant. Yes, it had blown up, killing nearly 600 people, but he could make more money there than a black man could expect almost anywhere else.

He married Alberta, a fellow Opelousas native who spoke Creole, little English, and who couldn't read or write. With their 10 children, they moved into a three-bedroom, one-bathroom home at 1732 Thompson Street in La Marque: Wesley and Alberta had a bedroom, the girls had one, and the boys had the room at the back of the house. "I had a white boy type of life at home," Michael Sr. said. "There wasn't nothing I couldn't have wanted and gotten."

Alberta died at 46 following "a brief illness," according to her obituary in the *La Marque Times*. Wesley Sam was a loving man, a capable cook, and obsessive about cleanliness—he would dust off his car every day, his surviving children said. But he wasn't quite up to the challenge of corralling all of those children. Who could? Instead he set his example through his work ethic, putting in a full day at Monsanto then mowing lawns with his sons in the evening. They'd do 18 yards a day, Wednesday through Sunday.

"My dad was a workaholic before anyone called it that," Michael

Sr. said. "He'd think you were sorry if you didn't have that work mentality in you."

Michael Sr.'s siblings went off to college, joined the military, and found middle-class jobs. His sister Geraldine would become La Marque's first black mayor.

Michael Sr., meanwhile, dropped out of school over the protests of his father but earned a GED. He wasn't much of a student anyway, and finding work in the area was a cinch for anyone who didn't mind getting a few smudges on their shirt. He worked in construction, at a chemical plant, and as a crane operator and a forklift operator.

Away from work, Michael Sr. and his brothers drank, chased women, and kept up the family tradition of fisticuffs. "We'd be out in the front yard fighting," Michael Sr. said, grinning at the memory. "Real fighting. Not no slapboxing."

One night in 1978, Michael Sr. met a woman named JoAnn Turner at a local nightclub. "She was fine and good-looking," Michael Sr. said. "And I walked her out."

Little more than a year later, JoAnn gave birth to a boy they named Russell. A year later, they had daughter Chanel. Julian was born in June 1982. They were young and in love, with three kids and jobs that paid middle-class wages. It didn't take long for Michael Sr. to settle into life as a family man, or long for it to be destroyed.

Here's a news brief from the Associated Press on September 23, 1982, with a dateline from Texas City: "The body of Chanel Roshaun Sam was found Monday night in about eight feet of water near a pier on which she had been playing. Her parents and neighbors searched for three hours before finding the body." The little girl, two years old, had apparently drowned.

After several days of grief, and desperate to rescue JoAnn from her despair, Michael Sr. suggested they go to the courthouse. And so, six days after their daughter died, they were married.

"I felt like she needed some support," Michael Sr. said. "It was the right thing to do, to bring something positive from it."

It wasn't enough. JoAnn turned to religion and became a Jehovah's Witness. Her conversion deepened the fissure in her marriage, because Michael Sr. was raised as a Baptist and felt his wife's new religion was too restrictive. She insisted the family not cel-

ebrate Christmas. "I celebrated it," he said. "But she didn't cel-
ebrate it with me. I still bought the kids gifts." (JoAnn didn't re-
spond to requests for an interview.)

Michael Sr. found his solace shooting dice. On Friday and Sat-
urday evenings, he would take his paycheck to a little wooden
shack in Texas City and gamble away the family's money. JoAnn
suspected the absences were because of another woman, Michael
Sr. said. But a mutual friend of the couple gave her the scoop. In
Michael Sr.'s version of the story, the woman told JoAnn that "he
ain't screwing none of us" but was just gambling.

One Friday night, Michael Sr. recalled, he won $700 and left
the shack with two friends on an impromptu trip to Boy's Town in
Nuevo Laredo, Mexico, an infamous red-light district just across
the Texas border. He didn't bother calling JoAnn to tell her that
he was leaving town.

"Weren't no cell phones back then, and I didn't stop and spend
the 25 cents to call," he said. When he returned Sunday, "she
bitched at my ass. But it was pretty funny. I had a blast."

The marriage continued to spiral, though Joshua was born in
1984 and Christopher in 1985. Michael Sr. finally filed for divorce
in February 1986. A brief attempt at reconciliation resulted in the
birth of Michelle in 1987. But the divorce was granted in 1988.

JoAnn was awarded primary parental responsibilities. Michael
Sr. would have access to the children two weekends each month,
and they divided up the holidays.

Michael Sr. was also ordered to pay JoAnn $250 each month
for child support. Within a few months, JoAnn returned to court
to complain that Michael Sr. wasn't meeting his obligation. Thus
started a four-year battle over child support. Michael Sr. was
charged with contempt of court at least 10 times stemming from
his failure to pay, according to court records. Twice he was sent to
county jail.

"It was because I was running around and spending money and
shooting dice," Michael Sr. said. JoAnn "needed more money, and
I was doing the very minimum. I should've been doing more."

Typical of their on-again, off-again relationship, JoAnn gave
birth in 1990 to Michael Jr.—right in the middle of their child
support dispute—and the next year to Ashley, the eighth and last
child they would have together. "Man, I had some phases with
JoAnn," Michael Sr. said.

In July 1992, JoAnn went to court to sign off on an agreement to release Michael Sr. from county jail and to clarify the terms of the support payments. At that point, according to court documents, Michael Sr. was behind nearly $4,000 in payments.

During the Christmas holidays that year, Michael Sr. said, JoAnn made a surprise visit to his house. "She wore one of those Mormon dresses—she knows that I like dresses," he said, laughing. This time, he said, she demanded more than a night together.

On May 3, 1993, Michael Sr. and JoAnn went to the county courthouse once again—to get remarried.

Michael Sr. took no small pride in raising sons who were every bit the hell-raiser that he was. People around the neighborhood called him a man's man. "My dad didn't take no shit off nobody, and I didn't take no shit off nobody," Michael Sr. said. "I wasn't a bad guy. But I was a 'I'll kick your ass' kind of guy."

"All of his kids were muscular and some bad dudes," said Charles Sam, Michael Sr.'s brother.

The toughest of the bunch was also the oldest: Russell. As a freshman, he was pegged as a future football star at La Marque High School. Michael Sr. fondly remembers how Russell would walk around the neighborhood, "always ready to slap a motherfucker."

But, he said, "I kept telling him to get out of that gang shit."

Here's a clipping from the Galveston County *Daily News*. It reports that on February 27, 1995, Russell was sent home early from La Marque High School for "creating a disturbance." A school administrator allowed Russell to walk home since his mother couldn't leave work to pick him up.

Instead of heading straight home, the newspaper said, Russell stopped at a house about a half-mile from the school. He was breaking into the back door when the homeowner fired at him three times through a metal door. Russell was clutching a screwdriver when his body was found. No charges were filed against the homeowner (who was also black).

The anger welled up within Michael Sr., who casually knew the man who had killed his son. There weren't many strangers on that side of town. Michael Sr. got himself a handgun. "I was going to kill him," Michael Sr. said. "I was going to go over there and end him. But my daddy saved me. He wouldn't let me go over there."

His father saved him. But Michael Sr. couldn't save his own sons.

At five feet four inches and 125 pounds, second-oldest son Julian had an unusually slight build for a Sam boy. He went by the nickname "Ice Pick." But he had a left arm that was made for pitching. "That boy could throw," Michael Sr. said. "He used to strike Russell out all the time. Those were the funnest days."

But, Michael Sr. said, "he wanted his own money" and begged his father to let him work. Michael Sr. eventually gave in, and Julian took a job with a local cable company.

Here's another headline from the *Daily News,* this one from October 22, 1998: "La Marque mother looks for clues into son's disappearance."

Julian was last seen outside La Marque's high school football stadium, where he had gone to buy tickets to the homecoming game. JoAnn told the newspaper, "What has me afraid is that he had just gotten paid, and had $200 on him."

"I should just not have let him work," Michael Sr. told *BuzzFeed News.* "I should have let him throw that ball. He would've been a left-handed pitcher."

Julian hasn't been seen since that homecoming game, and 16 years later the police maintain his disappearance is still an open case.

When Michael Jr. was born, his parents were scarred by the drowning of their daughter and were feuding over child support. When he was five, his oldest brother was gunned down. When he was eight, his second-oldest brother vanished.

His remaining brothers, Josh and Chris, tormented him constantly. "His brothers picked on him," said Michael Sr., who also grew up as the youngest brother in his family. "I'd have to go in there and tell them to quit that shit and leave him alone." Michael Jr. told *Outsports* he was a "punching bag" for his older brothers.

Josh was also showing a precocious ability to find trouble in the streets of La Marque. "No one had reached 18 yet," Michael Sr. said of his children. "I didn't think [Josh] was going to reach it either."

Michael Sr. and JoAnn decided that Hitchcock, a town only four miles away, might do them all some good.

<center>*</center>

Population 7,000, Hitchcock was founded in 1873 as a railroad station between Houston and Galveston. Today, it's a quiet two-stoplight town that sits along a state highway. By most socioeconomic markers—homeownership, median income, residents with college degrees (just 8.2 percent)—Hitchcock ranks below the Texas average.

The Sams settled into a well-kept, rose-colored, wood-frame house that sat along the railroad tracks and unkempt ditches on the black side of town. It seemed isolated enough from the troubles that La Marque had visited upon their family, but it wasn't.

La Marque police reopened the investigation into Julian's disappearance after getting reports that people had seen him in the area. "We think he left on his own free will and we feel strongly he is alive," the police chief told the *Texas City Sun* in October 2000.

JoAnn told the *Sun* that she also believed he was still alive. "He was at that age of rebellion," she said, suggesting he had run away from home. She told the newspaper that she wanted him to come home or at least call someone in the family to let them know he was okay.

In grief, Michael Sr. had quit his job at the post office. "I had always had a steady job, but I couldn't handle it no more," he said. "I felt closed in. Just thinking of it." He found work as a crane operator but was laid off soon after. He got a job working for a local pipe company and was let go again. Finally, in the fall of 1999, a family friend told him he should consider truck driving. Michael Sr. went to school in Dallas, and four months later was on the road, coming back to Hitchcock when he could, mostly on weekends.

"It was a steady job," he said, and one that answered a deeper need: "I had to get away. I wanted to get away."

The marriage crumbled. Michael Sr. and JoAnn remain legally married but haven't lived as a couple since he moved to Dallas in 2000.

Michael Jr. was 10 when his father started his life on the road. With JoAnn working late hours and taking extra shifts to provide for the children, Michael Jr.'s older brothers had their run of the house—and the streets. "It was bad," Michael Jr. said in an ESPN documentary about his life. "I'm a kid and I'm seeing some hardcore drugs in my house. My mother didn't know about it. If I told her anything, my brothers said they would kill me."

Craig Smith, one of his high school football coaches, saw it for himself. "Sometimes I'd drive over to pick him up and honk the horn and one of his brothers would come out to see if I wanted to buy" drugs, he told a crowd at the school's annual football reunion dinner in late July.

The criminal records of Michael Jr.'s brothers support these accounts: Josh has been arrested more than 40 times, including four convictions for drug possession, and Chris has tallied nearly 20 arrests.

In April, Chris was sentenced to 30 years in state prison for breaking into a woman's home, choking her into unconsciousness twice, then using her credit card at a nearby restaurant. Josh was put in the Galveston County Jail in July on a minor offense and was released last month.

"I got caught up in them streets," Josh admitted during a June interview with BuzzFeed News, a rare evening this year when he wasn't locked up.

Little of this came as a surprise to family members. Cousins remember being warned to keep their distance. "We knew it wasn't the ideal upbringing," said Joseph Sam, a nephew of Michael Sr. "They were always in trouble."

With his childhood saturated with grief and his older brothers descending into crime, Michael Jr. would have had to be a saint not to look for someone to blame. Conveniently, his father was already blaming himself.

Out on the road, far away from home, Michael Sr. remained tormented by the loss of his boys. Teaching them toughness had backfired; he'd armed them with tools for survival in one world that wouldn't work in almost any other.

"Life was going to be tough on them," he said. "Your skin had to be tougher than the others. But I also wanted them to make the right decisions."

Somewhere in these years, Michael Sr. began to lose the last of his sons—not to death or crime, but to rejection.

On his first day of third grade, in a new town and new school, Michael Jr. was seated next to a chubby, snowy-haired boy. Michael Jr. wasn't saying much to his new seatmate. The silence went on for so long and got so awkward that eventually the boy spoke up.

"I told the teacher that I didn't want to sit next to him because he was too quiet," said Robert Dohman. "He turns around and

goes, 'Hey, blondie boy, I'm not quiet!' And that's the way me and Michael get along now."

Michael Jr. was voted "friendliest" by his sixth-grade classmates and elected homecoming king in eighth grade. His popularity was a testament to his ability to navigate the unspoken color line of a small Southern town; most of his close friends were white.

"My grandma," said Dohman, "was very old school and wasn't into all that racial mixing. But when I had Michael over, he'd always be the first one to come over and give everybody a hug. Even her. He really changed the way my grandmother looked at black people. She would even smile when he came around."

Michael Sr. said he saw little of the outgoing side of his son, saying he was quiet at home. But coaches and teachers remember him as a precociously self-assured teenager who could start a conversation with anyone. After football games, Michael Jr. was known for going into the bleachers—uniform and pads still on—to introduce himself to parents.

Michael could "talk to a group of 15-year-olds and then set there and talk to a group of 55-year-olds and not feel out of place either," said Smith, now head football coach at Hitchcock. "I just never had a student that could just go and talk to a group of people. He would make friends all the time."

Even in what was ostensibly enemy territory. Smith recalled a track meet at Danbury, a nearby town that is 90 percent white, less than 1 percent black, and had developed a reputation for being unfriendly to minorities. Except, apparently, Michael Jr.

"I can remember some Danbury parents cheering and rooting for Michael running the 100-meter [dash]," Coach Smith said. "You just didn't see that, if you know anything about Danbury."

Maybe the biggest benefit of playing sports is that it kept Michael Jr. away from his brothers. The coaches, who also worked as teachers in the district, knew all about Josh and Chris: their obvious athleticism had never proven to be worth the trouble. But Michael Jr. was charting a path different from the men in his family. Michael Jr. greeted people with hugs, not fists. He was going to be the first to graduate.

"Michael was a good kid," Michael Sr. said. "He said he didn't want to be like his brothers." Left unsaid was that Michael Jr. clearly felt the same about his father.

On fall Friday nights, Michael Sr. said he would find a seat

somewhere in Hitchcock's football stadium, away from the crowd and sometimes with his father, Wesley. After nearly 30 years as a father, he said, he could finally engage in the autumn ritual familiar across Texas.

"I didn't miss [any] home game his senior year," Michael Sr. insisted.

There isn't anyone who can corroborate his perfect attendance. Family and friends say they're sure he went to some games but don't know about all of them. The coaches at Hitchcock High can remember seeing or, rather, hearing, Michael Sr. only once in four years: a game in Michael Jr.'s sophomore year.

"I heard this guy yelling at Michael and I turned to Michael and asked him, 'Who the hell is that guy?'" Smith recalled. "Michael said it was his father. That's the only time I've ever seen him."

Those stadiums can be hubs of activity on Friday nights, and coaches are notoriously focused on the events unfolding well away from the stands. It would be easy to miss someone on game night, *right?*

"Let me say this in a nice way," Smith said. "I didn't know him, and I know a lot of people in town. I can look up in those stands and know who's there."

Michael Sr. said he didn't make it a priority to spend any time with the parents of Michael Jr.'s friends or the alums and other regulars who would show up at school events—most of them white. "I never did know them," Michael Sr. said. "And I never tried to go out of my way."

Michael Sr. said he took a job with a trucking company based out of Ada, Oklahoma, so that he could arrive in Hitchcock by the start of kickoff Friday night. He assumed his son appreciated what he considered a significant sacrifice of time and money; coming back to Texas without a load meant he wouldn't get paid for the drive home.

It wasn't until earlier this year, when media outlets began saying that he had abandoned his son, that Michael Sr. learned he was being phased out of the story of his son's childhood. He never thought all those years on the road would mean that he wasn't there.

"Michael's family was the city of Hitchcock," said Dohman, Michael Jr.'s childhood friend.

Told what Dohman said, Michael Sr. looked straight ahead, the

anger washing over him. Sitting on that patio at the nursing home, he was, for a few moments, that angry Sam boy ready to fight.

"The city of Hitchcock didn't buy his goddamn clothes, a roof over his head, or the bed that he slept in," Michael Sr. said. "The city of Hitchcock can kiss my ass." He paused. "I should have kept those gas receipts."

Of course, Michael Sr. never thought he would need them. He also never thought the family of a high school teammate—a white one—would get so much credit.

Once Michael Jr. revealed in February his plans to become the NFL's first out gay player, the two media outlets with which his publicists coordinated the announcement wrote this:

> The *New York Times:* Sam found a comfortable place off the field as well, in large part because of Ethan Purl, a classmate and the son of Ron Purl, the president of the local branch of Prosperity Bank. Ron's wife, Candy, made sure their house was part recreation center and part counseling hub for their children and their friends. By Sam's senior year, he had his own bedroom in the Purls' house, along with chores like cleaning the pool and carrying the grocery bags. "I look at our house as a kind of safe haven," said Ron Purl, who keeps a photograph of Sam in his Missouri football uniform in his office. "He is just another son. If he did something wrong, he got yelled at just like the others did."

> ESPN: The relationship started when Candy Purl, Ronnie's wife, invited Michael to dinner during his freshman year of high school. Ronnie, a man with a personality much bigger than he is, discovered a kid he didn't recognize and demanded to know, "And who are you?"
>
> "Without skipping a beat, my brother replied, 'I'm Michael Alan Sam Jr.!,'" said Ethan Purl, Ronnie's son. "And after that, he never left."

"That's a bunch of shit," Michael Sr. said. Sure, he said, his son went to the Purls' on weekends, but "Michael lived at home to the day he graduated."

"He lived with the rest of us," agreed Michael Jr.'s sister Michelle.

"The Purls only helped [him] in [his] senior year," his aunt Geraldine said. "If the Purls were really good people, they'd tell Michael that he was wrong. That he should acknowledge his mother and daddy."

After a brief phone conversation in which he said he didn't have time to speak, Ethan Purl did not return repeated phone

calls. Ronnie Purl declined a number of interview requests. "Without Michael's approval I will not be able to speak with you," he said in an email. "Being in banking, I am very aware of privacy issues."

Michael Sr. said he met the Purls at least once, when he accompanied Michael Jr. on one of his visits over there.

"I just wanted to see where Michael was going, to make sure where he was going was the right environment," Michael Sr. said.

In fact, Michael Sr. liked that his youngest son had white friends. He was convinced his association with them might mean better grades, a high school diploma, and maybe even college — the chance at success that his other sons never had.

"He wasn't messing with the black guys trying to sell drugs and doing drugs — I thought that was a good thing," Michael Sr. said. "As long as he wasn't doing nothing crazy, wasn't in no cult, I was all right with it."

When Michael Jr. was at the University of Missouri, Michael Sr. began noticing some changes in his son, he recalled. There was that road trip from Dallas to Houston with Michael Jr. and one of his college friends, Vito Cammisano, a member of the men's swim team. What struck Michael Sr. was his son's taste in music.

"He knew all of them white songs," Michael Sr. said. "He knew country, Taylor Swift, all that stuff. I'm like, *What brother knows all of them white songs?* That tripped me out."

On another one of Michael Jr.'s trips home with Vito, Michael Sr. noticed their relationship seemed much closer than a simple friendship. How else to explain Vito coming home for the holidays? Michael Sr. waited until they returned to Missouri to broach his suspicions to his wife. "I told JoAnn, 'You know, Mike ain't bring his girlfriend but he brought this dude. That's kinda funny,'" Michael Sr. said. "But she swore up and down" that he wasn't gay. "I kept asking Mike, was this boy funny? 'No, Daddy, no. Ain't nothing wrong with Vito,' he'd say.

"He didn't act gay then either," Michael Sr. said of Vito.

But during a visit to Missouri for one of Michael Jr.'s games last fall, Michael Sr. became certain about Vito.

"I shook that boy's hand, and that boy's hand felt like a woman's," Michael Sr. said. "And the boy looked different. I told my brother that that boy right there is gay."

When they went out for dinner later that night, Michael Jr. showed them a picture of a woman he said he was dating; Michael

Jr.'s Instagram account has lots of pictures of him in college posing with young women.

"I still had some suspicions," Michael Sr. said. But other family members "didn't wanna believe it. I had intuition about that boy."

That intuition was finally confirmed this year. On February 4, Michael Sr.'s birthday, he received a text message from his son. "I could tell his PR guy wrote that message because Mike don't talk like that," Michael Sr. said. "It was some bullshit. *I wanted to inform you that I'm gay.*"

That's all you've got to say? Michael Sr. remembered texting Michael Jr. in response. "He texted me back, *Happy birthday.* So I went out and got drunk."

Five months later, in his room at the nursing home watching the red carpet show before his son would receive the Arthur Ashe Award, Michael Sr. grew wildly upset. He started calling and texting family members and friends.

With Vito at his side, Michael Jr. had been asked what was the most difficult part of coming out. He told the interviewer that it was telling his friends. Michael Sr. was incensed.

"If it was so hard to tell his friends, why didn't he tell us first?" Michael Sr. said. "It was harder for him to tell us."

And it probably was. One recent afternoon, Michael Sr.'s brother Charles asked if Michael Jr. might go back to women. Michael Sr. responded, "Women don't really want to mess with you after doing all that gay shit."

Michael Sr. is never going to be the spokesman for Parents and Friends of Lesbians and Gays. He's not thrilled about his son's sexual orientation. But he also hasn't disowned his son. He never says his son is going to hell. He doesn't talk about trying to cure him or make him straight. In his own rough-hewn, coarse way, Michael Sr. has accepted that his son is gay. "I love my son," he said, "and I don't care about what he do."

The family rift that the ESPY Awards exposed to a national audience had been there, deep and wide, for a while.

Seven months earlier, in December 2013, Michael Jr. came to Houston as one of the nominees for the Rotary Lombardi Award, which is awarded to the best college lineman or linebacker. Instead of asking his family to attend as guests, he invited the family of Missouri football teammate Will Ebner.

"We found out Will and I were going to be part of his family

representing him," said Elaine Ebner, mother of Will Ebner. "If someone else had come from his family, I would have wanted them to be center stage. I know my place. Mainly, I just wanted to be whatever he wanted me to be."

Michael Jr.'s aunt Geraldine managed to score tickets from a friend who was a member of the Rotary Club. She also sat in the area designated for family. "When I got there, [Michael Jr.] was glad to see me. It's always good to have family there," she said.

Days later, Michael Jr. graduated from the University of Missouri with a degree in parks, recreation, and tourism. Everyone in the family—except Josh and Chris, who were both in jail—made the 600-mile road trip from Texas to celebrate the first of JoAnn and Michael Sr.'s children to graduate from college.

To commemorate the occasion, Michael Jr. posted a picture on Instagram of himself in a cap and gown, a wide smile on his face and an elbow comfortably resting on the mantel of a fireplace. "It's been a long time coming," read his caption. He was alone in the photo and made no mention of anyone else being there—in that or any of his other public social media posts from the time.

Later in December, during the week of the Cotton Bowl in Dallas—Michael Jr.'s final college game—Michael Sr. said his son borrowed his car and spent all of his time with Vito and teammates. Michael Sr. also said his son lied to him about the location of the team hotel and then didn't call him, or return any of his calls, for the rest of the week.

"I had to call him to get him to bring me my car back," Michael Sr. said. "I kept calling and calling. He didn't bring the car until the last day, and the game was the next day. He didn't talk to me or nothing."

In May, on the weekend of the NFL draft, Michael Jr.'s family was conspicuously absent when TV cameras followed him around at his agent's home in San Diego. He declined an offer from his father's family members to attend a draft party they wanted to host in Dallas, his aunt Geraldine and Michael Sr. said. Instead, he spent the weekend in California with Vito, some friends, and his agents.

"If he's so ashamed of us," Geraldine remembers one of his sisters telling her, "why doesn't he just change his name?"

The day the Rams drafted him—when he was so happy that he kissed Vito and smeared his face with celebratory cake—might

end up being the pinnacle of Michael Jr.'s NFL career. Now, cut from his second team, he is learning something his father learned long ago: life can take what you want most.

Since 2000, *Outsports* noted, every single Defensive Player of the Year from the five major college football conferences made it onto an NFL team—except Michael Sam Jr. And it's not that he played poorly in preseason. Far from it. He totaled 11 tackles and three sacks, a figure that left him tied for fourth in the league. His bold announcement of his sexuality, which garnered him glamorous accolades, may have also destroyed his football career.

Disappointment and loss are feelings Michael Sr. knows well, of course, so the two Michaels have more in common now than they may have ever had. And yet Michael Jr. doesn't come to his father—or anyone in his family—for comfort. He keeps his distance.

To Michael Sr., sitting in his wheelchair or taking a drag on one of his Kools, that distance can feel like death. He doesn't want to lose another son.

JEREMY COLLINS

Thirteen Ways of Looking at Greg Maddux

FROM SB NATION

1. First Pitch

THE JOKE, said Braves broadcaster Skip Caray, is that if *half* the people who claimed to be at Atlanta–Fulton County Stadium during the Bad Times (1985 to 1990) had actually been there, no seat would've been available. Jason and I were there—wandering, hounding autographs, chasing foul balls across acres of empty seats. We smoked our first cigarette in the solitary shade of the orange upper deck in left-center field. Once, with no crowd noise to compete with our pubescent jeers, Padres slugger Jack Clark turned and flipped us a bird.

The stadium organ waltz of another Braves lost season was the soundtrack of our summers.

Routed. The Cellar. *Loserville, USA.* Defeat for the Braves was inevitable until it wasn't. In the summer of '91, enchanted words— *Magic Number, Clinch, The Pennant*—belonging to distant cities—New York, St. Louis, L.A.—could suddenly be touched each morning in the paper. Now only winning mattered. And the game rewarded us each fall by finding new ways to break our heart.

The Twins of Minnesota that fall. The Blue Jays of Toronto in the '92 Series. The Phillies—the *fucking* Phillies—in the '93 NLDS. The Strike in '94.

But then there was 1995. On October 21—World Series, Game 1—Jason and I and 51,874 fellow Braves fans poured into Atlanta–

Fulton County Stadium. Now college roommates with almost calloused baseball hearts, we wedged into Section 311, high up, directly behind home plate. On the mound, warming up, blowing into his right hand between pitches, stood Gregory Alan Maddux.

Jason kept a picture of Maddux above his desk in our dorm room at Young Harris College in the north Georgia mountains. A beautiful athlete, the best on campus, Jason played only intramurals and spent serious time at his desk. A physics workhorse and calculus whiz, he kept Maddux's image at eye level.

Shuffling and pardoning down the aisle to our seats, Jason stopped and squeezed my shoulder. "Look," he said.

Maddux strode toward home, hurling the ball through the night.

It's 2014. I'm 37. My wife and daughter are both asleep. I'm a thousand miles from the stadium-turned-parking-lot. On YouTube, Kenny Lofton of the American League Champion Cleveland Indians looks at the first pitch for a ball. Inside, low. I don't remember the call. I remember all of us standing, holding our breath. Then I remember light. Thousands of lights. Waves of tiny diamonds. The whole stadium flashing and Jason, who would die five months later on the side of a south Georgia highway, leaning into my ear and whispering, "Maddux."

2. *Prospects*

SCOUTING REPORT: *Greg Maddux, age 18, by Chicago Cub Scouts Mapson and Jorgensen*

Height: 5'11, Weight: 155, DOB: 4/14/66. Home: Las Vegas, Nevada.

Abilities: I really believe that this boy would be the number one player in the country if he just looked a little more physical. Has average to above average fastball now. He has a big league CB but needs to be more consistent with it.

Weakness: Lacks control on all his pitches. Just has to get ahead of hitters more often. Sometimes cocks his wrist too early on his curve and telegraphs it.

SCOUTING REPORT: *Jason Kenney, age 19, by Boyhood Friend & College Roommate Collins*

Height: 6'2, Weight: 216, DOB: 1/9/77. Home: Atlanta, Georgia.

Abilities: Three-Sport Athlete. Center Fielder, Georgia Little League
World Series team, 1990; Fullback and Tight End, Atlanta Colts Pop
Warner Football National Champions, 1991; Guard and Small Forward,
Dunwoody High School, Georgia High School Basketball Champions,
Undefeated, Ranked No. 3 by *USA Today*, 1995.

A "natural." Hyper-competitive. Crazy instinctive touch and feel. In-
spires envy.

Once bowled a 290 in Rome, Georgia, while consuming 2½ pitchers
of Bud Light.

Weakness: Lacks control (drinking). Dismissed from basketball
team two days before state title game—showed up drunk (again) to
school. Binge drinking since age 14.

3. The Caddie-Fanatic

Trouble found Maddux on the second pitch. Kenny Lofton—that
leadoff fury with legs electric—hit a scorcher to sure-handed short-
stop Raffy Belliard, who butchered the ball. Lofton stole second.
Lofton stole third. Baerga bounced to short, Lofton scored.

One–zip.

"It's okay, Gregory," Jason said.

Jason didn't speak directly to Tom Glavine or John Smoltz or
any other athlete. Unlike me, he wasn't prone to hero-worship.
As a kid, he didn't wear the jerseys of Dale Murphy, Dominique
Wilkins, or Deion Sanders. Jason identified more with the game
and the desire to be playing. His father, Charles Kenney, played
basketball at Georgia Tech and tried out with the Hawks. His older
brother, Keith, went to Tech on a hoops scholarship. Jason, Boy-
Midas, was next.

"Nothing we can do about that," he instructed Maddux.

When Jason started attracting attention for his abilities on the
diamond and the court, he answered the Dionysian call of the
party. His cup overflowed. In college, he estimated he spent 75
percent of his high school nights drunk or high. Jason told me
this sober one winter morning, months after the World Series, at
breakfast. His tone didn't betray bragging or bitterness, just curi-
osity. Instead of ACC ball at Tech, Jason was playing against me
that winter in an ancient, empty gym in the mountains of north
Georgia.

Maddux escaped the inning. Jason stood, excused himself, saying he needed a drink.

Twelve-packing our way through the Colorado Rockies and a sweep of the Reds, we drank beer in the playoffs just as we did in the regular season. Every game. Except for Maddux's. Jason didn't drink when Greg Maddux pitched. "We're good," he'd explain, though it wasn't clear where the boundaries of "we" began or ended.

Maddux was warming up to begin the second when Jason returned with two cups of coffee and a bag of peanuts. He handed me a coffee.

"Let's get to work, Gregory," he said.

Jason used "Gregory" when Maddux was in trouble, which was rare that year (19-2, 1.63 ERA). But against Cleveland—Lofton, Albert Belle, Jim Thome, Manny Ramirez, Eddie Murray—the water was deep.

"There you go, Gregory. Fastball inside. Now, changeup away."

During his tenure with the Braves, Maddux had a cadre of entirely forgettable catchers: Damon Berryhill, Charlie O'Brien, Eddie Perez, Paul Bako, Henry Blanco. Maddux's personal pitching valets. Catcher caddies. Unknown to the sporting world in 1995, Maddux also had a singular fan, a real fanatic, from the Latin *fanaticus,* meaning "enthusiastic, inspired by a god."

"There you go, let him ground out, Gregory."

"Cutter inside. Handcuff him. Yes. Like that."

"Curve, Gregory, then fastball, then change."

By the third, Jason was speaking only to Maddux, calling pitches and predicting where the outs would fall. *Grounder Belliard. Ground-out Lemke. Strike three looking.*

Maddux found a groove, a keyhole, and Jason did too.

It'd be too much to tell you that every pitch and pop of the bat traveled the path of Jason's words, but for three straight innings the ball seemed to do exactly that.

4. Fish Story

Over the years, I've shared little about World Series Game 1. I don't trust my words. That for which we find words, Nietzsche

writes, is something already dead in our hearts. Besides, the heart
of baseball is already clogged with stories of Too-Soon-Gone-All-
Star-Best-Dead-Buddies and Forlorn Fathers. I don't trust memory
when it's sweetened by a sentimental, high-fructose, *Field of Dreams*
corn syrup.

What I saw, though, is what I saw. And only recently have I
inched closer to the truth.

Before the Internet was in our pockets, *Sports Illustrated* arrived
once a week in the mail. It was a big deal. Babe Ruth had Grant-
land Rice, DiMaggio had Jimmy Cannon, and in our days Greg
Maddux had Tom Verducci. On August 14, 1995, the week we en-
rolled as freshmen at Young Harris College, the cover of *Sports
Illustrated* featured Greg Maddux with the headline: "The Greatest
Pitcher You'll Ever See."

In the cover story, Verducci attempts to explain in prose Mad-
dux's astonishing range of gifts: intelligence, control, humility,
instinct. "But," Verducci writes, "he is even better at analyzing hit-
ters—so good that four times this year, while seated next to Smoltz
in the dugout, he has warned, 'This guy's going to hit a foul ball in
here.' Three of those times a foul came screeching into the dug-
out."

Jason's *SI*s from August 1995 to March 1996 now sit in a trunk
in my closet. A few weeks after the accident, his father Charles
gave me the magazines along with Jason's Little League baseball
cap, white Adidas basketball shoes, and Physics notebook. Charles
said that Jason loved me like a brother and I wasn't ready to hear
that yet. Each item, even the date-stamped magazines, stood as sin-
gular reminders of my greatest failure.

I can't think of Jason today, or of the days leading up to his
death, without thinking of Greg Maddux. And I can't think of
Maddux without thinking of Verducci. With Maddux's Hall of
Fame induction this summer, after having not opened the trunk
in years, I cracked it open, brushed the dust off Verducci's article,
and found the movie of my memory experiencing technical dif-
ficulties.

What unsettled my memory are two events stuck within the
timeline of my best friend and our favorite pitcher.

It's September 1995. Jason and I are fishing the banks of a golf
course pond near Lake Chatuge in north Georgia. A golfer lines

up his 8-iron approach. Jason says, "Watch. He's going to shank this. But don't move. It'll land between us." The shot slices. Rises. The man yells, *Fore!* A heat-seeker, the ball hits right between us. The man issues a stream of apologies. Jason looks at me, winks, and casts his line back into the water.

It's October 1995. World Series Game 1. Maddux is dealing in dark matter and the ball is dancing as Jason calls pitches *and* outs. This Jedi-Mind-Meld can't last forever, but it's happening. For five innings Maddux is no-hitting Cleveland and Jason is part of the orchestration. The moment is as real as the spinning Titleist golf ball streaking past my left ear.

For years, I chalked up both memories as spooky coincidence. Jason had somehow accessed Maddux's wavelength. Now, I know better. Jason read Verducci closely. The picture at his desk was the first step. Each time he glanced up from his work, those calm brown eyes were the eyes his met. At the pond and at World Series Game 1, he decided to experiment further. Jason wanted to graph Maddux's control and command onto his own days, which had so often before drifted toward the edge of the road.

5. A False Summer

See Greg Maddux: surviving Albert Belle; frustrating Eddie Murray; freezing Manny. *Fly-out. Grounder. Strike three.* Jason's words, barely over a whisper, move with the ball. And the ball changes— it's an aspirin, a Wiffle ball, a whitetail.

Maddux works quickly. The bill of his cap dips his eyes in shadow. Batters must locate the ball—a dart, a dove—from a man inside a mirage who's locked in a conversation with himself and, apparently, my best friend.

See Jason Kenney: elbows on knees; holding a cup of coffee like a prayer; eyes locked on Maddux. He is 18 and he is handsome and his face is prematurely lined. He's wearing jeans and a gray hoodie. His eyes won't leave Maddux. To understand what Jason sees in Maddux, you have to travel back five years and 515 miles to Bloomington, Indiana. You have to see what he wanted to find in himself.

Look at Jason. We're 13. Sharing a dorm room at Indiana Uni-

versity at the Bob Knight Basketball School. Two boys in Air Jor-
dans amidst a sea of boys in Air Jordans. Curfew. Lights out. Win-
dows open. Jason is telling me about his dad.

Earlier that day, during the team games before lunch, Jason put
on such a show that IU assistant Ron Felling and Coach Knight
(tanned, huge) took up spots under the basket. They watched
Jason drain a three, defend the pick-and-roll, grab weak-side re-
bounds, and—with the game tied, seconds left—drive hard and
draw a foul. With Bobby Knight looking on, arms crossed, Jason
sank the first free throw and then the second. All net.

After the game, Knight—unsmiling—approached Jason and
the same hand that fell on the shoulders of Coach K, Bird, and
Jordan now rested tenderly on Jason's. Anointment. Knight spoke;
Jason nodded. Knight kept speaking; Jason kept nodding. Finally,
Knight smacked Jason—not softly—on the shoulder and Jason
jogged off the court, head down.

At lunch, Jason brushed off our table's persistent questions, say-
ing Knight just gave him a pointer on defending the post.

Nonchalant at lunch, at night, in the dark, Jason pontificated.
Did you know, he asked, *that I've never been this far from home?* What
would his dad say about the free throws? Could I tell his knees
were shaking? Did I know Charles grew up without a dad? Just
drove off when Charles was seven. Alcoholic. Landed in Miami.
Did I know playing ball became Charles's obsession? Did I know
Charles led the state of Georgia in scoring his senior year? Did I
know Charles vowed to God, each time one of his six children was
born, to be a good father? Did I know that Jason had promised
himself to make his dad proud? That he was going to play at Tech
too? That this was why he played so hard?

There was a lot I didn't know.

For the rest of the week, counselors at camp—high school
coaches, small-college assistants—called Jason "Bailey Junior" after
the ballyhooed Hoosier recruit, Damon Bailey, who'd just arrived
in Bloomington. Every day, in drills, getting water, at the IU book-
store: *Hey, Bailey Junior.* Made me proud. *And his sidekick.* Made me
sick.

Riding down I-75 in a minivan as Jason slept, I saw a line of
future coaches and scouts waiting to put *their* hands on Jason's
shoulders. I took stock of my mere adequacy against his star. A

Jason highlight reel had already played in my head; in Indiana, he added narration, a voice-over, a past, present, and future.

I never forgot Jason's promise.

Careful what you promise.

Every child dreams perishable dreams. It requires a hard lunacy to hold a friend accountable to their summer camp musings. But not every kid has the gift. I couldn't let go of Jason's potential. Neither could he. The deficit between his incredible promise and our intramural reality drove Jason's preoccupation with Greg Maddux in the fall of 1995. Maddux: that rare athlete (rare person) who realized the absolute limit of his potential.

That wasn't all, of course. There was more. More to Jason's affection, curiosity, and interest. More than I can know.

See Maddux: top of the fifth; one out. Thome shortens his swing and punches a ball to left. Cleveland's first hit. See Jason smile, sip his coffee, say: "Sorry, Gregory. My bad."

6. *The Vow*

Greg Maddux! On top of a fire truck! Red lights spinning! No sirens, just cheers— *Maddux, Maddux, Maddux!* And there he was! Above us! Twenty feet in the air! Jason and I skipped Monday classes and made the hundred-mile pilgrimage south to stand shoulder to shoulder with half a million tomahawk-chopping Braves fans near Atlanta's Woodruff Park. World Series Victory Parade. And there was Maddux! Waving like an awkward emperor! Hair parted in the middle! Oh, Maddux! Jason grabbed his disposable camera and clicked as the City of Atlanta fire engine, approaching speeds of five miles per hour, crept down Peachtree Street, toward Auburn Avenue, carrying Greg Maddux out of sight.

In the first week of November, Jason got the film developed. Was he disappointed? The pictures revealed raised foam tomahawks, the heads of strangers, the side of the fire truck, and in one, the possible outstretched right hand of Greg Maddux.

A few days before final exams in November, Jason placed an index card on the bulletin board above his desk, just to the right of his image of Maddux. On the card, he'd written FOCUS. On another index card, below the first, he wrote: THINK BIG. After

the holiday break in Atlanta, during the first week of January, Jason wrote a quote from Emerson, "To be great is to be misunderstood," and tacked it above the image of Maddux. A few days later, while we were doing homework, Jason asked if I'd take a 40-day vow with him.

"What kind of vow?" I asked.

"A vow with God."

"With who?"

"God."

"About what?" I asked.

"Staying sober. For 40 days."

I hesitated. Whether I acknowledged it or not, Jason's "issues with drinking" were my upper hand. I didn't want to lose that advantage, even if it was illusory. Jason rolled his desk chair next to mine. "I've tried this before. I need you to hold us to it."

I recalled enough from Sunday school to know 40 was the number of days Jesus went to the desert and Noah sat drifting as the world sank. Jason had surrounded the image of Maddux with meaning, literally. Now I wasn't sure where that meaning was headed.

"What's the longest stretch you've gone without a drink?" I asked.

"Six days. Six days last summer. I tried the 40-day vow then."

"What happened?"

"Couldn't do it."

"Forty days?" I asked.

"Forty days," he said.

Saying *no* to Jason was hard, even if it wasn't clear what you were saying yes to.

"So let it be written," I said.

He smiled. "So let it be done."

The cheesy Technicolor lines were from Cecil B. DeMille's *Ten Commandments* starring Charlton Heston, a film we were subjected to 20 times a year in junior high. I went over to Jason's desk. The bulletin board shrine to Maddux began to take on a new light. I picked up a small desk calendar Charles had given him. Each day held a unique Bible verse. I counted out 40 days, and read. I counted again. Then I handed Jason the calendar and he made an audible sound as if being punched.

The Bible verse took the remaining spot to the left of the image of Maddux, and on it we marked off our days. If Jason was to become more like Maddux, it wouldn't be in the carnival barker voodoo of predicting the path of a ball. It would have to be in some deeper commitment—the very thing that makes us human: the capacity to make and keep a promise.

At the end of each day, Jason, not without self-dramatizing ceremony, announced the day completed and how many days we had left.

"So let it be written," I'd respond from across the room.

"So let it be done," he'd say, marking off another day next to Maddux.

7. *Control*

Whatever wavelength Jason found with Maddux fell flat in the seventh inning. Albert Belle, Jason's greatest fear, was on deck. Belle, who had 50 homers in a time when that meant something, had hit the ball hard each at-bat. Jason, suddenly silent, kept his head down, shelled his peanuts, and tried to drop each shell into the empty Dixie paper cup between his feet.

Carlos Baerga led off the inning. Maddux struck him out in three pitches.

Albert Belle—whose menace radiated from his massive eyes and bulging forearms—strode to the plate. Jason juggled peanuts from his right palm to his left.

On a 1-2 count, Belle hit a screamer toward third. Chipper Jones gloved it and fired to first. Out! Jason sighed. If Maddux could go the distance, he'd avoid having to see Belle again. On the next pitch, Eddie Murray hit a comebacker. Three outs. Eight pitches. As Maddux made his way off the mound, Jason stood and stretched with the assembled masses. Then he disappeared.

In the bottom of the inning, the Indians' staff lost control. Orel Hershiser fell apart, finally running out of duct tape and glue. He walked Fred McGriff and then, on four straight pitches, walked David Justice. His replacement, Paul Assenmacher, walked the pinch-hitting Mike Devereaux. The Braves pushed over two runs. In a battle of wills, the deciding question was control.

In November of 1996, eight months after the accident, my uncle Gary took me horseback riding in southern Indiana. We rode through the fog and chill of Hoosier National Forest. During the day, we never spoke about Jason, but I felt my uncle's concern in the way he treated his horses and me, and in how he'd carved out a day for us to be in silence in the forest. I felt it saying good-bye when he handed me his AA token—15 years sober. I keep it on my desk now, along with a Greg Maddux baseball card. Wherever I've lived, both have traveled with me like two amulets.

On the back of the coin is a prayer you've probably seen cross-stitched on the pillows in your grandmother's house or on the bumpers of diesel pickups: GRANT ME THE SERENITY TO ACCEPT THE THINGS I CANNOT CHANGE, THE COURAGE TO CHANGE THE THINGS I CAN, AND THE WISDOM TO KNOW THE DIFFERENCE. The prayer is often called the Serenity Prayer, but I think of it as the Control Pitcher's Prayer.

As a struggling young pitcher, Maddux found Harvey Dorfman, a former sports counselor and baseball guru—the troubled pitcher's Yoda. Maddux cited Dorfman in his Hall of Fame induction speech. For Maddux, his time with Dorfman represented a graduate course in control. What could he control? From his classic, *The Mental ABC's of Pitching*, Dorfman addresses the issue of control in reference to the Serenity Prayer: "That wisdom . . . requires introspection and awareness that is often obscured by the emotions of the moment."

The emotions, plus a tired right arm, made the moment too big for Hershiser.

John Smoltz once said of Maddux, "He never did more than he was capable of doing. He stayed within himself and stayed within his ability."

Later in the chapter, Dorfman quotes one of his most famous clients at length:

> Greg Maddux learned long ago to distinguish between what he could and could not control. "I can control the pitches I make, how I handle my mechanics, how I control my frame of mind. It benefited me most . . . when I realized that I can't control what happens outside of my pitching," he explained.
>
> In 1995, Philadelphia outfielder Ryan Thompson said of Maddux, "He's so good it's funny. It's like he's controlled by somebody." Funny to say, the somebody is himself.

Driving home after the game, I asked Jason where he went after the top of the seventh. Nowhere, he said. Just walked. It made him uneasy, he confessed, to care so much about something over which he had no control.

Jason hadn't returned until the middle of the eighth. Retaking his seat, he raised his thick eyebrows twice, allowing the faintest of smiles. Jason knew things I didn't. But at that moment, I knew. The Braves were going to win. This game. And the Series.

"Let's go, Gregory. Six more outs."

8. The Looking Glass

I wasn't sure how long he could keep it up—sprinting from one end of the dark court to the other, stopping under each basket, jumping up, slapping the backboard 10 times, and then back again. But he kept going. It was the middle of February and a winter storm had knocked out the power across campus and the entire Brasstown Valley. We were sitting at our desks, Jason in front of his Maddux shrine, when the world went dark.

Our routine that winter was to head to the gym every night after dinner, from 7:30 to 9:00. We'd shoot, lift, play one-on-one. The gym was like an old church—smooth, worn-out wooden floor with dead spots, a leak in the roof, the buzz of the fluorescent lights overhead. Deserted on most nights, we had the entire court to ourselves. The college once had a powerful team, but when the school dropped the program in the late '60s, it also stopped maintaining the gym. I was grateful that there wasn't much of a crowd for our games of one-on-one. As the vow went deeper, Jason became unstoppable. Usually I could steal a game or two by outworking him and getting hot from the outside, but that winter he was too quick, too strong, too focused, too *Jason*.

Some nights we played intramurals, and I was grateful for the reprieve. We could compete together and I could watch him beat someone else. Our team—a motley collection of former high school players of varying abilities—barnstormed through the fraternities and other intramural teams in front of crowds that *sometimes* reached double digits.

The night the power went out is the night the vow came into focus for me. Jason insisted, in the dark, that we still head to the

gym. He had to keep the routine going. I protested. He persisted. We took the ball and headed into the night. Inside, the gym was dark except for the soft red pools of light in the corner, from the glow of the emergency exit signs.

I jogged around the gym as Jason walked under the basket. In one motion, he sprang up and slapped the backboard. As soon as he landed, he jumped again. *Smack!* With both hands, Jason hit the glass 10 times and then ran down to the other goal and repeated.

Jason loved the motion and the movement of the game just as he loved the flow of the party and the blurring of boundaries when he drank. Sober, the game and the court became something larger—a renewed promise, a place of possibilities.

If Jason wasn't drinking, he *needed* to play ball, to compete, to win, to streak through space and slap a glass backboard. In the moment of competing, maybe his scoreboard clicked off. He no longer had to measure himself against the standard.

When I drank with Jason, the scoreboard of resentment I'd been updating for years would turn off. I'd temporarily forget the words *promise, past, potential, Tech, All-Star.* On the court, though, I rarely had the ability to concentrate the way Jason could—to become so lost in the game that the regular boundaries of time and space fade away and there is only the ball and the goal, the world shining in a vivid state of present tense.

Greg Maddux had this ability. Jason did too. The echo of Jason's palms pounding the backboard—flesh against glass—was unrelenting. In memory, each slap grows louder, more insistent. The night eluded my understanding then, and now I can only see around the corner of the memory.

But if I could show you Jason on that winter night in Young Harris, Georgia—running and leaping and slapping the backboard glass again and again—then you'd see everything I need you to see.

9. Complete Game

Heading into the final inning, Maddux had thrown just 82 pitches. The last three outs would require 13 more, but not before Kenny Lofton slapped a two-seamer into left and scurried and stole his

way around the bases until he scored. Neither Jason nor Maddux blinked.

With two out, Maddux got Baerga to foul out to Chipper and fireworks filled the brilliant October sky—cascading lights and drifting smoke. Maddux, immediately, demanded the ball. He was not smiling. He wanted the ball. Watching the replay now, it's an insight into Maddux's sense of history and timing. In the moment, I saw neither the fireworks nor Maddux. As soon as Chipper caught the ball, Jason wrapped me up in a hug and wouldn't let go. Eventually, he sat and exhaled. With the color gone from his face, the whole night seemed more like a boxing match than a baseball game.

The game was the longest of my life. Not officially—at two hours, 37 minutes it was just average. But afterward, we sat in our seats in silence for a long time. We watched the fans flock out of the stadium and the Braves leave the field. We watched the grounds crew go to work on the Bermuda grass, streaked with paint and the divots of cleats. We were the last in our section to leave.

We walked out of Atlanta–Fulton County Stadium, through the lots of beeping, jubilant car horns, past the minivans, past the pickup trucks, past the drunk, still screaming kids our own age, and into Jason's black Isuzu Rodeo. The same Rodeo we would climb into months later on March 20, 1996, headed to St. Simons Island on Georgia's Atlantic coast for spring break.

Jason and I kept our vow that winter quarter. We stayed sober 40 days. We made sobriety what we had often made drinking before: a competitive sport. A game. We kept the streak going all the way up until the road trip to St. Simons.

Seventy-three days sober, on March 20, at a seaside bar, we "fell off the wagon." Technically, we *flew out* of the wagon—the black Isuzu Rodeo—and afterward I slid Jason's obituary into the desk drawer of my new single dorm room back at Young Harris College.

On the way to St. Simons, Jason told me he'd had dinner with his dad the night before. His dad had just received his report card and insisted on steak instead of burgers. After the dinner, Charles told Jason he was so very proud of him. After the funeral, Charles told me the same story. And now I am telling you. We had traveled 321 miles. Our destination was six miles away when we pulled into the downtown parking lot by the lighthouse. We stopped at a bar. Figured we'd earned that too.

It started with a pitcher. And then another while playing pool. I don't remember how we ended up standing at the bar, but I remember the moment when the prospect of shots came up. And I remember exactly what we both did.

"We good?" Jason asked.

Translate: Stop now? Beer enough? Go home? Drink up? Your call.

In memory, this moment lingers and the decision hovers in midair, but in truth, I just shrugged. Smiled and shrugged.

"The signals we give should be clear," the poet William Stafford writes. "The darkness around us is deep."

You know the story from here. Your images are as good as mine. I have no memory of riding shotgun down a dark seaside highway. I can't see the confusion of lights at the traffic circle or the moment Jason slammed on the brakes, flipping the Rodeo, sending us out into the night. When we landed, Jason snapped his spinal cord and I—I spent the nights and years that followed searching for solid ground.

On or off the diamond, if Greg Maddux shrugged—playing dumb, deflecting a question, appearing aloof—it was for a purpose. His career is a testament to purposeful self-knowledge and the refusal to budge, to forget, to become someone he was not.

EMT and hospital officials had trouble identifying who I was. I didn't help. The hospital records state: *Patient is a well-nourished, well-developed white male who is intoxicated and confused and unable to provide any significant history. His companion was DOA.*

Every day can't be Game 1 of the World Series. The critical moments of any life only become so in the rearview. But standing in that sports bar, I knew. I knew Jason's blind spots and the miles we had traveled together. I knew he needed me. He knew that I knew.

We good? he asks.

And keeps asking.

And I smile. Smile and shrug. And the gold liquid pours and the keys are in his pocket.

10. Free Baseball: 1996

I did not stand with the swelling crowd at the Westview Cemetery in Atlanta under a bright, spring sun. I was in bed at the South-

east Georgia Medical Center with a broken nose, a broken foot, and road rash. I didn't miss, however, a single game Greg Maddux pitched that season. Except for one. The last.

Maddux went 15-11 with a 2.72 ERA and made 18 home starts in 1996. The drive from Young Harris was 100 miles. Gas was a dollar and a quarter. I had a 1986 Ford Thunderbird with over 180,000 miles and a shoddy transmission.

I drove down the rhododendron-lined highway and rolling Appalachian hills into a smog-enshrouded traffic hell. Park. Pay. Walk. I disappeared into the crowd of fellow believers. We marched down gridlocked Peachtree Street, past scalpers and T-shirt hawkers with car audio systems and sidewalk stereos set to *Whoomp! There it is! Whoomp! There it is!*

And there it was. Atlanta–Fulton County Stadium. Home. Scheduled for demolition. Final season. Farewell, friend. Designed with all the aesthetic subtlety of an East German architect, I entered its gates repeatedly that season to watch Greg Maddux on a mound of soft dirt—in night and day and sun and shade—do a very difficult and direct thing.

His record didn't reflect his brilliance. Compared to his four previous historically transcendent campaigns, the 1996 season for Maddux was a struggle, a grind. Bad breaks. I didn't find there a single extended metaphor. Everything was metaphor. I couldn't cry about Jason. I couldn't speak about Jason. I couldn't stop thinking about Jason. The terms *shock* and *survivor's guilt* didn't fill the Big Empty. So I committed myself to the Braves and Maddux and the rapture I found in those hours.

I kept score; I listened to Skip and Pete; I tried, and failed, to tune into Maddux's pitches. I hiked the concourses with echoes of the crowd through the haze of cigarette smoke and dried piss, each sticky step over a strata of spilt Coke. During the pennant race, I stood in concession lines with fellow-citizens of the South and argued SEC football. The push and pull of the people, the game, its music, the hovering humidity, even in the night—it felt like home.

If you destroy it, they'll still come.

On the drive back north, I would wrestle for miles. *You wanted to be him. And you wanted him gone. You wanted to shine alone.* Some nights in the hypnotism of the highway's white lines, I wanted to rip my teeth out. Sometimes, I shut my eyes and let the car drift

and tried to remember . . . the hum of the tires, the bump of the reflectors, the shoulder of the road . . .

Back in the mountains, in my single dorm room, I tried to sleep. I focused on Maddux's next scheduled start. The ballpark. The lineup. Tendencies. My elaborate lullaby.

"A baseball season is a novel written in the dirt," Atlanta sportswriter Dave Kindred once wrote. "There is no rushing to the end." The conclusion to the novel of '96 came in two parts.

When Maddux took the ball for World Series Game 2 against the Yankees, I sat in front of my tiny TV in Young Harris and had trouble breathing. Grief grants previously random dates new weight. October 21. That night marked the one-year anniversary of Jason and Maddux beating Cleveland. *C'mon, Gregory. Jason. Do it for Jason.*

And then Maddux did precisely that. Eight innings. Shutout. Four hits. They couldn't touch him. And he knew it. He was almost smiling. With each strike, each Yankee groundout, my heart cracked.

Jesus, Gregory, yes. Shred these motherfuckers.

The feeling was vicious. By the seventh, tears swelled in my eyes. Jason, Jason, Jason. The Braves headed home up 2–0 with the stage set. Three games in Atlanta. Win two and I could say good-bye to the season, the stadium, and maybe even Jason.

The Braves dropped Game 3, 5–2, after Bobby Cox pinch-hit for Glavine in the seventh. In Game 4, up 6–3 in the eighth with two outs and two on, All-Star reliever Mark Wohlers, whose fastball reached 103 miles per hour, had Jim Leyritz down 1-2. *Fastball, fastball, fastball.* A pitcher, Dorfman writes, must never forget who he is. On the fourth pitch, Wohlers shook off Perez. Wohlers threw a slider. The fat, dumb ball trailed back over the plate. Leyritz unloaded. The goofy, idiot ball hung in the air forever, but it was gone. Game tied. Game lost. Series tied. Series gone.

I couldn't stop watching the slow-motion replays of the slider. Something twisted in my gut; I could not accept the result. My mind and stomach looped and the room spun, but I couldn't take my eyes away. Wohlers's slider became the wreck I couldn't see, the tears I couldn't cry. It kept happening. The ball floating, moving in the wrong direction.

Slack-jawed, I turned off the television. I knew this script. Unlike Jason, my baseball spiritual arrangements tended toward

something darker. I knew Maddux's masterpiece was for naught. I knew in the way you know a team having grown up with them, that the Series was lost. I sensed some incredible waste. I couldn't watch anymore. I couldn't *deal*. It's not over till it's over, but for me it was over. I would read about it all later. And I did. Years later.

The next night, as the Braves lost Game 5, 1–0, I went to the gym and shot 1,000 three-point baskets. That was the goal. Shoot 1,000. Five nights a week, in the months to come, basket after basket, I shot until blisters opened on my feet and then I shot some more.

When Maddux lost the deciding Game 6, 3–2, I was at the gym shooting threes. I shot my 1,000. Showered. Did homework. Before going to bed, I stole a glance at a muted ESPN and saw a grinning Wade Boggs on the back of a police horse, celebrating.

The morning after the World Series defeat, with a backlog of homework, I finished *The Iliad*. Achilles' friend Patroclus is killed. He rages. Can't sleep. *But Achilles kept grieving for his friend, the memory burning on.* He honors his friend with funeral games. Competitions. Races. Sport as mourning. Reading, I felt comforted by invisible hands. I decided to play intramural basketball the next semester for Jason. Each long-distance shot now had a purpose. And each time I released the ball, I encountered something else.

You can't see it now, the gym is gone, but in the winter of 1996, you could stand under the basket, look up, and spot a series of handprints running up and down the foggy glass.

11. Another Spring

During that school year, I kept my uncle's AA token and a Greg Maddux baseball card by the lamp on my desk. I'm holding the 1995 Fleer Ultra Gold Medallion Number 129 right now. Maddux, centered in mid-throwing motion, is wearing the road grays with a gray T-shirt underneath. The background of empty stands and shadows suggests the old Three Rivers Stadium in Pittsburgh. Maddux's mouth is open. Eyes lasered. His face is pure concentration, as if he were flying a plane, playing the violin, completing a heart transplant.

Maddux is alone in the image. As every pitcher is. The mound a small and unforgiving island on a larger stage where one's capacity

for concentration is only as good as the next pitch. I've stared at this piece of cardboard more than any grown man should care to admit. Maddux's expression and movement—effortless, frozen in time on the card—take on a certain childlike quality. "May what I do flow from me like a river," Rilke writes, "no forcing and no holding back, the way it is with children."

In the image, Maddux is in that state of perpetual present tense. *Flow. The Zone.* He spent four years, from 1991 to 1995, operating in that state of grace. I've only brushed against it briefly.

On game nights, I touch the Maddux card before turning off my dorm room lights and heading across campus to the gym. Intramural basketball at Young Harris College in the spring of 1997 is as unglamorous as you might imagine. But it's basketball. And I'm wearing Jason's white Adidas basketball shoes. One March night, late in the season, we take the court against the Brothers of Alpha Xi, whose capacity for talking shit transcends their hoop skills. The talk is white noise, background.

The tip goes to Dustin Goode, our wing, who finds me at the top of the key, 20 feet out. I catch, shoot, and drain a three. On the next possession, I run off a screen on the baseline and get open in the corner for a deep three. Good. Throughout the first half, the ball keeps finding me and I keep shooting. *Splash, splash, splash.* The basket looks huge. There is no basket. Shooting the ball requires no more effort than skipping smooth stones across Lake Chatuge.

In the second half, if I'm doubled, I pass. If I'm open, I shoot. With 30 seconds left and the outcome long decided, the ball comes to me on a fast break. Instead of laying it up, I dribble out to the wing, 25 feet from the basket. With all the arrogance my 20-year-old self can muster, I wait. Dribbling, I wait. I wait for the defense to float back down the court. And when it finally does, with a defender running toward me, closing me out, his hand flashing in my face, I rise, release, and . . . *splash.* Holding my follow-through, I point to the sky until the buzzer sounds and the game is over.

Later, after a few teammates hug me, after we stand in line to shake hands with Alpha Xi, Leah, the director of intramurals, who keeps the books, comes over and shows me. I'd shot 12 three-pointers and made 10. She flips back to the year before. There it is. Jason's high for the year: 30 points. I smile. He scored it in a

variety of ways. Flying through traffic, elevating, attacking the rim. Spinning drives morphing midair into reverse layups. Jumpers at the elbow. Three-point bombs. The night he scored 30, he was smiling. It's still the way I try to see him now—rapturous with joy, one with the moment, the game.

My own game is limited. I can do one thing, and looking at the notepad I realize that I'll never again do that one thing any better. I thank Leah, pull my hoodie on, and walk out into the vibrating air.

The comet Hale-Bopp streaks across the sky each night in March 1997. I want a shower, but I don't want to go inside. So I walk across campus, down Maple Street, and over Corn Creek to the darkened baseball field. The chain-link gate clicks open. I step across the diamond, onto the perfect green, and take a seat in center field. Thin trails of clouds ring the mountains. I untie the knots, loosen the laces, and remove Jason's basketball shoes. Shoes off, socks off, my feet sink into the soft grass. The comet—a silver-white ball of iridescence hurtling 100,000 miles per hour through interstellar space with dusted-up foul lines—looks close enough to touch. I put my head into my hands and fall apart. I'm not ready as the feelings, all the colors of feelings, wash over me.

12. Man, Myth, Maddux

Twenty-three seasons, 740 professional starts with four different clubs—there are endless ways to look at Greg Maddux. So many chances for accidental poetry, mixed metaphor, tongue-tied tautologies. In the televised broadcast of Game 1, in the seventh inning, Al Michaels is reduced to, "That is Maddux being . . . Maddux." Who is Maddux? What is Maddux? Do you know Maddux?

He's a Magician. Modest. A Surgeon. Savant. Unassuming. Born in Texas, the family lives in Indiana, North Dakota, Spain. His first Little League team is in Madrid. His dad, an Air Force officer, is the coach. The jerseys are green. In Spain, under a diffuse yellow sun, many years earlier, Hemingway writes, "Any man's life, told truly, is a novel."

He's a Choir Boy. The Bat Boy? A Prankster. When he is 10 years old, the family settles in the desert city of kaleidoscoping lights.

He has a brother Mike. A sister Terry. His mom is a Henderson County dispatcher. Dad deals poker. His first love is basketball, but he can't, in his words, "guard anyone." So it's baseball. He can pitch. From guru Rusty Medar, he's taught movement over velocity. Deception. He is a Viking of Valley High.

He's an Accountant. Math Teacher. Confident. A Nose-picker. Hardworking. Everyman. He's No One You've Ever Seen Before. He is an Iowa Cub with a sad mustache. A perm. A mullet. He marries Kathy, his high school sweetheart. He gets The Call and promptly gives up a homer to the Astros' Billy Hatcher in extras. Cubs lose. He is 20 years old.

He works hard, but not that hard. He pees in Andre Dawson's hot tub. He loses 14 games his first full season. Off-season, Winter Ball, Venezuela, he works on his change. He wins 18 the next year. He gives up a grand slam to Will Clark in the '89 playoffs. He spends time with Mr. Dorfman and learns, in his words, to "like himself" and to stay within himself. The following year he wins 20 games. He wins at least 15 games every season for the next 17 years. In a postgame shower, he chats up rookie Chipper Jones while peeing down his leg.

He is a Brave. A dad. Two kids. A dog named Baxter. A multimillionaire. Four straight Cy Youngs. He is relaxed. Intense. He is not juiced. Many juice. "Shit!" he yells after missing to Jim Thome in Game 1 of the 1995 World Series. At that game, in the nosebleeds, an 18-year-old boy in a gray hoodie tries to use The Force. "Fuck!" he screams after ball three to Sandy Alomar in the eighth. That boy's friend watches him watch Maddux. Are they in a trance? How does trance work? Baxter is a Yorkie Terrier.

He is carving up the Yankees under the lights, in New York, in October, with such savage lucidity that the friend's hands are shaking. A Gold Glover. An Older Ferris Bueller. He's Genius. Gross. A Bobby Fischer. A Van Gogh. Professor. Mad Dog. Doggie. A scar runs under his double chin. He is a Cub again. Briefly a Padre. Twice a Dodger. The friend plans his days and nights around each Dodger start so he can listen to Vincent Edward Scully paint pitches and outs. He is 42 years old. He retires.

He is back in Vegas, back home. Follow him on Twitter @gregmaddux. With Kathy, he runs a foundation for battered women and kids with cancer. Hall of Famer. His induction speech opens

with a fart joke. He can't stop smiling. Chicks might dig the long ball, but in a besotted game, during a craven era, he was the best. Follow Baxter on Instagram @littlefellabaxter. In interviews, he says the most satisfying performance of his career was Game 1 of the '95 Series. Of that night, he says nothing, everything: "It was my first crack at a World Series game, and I was lucky enough to get to pitch. And we won too."

Now, he golfs. Plenty of time in the desert for golf. From dawn to dusk. All that light.

13. And I Feel Fine: Summer 1999

We were at the end. Goners. All of us—just sucking down the very last of our Starbucks Grande Triple Shot Caramel Frap with Whip. Evidence scattered everywhere. The plastic cups with bent green straws were abandoned on sofa armrests, near the Harry Potter overflow, next to *Conversations with God,* and left upside down in the urinals at the Barnes and Noble near North Point Mall in Alpharetta, Georgia.

Home from college, I worked as a "bookseller," saving for a future where multinational banks, utilities, and communications systems faced certain catastrophic collapse. Famine, Genocide, Global Chinese Takeover, and other untold horror awaited. We stacked title after title on a center display table, next to Oprah's Book Club, in perfect pyramids—Y2K Cookbooks, Y2K Survival Guides, *Y2K for Dummies.*

Can your vegetables.

During those summer weeks, fat men in Italian loafers read *Guns & Ammo* and *Car and Driver* as the espresso machine at our Starbucks annex hissed like an assembly-line whistle. In our parking lot, adjacent to an AMC 14 theater, caffeinated teens in polished, combat-ready Hummers and luxury SUVs blasted Limp Bizkit and Offspring.

Offer children and older family members measured reassurance.

Soccer Moms, Senior Citizens, Youth Groups—all of Metro Atlanta, it seemed, was devouring the "Left Behind" book series as if it were free Chick-fil-A. The books depicted a fiery future where real Christians ascend and the rest of us—Jews, Catholics, Follow-

ers of the UN, Muslims, Unitarians, Agnostics, Atheists, Other(s) —
claw out each other's eyes. *But I tell you,* that first-century Mediter-
ranean Jewish Peasant said, *love one another.*

Arm yourself.

As a self-serious English major, I kept a poetry journal in my
pocket. Poems? Just words really, some my own, some others,
mostly half-memories of Jason. I wasn't alone in thinking of the
dead. Each night, bleary moviegoers wandered into the bookstore
with *The Sixth Sense* and *The Blair Witch Project* still in their eyes.

Store gallons of fresh, distilled water.

We wished to see dead people and each, in our own way, wished
for The End. Mostly, though, we wanted to see Celebrity. Ringed
by gated country club communities, golf courses, and horse farms,
Alpharetta was haunted by pro athletes and musicians. It turned
out Celebrity—just like us!—preferred to be surrounded by books
while skimming magazines.

Don't forget the batteries.

Look! Bobby Brown and Whitney Houston! Is that Falcon QB
Chris Chandler? There's Terance Mathis. *Shhh* . . . those are the
parents of slain child beauty pageant contestant JonBenét Ramsey.
Over there—NFL linebacker Cornelius Bennett! Elton? Elton
John?

Maintain constant vigilance. Keep a checklist.

Among the staff, we made Celebrity Spotting a game of rhetori-
cal *Jeopardy!* clues only. *Don't go chasing waterfalls over in Self-Help.*
No names. *Hey, you might be a redneck if you're shopping in Bargain
Books.* When Celebrity breezed by, customers cleared the aisles, re-
moved their oversized sunglasses, and set their Starbucks down.

Are you good with your hands?

I tried to Maddux Up and focus. Taped inside my tiny locker in
the break room, I kept a 1987 Maddux Topps baseball card and a
Xeroxed passage from Joseph Conrad's *Heart of Darkness:*

> I don't like work—no man does—but I like what is in the work—the
> chance to find yourself. Your own reality—for yourself not for others—
> what no other man can ever know. They can only see the mere show,
> and never can tell what it really means.

Late in the summer, on a slow weekday evening, I was working
the front registers alone when I looked up and saw Greg Mad-

dux—plaid golf shorts, canary yellow golf shirt—standing behind the red-velvet rope, a few feet away, waiting for me to look up.

In the Gospels, Jesus goes hiking with several disciples when he's suddenly lit up, arrayed with light. The shining forms of Moses and Elijah appear. A shout-out from the past. Transfiguration. As Maddux walked toward me, I didn't see the illuminated bodies of Sandy Koufax or Bob Gibson. Instead, on either side of Maddux, I saw Mickey Mantle and Ted Williams. Not their ghosts. Not Mantle leaking tears to Bob Costas or Williams riding a golf cart with Tony Gwynn. But *The Mick* in '56 and *Teddy Ballgame* in '41. They were in black and white, as if stepping out of a book, and then they were gone.

Years later, driving my pickup down I-15 in California, it connected: as a boy, at meals, my father switched his fork from his right hand to his left and back again, in an endless quest to emulate the switch-hitting Mantle. In his west Atlanta boyhood room, Charles kept a picture of Williams beside his bed; in his office now in Montana, an advertisement for "Ted's Creamy Root Beer" graces the wall. Both men still recite volumes of Mantle and Williams statistics and stories.

Maddux set his books on the counter—two Dr. Seuss titles, a traveler's guide to Tuscany, and a copy of *Golf Digest*.

Words. I had to say something, but what? *You almost singlehandedly saved the life of my friend.* Could I say that? *During my own bad time, you helped steady the days.* Could I ask about October 21, 1995? *Did the ball feel lighter that night?* What could I say?

I asked Greg Maddux if he'd found everything he was looking for.

He nodded and pushed his glasses up the bridge of his nose.

My hands moved deliberately and I felt the pressure not only of the past, but the future. *This* moment, right now, leaned in. Years from 1999, I'd be trying and failing to say what Greg Maddux had meant to Jason and me and what it was like standing face-to-face.

I rang up his books and asked if he needed any of the items individually gift-wrapped.

He shook his head.

I asked if he wanted a bag.

Again, he shook me off.

I announced the cost and Maddux paid in cash. Making change, I slid his receipt inside the travel book.

"Sir?" I said.

Maddux raised his eyebrows.

"You've mastered your craft. Your flame burns clear and bright."

Hack-Hemingway with a splash of Bad Updike. Sorry—it was all I had.

Maddux kind of smiled.

"Cool," he said, before pausing a beat and then saying the one word I wish I'd said all along. "Thanks."

ELIZABETH MERRILL

Being Tommy Morrison's Son

FROM ESPN.COM

MIAMI, OKLA. — His daddy's life was violent, disturbing, and R-rated, and that was on a normal day, but Trey Lippe's mom swore their son would live an average boy's life. He'd play with Transformers, run through the aisles of Wal-Mart looking for Ninja Turtles, and toss footballs in a fenced yard. He'd carry her name, to keep him safely out of the public eye. But ultimately that didn't matter because his daddy was Tommy Morrison. When Morrison was diagnosed with HIV, a group of parents wanted to ban the little boy from kindergarten because they were convinced that he would infect them all. "Mom, am I sick?" he asked Cristi Lippe.

He was healthy and fine, but life would never be normal. Every child, especially a boy, needs to know his father. And that's when things got strange.

Perhaps the best story Trey Lippe has to tell about his dad is kind of fuzzy. He was four or five years old, far too young to understand fame, eccentricity, or what made Tommy Morrison tick. The story involves a leopard, or maybe a cougar—Tommy had both in those days, so let's just call it a large, exotic cat. Morrison, at the height of a boxing career that earned him millions of dollars and countless female admirers, had his son over for a visit one day when, for some reason, he decided it would be funny to place him in a cage, alone, with the cat. It was enormous to a little boy, but was also declawed and defanged, a detail Morrison declined to mention to his son. The cat closed in, opened his mouth—and licked Trey, sandpaper tongue on baby-soft skin. Morrison couldn't stop laughing. The kid couldn't stop crying.

Nearly 20 years later, Lippe still has questions about his dad, but he believes he knows why his father put him in that cage. He wanted him never to be afraid.

On February 15, in a smoky Oklahoma casino somewhere off Interstate 44, Trey Lippe made his professional boxing debut in front of about 1,000 cowboys, mulleted gamblers, and starry-eyed fans looking for the next Great White Hope. The fight wasn't publicized much outside the eastern part of the state because, if word spread that Tommy Morrison's son had taken up boxing, it would've drawn far too much hysteria for a young man who didn't know how to jump rope six months earlier.

Lippe looks as if he came straight out of central casting, with a rock-solid body and boyish good looks that came from his father. A few hours before his debut fight, he walked through the lobby of the Buffalo Run Casino, and Morrison's old trainer, Doug Dragert, got goose bumps. "I could've sworn up and down," Dragert says, "that it was his dad."

The reasons for Lippe becoming a boxer at 24 would be obvious if this were a movie, such as *Rocky V,* which Morrison starred in so many years ago. He'd be doing it for his father, to better understand him by following the same path. To make him proud. But Lippe insists he's fighting for himself. He waited tables at a steakhouse before this, sold discount clothing, and worked construction 10 hours a day, a job that made him good money, but then he was too tired to spend it. Lippe, a former college football player at Central Arkansas, said he was at a crossroads in his life and missed being an athlete. That's why he's doing this.

So maybe it's merely a coincidence that he decided to pursue boxing late last summer, as Morrison lay dying in a hospital bed in Omaha, Nebraska. Lippe reached out to Tony Holden, Morrison's old promoter, to hear stories about his dad and the good old days. But he also wanted to ask Holden what it would take to become a boxer. Holden hadn't seen Lippe since he was a tiny kid. He immediately tried to shoot him down. "The industry is in the toilet," Holden told him. He could waste four years on it, get nowhere, then ask, "What have I done with my life?"

Shortly after Morrison died on September 1, Lippe got ahold of Holden. He told him he was going to fight with or without his help. Holden sighed. He said he'd help him.

It hasn't been easy, working alongside a ghost. Holden and Morrison grew up together, two young men finding their way around the ring in a golden time for heavyweight boxing in the early 1990s. Tony was Tommy's big brother. He told him what to do, and Morrison, in turn, usually did the opposite.

Being around Lippe is both exhilarating and sad for Holden. In one of their first meetings last fall, just after Morrison's death, Lippe walked into Holden's office and saw a poster of his dad on the wall. Holden told Lippe that his dad loved him. He used to talk about him all the time. And then they cried like babies.

This wasn't going to be like the old days. Holden laid down strict rules when they started: no entourages, no womanizing, no cell phone the day of a fight. If Holden didn't think Lippe had what it took to be a fighter, he'd have to quit.

But Holden sees something in the 24-year-old who is starting way behind his father. He sees someone who will listen.

"The timing was—perfect, you know?" Holden said after a pause when asked why Lippe is boxing.

"I have no doubt he's doing it for himself. I just feel like he's been inspired by his father."

Lippe's first opponent would be Kris Renty, a 21-year-old from Oklahoma City with an orange hi-top fade and a background in mixed martial arts. Renty had one professional fight under his belt, a knockout victory.

Seven hours before the fight, Holden, Dragert, and trainer Peppe Johnson went over Lippe's final preparations.

"You're a banger," Dragert said. "He can't touch you."

Everyone around Lippe seemed nervous. Dragert went on and on with stories about Lippe's dad. There was the time Tommy beat Bobby Quarry, and Morrison and Dragert hugged and shared a glass of champagne in a hotel room, just before the victory party, and Morrison looked at him and said, "We're back," because he always gave credit to his team, the collective "we." There were stories about his stinky feet—they were so rank that Dragert would tie his shoes together and hang them out the window—and about how Tommy always wanted to be Elvis, so he could take care of his friends.

"What kind of music do you like?" Dragert asked Lippe.

"Rap," he said, and Dragert groaned.

He told him he needed to listen to something relaxing before

his fight, something that wasn't rap, and Lippe just smiled. Holden thought that the stories were too much and that they wore Lippe down. He wanted to tell Dragert to stop. But as the fight got closer, Holden noticed something. Lippe appeared to absorb it all in a peaceful manner.

He put on a pair of trunks, replicas from his dad's fighting days. On the belt, in giant letters, it said, TOMMY. Holden had to walk out of the room when he saw Lippe hitting the mitts, in the trunks, because he was starting to cry. "I miss him," he said of Morrison.

The second-to-last fight on the card was finally over, and Lippe walked to the ring. Holden put his arm around him. He told him to stay calm, keep his hands up, and think defense. And Lippe did exactly the opposite.

Tommy Morrison, even in his adolescent days, was like a bottle of Mad Dog. You knew that he was bad for you, that he was trouble and would leave you with a massive headache, but you just had to have a swig. Cristi sat next to Morrison in Mr. Sherman's class in middle school. Morrison was unlike any other boy in the school. He had a tattoo. He drove a car. He was 13 years old.

Cristi couldn't stop staring at his tattoo, and finally, Morrison asked what she was looking at.

"Is it real?" she asked.

"Well," he said, "what do you think I got it out of? A Cracker Jack's box?"

She was Cristi Rader back then, daughter of Ken Rader, who just happened to be the principal of Jay High School. Her family, of course, worried about her hanging out with Morrison, especially when he dropped out of school for a while to work with his father.

But Cristi, a sassy jock and an All-State basketball player, couldn't stand it when someone told her she couldn't do something. It made her want it even more. And Morrison, no doubt, liked that spunk. They'd go fishing together; they'd hit a speed bag together.

They were on again; they were off again.

On their first date, he took her to see *Rambo*, which was fitting because Cristi loved Sylvester Stallone. Her basketball team used to run out onto the court to the song "Eye of the Tiger." They didn't know then that in a few years Morrison would be playing the character Tommy Gunn in *Rocky V* with Stallone.

For 15 years, Morrison had her heart, even when she knew he shouldn't.

"Let me just tell you," she says, "he had a way. He was smooth, and he did have a heart. He was a good person. He just had a lot of demons—I guess issues. I don't ever want to put his mom down or his dad down, but he had a hard life.

"We loved each other as much as we knew about love at that time. He never knew how to let go. Nor did I."

Cristi says she had a full-ride basketball scholarship at Connors State College in Warner, Oklahoma, but she couldn't quit Morrison. At the start of her sophomore season, she noticed that something was off. She couldn't hit a basket and kept falling down. She figured she had the flu, so she went to the school nurse, who told her she was pregnant. She called her parents.

"That went over like perfume on a skillet," she says.

But they supported her. Trey arrived via C-section on September 27, 1989. Cristi went back to school a week later. Her basketball days over, her only goal now was to get a degree so she could take care of him. Trey went to day care, to a couple who were called "Ma" and "Pa," and Cristi started sobbing during a class. She felt horrible for leaving him.

"I just knew he was wondering where I was," she says.

Tommy was her soul mate, but Cristi was eventually able to let him go. He had a lot of soul mates. She got her degree from Northeastern State University, landed a teaching job in Wyandotte, Oklahoma, and eventually met Mark Lippe, a former tight end at the University of Tulsa. Lippe, a football coach, provided stability for Trey.

He had two dads. Mark was the authoritarian, the one who pushed him on the football field. Tommy was the overgrown kid. He was never out of Trey's life, although he did drift like the wind over the plains. He bought presents for Trey, when he was boxing and still had money, and played Nintendo with him. Cristi learned to get along with whomever Tommy was seeing at the time.

Tommy had two other sons, Kenzie Witt and Tristin Duke Morrison. Witt, who's 23, also recently began pursuing boxing and is expected to fight sometime in the next year.

Years ago, for Father's Day, Tommy sent Mark Lippe a card. He thanked him for raising Trey.

"He was my dad," Trey says of Morrison. "But really, he wasn't . . . It was kind of like we were best friends. I mean, he gave me dad advice. He made a lot of mistakes. He told me a lot about the wrongs not to do. That's how people learn. You can learn from somebody else's wrong."

Trey was three when Morrison, at the peak of his career, beat George Foreman for the WBO heavyweight title. He kept a breakneck schedule back then, with far more fights than the average boxer of his stature, because Morrison's camp wanted to keep him busy and out of the bars and trouble. There was little room in his life for Trey, and it was probably for the better. His life was no place for a kid.

Trey saw his dad fight but was too young to process it. All he remembers are the bright lights and his dad holding him in his arms.

People close to Morrison say he wanted to be a good father. Cristi knew it. But there was never a good time. Not when he was fighting, not when he reluctantly retired in February 1996 after he tested positive for HIV. His life was a mess after that. His entourage was gone; people wouldn't go near him for fear of catching AIDS; and Morrison slipped into an abyss of drugs and loneliness.

"Tommy had snakes in his head," Holden says. "There's never an excuse not to be a good parent. And Tommy knew he failed. [He just] wasn't there for him."

He'd call up and say he was coming to his football games, and oftentimes, Cristi would intercept the call because she wanted to make sure he was actually coming. She reminded him of when they were in high school and Tommy used to cry in the parking lot after football games because his father didn't show up to watch him play. "Don't you do that to Trey," she'd say.

When Trey got a scholarship to Central Arkansas to play football, Morrison used to ask Holden to go to games with him. He was proud of his son. He wanted him to be a boxer and offered to train him numerous times. But Trey put it off because he was playing football. And then it was too late.

It is unclear when Morrison stopped taking his HIV medication—he repeatedly denied the existence of HIV in the years after initially admitting he had it in '96—but, according to Morrison's friends and family, he was "out of it" mentally in the final few years

of his life. He was gaunt; he constantly lost track of what he was saying; and his speech was slurred.

"He would just ramble on and on," Cristi says. "I don't know how to describe it, but he just wasn't sharp like he used to be."

Two years ago, Mark and Cristi took Trey to see his father in Pigeon Forge, Tennessee. Morrison was very sick by then. He could speak, Cristi says, but not very clearly. He knew who they were, and tried to be cool and crack jokes. "It was heartbreaking," Cristi says. It was the last time they saw him.

For years, Holden insisted that he was retired from being a boxing promoter. He was very close with two fighters, Morrison and a super middleweight from Kansas City, Missouri, named Randie Carver.

Carver was articulate and bright and brought a 23-0-1 record into a September 12, 1999, bout with Kabary Salem at Harrah's Casino in North Kansas City. Carver was head-butted repeatedly, was knocked down in the 10th round, and lost consciousness. He died two days later.

Holden cannot deal with losing another fighter. Especially not Tommy's kid. So Lippe's debut fight, the day after Valentine's Day, was almost unbearable for Holden. What if he didn't have it? What if he got knocked down? What if he got killed?

By this time, they had spent so much time together, Lippe had become like a second son to Holden. Holden even let him do odd jobs for him — driving him around Oklahoma — to supplement his income.

Holden worried he was going to have a breakdown before the fight. "God," he said to himself, "don't let me lose it tonight." But he couldn't help it. The kid looks so much like his dad; they just lost his dad; and here he comes out in those trunks. Trey is 24 years old. Tommy beat George Foreman at 24.

The bell rang, and Lippe came out aggressive and reckless with little interest in protecting himself. He was knocked down 30 seconds into the fight.

Lippe saw the ropes, but he couldn't hear anything. The hit, he claimed, didn't hurt. He popped back up, then peppered Renty with a series of power punches. He overpowered Renty, whose eye was nearly swollen shut by the end of the first round. The fight was stopped at 1:48 in the second round.

Morrison's mother, Diana, was in the crowd. She sobbed as she watched Lippe celebrate.

Holden wasn't as enamored. He told Lippe that he did just about everything wrong, that he made it a slugfest, that he went into the ring looking for a knockout and tired himself out. He gave him a C-minus grade. He also knew that Lippe was nervous and would learn from it.

Lippe told him that he felt his dad when he was walking to the ring. He felt as if Tommy was there with him. Holden said he felt it too.

Lippe will fight again Saturday at the Buffalo Run Casino in Miami, Oklahoma, facing Dee Burchfield in a four-round bout. It will be Burchfield's first professional fight. Holden says he's more concerned with getting Lippe time in the ring than seeing how he matches up against opponents.

He has already noticed a huge difference between Tommy and Trey. With Lippe, there is no Jekyll and Hyde, no sweetheart and screwup rolled into one. He's steady and seemingly without distractions, at least for now. He has learned from his father, and from his own mistakes.

Lippe was kicked off the football team his senior year at Central Arkansas after he repeatedly showed up late for meetings and let his grades slip. When football was gone, he was lost.

Clint Conque, his former coach, says Lippe was never a bad kid. He said the team hated to lose him. He was passionate about football, was a ferocious hitter at defensive end, and, according to Conque, was one of the team's hardest workers. Problem was, Lippe didn't always carry that intensity into the classroom.

In his three-plus seasons at Central Arkansas, he never talked much about his father, although his teammates knew he was Morrison's son.

"I don't know why he didn't speak about his father more," Conque says. "I don't think it had anything to do with embarrassment or pride. I'm sure he was really proud that his dad fought for heavyweight champion of the world. I just think Trey's a private person.

"But when he got out on the football field, he played with a chip on his shoulder, with great passion, great violence. When he hit you, you knew about it."

Lippe says he hated it when he was a kid and his friends used to ask him about his dad. They always wanted to talk about the bad stuff. Inevitably, the same question came up over and over. Did he have HIV? They never asked what he was like, if he was a good person. Lippe will always believe that he was.

"Yeah, I wish I could've spent more time with him," Lippe said. "But I enjoyed what I had with him. I wish I could've had more. Am I doing this to make him proud of me? That's a plus. But this is something I've gotta do with my life. I think I could be good."

Shortly after they teamed up, Holden suggested making a few nods to his lineage, and Lippe was hesitant. He didn't want to be cashing in on his name, but then Holden said that Tommy would've loved it. So now every time he fights, an announcer will bellow a name that's bound to draw attention. Trey Lippe Morrison is entering the ring.

DAN O'SULLIVAN

Money in the Bank

FROM JACOBIN

THE HEADQUARTERS OF the World Wrestling Federation has the manicured look of a call center. Or the back office of a bank—its black, reflective glass exterior concealing a few hundred third-shifters, examining checks for floating endorsements and mis-keyed routing numbers.

It is no Dallas Sportatorium, Fritz Von Erich's legendary wrestling venue, a low-hanging mess of shingles and rickety bleachers, filled from its dirt floor to exposed rafters with beer, popcorn, and hooting. No rival wrestling promoter will ever drive his Corvair to the Federation's Stamford home in the dead of night, heft a jerry can onto the roof, and torch this building.

It is the strange fate of America, in its waning days, that even wrestling—carnival redoubt of grifters, heels, and freaks of every stripe—would wind its way into the colorless confines of a ratty corporate park. Today, World Wrestling Entertainment—now re-named, per a legal settlement with that more genteel WWF, the World Wildlife Fund—trades on the New York Stock Exchange with a market capitalization of over $856 million.

Jim Barnett, one of the most powerful godfathers in the mid-20th-century "Territorial Era" of wrestling promotion, boasted that he dealt with only three coteries: kings, prime ministers, and dictators. Barnett more typically dealt with sweaty jobbers and Georgia babyfaces, with names like "The Continental Lover" or "Geeto Mongol," but the claim is perhaps not as ridiculous as it appears. Historically, professional wrestling, with its screaming neon lunatics, potbellied big daddies, and tasseled "ring rats," has

been considered too absurd to be taken seriously—deprecated by sportswriters and ignored by politicians, its fans derided as low-class marks.

This—the notion that pro wrestling is a fixed, low-rent travesty, undeserving of serious mainstream scrutiny—is the single greatest angle ever sold by the wrestling industry.

There are competing theories as to the origin of the term "kay-fabe," beyond its provenance in the strange lingo of the carnivals from which American pro wrestling emerged. But as to the meaning, there is no confusion; it is the central axiom of the business. As explained by journalist David "The Masked Man" Shoemaker, kayfabe is "the wrestlers' adherence to the big lie, the insistence that the unreal is real . . . the abiding dogma of the pro wrestling industry."

And the flip side of kayfabe is that, in an industry where the unreal is real, where Hulk Hogan is a "real American" fighting for the rights of every man, truth wears a mask.

Nothing is more real—and more obscured by the smoke and mirrors of the mat—than a simple fact: the billion-dollar spectacle of pro wrestling relies entirely on the ruthless economic, mental, and physical exploitation of its performers. In that world of lingering physical ailments, screw-job employment contracts, and chuga-lug drug abuse, Hulk Hogan is a millionaire named Terry Bollea, a favorite of WWF management, poached from a Minneapolis wrestling promotion and transformed into the star of "Hulkama-nia." In that world, in 1986, Bollea ratted out his fellow wrestlers to crush a nascent unionization drive ahead of Wrestlemania II. In that world, wrestlers are exploited and injured and thrown away—their final contribution to the world, a mortality rate on par with day one of Antietam.

For a fake sport, pro wrestling sure has a lot of real casualties. Its only business model is fear.

Professional wrestling's success was shepherded throughout the mid-20th century by the National Wrestling Alliance, a viciously antilabor cartel comprised of the country's leading promoters. Colluding to control wages, stifle competition, and crush any resis-tant wrestlers, the NWA survived a federal antitrust investigation to dominate pro wrestling well into the seventies.

Yet it wasn't until recent decades that wrestling would grow un-

believably profitable, just as control of the entire industry came to rest with one corporation. On New Year's Day, 2014, WWE CEO and chairman Vince McMahon could claim to be a billionaire in almost full control of the industry.

But these machinations are the stuff of rich men. Most wrestlers are not rich men.

A History of Violence

"There is more intrigue connected with professional wrestling than anything else but communism and television," deadpanned *New York Daily Mirror* sports columnist "Redoubtable" Dan Parker, in 1956. "Wrestling promoters," Parker continued, "hold their conventions on spiral staircases with coats of mail under their shirts as protection against back-stabbing."

Parker would know. A withering commentator on the sports underworld, two decades earlier, he had published the insider testimony of Jack "Halitosis Kid" Pfefer, in what would be one of the first prominent press exposés of pro wrestling. Pfefer's snitching was mostly limited to exposing that wrestling champions, like "Golden Greek" Jim Londos, had been preselected by the "Trust," composed of promoters Jim Curley, Ray Fabiani, and the legendary Toots Mondt. The winner of a title bout had not bested his opponent; the promoters had determined who would win, based on a consensus of what would be best for business. The revelation that promoters were powerful enough to collude in labor suppression and market manipulation across an entire continent was lost in the maelstrom.

It would be a story Parker would continue to cover, as control of the wrestling world accumulated under the aegis of a few powerful men. In 1948, several regional promoters met in Waterloo, Iowa, to form the National Wrestling Alliance. The NWA would dominate the sport for the next three decades, and would, at its height, come to incorporate 40-some-odd "territories" across North America, the Caribbean, East Asia, and the South Pacific.

If the persistent rumors of organized crime's involvement in wrestling are little more than an urban legend, it is because there

was no necessity for wiseguys. The NWA was its own mafia. And its duties largely consisted of coercing, putting over, or stretching the one commodity without which the entire enterprise could not function: the wrestlers.

The Cartel

The logic of the NWA was simple. No single promoter could, at that time, exercise control over pro wrestling throughout the United States. The next best option for promoters, eager to make money in a sport both less scrutinized *and* more popular than boxing, was industry-wide collusion. The formation of the NWA allowed for promoters to mediate any disputes and to demarcate the territories in which each member would be allowed to stage matches—thus, "The Territorial Era."

Eddie Graham would run wrestling in Florida; LeRoy McGuirk would hold dominion over Oklahoma; Don Owen would entertain the marks of Oregon and Washington State; and so on.

After carving up the habitable world, the NWA's next step would be to strangle any outside competition in the cradle. Non-NWA promotions, also known as "outlaw promotions," would be ruthlessly stamped out if they attempted to stage wrestling shows in NWA territory. Blockbuster NWA shows would suddenly be staged across town, on the same night, as an outlaw promoter's show. Star wrestlers would agree to appear in an outlaw show, then get bribed to stay home—the outlaw promoter eating the cost of a heavily advertised no-show. Midlevel wrestlers would be threatened with the blacklist for appearing on an outlaw card.

More extreme measures might be taken by unknown parties: municipal coliseums and arenas would suddenly shred contracts, threatening phone calls would be received, and mysterious fires would be kindled. And if all else failed, the NWA could go to the extreme of scorching the earth—"burning" the territory with an overwhelming glut of bad shows, underwhelming scripting, and mediocre wrestling, until business all but evaporated in the area.

This was just how the alliance treated rival *promoters*. For the wrestlers, it was even nastier.

The Jobbers

Labor coercion by management—in almost any industry—need not take the form of a threat. More often than not, management will present a false choice: you can go wrestle as a jobber for one hundred bucks a week for Ed McLemore, out in Texas, or you can not. It's fine if you don't. But you might not get another call. And of course, for those who had something to say about any of this, the NWA had other hardball responses.

Promoters conspired to fix wages around the country and agreed to not pay above the going rate for most wrestlers, with the exception of a few top-drawing stars who might be granted contracts—lest they jump territories or ditch promoters. Intimidating the workforce was imperative for promoters. Big Jim Wilson, an ex-NFL lineman and former wrestler who, after being blackballed in the industry, would attempt to build support for tight governmental regulation of wrestling, would identify the key expense which could meaningfully impact the promoters' profit margin:

> Without one MBA among them, wrestlers deduced the most important line item in pro wrestling's accounting spreadsheets—*the incredibly low business costs*. As a business, the wrestling industry's only operating expenses were monies paid for arena rentals, TV production, and talent—wrestler compensation. With some quick calculations, wrestlers concluded that talent compensation could not possibly constitute more than 15% of wrestling's gross . . . wrestlers should have realized they were the industry's biggest marks.

It should not be surprising that in an industry controlled by, at most, 30 village Napoleons, in which promoter profits could easily be increased by a wide margin merely by keeping labor expenses as low as possible, labor suppression would be vigorous and multi-faceted.

A 1921 article by sportswriter Al Spink about the aforementioned "Curley Trust" detailed one of the most commonly employed forms of coercion exercised by promoters against wrestlers—the blacklist. His column, profiling "Marin Plestina, greatest wrestler in the world," found that Plestina had been blackballed by Curley from competing in any championship bout, across North America: "Here today is actual evidence of the existence of a wres-

tling trust that would bar from all wrestling contests . . . men who are of good standing in the professional wrestling game."

The threat that any wrestler could, if he said or did the wrong thing, be permanently blackballed in his only profession was usually sufficient to ensure compliance. Wrestlers could complain all they wanted—about getting paid $30 a gig; about paying for "gasoline runs" on far-flung road shows; about being compelled to do "blade jobs," the cutting of one's forehead midmatch to induce bleeding—but for most wrestlers, fear was a gag.

Wrestlers regularly complained of irregularities in the gate receipts, counting the number of people in the audience midmatch, then finding half that number recorded in the ledger, as promoters pleaded poverty in cutting the checks. But what could they do? This was not a localized problem; this was the brick and mortar of professional wrestling for most of the century.

A 1973 lawsuit brought by blacklisted wrestler Don "Mr. X" Pruitt exposed other nasty mechanisms of NWA coercion, including the corruption of state athletic commissions, forced "heel turns" meted out to turn would-be champions into despised bad guys, and "stretchings"—the intentional injury of wrestlers in the ring, ordered by promoters in retaliation for some perceived slight.

What self-deception and a nonstop party culture could not palliate for wrestlers, vicious intimidation could.

Mr. McMahon's Neighborhood

One possibly apocryphal story tells of a phone call in the early eighties between Ted Turner and wrestling's *éminence grise,* WWE CEO and chairman Vince McMahon. Turner, by then an extremely powerful cable programmer and billionaire, grandly announced, "Vince, I'm in the wrassling business"—to which McMahon is said to have responded, "That's great, Ted—I'm in the entertainment business."

If the call never happened, it may as well have. It was in this era that McMahon, the once-estranged son of a New York–based NWA promoter, would commence a multi-decade war on his erstwhile partners, with the aim of aggressively reshaping the industry into "sports entertainment" with only one promoter at the apex.

The explosion of pro wrestling in the eighties, with the advent of "Hulkamania" merchandising and MTV cross-promotion, heralded an astonishing new level of cultural relevancy and profitability for the industry. Those profits came at the direct expense of the wrestlers.

Since the early eighties, the story of pro wrestling has more or less been the story of a burgeoning monopoly, that of McMahon's WWE. There is no such thing as a nice billionaire, and Vince is unexceptional in this regard.

Aggressive Expansion

The first chapter in the WWE story is one of what the conservative economist Joseph Schumpeter might call "creative destruction," in which McMahon, using the power of cable TV, cartoonish pop aesthetics, and governmental deregulation, co-opted or ruthlessly destroyed his competitors. Perhaps the closest analogy was the contemporaneous destruction of the Mafia's stranglehold over Las Vegas gambling and the rise of the new, glittering Vegas Strip. No more knuckle-dragging goombahs, with all the PR skills of a pot of lampreys; it would be corporate titans like Steve Wynn or Sheldon Adelson in charge, so that everyone could pretend organized vice was a clean trade.

Like the oligarchs of nineties Russia, most of whom entered the post-Soviet era as ambitious, well-connected crooks without much in the way of a conscience, McMahon was well positioned in advance of his campaign to dominate the industry. His father had bequeathed him the most prized NWA territory, New York City, and with it, the glittering crown jewel, Madison Square Garden. McMahon the Elder had been one of the earliest pioneers in the nationwide broadcasting of wrestling, and it was to be with this cudgel that McMahon the Younger would smash his adversaries.

McMahon simply bought out many promotions, such as Georgia Championship Wrestling. By aggressively headhunting star wrestlers, promising jobs to rival promoters, and paying well above market price for ownership stakes in rival outfits, McMahon was able to make significant inroads into regional markets across the country. The advent of pay-per-view was ultimately even more deadly. Cable spectaculars like "Wrestlemania" not only generated

millions of dollars in revenues for McMahon; broadcast nationally, they trampled across the old dividing lines.

There were some formidable opponents, who might have managed to turn the tide against the WWF had they united. Instead, McMahon won that war, defeating every colorful peacock in his path, from the Carolinas' Big Jim Crockett, to Minnesota's Verne Gagne, to, eventually, Atlanta's own Ted Turner.

Since the incorporation of Turner's WCW into the WWE in 2001 and the end of the "Monday Night Wars," there has been no serious competition in the world of pro wrestling. Unsurprisingly, this has not translated into greater prosperity for most wrestlers.

Requiem for an Independent Contractor

The evolution of pro wrestling's public image has put wrestlers in a bind. Vince McMahon is a white-collar sleazeball, but one with a bottomless supply of starch. A "leper with the most fingers," McMahon has a certain oily charm in spite of himself and can honestly say that he has taken bumps alongside his wrestlers. The inequities of the wrestling industry are not as stark as they were in the days of the NWA machine, when McMahon was promoting shows in northern Maine; they have been carefully massaged with all the skill the modern corporation can bring to bear upon a knot in the muscles.

Pro wrestling's greater visibility as cheesy adolescent fantasy tends to mitigate the public backlash the industry *should* receive each time another wrestler dies young. This very quality of mainstream disrespect has largely served the interests of a blood-soaked business.

If the NWA was a down-home *cosa nostra* of sorts, a twanging syndicate of hucksters in loud sport coats, McMahon was the slick corporate raider, a gorilla whose suit actually fit. McMahon doesn't speak like a good ole boy; he sounds like Mitt Romney. This is no coincidence. In its aggressive campaign against state regulation, dislocating terms of employment, and poisonous, often fatal working conditions, the WWE is a corporation only a Republican senator could love. "I'm an entrepreneur," McMahon deigned to inform Bob Costas. "I'm what makes this company, my company and this country, go round and round. I take risks."

Round and round. It's true. Like a true entrepreneur, Vince McMahon does take risks—usually with other people's lives, from lowly, forgotten jobbers like Charles Austin and Darren Drozdov, both of whom were paralyzed wrestling in WWF matches, to bona fide stars like Owen Hart, who died after falling 78 feet out of a stunt harness and into one of Vince's rings. Whether you're low-status "enhancement talent," whose only job is to make the baby-faces look good, or wrestling royalty like the Hart family, all of Vince's wrestlers share one important commonality: they are not employees of World Wrestling Entertainment, Inc. Rather, they are independent contractors, freely furnishing their services in an ostensibly voluntary arrangement with a corporation.

The orchestration of pro wrestling heavily depends on such apparently minor distinctions, on degrees, and feints. Take, for instance, the piledriver. Executed correctly by two working wrestlers, it is a safe move, a staple of the mat. Executed slightly incorrectly, it can lead to paralysis, death, or an injury of the sort which possibly shortened "Stone Cold" Steve Austin's career.

Another delicate maneuver: is a pro wrestling match a competition, or an exhibition? A seemingly minor distinction—but in the eighties, the money men of pro wrestling broke kayfabe, that code of silence safeguarding the industry's competitive integrity, to all but bellow at state lawmakers that the matches were predetermined, that the whole show was "fake."

Why? The benefits were compelling. If pro wrestling is just "entertainment," there is no need for regulatory scrutiny. By pushing through deregulation, with the help of sleazy right-wing lawyers like Rick Santorum, the WWF wriggled out of paying taxes on their TV broadcasts and sloughed off any oversight by state athletic commissions. In New Jersey, for instance, following the state legislature's 1989 deregulation of the industry, the state "would no longer license wrestlers, promoters, timekeepers and referees," and wrestlers "would no longer be required to take physical examinations before an exhibition"—a fateful dereliction in a business rife with injury.

The cultural consensus which continues to dominate this nation is that greed only exists for Cadillac-driving welfare queens and fat-cat union bosses. It is never accounted as greedy, for instance, that the entire aim of three decades of dislocating economic policies has been to squeeze blood from a stone, depriving

laborers of basic securities so as to legalize labor exploitation. So it is that wrestlers are never "employees"—but rather, independent contractors, who, like the wandering samurai of feudal Japan, or the noble free lances of 12th-century England, face the strong likelihood of penury, injury, and an early death. As independent contractors, wrestlers must file state income tax returns in each state that they wrestle—an onerous task—as well as pay a punishing self-employment tax.

As attorney and academic Oliver Bateman writes, "Most low-level performers and members of the female Diva division operate on short-term guaranteed contracts in the mid-five figures, out of which they must pay for their travel, food and lodging."

Despite their putative "contracts," the wrestlers can often be fired by the promotion at any time. The WWE does not pay into Social Security or unemployment insurance for the wrestlers and, in an industry in which late-life financial jeopardy is all too common, provides no pensions.

But the most immediately punishing consequence of this employment status is the lack of any form of company-paid health insurance. McMahon scoffs at this criticism, claiming "anyone who makes the kind of money that they make can easily afford their own health care," and that "most independent contractors have their own health care."

Just ask Bret "Hitman" Hart, five-time WWF champion and scion of the legendary "Hart Foundation." Hart seems like a good guy, a huge star widely respected for his abilities and professionalism, once shooting that "the real art of professional wrestling . . . is to never get hurt and never hurt anyone else."

But in 1989, in a pay-per-view match in London Arena, strongman Dino Bravo awkwardly slammed Hart into a fence, breaking his sternum and several ribs. Only seven weeks later, Hart was wrestling again. Hart, paying his own health care costs, later admitted to receiving only a couple hundred dollars a week from the WWF while he recuperated. With a wife and several children to support, Hart could not afford to rest any longer. Maybe that was the point; the only party Hart's rapid return benefited was the WWF. In 2000, a concussion sustained at WCW Souled Out put Hart out of commission again—this time, for good.

Unlike many wrestlers, including some of his own relatives, Bret Hart has avoided the personal and professional pitfalls to which so

many wrestlers succumb: drug addiction, serious injury, and premature death. English-born Davey Boy Smith did not. One of the physically strongest wrestlers ever employed by Vince McMahon, despite his relatively small stature, Davey and cousin Tom "Dynamite Kid" Billington constituted a legendary tag team dubbed "The British Bulldogs." As recounted by David Shoemaker in his book *The Squared Circle,* their fates would be nothing less than horrific.

In 1986, in a match against the Magnificent Muraco and Cowboy Bob Orton, Billington suffered a sudden, debilitating back injury. In the footage, Billington can be seen lying in agonizing pain for minutes until he is carried off, with no ringside doctor in sight. The match was not stopped, the unaware Orton and Muraco continuing to pound the prone Dynamite Kid. Billington kept wrestling for another decade, at times barely able to walk. Last year, Billington suffered a stroke, his heavy steroid use a contributing factor.

Smith's story was more bleak. Following a serious back injury at the 1998 WCW Fall Brawl, caused by a faulty trap door the wrestlers had not been warned about, Smith contracted a staph infection; he was released from his WCW contract via FedEx, as he lay in a hospital bed. He developed a dependence on prescription pain medication, a common condition for the pain-wracked wrestler, for whom sleep is sometimes impossible. In 2002, Smith was dead of a heart attack at age 39.

As recounted by Shoemaker, wrestler Bruce Hart squarely laid the blame for Smith's death on the demands of the business: "Davey paid the price with steroid cocktails and human growth hormones." This is not an anomaly. Following the deregulation of wrestling in Pennsylvania, McMahon nevertheless retained state-licensed ringside physician Dr. George Zahorian for matches in the state. Zahorian was best known for lending wrestlers his prescription pad in the eighties to meet a staggering demand for steroids, with Hulk Hogan being his main client. The message was clear, at a time when Hulkamania and Jim "Ultimate Warrior" Hellwig were the WWF's main attractions: if you want to be a star, you need to get preposterously muscled—and if you want to get preposterously muscled, you'll want to hit the 'roids as much as the gym.

The specter of locker rooms awash with discarded needles eventually led to a blockbuster trial in which the federal government

charged McMahon and Zahorian with drug trafficking. While Mc-
Mahon narrowly avoided prison, Zahorian eventually admitted his
complicity, arguing—perhaps not implausibly—that he felt it best
to supply the WWF's wrestlers with a clean supply of steroids, as
they would have sought the drugs elsewhere. Demand was just too
high.

While steroid use has declined in the industry, or at least be-
come less visible, the damage is still being felt; too many hearts
have been broken, literally, by the regimen of human growth hor-
mones, painkillers, cocaine, and grueling workouts, as the older
generations of wrestlers continue to die at an appalling rate. Mc-
Mahon evidently doesn't see that, laughing at the notion that ste-
roids are "deleterious to your health," and going so far as to muse,
"What is abuse of steroids? I don't know what that is. No one can
tell you what that is . . . You can abuse sugar or any other substance
or any other drug."

Sugar. Maybe so. Perhaps Chris Benoit had merely indulged in
too many sugary snacks. How else to explain the strange case of
Benoit, other than the extreme, and natural, conclusion of McMa-
hon's three-decade war on the senses? On the very night Benoit
was to be crowned ECW Champion by the WWE, a prize every
wrestler tosses and turns at night dreaming about, the wrestler was
running headlong into an inferno.

Over the course of the weekend, he strangled his wife, Nancy,
then drugged and suffocated Daniel, his seven-year-old son. He
sent vague texts to a few fellow wrestlers, excuses about missed
flights and food poisoning. After placing a Bible next to each
corpse, Benoit hanged himself using the pulleys of his home gym,
the weights, in death as in life, providing the ballast.

The WWE's reaction was to immediately declaim any responsi-
bility for Benoit's warped, murderous state of mind, and then to
scrub him from wrestling history. This angle, in which pro wres-
tling had as much relationship to the bloodshed as an onlooker
to a pileup, was flagrantly dishonest. Benoit was well known in the
industry for taking hits from metal chairs to the back of the head,
as well as for employing a particularly punishing diving headbutt
move. The deadly effects of untreated concussions are now known
to football fans—and yet your average NFL player suits up, at most,
maybe 16 times a season. As Shoemaker notes, a wrestler does so
perhaps 200 times a year.

The result, as postmortem examination would show, was that at the time of his death, Benoit had the brain of an 85-year-old Alzheimer's sufferer, with broad swaths of gray matter gone brown, indicating severe dementia. As if this were not enough, sports journalist Irv Muchnick notes that "Benoit's system had been so messed up by decades of anabolic steroid abuse that he was no longer producing enough male hormones on his own, and was being prescribed off-the-charts quantities of injectable testosterone." The horrific biological result of this, continues Muchnick, was that Benoit's postmortem toxicological exam recorded 59 *times* the level of testosterone as would be found in a normal adult male.

Nancy Benoit's sister would later state the medical examiner had confided that "Chris was on his way to death within 10 months," and that, like his late friend Eddie Guerrero, Benoit's heart "was huge, about three times normal size, and it was ready to blow up at any moment." This nightmarish physical specimen, a marriage of brain death and hormonal insanity, was once a wrestler.

Still, even this, as violent an apotheosis imaginable, was not enough to meaningfully change the business. The government's post-Benoit investigation of pro wrestling was derailed almost immediately, as McMahon and his Pupkinesque attorney, Jerry McDevitt, used their Capitol Hill invitation as an opportunity to testify about smiling, thespian talents, and Frank Deford's bowling shoes.

McMahon's skillful, unrepentant evasion of federal oversight is nothing new; it's as much a part of wrestling as the suplex or Irish whip. A 1957 column by Dan Parker, following a toothless, unenforced Justice Department consent agreement with the NWA, rings as true today as it did then: wrestling promotion is a confederacy of sleaze, and will remain that way until its demise:

> The squareheads of the wrestling racket, whose brains tick like bombs when they meditate, ruminate or even mediate, as they did in this case, tacitly admitted their guilt when the Dept. of Justice accused them of operating a combination in restraint of trade by offering no defense . . . Using such weapons as the boycott, the blacklist and coercion, they bottled up the wrestling business for themselves, along with the television rights and control of the champions they made and unmade.

Even when the babyface prevails, the bad guy still wins.

Finishing Moves

The more afraid a wrestler is of his future, of his place in the sun, the more money a promoter makes. A wrestler enters the ring, to music, to a huge pop, to jeers. He wrestles, he struggles, he sells, he wins, he loses, clean in the middle—he does it again, and again—and then, someday, he doesn't, because he's dead. The heat a good wrestler can draw, working a crowd, only makes the silence that much more deafening.

It is hard to think of a laborer—outside of, perhaps, the sex industry—who better exhibits this rotten duality, of desirability *and* disposability, of being "warmly welcomed, always turned away," than a wrestler. It is no coincidence that the romance at the center of Darren Aronofsky's *The Wrestler* is between an aging wrestler and an aging stripper—each is "the truest representation of the wage-worker as portrayed by Marx":

> Both Randy and Cassidy live on the fringes of society: they are employed in sectors which are regularly mocked and derided, and their personal lives, much like their physical bodies, are ravaged by scars . . . They have no means of income, no means of survival, nothing to sell but their bodies and the labor these bodies can produce. And so they sell them, for decades, and when their bodies are exhausted they are left in poverty.

Throughout history, pro wrestlers have been largely unable to bargain for their compensation or type of work; with no guaranteed income, of the sort generated by an equitable contract or official employment, most wrestlers have been happy to take what they can get. They are not alone, as almost any wrestling fan will already know, from the thousand cuts of daily life in a fugitive economy. Flux has been the name of the game for promoters, maximizing profits by keeping their labor market anxious, the wrestlers peripatetic, the next payoff uncertain. You may be swapped in if you're lucky, but when spent, you'll be swapped out.

The story of pro wrestling in the 20th century is the story of American capitalism, filtered through a dreamy aspect, of gallant grapplers, of mustache-twirlers, of princesses and salt-throwers and masked spoilers. Kayfabe is a slinky thing, in what it masks: it's

sheer enough to let us marks in on some of the fun, yet supple enough to obscure most of the human cost.

Ever since Frank Gotch defeated George "The Russian Lion" Hackenschmidt before 25,000 spectators, amid the Chicago stockyards and slaughterhouses, in a match that grossed $87,000 at the gate—*in 1911*—pro wrestling has been too lucrative for promoters to be fair to its labor. The official organs of the wrestling industry served like a particularly bruising temp agency, with no permanent employees, no solid ground to stand on—just badly paid tumbleweeds in tights, drinking beer and eating baloney sandwiches on an endless, meandering journey into the next turnbuckle.

They kept men in fear, of one another, and of what life had to offer. For all their physical expertise and technical repertoires, wrestlers could not contest their own fates.

"Every man's heart one day beats its final beat," snarled Ultimate Warrior on *Monday Night Raw* in April, in a valedictory warmup for his WWE Hall of Fame induction that same week. "His lungs breathe their final breath and if what that man did in his life makes the blood pulse through the body of others and makes them believe deeper in something larger than life, then his essence, his spirit will be immortalized."

A day later, at age 54, Jim "Ultimate Warrior" Hellwig was dead—a sudden, fatal heart attack of the sort which claims the lives of so many wrestlers in middle age. His speech was rendered weirdly haunting, speaking as it did for so many others. Hopefully, a career spent wrestling does resolve itself into something transcendent, and larger than life; life is not a commodity much apportioned to wrestlers.

"I'm telling you," confessed five-time NWA heavyweight champion Wahoo McDaniel in the last years of his life, as recorded by Shoemaker. "There's so many of them gone and died. A lot of my buddies have died . . . I don't know what it is."

Gone, gone, gone. They take to the wings and disappear.

Gorgeous George, the first celebrity heel, drank himself to death at age 48, inhabiting the lowlight of a chicken farm. The mighty Andre the Giant was dead at 46, the strain of his gigantism too much for his heart. Road Warrior Hawk, Bam Bam Gordy, and Ray "Big Boss Man" Traylor, all noted heavies, all too died of heart attacks, all in their forties.

The fatal drug overdoses, too many to count—Brian Pillman,

Brian "Crush" Adams, "Ravishing" Rick Rude, "Mr. Perfect" Curt Hennig, Louie Spicolli. Three of the Von Erich brothers killed themselves; a fourth, the star, David Von Erich, overdosed at the tender age of 25. "Macho Man" Randy Savage, and his lovely consort, the alluring Miss Elizabeth, are both dead; Miss Elizabeth's last boyfriend, Lex Luger, is partially paralyzed from a stroke. Dino Bravo was shot dead while watching hockey; his murder has never been solved. Chris Kanyon, the first WWE wrestler to come out as gay, sued McMahon over the "independent contractor" scam, fell out of work, and, suffering from bipolar depression, killed himself. Junkyard Dog fell asleep driving and crashed. Eddie Guerrero died of a heart attack at 38, so wracked by pain in his final bouts that he could barely wrestle. The list doesn't end.

Pro wrestling puts over its servants in ways they couldn't have imagined, but it seems like every pop is followed by a bump. Even the ringside talent isn't immune. Everyone pays a price. Legendary announcer Bobby "The Brain" Heenan was a master of pomposity, a half-clever buffoon, whose angle as an absurdly grandiose, quick-witted weasel produced genuinely funny comedy. Heenan's antics—wailing in Andre the Giant's grip, hissing at the Hart family—was everything joyous about wrestling, a kinetic comedy of manners, in which the collision of two human beings could, for a few moments, take on some sort of grand dimension.

And now, Heenan cannot speak, robbed of his gift by throat cancer, his talents revoked before he dies. It's unfair, and it's maddening. The frustration with it all, with all the damage and waste and graft, brings to mind Heenan's sputtering objection when he was ostensibly fired on TV by wrestler Paul Orndorff. Unlike most discarded wrestling luminaries, Bobby fought back, jabbing his finger and standing on his toes: "I am a man of dignity! I am a man who deserves respect!"

It would be a good line to rally the misbegotten wrestlers, a battle cry for the real bout they need to contest. But then, Bobby "The Brain" Heenan was a comic heel. In pro wrestling, it's always been understood: dignity is strictly for punch lines.

Many thanks to Tom Keiser, Bill Hanstock, and David Shoemaker for their invaluable assistance.

RICK BASS

The Rage of the Squat King

FROM NEW NOWHERE

"I can't feel anything, I can't see anything—and yet I must feel
and see everything, at the same time."

WHEN I WAS a young man in college, and a competitive weight-
lifter, there was a man we revered greatly, who was the world's
strongest squatter. The squat is a lift that combines, I think, brute
strength in equal measure with technique.

In the squat, you place the bar, loaded with its ponderous
weight, across your back. You lift it up out of a rack and take one
and a half or two steps backwards. You wear a thick leather belt
cinched tight around your belly to keep your intestines from blow-
ing out under all the pressure, and you wrap your knees tightly
with elastic bandages to keep the somewhat fragile, intricate ar-
rangement of ligaments, tendons, and cartilage from uncoiling,
snapping, and spraying out everywhere like the broken springs
from a Swiss watch—but that's all the support you get. Other than
that, you're on your own.

You sink down into a crouch, with that weight on your back. It's
heavy. It tries to keep driving you down, all the way down.

My lifter friends and I would occasionally see the champion of
this lift, Fred Hatfield, aka "Dr. Squat," perform his greatness on
television, on obscure Saturday afternoon sports specials.

He would snort and do this odd little shuffle-step, and then
rush out to the bar that rested waiting for him in the squat rack.
He'd be howling and huffing and puffing, rolling his eyes and his
head like a Chinese dragon.

He would run up to the bar and grab it and shake it, get under it and maneuver his back beneath it, wriggling himself into position—not unlike someone taking pleasure in his lover's embrace—and then he would lift the weights free of the rack and back out with the horrible weights draped across his back, the iron bar bending and bouncing, there was so much weight on it. He would plant his feet, look skyward, huff twice more, a third time, and then he would go down.

His mouth would open in a groan as he sank, and his eyes would roll and bulge as if about to pop. Veins would explode into view everywhere, veins not just in his arms and legs and shoulders, chest and neck, but in his face, in his hands, across his nose, everywhere, with his face turning red and then purple, and his knees and elbows quivering.

And then the weight would begin going back up—being driven slowly, infinitesimally, upward again.

Twenty years later, I decided to track him down—to see if he was still squatting. I visited him at the headquarters of the World Wrestling Federation, in Stamford, Connecticut, where he had taken a job training the wrestlers how to get bigger and stronger.

When I enter his office, my first thought is how very much he seems not to belong in this place, this building, with its well-dressed executives walking down the silent carpeted hallways. He's dressed in a white sweat suit and tennis shoes, a red T-shirt, and wears a blazing pink baseball cap with the words SIMPLY THE BEST on it, and he looks trim, almost nautical. He's neither tall nor short, nor is he really either heavy or light.

We walk past office after office of accountants and public relations folks—so many pale, skinny, young white men, all the same age, and all slightly skittish as we pass, and all seeming to fail to exude—is it presumptuous to say this?—any semblance of spirit whatsoever.

"The pencil-necks," Hatfield mutters under his breath. He shakes his head. "Let's just say I don't have very much corporate acumen," he says. He's rolling off the balls of his feet, rising up on his toes with each step, and maybe it's just that the gearing of his body is all wrong for him to be walking without any burden.

In his office, he has a computer perched before him, a big one, such as you might use to pilot an airliner. He prints out his ré-

sumé, or rather a 20-page partial résumé, for me—and though it would be interesting were it someone else's—a kind of a caricature of some kind of superman—I scan it somewhat impatiently.

Gymnastics champion, soccer champion, author of 60 books, strength consultant to world-class athletes such as Evander Holyfield and Hakeem Olajuwon, schooled in Naval Communications, Pensacola, Florida, for top-secret and crypto-clearance with the Office of Naval Intelligence . . . taught statistics at Newark Stone College, 1972–1973 . . . computer programmer for Pratt and Whitney Aircraft, enlisted as U.S. Marine Corps decathlete, cross-country . . .

"Did you ever have the feeling that this lift—the squat—was designed perfectly for your body—that you had the perfect leverage and musculature for it?"

Hatfield doesn't really bristle, but I've touched some nerve, way down there. "Everybody thinks I excelled because of a God-given gift," he says, his voice a bit thick with emotion. "Obviously, I had the genetics. But my genetics alone weren't enough to get me beyond a certain level." He shrugs. "I spent several years squatting around only 550 pounds.

"I was wallowing in mediocrity," Hatfield says. "And I decided: Hey, enough is enough. I'm going to develop my own science."

He punches away on the computer, drawing up data.

"I began the arduous task of categorizing all the various factors that could affect strength," says Hatfield. "I fashioned a working definition of strength as ability to exert musculoskeletal force" (he's speaking carefully now, reading from his computer screen), "given existing constraints stemming from: Structural, Anatomical, Physiological, Biochemical, Psychoneural/Psychosocial, External and Environmental factors."

"Is that all?" I ask, like a smart-guy, standing there in the shadow of 500 pounds, but Hatfield either doesn't hear me or ignores me.

"I cataloged 35 or 40 different factors which must be accounted for to truly maximize strength," he explains. "I used eight different ranking technologies . . . and applied multiple factor analyses . . . in the statistical sense of the word."

His computer beeps and whistles.

"Significant factors affecting a squat include muscle fiber arrangement—musculoskeletal leverage—freedom of movement between muscle fibers—sensitivity of glandular functions . . ."

"This is very enlightening," I tell him.

Hatfield corrects me. "It's revolutionary," he says.

"I considered each point along the ATP/ADP glycolytic pathway," he says in a quieter voice—almost conspiratorial. "I made graphs of the various percentages of the energy-delivering processes over time—CP-splitting, ATP-splitting, oxidation, glycolysis . . . I thought," Hatfield's almost whispering, "how will I be able to exert maximum force and how can I augment that application? And that, my friend, is why I broke world records.

"There is a place you go to," Hatfield tells me, speaking carefully, precisely—"call it out-of-body experience, call it state-of-mind, call it whatever you want—that is not achievable except by the most intense and pure focusing of your passion. And only after years of intense concentration are you able to reach this zone. It's a place where the movement of your lift becomes perfect; it's not even a part of your consciousness. You're simply out of tune with the weights on your back: you're part of the iron, and it's part of you. You go down, and you come up."

Hatfield leans forward, as if delivering a promise. "You could literally blow a muscle out in the process, and you'd never know it. You can't hear the crowd screaming. You never feel the sweat that is dripping down into your eyes. Nothing.

"And then all of a sudden you're done, and you've broken a world record by over a hundred pounds—and you literally cannot remember having done it.

"I got to the point where I was able to enter that state at will," Hatfield says.

Hatfield grew up in an orphanage in Cromwell, Massachusetts, where he was sent with his three older sisters when he was seven.

"Certainly I knew from that early age that I was not the same as the other kids. They all had mothers and dads, and all I had was 72 nonsibling rivals, more than anything else. You had to fight for seconds at the dinner table. You had to fight for just a little affection from your counselor. But it was kind of a strange relationship, because on the one hand there was that inadvertent rivalry, and on the other hand, there was a sense of protectiveness and camaraderie and shared passion amongst all of us."

Fred and I take the elevator to the top of the WWF building and walk out onto the rooftop patio. It's a hot, hazy summer day,

but there's a good wind blowing, up high like that, and it's a nice patio, with picnic tables and a view of the Long Island Sound, sailboats in their slips, blue water, and forests and hills beyond, and steeples and rooftops visible through the trees.

"There's my home, out there," Hatfield says, pointing across the bay to a steeple rising from the woods on the farthest hill. "We live right there," he says with a pleasant, almost childish satisfaction. I like how long Hatfield stares out there in the direction of that steeple, towards his home, and the comfort I seem to sense it fills him with. He stands there looking out across the water just a hair longer than I think you or I would, and I like that.

Next, Hatfield takes me down to the gym that's available for WWF employees. It's a nice gym, of course, with a leg press, a squat rack, and a modest amount of iron. Dumbbells, barbells, etc. But it's obvious Hatfield doesn't train here. It doesn't have enough weight, and more importantly it doesn't feel quite right. It doesn't have that lingering echo of grunts and groans and shouts. Hatfield admits that he trains at home now—that he tried to work out here, but there were a few problems, not the least of which were technical. He points out with pride the powerlifting platforms he designed—"floating platforms," he calls them, built out of polyurethane-and-hard-rubber interlayering, to cushion the floor against the heavy weights being dropped back to the floor, as happens at the end of a heavy deadlift, or any Olympic lift.

Hatfield explains that the whole building is a concrete frame, so that it's rigid, and that even with his floating platforms, the whole building would shake whenever he was working out with his heavy weights. It made the pencil-necks and the "B-B's," as he calls them, nervous, but the most significant complication was that it kept shutting down all the computer systems, and that at the end of one heavy lift, the building shook so hard it did about $50,000 worth of damage to the computers, and they were down for a week . . .

"I don't have very much corporate acumen," Hatfield says again.

In the orphanage, it wasn't as if everyone was chosen, except for young Fred. That might be too horrible to imagine—72 other orphans being selected for adoption, while year after year, strange Fred, young Fred, and then not-so-young Fred, being bypassed, every time. That might be too much for any human body, any hu-

man body, cell-split or not, to stand up to; though who knows what the real outer limits are? Would he have gone on to squat past his record 1,100 pounds, and on to 1,200, or 1,300 pounds? Probably not. Surely his record is very near the outer limits.

Several kids from The Home were adopted. And Fred had his chance.

"It was a family from New Jersey," he says. "These people had a rich grandfather. In fact, as I understand it, the grandfather— I'm remembering things that haven't been in my mind since the time I was 12—he had something to do with the machinery that Friendly's Ice Cream used to make ice cream. He invented all that stuff."

They chose Fred, this strange young bull, to go with them on a trip across the country, that summer—to take him out on a test run, a 90-day trial.

Except they didn't want to take Fred's three sisters, who were also in The Home—a younger sister, nine, and two older sisters, 13 and 14. Fred was 12.

He went anyway. Just to say he'd been. And to check it out; to give it a chance.

They drove west in a big brand-new '55 Cadillac, a yellow hard-top. The deal was that the grandfather, who wasn't going on the trip, would let the mother and father take his Caddy on this trip if they brought the grandmother along with them. There was a daughter too, who was Fred's age.

They left New Jersey and went through Pennsylvania. Fred remembers that, because it was the first time he'd ever seen an oil well. And even though they didn't have any air conditioner, they drove in the day, and stopped at motels in the evenings. There weren't many superhighways back then, if any, so they went through a lot of small towns. It was all new to Fred, stuff that he'd never seen before, maybe never even dreamed before, and it must have wedged in his mind like a crack of light or must have pried open some spaces inside him, like roots spreading, and tried to let something else in. Some abatement of the franticness and rage, perhaps, though perhaps too, it only allowed in oxygen, which enabled the flame to burn brightest.

"We stopped at all the typical tourist places," Fred says. "The Painted Desert, the Grand Canyon . . . We drove through Yosem-

ite, including the tree, which was almost impossible to do, with that big brand-new Cadillac . . . There was only about one inch on either side of the car."

It didn't work out. Fred rode in the backseat and knew, they all knew, it wasn't going to work out. He sat back there with the daughter, this quintessential American family, and surely they must have been able to sense even then his otherness, his animalness — his hot raw heart burning in the backseat of their car like a lump of lead that has just been pulled from a bed of coals.

"We were driving across the desert," Fred says. "I remember the guy was driving, the father — his name was Emmett Huntz — and I had my arm out the window with a little piece of paper in my hand, and it was flapping in the breeze, making a horrible racket; and I was doing it just to piss everybody in the car off.

"And all of a sudden Emmett was swerving the car wildly like that!" — Hatfield waves his arms, flaps them like a stork's wings.

"Well, I come to find out I had my arm out the window so far that it was about to get taken off by this bridge that we were passing!

"It became very clear to me that I didn't want to have any part of this family," he says. "And I missed my three sisters, who were at the orphanage without me. I felt sort of a sense of protectiveness, and I said, 'There's no way these three girls are going to grow up without my influence.' And so I opted to go back to the orphanage."

You mention the squat to Fred Hatfield, and the old lifter will talk to you about concentric strength, static strength, and eccentric strength; about starting strength and explosive strength . . . He will talk about tissue leverage (interstitial and intracellular leverage stemming from fat deposits, sarcoplasmic content, satellite cell proliferation and the accumulation of fluid) . . . extent of hyperplasia (cell splitting) . . . stroke volume of the left ventricle . . . ejection fraction of the left ventricle . . . motor unit recruitment capacity . . .

"Do you ever get under a heavy weight," I ask him, "and find yourself thinking, 'I can't get this today'? And if so, what do you do?"

There is a long pause while Fred searches his memory valiantly for a time when he might have been mortal.

"If I ever have felt that," he says finally, speaking very carefully, "it was only extremely occasionally. Offhand, I can't remember any . . ."

"Have you ever had to scramble, to continue training?" I ask him. "Have you ever been in a situation where you didn't have access to a good gym?"

Hatfield rejects that notion out of hand; bats it away.

"You have to learn to take control of your life!" he cries. "You have to ensure that doesn't happen!

"Only a fool would go into the desert without water!" he cries.

"Have you ever felt passion, Rick?" he asks me later. "Do you know what it is?"

"Well, yes," I begin, "I've . . ."

"Passion," says Dr. Fred Hatfield. "Allow me.

"Passion," he says, "is not 'the need to achieve.' Instead, it is a burning desire to exceed all bounds!" He pauses, then says, "IT IS NOT A 'COMMITMENT TO EXCELLENCE'; RATHER, IT IS UTTER DISDAIN FOR ANYTHING LESS!

"NOT 'SETTING GOALS,'" says Dr. Squat. "GOALS TOO OFTEN PRESCRIBE PERFORMANCE LIMITS!"

There is a stern pause.

"THERE IS NOT FORCE OF SKILL OR MUSCLE," says the Doctor. "RATHER IT IS THE EXPLOSIVE, CALAMITOUS FORCE OF WILL!"

It should not surprise a gentle reader that just a few weeks before my visit, at the age of 50, he broke the record for the 198-pound bodyweight class, with a squat of 860 pounds.

Hatfield drives me out to his house, where I meet his trim and friendly and hospitable wife, Joy, who also used to be a competitive powerlifter. I look at pictures of their children, and pet their dog T-Bone, who they adopted from a pound. He's a fine dog; it's a fine, nuclear family.

On the drive back, we get caught in a traffic jam. Hatfield's driving. I ask him if he has any secret rituals in preparing for a record squat, such as the 1,100-pound lift that he and Joy referred to as "The Giant Squat." And once more, Hatfield referred to being able to "go to another place.

"There's a place within each person's mind where there is no

pain, no negative force," Hatfield tells me once more. "Where only positive forces dwell. And that's the place I need to be, to put that kind of weight on my back and have the capacity to ignore the sound of the crowd, and the pain; the fact that my shoelace is untied, or that the judge is picking his nose—or any of the other disconcerting cues in my immediate environment. Those things must be completely ignored in order to execute the task at hand, which is nothing more than sheer movement: going down, and coming up.

"I can't feel anything, I can't see anything—and yet I must feel and see everything, at the same time. And it's a matter of pure movement, with no other sensations creating distracting noise."

The jackhammers blast away, up ahead of us. Cement mixers groan and growl and roar. It's some kind of construction ahead, instead of a wreck, or perhaps it's both. Hatfield jerks in his seat, as if willing himself to be free of the jam. "I don't know what happened with this traffic," he says. "Aw, Gawd," he huffs. "We're only half a mile from our exit."

The jackhammers chatter louder. "It's right there," he says, "the exit that we're trying to get to." He exhales. "In sight of it!" he says. Blows out steam; rocks, fidgets.

To try and calm him down, I brag on that dog of his—that sweet hound T-Bone.

Hatfield looks uncomfortable for a minute—looks uncertain.

"I wouldn't know the first thing about what constitutes a good dog," he says finally. "If it'll not crap on my rug, I like it." He laughs nervously. "That's why T-Bone is still there. And he loves kids too. We got him at the pound when he was less than a year old."

"First dog you've ever had?" I ask.

"No, out in California, we had a couple of Lhasa apsos. They were fine, you know? They weren't real nuts about being on a leash, but other than that, they were fine. Then we moved to a bigger house, and they turned—I swear to God—into Satan. They started chewing up my furniture, peeing everywhere. I had to sell 'em both.

"Then we got a pit bull. But then he ate a Brittany.

"So then we had another dog, sort of like a dingo type of dog. And I just couldn't housebreak that dog for anything. I have not had good luck with dogs," Hatfield concludes.

"Somebody had already worked with T-Bone, though," he adds. "It was obvious. Because he would fetch, and heel, and sit, and all of those things." Hatfield stares out at the glacier of traffic, none of it going anywhere. "He appeared to be a very well-trained dog already, when we got him from the pound."

I remembered the way he used to rage, when he would approach that iron bar, in the olden days. What I think might have finally happened within him is that the calm has finally arrived, or almost arrived—that it has come as if from within the iron, leaving the iron like a fever.

Serenity lay beneath the rage, it seems, but surely it must have been a long way down there, and the iron, the weight, so heavy.

CHRIS BALLARD

Haverford Hoops

FROM SPORTS ILLUSTRATED

"YOU WANT A STORY?" my brother said. "You should write about the Streak."

This was last year, over a beer. My brother is 41 now, a successful doctor with two kids. And here he was, still talking about his Division III college basketball team.

You know those stories about a wise coach who inspires a group of plucky overachievers to overcome the odds and win state, or whatever?

This is not one of those stories.

In the beginning—before the run at the record, the national media, and the fellatio strike—there was just a college basketball team and a coach.

In the fall of 1990, they huddled in a locker room in Rochester, New York. The young men sat on metal benches. In front of them paced a burly, exuberant 33-year-old, though David Hooks didn't pace so much as stampede around the room, trailing optimism in his wake. He spoke to the players of opportunity. Of playing like caged lions. Of leaving it all on the floor. And then, because Haverford College was a Quaker school, he asked if any players wanted to speak.

Dan Greenstone, the team's skinny sixth man, raised his hand. "There are two ways you can look at it," he said, peering around the room. "You can think, We're playing the national champions! Or"—here Dan affected a mock-scared tone—"We're playing the national champions. Which one is it going to be?"

Inside each of those young men, something stirred. Why couldn't they beat the University of Rochester?

Thirty minutes later, the Fords took the floor. And over the next two hours, they did indeed make history.

By losing by 70 points.

The Haverford sports information director confirmed it afterward: the 104–34 defeat was the worst loss in the school's nearly 100 years of basketball.

Years later, Greenstone points to that evening as the moment when his idealism was fatally pierced. "Because," he says now, "it just seemed to me that we were working really hard and we cared a lot and that should be enough."

He pauses. "And let me tell you, it most certainly was not."

Exceptional basketball teams require certain ingredients. Talent, of course, and great coaching, as well as chemistry and a strong work ethic. These are the teams you read about in books and see in movies. They provide inspiration, teach us lessons.

But what about bad teams? Not the merely mediocre, but those that achieve transcendent, soul-sucking badness. Teams that can lead men to question their purpose on this planet—that can cause a coach to sit deep into the night, cross-legged on his living room floor, eating bowls of Frosted Flakes, trying not to cry and watching late-night ESPN games, just to be reminded of the way basketball can be played. Those types of teams also require their own peculiar alchemy. And they also teach lessons, if different ones.

The Haverford basketball squad of the early 1990s was such a team, and it has its own story, an epic quest for victory. Not to win a national championship, or a conference, or a tournament.

No, the Fords were just trying to win one game.

Let's start at the beginning, back in the spring of 1990, when the Streak was fresh and new and almost endearing, the way funny-looking babies are before they grow into funny-looking adults. George H. W. Bush was still in office. The Black Crowes had just released their debut album. *Pretty Woman* was in theaters. And the men's basketball team at Haverford, a liberal arts college of 1,200 in the leafy northern suburbs of Philadelphia, had just completed

its 12th consecutive losing season, finishing 3-21 and dropping its final 11 games.

Of the players, Jeremy Edwards took the losing the hardest. A six-foot-three sophomore shooting guard, Jeremy was far and away the best player on a team that was both undersized and undertalented. A legitimate high school recruit from St. Albans in Washington, D.C., he could slash to the basket, stick midrange jumpers, and run forever. With his short dark hair, olive skin, toned physique, and killer smile, he was also the closest thing at Haverford to a matinee idol. And he took basketball very seriously. Four or five times, he'd cried after losses.

Jeremy was exasperated by Haverford. Not an Ivy, nor a "name" liberal arts college on the level of Williams or Amherst, Haverford was a progressive, intellectual school with a serene campus featuring duck ponds and 19th-century stone buildings. There were no fraternities, no football team. Instead, there was an honor code and a fervent embrace of the then-dawning political correctness movement. This was a school where "women" was often spelled "womyn," where the Bisexual, Gay, and Lesbian Alliance held kiss-ins, and where the student-run pizzeria changed the Hawaiian pizza to Canadian Bacon and Pineapple, lest any Hawaiian student be offended. That no one had ever seen a Hawaiian student at Haverford was beside the point.

It wasn't that sports were unimportant at Haverford. The cross-country team was excellent and the baseball team promising. Even the hoops squad had once been formidable, back in the '70s when it starred a deadeye forward named Dickie Voith, who later scored an invite to Golden State Warriors training camp. No, it was just that there were a lot of things at Haverford that seemed even more important.

Jeremy knew this. Even so, he was unprepared for what he saw upon walking into the men's room at the campus center one afternoon that spring. There, standing at the urinal next to his, was a fellow student reading a chemistry textbook while he peed.

With a highlighter in his mouth.

That was when Jeremy finally snapped. He decided right then and there—midstream—that he had to leave. A month later, after considering transferring, he announced that he was taking a year abroad, in Spain, to clear his mind.

It seemed fitting. Coming off a dismal season and burdened by

an 11-game losing streak, Haverford had just lost its best player. The Streak was about to go national.

It took a committed optimist to assess the roster the ensuing fall and see in it the potential for greatness. Fortunately for Haverford, or perhaps unfortunately, the team was led by the most committed of optimists.

David Hooks was one of those coaches who believed in the impossible, even when other impossiblists wouldn't. This was a man whose glass could be dry, shattered, and tossed into a recycling bin and still be half-full. He'd grown up in Dayton, Ohio, where as a rugged six-foot-three power forward he'd made second team all-conference in a conference that included future Trail Blazers star Jim Paxson. Inspired by his coach at Oakwood High, Hooks went on to become a high school coach and later a DIII assistant at his alma mater, Guilford College in Greensboro, North Carolina. Haverford was his first collegiate head coaching job.

Now, in October 1990, in his third season as Fords coach, Hooks stood in front of his team at practice, eyes afire. In years to come, with his soft cheeks, deep-set eyes, burgeoning belly, and booming voice, Hooks would bring to mind a clumsy, affable Berenstain Bear. But for now, at 33, he was fit and sturdy, his brown hair cropped close. He looked like an athlete. And he had a plan to halt the Streak.

"This season," Hooks declared, appraising the pale, skinny players, "we will be the best-conditioned, hardest-working team in America."

The players assumed this was hyperbole. It was not.

In the weeks that followed, the Fords ran through endless defensive "foot fire" drills followed by endless defensive slides. For a break, they ran endless wind sprints—"fivers" in Hooks's parlance. Sometimes the coach scheduled practice from 10:00 p.m. to midnight and then from six to eight the next morning. After doing the math, some of the players slept in the small, musty training room, wrapped in towels.

Hooks's strategy might have worked—emphasis on might—if not for a few important factors. The first was the Haverford gym. Alumni Fieldhouse (or the Quakerdome, as students called it) was a giant concrete box that housed three basketball courts encircled by a running track. For games, Haverford staffers wheeled

out bleachers and red tarps in an attempt to create intimacy. It did not work. The worst part, though, was the floor: 1/8" of rubber seemingly spray-painted on top of concrete. It was like a great red magnet. On the rare occasion that a player arrived at Haverford able to dunk, the Quakerdome reduced him to weak finger rolls within weeks.

Then there were the players themselves. These were not elite athletes, but rather student-athletes, the kinds whose bodies weren't built for endless defensive slides. By the end of preseason, almost half the Haverford players were nursing groin strains.

Yet Hooks remained confident. These things take time, after all.

If there was a glimmer of hope for the Fords that fall, it arrived in the form of a trio of new recruits.

On the second day of practice, the first of the three, six-foot-seven big man Tim Ketchum, blacked out, destined to miss the season for a condition that at first was thought to be heart-related but was ultimately deemed benign. Not long after, recruit number two, point guard Jacopo "Yak" Leonardi, injured his back, ending his basketball career at Haverford. As for the third, a six-foot-five forward with flowing hair named Hunter, he never even showed up for practice. He decided to play Ultimate Frisbee instead.

Thus the 1990–91 Fords roster combined a lack of size with a lack of experience to devastating effect. The team had only four upperclassmen and two players over six-three — make that one, after springy power forward Russ Coward broke his leg. So in most games a six-foot-two sophomore forward named Jon "Feds" Fetterolf jumped center. The team's best three-point shooter, Eric Rosand, had a fractured finger on his shooting hand. As for Dan "Greenie" Greenstone, the hardworking sophomore orator, he was not only devoid of discernible natural talent but had scored all of seven points the previous season.

The new season began exactly as one might expect. First came the Rochester debacle. Now you might be wondering why a coach, armed with such a roster and in the midst of a losing streak, would schedule the defending DIII national champions in a season-opening road game. If so, you would not be alone. But Hooks — whose heart was usually in the right place, if not always aligned with his brain — believed in exposing his team to the best.

Similarly, a different coach might not have appraised this array of talent and thought, *You know what I should do with these boys? Run an up-tempo offense.* Because usually when you possess a deficit of talent and size, you want to limit possessions. Slow it down. Grind it out. But Hooks? He taught his players the Kansas two-break. He encouraged them to push it up the floor. He was trying to build a system, after all.

So Haverford lost. Big. When the Streak was at 15 games, the Fords traveled to Lebanon Valley College, in rural central Pennsylvania. The Lebanon Valley football team sat behind the Haverford bench in the packed gym, heckling with gusto. Early in the game one of Lebanon Valley's big men, a ripped, suspiciously old-looking guy, follow-dunked on Feds. Then he emitted a primal yell, dropped the ball on Feds's chest and, to the great delight of the crowd, shimmied.

In the locker room at halftime, Hooks ripped into the Fords in a courageous attempt to motivate them. He roared, "Come on! BE MEN! We have 12 players with five fouls each. THAT'S 72 FOULS WE CAN USE!"

Without pausing, Hooks continued: "Why are you afraid to take a charge? Come on . . . are you going to let yourself be intimidated by some 25-year-old rapist?" Hooks stared the players down, eyes burning. "I once got hit in the nuts with a lacrosse ball going 90 miles an hour, and I still might be able to have kids. So what are you afraid of?"

Hooks's speech did not have the intended effect. To the contrary, like many things Hooks said, it just raised questions. After all, these were Haverford students. They were taught to think critically. To question authority. And so that's what they did. Didn't 12 times five equal 60, not 72? And, if you thought about it, shouldn't they be afraid of a 25-year-old rapist? And what of Hooks's testicles? What did they have to do with toughness? Hooks didn't choose to get hit there, right?

Adding to the awkwardness in situations such as these, Hooks was both a poor speller and not much for grammar. One time, in the middle of a locker room sermon designed to whip the team into a frenzy, he wrote *ARE WE WINNING OR LOZING* on the board. More than once he described an opposing guard on a scouting report as having a *descent handle*. He labeled the nylon sack holding players' wallets as the "Valuable Bag," which led to

philosophical discussions between Ketchum and Nick Cirignano, an amiable freshman guard—because, while usually one would call such an item the valuables bag, once filled with wallets it was, technically speaking, a valuable bag.

So at Lebanon Valley, as often was the case, Hooks's speech only confused the players. They went out and lost by 57.

By Christmas the Fords were 0-9 and the Streak stood at 20. Hooks responded by holding three-a-days over break. The team's first game of the new year was against Earlham, a fellow Quaker college in Indiana, a rare opportunity to pick up a win. Here is how Earlham coach Pat Williams summed up the game in the paper the day after: "It was like UNLV playing Princeton, with us as UNLV. We're not in that situation very often."

It only got worse. In mid-January the Fords lost by nearly 50 to a Johns Hopkins team that starred a deadeye shooter named Andy Enfield, who would one day lead a Cinderella team to the Sweet 16 of the NCAA Tournament.

After losing to Washington University in St. Louis by 49, the Fords went national. The *USA Today* sports section included a blurb on Haverford's 26th consecutive loss. To the players, it was embarrassing. After all, who joins a college sports team expecting to lose like that? They had become the Washington Generals of DIII. The possibility of the first winless season in the school's history loomed.

Hooks remained stubbornly optimistic. "If I had to do it over again, I'd do it the same way," he told the Haverford paper, the *Bi-College News,* of scheduling so many tough games. As for the losses, he saw a silver lining: "It's been a year of hard lessons, but that's O.K., because most of these kids still have two years to take these lessons and do something with them." In the locker room he told the players, "I know you think I'm crazy, but we're going to win a national championship at Haverford."

It was around this time that the players learned something interesting about Hooks's background. Years earlier he had earned a master's degree from North Carolina–Greensboro—in, of all things, sports psychology. For his thesis, Hooks had interviewed Bobby Cremins, Dean Smith, and, in a seminal moment in Hooks's life, the great John Wooden himself.

The topic of that thesis?

How to motivate college basketball players.

*

Week by week, the Streak grew: 27, 30, 32, 34.

Even during those dark days, the team remained close. Haverford might not have been a big-time program, but its players possessed something that players at most big-time programs don't: genuine affection for each other. They came from an array of backgrounds—sons of pastors, Coca-Cola distributors, small-town teachers, and big-city professors, but they were all smart. All committed, to a degree they would later marvel at. They ate together in the cafeteria, enduring Vegetarian Night, when the school served something called a cheese cutlet. They hung out in the library, the unlikely epicenter of Haverford's social scene. On weekends they drank Keystone Light and sat in their dorm rooms throwing Nerf footballs back and forth and telling Hooks stories. And at parties they served something they called Red Wave Punch. (In an attempt to make the Fords sound more formidable, Hooks had rechristened the team the Red Wave.) Its ingredients included all manner of strange liquors, and it was supposed to be consumed only by players and friends of the program. It was awful. It was wonderful. The recipe is still handed down today.

Now, as the '90–91 season drew to a close, Haverford had two chances to win. The first came in late February, in the biggest game of the season—and every season, for that matter—against Swarthmore, aka Swat. The two colleges were historical rivals, competing across all sports for the annual Hood trophy. Most games, Haverford drew only a couple of hundred fans; against Swarthmore crowds often topped 1,000.

This season's matchup held more import than most—because of the Streak, of course, but also because it was Senior Night at Swat. And as the fates would have it, Swarthmore's best player that season was a senior named Mike Greenstone.

An outsider might not have pegged the two Greenstones as brothers. Mike was six-two, broad-shouldered, and blue-eyed. On the court, he played with fluid grace. He had been a star in high school before Swarthmore. Confident and serious, he already knew what he wanted to be (an economist) and how he was going to achieve that goal (Princeton grad school). Dan? At five-eleven and 160 pounds, he was skinny, gangly, and a bit goofy, the kind of kid who always had bedhead and never seemed to master the act of shaving. Whereas Mike was earnest and intense, Dan was sarcastic and self-deprecating, the type of guy who pursued arguments

to their logical if at times awkward conclusions. He was not, he would happily tell you, exactly killing it with the ladies. He'd been a reserve until his senior year at a small private school in the Hyde Park area of Chicago. If not for Haverford and Hooks—who'd recruited Dan, much to his surprise and delight—it's unlikely he would have been playing college basketball.

Partly because of this, and partly because it was his nature, Greenie worked his ass off. With few physical advantages, he relied on hustle and defense. "It was almost like you could see the basketball player inside trying to rip through that skin that was holding him back," Hooks would say many years later. "It was amazing to watch his never-ending effort to play through the lack of talent."

Greenie had been conflicted about the 1990–91 season. He hated losing as much as anyone else on the team. On the other hand, because of all the injuries and his hustle and improvement, he was playing serious minutes as the sixth man. He didn't score much—just over three points a game—but ask anyone on that team and he'd tell you that Greenie was its heart and soul.

Which explains in part why he'd been so disappointed the first time Haverford had played Swarthmore that season, a few weeks earlier. In that game, which Swarthmore won easily, Mike Greenstone had scored 18 points. Dan? He went 0-5 from the field. Though he did manage to rack up five fouls.

Now, as Greenie prepared for the Swarthmore game, he felt a swirl of emotions that one would never wish upon someone that age.

The call had come the previous February. Dan wasn't in his dorm room, and there was no voice mail back then, so his mother tried the front office. People there called the basketball coach.

That's how it came to be that Hooks was the one who knocked on Dan's door that day, his face drained of its usual enthusiasm. Your father is dying, Hooks said. His cancer has spread. It's serious. It's time to go home.

That afternoon Hooks drove Greenie to the airport. He walked his player through security to the gate—you could do that back then. Then Greenie and his brother and Hooks and Lee Wimberly, the Swarthmore coach, sat together and talked. About everything. About nothing.

A few days later, David Greenstone passed away at age 52. The *New York Times* ran an obituary. The funeral was held on Friday, February 23, in Chicago.

When Dan returned, he said little about it. There was nothing to say.

Now, a year later, it was Senior Night at Swat. Dan's mother and grandmother flew out. Both wore Swarthmore sweatshirts.

On a cold, rainy night, the Swarthmore gym was jammed. The team was 16-4 and headed to the postseason. The Fords were 0-24. The Streak stood at 34.

Mike Greenstone started, of course, and scored a few buckets early. Then Dan came into the game, and the Swat crowd heckled him mercilessly. Dan tried to ignore it and focus on the game.

By halftime Swarthmore led by 25. Then, in the second half, Mike Greenstone broke the 1,000-point barrier. On, of all things, a four-point play. The player who fouled him? Yup, you guessed it.

The refs stopped the game, and Swarthmore held a ceremony honoring Mike. He was presented with a game ball. The crowd showered him with love. His hair looked perfect.

Swarthmore went on to yet another win, and Haverford to yet another loss. Only this game was different. Let the record show that on this night, even though Haverford lost by 36, the Fords' leading scorer was not sophomore guard Joey Rulewich, or Rosand. In front of his mother, in a gym where the opposing fans yelled "GREENSTONE'S BROTHER SUCKS!" all night, Dan Greenstone went 6 of 7 from the field. He pulled down five rebounds, hit his only free throw, and, in scoring a career-high 15 points, knocked down both of his three-point shots.

After swishing the second, Dan backpedaled down court and, without looking, pointed a finger at the hecklers in the stands.

Beating Swarthmore would have been emotional and certainly vindicating. But it also would have been highly unlikely, as all but Hooks would have acknowledged. Vassar was a different matter.

Only once all season had Haverford finished within 19 points of an opponent, and it had been against Vassar, in December, when the Fords lost a heartbreaker, 69–64. Now the season finale loomed.

Hooks stayed up most of the night, watching film and working

on strategy. Greenie did visualization exercises in his dorm room. The buzz on campus built. "Vassar Last Chance for Ford Victory," blared the *Bi-College News*. The Streak stood at 35.

In his office, athletic director Greg Kannerstein mulled the potential ramifications of a loss. After all, Haverford was starting to enter historic territory. The Division I record for consecutive losses was 37, by the Citadel back in 1954–55. For Division II it was 46, by Olivet in 1959–61. And for Division III, the record was 47, set by Rutgers-Newark from 1983 to 1985. There was still time for Hooks and his team, but not much. Just the previous spring, Haverford had been named a top-10 liberal arts school by *U.S. News & World Report*. Kannerstein knew that going down as the worst college basketball team in history wouldn't be the best thing for the school's reputation. And a nice long off-season would be all it would take for the media to sniff out the story.

In the first half against Vassar, Haverford did little to inspire confidence. Jumpers clanged off the rim, layups rolled out. At halftime Vassar led by 11. Then, to everyone's surprise, the Fords closed the gap in the second half until, with only 30 seconds remaining, they were down but six, 70–64.

That's when the magic began.

Rising up on the wing, Greenie swished a three-pointer, his fourth of the night, to give himself a new career high of 19 points. Vassar missed two free throws. The teams traded possessions, but Haverford came up dry. Then, with only seconds left and the Fords still down by three, they had one final chance. It would have to be a desperation heave. Just inside the midcourt line, Rosand—the kid with the broken finger—caught the pass, turned and released a 38-footer. The buzzer sounded. The ball hung in the air.

Swish.

The Fords dog-piled Rosand. Twenty-odd years later, reserve guard Nick Cirignano would remember that moment above all others. "After that horrible season, it was such an elated moment," he says. "We jumped on top of him, and he was giggling like he just stole something. I've never felt happier in my life."

Unfortunately there was still overtime.

Back and forth the lead went until, again, the Fords found themselves down by three with seconds left. This time it was Rulewich—the stoic sophomore who'd been the team's best player all season—who had the ball in his hands and a chance to tie it at the

buzzer. In the stands, his father, Butch, who'd attended every one of Joey's games since CYO ball, watched and prayed.

Joey took one hard dribble and pulled up from behind the line. The backspin was perfect. The shot was on line. It hit the rim. It swirled in.

And then out.

Joey fell to the ground. Butch slumped. Hooks collapsed. Greenie died a thousand deaths.

The Streak lived for at least one more season.

The postmortem was not pretty. For the season, Haverford's average margin of defeat was 34 points. No player finished in the top 10 in the conference in anything. At the awards banquet, Hooks chose not to give out an MVP award. One could have made a case, and some on campus did, that Haverford had just completed the worst season in modern college basketball history.

By now, the media was on to the story. In a feature in the *Philadelphia Daily News* titled "It's Not Whether You Win," Hooks was described by reporter Bill Fleischman as "34 going on 64." The writer also quoted Greenie as saying, "We're real young and we just had a year from hell."

Kannerstein, the athletic director, stood by Hooks in the article. He described the coach as possessing "a lot of energy and a low discouragement threshold." Later in the article Kannerstein summed up his coach with an unfortunate turn of phrase: "David has exceeded my expectations in terms of energy and failure to give up."

That spring, attention was momentarily diverted from the Streak when the women of Haverford went on strike. Not just any kind of strike though: a fellatio strike.

The problem began when the freshmen on the lacrosse team, which was also coached by Hooks, painted a sign to rally the campus for the end of the school year's competition between Swarthmore and Haverford for the Hood trophy. Their choice of slogan managed to be both tasteless and clueless: SWAT WILL GET DOWN ON THEIR KNEES AND GIVE US HOOD.

This went over about as well as you'd expect. In these pre-Internet days, campus conversation centered around the six-foot-by-eight-foot cork-backed comment boards outside the student center. Within hours the boards were filled with angry missives: about

how offensive the slogan was; about how it encouraged a sense of male dominance. Some commenters wondered if it didn't connote violence.

As was protocol at Haverford, the honor council held a "plenary" akin to mediation. A day later, with no resolution, the women of Haverford concocted their own slogan in response. That's when the small construction paper signs began showing up, taped to lampposts, the walls of dorms, and the sidewalks. In black print they read: FELLATIO STRIKE.

As luck would have it, Jeremy Edwards returned from Spain just in time to catch the tail end of the strike (which was eventually resolved to everyone's satisfaction). *Well,* he thought, *it appears as if nothing changed at Haverford while I was away.* The same applied, he noted, to the fortunes of the basketball team.

After all, the last time the Fords had won, in January 1990, Jeremy had been the leading scorer.

The *Sports Illustrated* College Basketball Preview arrived in Hooks's mailbox in October 1991, with Christian Laettner on the cover. Like thousands of other Philadelphia-area residents, Hooks leafed through the issue, past the stories about Duke, Michigan, and LSU center Shaquille O'Neal. Then, on page 122, he saw it. The story's headline: "Can the Fords Get Started?"

It began: "Haverford (Pa.) College almost has to have a better season than it did in '90–91. The Fords, 0-25 last season, have a 36-game losing streak that dates back to January 1990."

Hooks, who aspired to be a Division I coach, had always dreamed of making it into *Sports Illustrated.* But not like this.

Fortunately, reinforcements were on the way. The first was Gabe O'Malley. The son of an Irish bar owner, Gabe was a tough, smart redhead who'd been a star six-foot-four forward at BB&N School in Cambridge. The second recruit was a six-three shooting guard who transferred from a far-off land known as California: my brother, Duffy.

Duffy was a rare breed at Haverford: a player with both length and range. An all-conference player in high school, he had been the last cut at UC San Diego, a perennial DIII power. In Haverford he saw a second chance.

Adding to the good feeling in the fall of 1991, Edwards—Jer!—

was returning to the team, along with big Tim Ketchum and Russ Coward, who were back from season-long injuries. Haverford suddenly had what appeared to be a (relative) wealth of talent. There was talk of a .500 record, perhaps even a run at the postseason.

Then, in the fall, everyone got a look at Edwards on the court. He struggled through sprints. There was no lift on his jump shot. He appeared to have really enjoyed his time in Spain. "If this guy is supposed to be our savior," Cirignano said to Greenie after one early practice, "we're in deep s—t."

Never one to disappoint, Hooks had again set up a brutal schedule, the Streak be damned. Haverford would play road games at DIII powerhouses Williams, Wesleyan, Middlebury, and NYU.

The program also had three new faces: two new assistants—Kevin Small and Kevin Morgan—and, to the delight of the players, a bright, shapely freshman named Lila Shapiro who'd signed on as the scorekeeper. Lila, a sports nut from Baltimore, became the team's biggest fan. She accompanied the Fords on road trips. If some of the players harbored crushes on her, she paid little attention; she was there to do a job. Besides, as she says now, "Remember, we're talking about Haverford guys. It wasn't like traveling with the Ohio State basketball team."

It didn't take long for the preseason optimism to dissipate. In the opener, against NYU, the Fords lost 98–82, matching the Division I record for consecutive losses. The next day they lost by 32 to Neumann University. Then to Gettysburg by 33. Expectations were replaced by desperation. The Streak stood at 39. History beckoned.

For the players, it had become painfully embarrassing. It was neither easy nor fun to be a member of That Team With the Losing Streak That Was in *SI*. Especially because most of the Fords had been the best players on their high school teams. These were young men who'd stayed ahead of the curve in life. They'd studied hard, worked their butts off, done well in academics. They were supposed to be going places. And now local fans came out to gawk at them, hoping in equal measure that the Fords might win and lose. Sometimes Haverford provided unintentional comic relief. Such as the time, during layup lines in a packed opposing gym, that Duffy took two strong dribbles toward the hoop and then

tripped over his own shoelace, which he'd looped so long that it had become snagged on his toe. He tumbled to the floor. The fans roared in laughter.

"Get up!" whisper-shouted a teammate.

Only, with his shoelace snagged, Duffy couldn't get up. Eventually, to the delight of the crowd, he crawled off the floor on his hands and knees.

Meanwhile, and more troubling, Hooks didn't seem to be improving as a coach. He became myopic. He had run the same offense for years, yelling out "Two! Two!" to signal the two-break on nearly every possession, just in case anyone didn't already know what was coming. His rotations were wacky. In one game he started big Tim at center and then, after subbing him out in the first quarter, either chose not to or forgot to put him back in. In another game one of his wing players got hot, hitting three consecutive three-pointers. Hooks immediately subbed him out, to the bewilderment of his teammates. Afterward Butch Rulewich, Joey's dad, asked Hooks why. His answer: it was his turn to come out.

As much as Hooks frustrated the players, though, none of them could bring themselves to dislike the guy. He may have been in over his head as coach, but his heart was in the right place.

Remember when big Tim Ketchum blacked out on that second day of practice? It was Hooks who insisted he get fully checked out, who cautioned him against returning early and then checked on him daily in the months that followed, becoming, in Ketchum's words, "a kind of father figure at a scary point in my life." Hooks's crazy scheduling? Part of it was for the benefit of his players. He took the team to play the University of Chicago one year so Greenie could have a homecoming, and a year later he figured out a way to get the Fords to UCSD for Duffy's sake.

Most of all, Hooks's character shone through in his reaction to the death of Greenie's dad. It wasn't just that he was the person to tell Greenie and drive him to the airport. But at the funeral, a few rows back from friends and family, Greenie noticed a lightly sweating, not-so-lightly crying bear of a man. During the season, while living on a $35,000 annual salary, David Hooks had paid out of his pocket to fly to Chicago to support one of his freshman benchwarmers.

This was the side to Hooks that not everyone saw, hidden be-

hind his relentless optimism and occasional buffoonery. He truly cared, about the kids and the team. And now the Streak was slowly destroying him.

He'd taken the Haverford job out of desperation. His fiancée had been accepted into a graduate program at Drexel, and the couple was moving to Philadelphia from North Carolina. Needing a job, any job, Hooks applied to 70-odd schools in the metropolitan area. Meanwhile, Haverford needed what amounted to a coaching unicorn: someone qualified to coach both basketball and lacrosse who would do so with no paid assistants, a tiny budget, and no promise of a faculty position. All for low pay.

In his first two games as coach, Haverford lost by a combined 111 points. On the drive home to his one-bedroom apartment on City Line Avenue that second night, Hooks fantasized about driving into the river. Anything to avoid that kind of embarrassment again. As he would later tell a *Philadelphia Daily News* reporter, "Any sane person would have packed his bags up at that point and split."

But of course that's not what Hooks did. And in the three years since, he had lived and died with the job. He worked long hours, running practice during the day and then driving his silver Chevy Corsica across eastern Pennsylvania at night, a cold cup of coffee next to him, searching for recruits who might be persuaded— somehow, some way—to come to Haverford. Sometime after 1:00 a.m., he'd collapse into bed. In his free time he prepared binders for the players that included pages upon pages of drills and crazy-hard plyometric programs as well as inspirational clippings: everything from John Wooden's pyramid of success to passages from Dante to a poem that encouraged players to "show us all the colors of your rainbow."

On nights the team played, and of course lost, Hooks went home a wreck. He'd pour a big bowl of sugary cereal and sit down on his living room floor with his golden retriever, Hoops, whom the players had bought for him. Deep into the night, the two would watch college basketball on ESPN, so Hooks could see the game the way it was meant to be played.

He never gave up hope, though. And now, on Monday, December 2, 1991, he was certain the end of the Streak was at hand. Haverford was playing at Philadelphia Pharmacy, a college that is exactly what it sounds like: a school for aspiring pharmacists. It

was an eminently winnable game. Anticipating history, a couple of Philadelphia TV stations sent reporters. Their trucks idled outside. A crowd of 150 showed up.

Hooks knew he needed a special speech for such a night. So he gathered the team in the locker room before the game and mustered his best fire and brimstone. He talked about destiny and desire. For once the players were with him. They drummed their feet. It was time! Soon Hooks was in a frenzy, sweating and jumping around, and he built to a climax. "Okay!" he roared. "I want you boys to run out there like caged snowbirds and kill them!"

With that Hooks sprinted out of the locker room toward the court. The players stared at each other. They were supposed to run out after him. But an important question hung in the air. "What," Russ asked, "is a caged snowbird?"

Philly Pharmacy won 75–62. The Streak had hit 40.

Everyone on the team, save the freshmen, knew what that meant: it was going to come down to Gallaudet.

Founded in 1864, Gallaudet College is located in Washington, D.C., on a picturesque 99-acre campus. An esteemed academic institution, it boasted an enrollment of 1,800 and a rich athletic history. The school was, without question, the premier basketball program in the United States for the deaf.

Hooks took the Philly Pharmacy loss harder than anyone else. The long hours and the stress of the Streak were beginning to affect his marriage, and the media commentary was wearing on him. Worse, the schedule only got harder in the weeks ahead. If the Fords didn't beat Gallaudet, which came into the game 0-4, the 47-game record loomed.

There was only one thing to do. On Monday, two days before the game, Hooks gathered the players at practice and announced that he would be focusing on a specific defense. It was called the "run-and-jump trap." When an opposing point guard brought the ball upcourt, Hooks explained, the primary defender would force him to the sideline. As that happened, a defender on the opposite side of the floor would leave his man, sprint across the width of the court, and trap the ball-handler from behind.

Most of the time it was a risky defense, the kind that could be thwarted by something as simple as communication. All an offensive teammate had to do, after all, was shout out, "Double coming!"

and the ball-handler could avoid the trap. Provided, of course, the ball-handler could hear his teammates.

Game day dawned cool on Wednesday, December 2. By the 7:30 p.m. tip time, the temperature was 36 degrees. Fans streamed into the Fieldhouse, bundled in long coats and hats. There was, for the first time in a while, a real buzz. Attendance was listed at "capacity"—more than 1,000 people. And this time there were even more TV cameras. Everyone expected a win.

The Fords were nervous; a number had taken multiple finals earlier in the day. PA announcer Thad Levine, a sophomore baseball player who was close with the guys on the team, rolled his syllables. "WELLLLCOME TO THE QUAAAAAKERDOME!!!"

Levine announced the starting lineups. For Haverford, that meant Jer, Russ, Duffy, Joey, and Big Tim. Meanwhile Gallaudet's star was point guard Anthony Jones. Though only five-eight, Jones was built like a linebacker. A year earlier, he'd finished among the top 10 Division III scorers.

High up, on the lift behind the stands, Haverford freshman jayvee guard Tom Mulhern ran the video camera. He could feel the hope in the stands but also the dread; if the Fords couldn't beat Gallaudet, the streak might never end.

For once Haverford raced out to a lead. Midway through the first half, Hooks went for the kill, deploying the run-and-jump and telling the Fords to drop back into a 2-3 zone instead of man-to-man. It worked just as you might imagine—chaos in the Gallaudet backcourt, Haverford layups—and the Fords took an unprecedented 27–12 lead. In the portable bleachers the students went nuts. Haverford was the kind of school where people supported their friends, and the stands were packed with dormmates and girlfriends of the players, teachers, and lacrosse players. Then again, since this was Haverford, some of them had brought their textbooks.

Just when it looked like the game might turn into a rout, Jones heated up. A pull-up three. Another three. Gallaudet was also adjusting to the run-and-jump; after all, this was the school that invented the football huddle so other teams wouldn't steal its signs. By halftime Haverford's lead was cut to seven. Jones already had 18.

The Fords sprinted off the floor and up the stairs to their tiny, fire-engine-red locker room. There Hooks paced and shouted and sweated. The run-and-jump was working, but not well enough. Jones was killing them. Greenie could see a mixture of desperation and wild hope in his coach's eyes. And, in that moment, even though Greenie was no longer in the rotation—the downside to all the new talent was that gritty, skinny sixth men were shunted far down the bench—he realized that he wanted this win for Hooks as much as for himself and the team. This guy, Greenie thought, needs this.

As the second half began, Lila watched from the scorer's table. By now she knew the players. She knew how hard some of them took the losses. And she continued to be amazed by how they never turned on each other or threw in the towel. What losing team doesn't suffer from bad chemistry? She wasn't supposed to cheer—usually she just muttered under her breath—but on this night it was hard not to.

Only, as the minutes ticked by, there was little to cheer about. First Gallaudet closed the gap. Then it took the lead. Lila felt her stomach sink. Not again.

At least Haverford stayed within striking range. Duffy drained a couple of long threes. Reserve guard Brett Kolpan harassed Jones on D, then swished a big three himself. Amazingly, Haverford held the lead with less than a minute to go.

Naturally, the Gallaudet center sank two free throws. Overtime.

This time there would be no miracle heave, no dramatic finish. Later that night, as he slumped in a chair at nearby Gator's Pub, slugging back a beer, Hooks would think back on that overtime period. How his boys had sunk 12 of 16 free throws. How Kolpan had somehow shut down Jones. How Jeremy, the prodigal son, had led the way with 18 points overall, followed by Duffy with 17. Hooks would have to stop himself from crying right there in the bar. "It was almost like the gods of Basketball had had enough of this," he would say years later, "and they were ready to cover the basket just enough times to help us win."

In the moment, though, when the fans giddily counted down the final 10 seconds, and then that final buzzer sounded and the scoreboard read Haverford 87, Gallaudet 82, it was pure pandemonium. After nearly two years, the Streak was over. From the portable bleachers a torrent of crazed, whooping students engulfed

the team. It was the first time in anyone's memory that Haverford kids had rushed the court. Hooks, sweaty and ecstatic, bounded up and down, fist-pumping and yelping, while, nearby, the cameras rolled. In the locker room someone pulled out two bottles of champagne and sprayed like crazy, speckling the walls with foam and dumping alcohol on the heads of Jer and Joey. The TV cameramen were kind enough to ask their bosses to describe it on-air as "sparkling cider."

Even though it was a school night, the players stayed up, celebrating, watching themselves on the 11:00 p.m. news, and then again on the late-night broadcast.

The next morning, a story in the *Philadelphia Inquirer* detailed the game. "It was beginning to get a little heavy," Hooks said of the Streak. "I think any human being, you tend to question yourself."

For its part, the *Bi-College News* featured a photo of the scoreboard with one word above it: "FINALLY." In the accompanying story the author likened Haverford fans, players, and coaches to released hostages. "If one game can turn a program around," Hooks told the paper, "I think this is the one."

John Wooden's pyramid of success promises that if you value process over outcome, then outcome will take care of itself. But what if the outcome doesn't take care of itself? What if you still lose? How are you supposed to feel then?

It is a snowy afternoon in December 2013, and David Hooks greets a visitor outside the main office of West Nottingham Academy, a small boarding school in the rural nowhereland halfway between Baltimore and Philadelphia. He is the school's athletic director, college counselor, and boys' basketball coach, and on this day he is wearing jeans and, in spite of the weather, a tan short-sleeved polo shirt. There is a coffee stain on the right breast. Hooks is, as always, enthusiastic. He leads a guest up to a small second-floor office stuffed with the paraphernalia of a peripatetic coaching life: photos and banners and books. Occasionally his phone chirps out the *SportsCenter* jingle. He apologizes for delaying the appointment. While bringing home a Christmas tree during a blizzard, Hooks lost control of his pickup truck and plowed into a telephone pole. He spent the morning getting the car fixed.

Now, a cup of coffee in hand, he begins to talk Haverford. In the end he did turn the program around, though it got worse be-

fore it got better. After beating Gallaudet, Haverford embarked on a grueling Northeast road swing against Williams and Middlebury. More classic Hooks-ian moments followed. Like the time he took the team to the Basketball Hall of Fame and injured Duffy while mock-contesting his jump shot, sidelining the player for a month. And the time, on a team trip to the mall before a game, that Hooks broke his ankle trying to take a shortcut down a grassy slope, requiring emergency surgery.

Finally, Hooks's recruiting efforts paid off. He enticed two legit prospects, Chris Guiton and Jamal Elliott, to come to Haverford. The team's record went from 5-19 during the Streak-busting season to 5-19, 11-15, and, in 1995–96, 16-13 and a postseason berth. "Playoff Fever Hits Haverford Tonight," declared the *Daily News*.

Unfortunately, Hooks wasn't there to experience it. Nine months earlier, he'd left for a volunteer assistant job at Penn, leading local papers to suggest that he was either pushed out or was asked to resign. Today on the Haverford website the history of the basketball program jumps from 1983 all the way to the sentence, "The program awakened after a sluggish decade in 1995–96." There is no mention of David Hooks or the Streak.

After Penn, where he worked under Fran Dunphy and endeared himself to players, he worked at a country day school in Lancaster, Pennsylvania, at a small high school in Maryland, and one in New Orleans. The years went by. His two children, Kristen and Jordan, went from preschool to middle school and beyond. Hoops, his beloved golden retriever, passed away. He got divorced. He got a new golden, Beauregard. He remarried. He's still coaching, still passionate about it.

On this afternoon he leads the West Nottingham team through a practice. Most of the boys are international students. Some don't appear to know all the rules of basketball. Hooks isn't dissuaded. He runs them through "foot fire" drills, exhorting them as loudly as ever.

At 57, Hooks still has big dreams. He says he'd like to be a Division I coach someday; maybe he could do what Brad Stevens did at Butler. He remains driven by the chance to mold young men's lives, by seeing the Danny Greenstones of the world make the most of their talent.

Talk to those who knew Hooks, and they aren't surprised. Kevin

Small, the Haverford assistant, went on to become the head coach at Ursinus. He calls Hooks "a dying breed." He says, "So many coaches are out for themselves, and self-promoting. [Hooks] really cared about the team. He was Sisyphus. He was always pushing a rock up a hill. It always rolled back on him. But, God bless the guy, he was always ready for pushing it back up again."

Or as Nick, the reserve point guard, puts it: "I've never been around someone who had such a passion and such great enthusiasm for something he was so ill-suited to do."

Now, in Maryland in a musty athletic office after practice, Hooks tries to explain his life's philosophy. He refers to the poem "The Bridge Builder," about an old man who lays down a bridge for those yet to come. Finally, he tells an anecdote.

The night before, he says, he and his wife sat down to watch the movie *Armageddon* for "like the 20th time." His wife didn't understand why he wanted to see it yet again. "The reason I watch this over and over is because I want to be on that spaceship," Hooks told her. "I want to be those guys saving the world."

She didn't get it. "But why would you want to leave your family back on earth?" she asked.

"Well," Hooks said, "earth wouldn't be here unless I went."

You want a story? You should write about the Streak.

This fall will mark the 25th anniversary of the season the Streak began. In the years since, the Fords have been pushed further into the history books. In the mid-'90s Rutgers-Camden lost 117 consecutive games. Forty no longer seems so bad.

The players remain united by the Streak, however, and on a weekend this January they gathered back at Haverford, arriving from all over the country: Chicago, Texas, California, D.C., Boston, Indiana. There are lawyers, doctors, and professors. One works at the Brookings Institution, another in the State Department. An unusually high number went into sports. Joey is a successful high school coach in Highstown, New Jersey. Russ Coward led the girls' team at Westford Academy, near Boston, to the state finals this year. Dave Danzig, a reserve on the Streak teams, became an assistant in Germany, coaching the Würzburg Buckets, Dirk Nowitzki's old team. Jeremy founded the SportsChallenge Leadership Academy, an educational nonprofit in D.C. Feds is a lawyer who occa-

sionally represents baseball players. Recently he and Thad, who is
now the assistant GM of the Texas Rangers, worked on a deal for
relief pitcher Chris Ray.

Over the weekend the players ate gooey cheesesteaks at Bel-
la's and drank cheap beers in the wooden booths at Roaches &
O'Brien, where apparently smoking is not only still legal but also
encouraged. And on Saturday afternoon they sat in Haverford's
new state-of-the-art gym as the Fords (1-6 in conference play)
hosted Dickinson College in front of 150 or so fans. In a famil-
iar scenario, Dickinson trotted out three rotations players taller
than Haverford's lone "big" man, six-foot-five senior Brett Cohen.
The Fords? They started three guards under six feet. After digging
an early hole, Haverford clawed back and had a final shot to tie
the game in regulation. Cohen's three went in, then out, just like
Joey's once did against Vassar.

A quarter-century later, the players have processed the Streak
in different ways. Some, like big Tim and Russ, use the story as
an icebreaker. It's a tale they know will get a laugh, one that both
reflects well on them (Hey, I played college basketball) yet is self-
deprecating (and boy did we stink).

Others still grapple with the experience. Even this far down the
road, Gabe's still disappointed. Disappointed that the team lost.
That he never had even a .500 record in college. That he became a
better player after college. He's not alone. Like Jeremy, Gabe went
on to play pro ball, in Wales. Duffy still plays in high-level tourna-
ments and leagues in the Bay Area. The Fords wonder if this was
an unintended consequence of the experience—if they keep play-
ing today because they are forever trying to prove themselves.

Then there is Greenie. As planned, his brother, Mike, became
a renowned economics professor: he served as the chief econo-
mist for Barack Obama's Council of Economic Advisors in the
first year of the president's administration. Greenie? He moved
to Chicago and became a history teacher, one who's won awards.
Five years ago he published his first novel. In it there's a familiar
scene involving a basketball team in a game against a school for
the deaf. Two years ago that novel was optioned by the actor Ed
Burns. Greenie is working on a screenplay. Like many writers, he
has turned tragedy into material.

Viewed from one perspective, many of the former Fords are
spending their lives trying to right old wrongs. That would explain

the disproportionate number of basketball coaches among them, each now training kids the way they wish they'd been trained. And Jeremy, the captain of that team—the one who cared the most—is an evangelist for effective leadership in sports. It's as if he's determined to stamp this out.

One thing's for sure: the Streak still bonds them. They remain remarkably close. Seven of Jeremy's nine groomsmen came from the Haverford basketball program. The others see teammates regularly. Last year five Fords gathered in California for the 50th wedding anniversary of Duffy's parents. That's not common. Those of us who didn't experience such sports camaraderie marvel at it. Two years after Greenie's father passed away, his mother died suddenly. Though he remains close with his brother, he says the Haverford basketball team became like a surrogate family.

Thad, the old PA announcer, brings up this point on Saturday night, as the group talks over beers. "At other schools, they were improving on themselves as basketball players, but were we gaining on them in life?" he asks. "Are they sitting somewhere, talking about how terrible they were? I don't think it was mutually exclusive—we certainly could have won and still had these relationships. And maybe we should have invested more in the sport. But at what expense?"

He pauses. "I don't know the answer to that," he says. "But I know we spent a hell of a lot of time investing in each other. We didn't fall short of that by one iota. No one beat us at that."

Some things change. Some never do.

On the Saturday morning of the reunion weekend, the Haverford Streak crew gathered at the shiny new campus gym to play some ball. They took the court in ankle braces, rubbing balky knees and slicking their hair back over bald spots—Greenie and Nick and Duffy and Gabe and others. They moved slowly and complained loudly.

Soon a group of recent college players came in, young and tall and springy. The numbers were right. A game of four-on-four was arranged, the young guns versus the Haverford vets. Once again, the Fords took the court together.

You can probably guess what happened.

That's right, they won.

TOMMY TOMLINSON

Precious Memories

FROM ESPN THE MAGAZINE

CHAPEL HILL, N.C. — Dean Smith doesn't watch the games any-more. The motion on the screen is too hard to follow. Now he thumbs through golf magazines and picture books. Most of the books are about North Carolina basketball. They seem to make him happy. He turns the pages past photo after photo of himself. Nobody knows if he knows who he is.

Music seems to make him happy too. About a year and a half ago, a friend named Billy Barnes came over to the house to play guitar and sing a few songs. Barnes played old Baptist hymns and barbershop quartet tunes — *Daisy Daisy, give me your answer true.* Music he knew Dean liked. But nothing seemed to get through. Dean was getting restless. Barnes asked if he could play one more song.

After every basketball game, win or lose, the UNC band plays the alma mater and fight song. The Carolina people stand and sing. Barnes knew Dean had heard the song thousands of times. He started to play.

Dean jumped to his feet. He waved at his wife, Linnea, to stand with him. He put his hand over his heart and sang from memory:

> *Hark the sound of Tar Heel voices*
> *Ringing clear and true.*
> *Singing Carolina's praises,*
> *Shouting N-C-U.*
> *Hail to the brightest star of all*
> *Clear its radiance shine*
> *Carolina priceless gem,*

Receive all praises thine.
I'm a Tar Heel born, I'm a Tar Heel bred,
 and when I die I'm a Tar Heel dead!
So it's rah-rah Car'lina-lina, rah-rah Car'lina-lina,
 rah-rah Carolina, rah, rah, rah!

"It was just pure joy. That uninhibited joy in the music," Linnea says. "It's one of those moments that you know there's more there, or momentarily there, than sometimes you're aware of."

This is what she hopes for now. A moment of joy. A moment of connection. A moment when Dean Smith is still there.

Why do we care about sports to begin with? Why do we watch? Maybe this: to connect. In the arena, or in a sports bar, or maybe just alone on your couch, you watch your favorite team and you plug into something bigger than yourself. It's a hedge against the coldness of the world. Heaven is other people.

For 36 years as the Tar Heels' head coach, Dean Smith built a family. He created a shared identity for the legions of UNC fans who still buy the tickets and wear the T-shirts and paint their dens Carolina blue. His teams won 20 or more games for 27 years in a row. But more than that, they won with a selfless style. Dean's most lasting invention was his simplest: when you make a basket, you point to the player who threw the pass. He taught his team, and those who watched, that everyone is connected.

Inside the big Carolina family, he built a smaller family—the players and coaches and staffers who came to see him as a teacher, a guru, a role model, a surrogate dad. They asked his advice on everything from sneaker contracts to marriages. He called on their birthdays and got tickets for their in-laws. He built lifelong bonds.

But for the past seven years, maybe more, dementia has drawn the curtains closed on Dean Smith's mind. Now he is 83 and almost no light gets out. He has gone from forgetting names to not recognizing faces to often looking at his friends and loved ones with empty stares.

Here is the special cruelty of it: the connector has become disconnected. The man who held the family together has broken off and drifted away. He is a ghost in clothes, dimmed by a disease that has no cure. Even the people closest to him sometimes slip into the past tense: *Coach Smith was.* They can't help it. They honor

him with what amounts to an open-ended eulogy. At the same time, they keep looking for a crack in the curtains. They do what people do when faced with the longest good-bye. They do the best they can.

Three times a week, a caregiver wheels Dean Smith into the Dean Smith Center. He still has a little office in the arena built in his name. Linnea thinks the routine is good for him. Linda Woods, his administrative assistant since 1977, answers his calls and checks his mail. She writes back *I'm sorry* to autograph seekers. Woods is retired except for Dean. When he's there, she's there. Dean often eats lunch at the office. He loved the double BLTs from down the road at Merritt's Store & Grill. But these days he eats soft things in small pieces. On the good days, he feeds himself.

When he coached, his office was a disaster: "I had files," Woods says, "and he had piles." Now it's mostly the golf magazines and the picture books. Woods turns the pages with him. *You played that course with your friends,* she'll say. Or: *Look at all that dark hair you had on your head.*

She never asks if he remembers.

Dementia steals memory, and here's another twist of the knife: Dean's memory might have been the most impressive thing about him. It was astonishing, like a magic trick. Dave Hanners, who played and coached under Dean, was going through old game films one morning in 1989—Dean had decided to send his former players tapes of their best games as gifts. Hanners was watching a game against Notre Dame when Dean walked by and glanced at the screen. A few seconds later, he said: *Watch this next play. Yogi Poteet is going to get a backdoor pass from Billy Cunningham and score. Next time down, they switch places. Yogi's going to throw the pass and Billy will score.* They watched together, and it played out exactly as Dean said.

When did you watch this film last? Hanners said.

Oh, I guess when we looked at it the day after the game, Dean said.

The game was from 1963.

No one knows what's still in there. Does he remember the numbers: 879 wins as UNC's head coach, 13 ACC tournament championships, 11 Final Fours, two national titles, an Olympic gold medal–winning team? Does he remember the moments: Michael Jordan's jumper to beat Georgetown; Michigan's Chris Webber calling a time-out he didn't have; those heartbroken students

pressed against the windows when he announced his retirement in 1997? Does he remember the players: Jordan and James Worthy and Sam Perkins and Brad Daugherty and Kenny Smith and Bob McAdoo and Phil Ford and Walter Davis and Bobby Jones and Larry Brown? Does he remember coming back from eight down with 17 seconds left against Duke?

Does he remember Duke?

More than 5 million Americans have Alzheimer's, and another million-plus have other forms of dementia. (Another college basketball icon, Pat Summitt—who set the NCAA wins record of 1,098 as the women's coach at Tennessee—was diagnosed with early onset dementia, Alzheimer's type, at age 59 in 2011.) It's a tragedy and a mystery for every family that watches a loved one fade away. Linnea Smith, a psychiatrist, describes her husband's condition in clinical terms: neurocognitive disorder with multiple etiologies. That means it includes elements of Alzheimer's, Parkinson's disease, vascular dementia, and the normal decline of old age.

She also describes it in two simpler words: *relentless loss.*

Bill Guthridge, his oldest friend, has the office next door. They've known each other 60-some years; in the early '50s, when Dean was a backup guard at Kansas, he briefly dated Guthridge's sister. Dean followed Guthridge's coaching career, and in 1967 he hired Guthridge from Kansas State. Over the years, Coach Gut had regular offers to be the head man somewhere else. He got on a plane once to take the job at Penn State, but changed his mind on the layover. He ended up spending 30 years in UNC's second chair. When Dean decided to quit in '97, he didn't announce it until October—way too late for the athletic department to hire anybody but the man waiting there on the bench. Guthridge coached three years and took the Tar Heels to two Final Fours. Then he retired too. He got his taste.

Guthridge could deal with Dean's irritability, his need to control the smallest things. Hanners remembers Guthridge getting behind the wheel to drive them across town to lunch and Dean starting in before he could crank the car: *Which route are you taking? Where are you turning off? Do you know the best way?* Guthridge would glance over and say: *Well, Coach Smith, I thought I'd go through Mebane* (Mebane being about 20 miles from Chapel Hill). They

squabbled and picked and laughed and talked for all those years. They sat side by side on the bench and now side by side in their little offices. There is one difference now. When Dean comes in, Guthridge slips away.

"It's something that I have learned to stay away from," he says. "Because it breaks my heart."

Every so often, Roy Williams walks over from the big office around the corner to check on Dean. Williams played on the freshman team at UNC, kept practice stats for Dean, taught at his summer camps. He was a high school coach with a losing record when Dean offered him a job as a part-time assistant in 1978 for $2,700 a year. Williams drove all over the state selling UNC calendars until he got full-time pay. He stayed 10 years, left to be head coach at Kansas, shocked the Carolina family by turning down the job when Coach Gut retired, then took it when UNC called again in 2003.

In the space of two sentences, he calls Dean an icon and a hero. He still remembers the night before he left for Kansas, dinner at the Smith house, Dean pulling him aside and saying: *Just be yourself. You don't have to be anybody else. You're good enough. And don't take the losses so hard.*

He still takes the losses hard. His sister died of complications from Alzheimer's. Now he sees what happened to her happening to Dean.

"It's hard to see him," Williams says. "Because I want to remember the '70s, '80s, '90s, and early 2000s. That's what I want to remember."

Dean sometimes thought he retired too early. Linnea, who once wrote an academic paper on post-retirement depression, worried he would mope. But he enjoyed those first years away from the sideline. He spent more time with his kids—he has five grown children (three from his first marriage, two with Linnea) and six grandchildren. He watched the Tar Heels as a fan, his heart pounding in a way it never did on the court. He took detailed notes on every game. He never shared the notes unless he was asked, but if somebody asked, he was thrilled. Sometimes Williams would ask Dean to draw up a play or two. It didn't hurt to have an unpaid assistant who retired as the winningest men's coach in college basketball history.

He had always made time for someone in the inner circle—he

would stop an interview or usher out a guest if a former player was on the phone. But now he really had time to talk.

"Then I noticed one day," Woods says, "that he was starting to forget some of their names."

Looking back, Linnea thinks Dean's memory started to erode in 2005 or 2006. But everybody in the Carolina family noticed after he had knee replacement surgery in 2007. He had a bad reaction to the anesthesia. He went home but then had to go back in the hospital. When he finally came out, he was disoriented. He would see a former player he'd known for years, and, instead of calling him by name, he'd nod and say: *Young man.*

One day he drove to the Smith Center, and instead of parking in his normal space, he left his car on the patio of the Rams Club building next door. "It's hard to get a car over there," Linda Woods says. That was about the end of his driving.

Now a specially equipped van takes him around in his wheelchair. Not long ago, Woods was helping strap him in the van so he could go back home. She felt a tap on her shoulder: "I looked up and Coach Smith had the biggest smile on his face. I hadn't seen that smile in a long time. That was the reward for my whole week."

Woods says Phil Ford visits more than anybody else. Michael Jordan is the greatest player to come from UNC. But the greatest player *as a Tar Heel*—and still the most beloved—is Phil Ford. He made first-team All-America three times as Dean's point guard from 1974 to 1978. He finished as UNC's all-time leading scorer and even now ranks second, behind Tyler Hansbrough. (Jordan is 12th.) Ford ran the Four Corners offense, the delay game that iced Carolina wins and led to the shot clock in college ball. It was Dean's highest tribute—control of the team on the floor. After Ford's NBA career, Dean hired him as an assistant. And in the '90s, when Ford picked up two DUIs and admitted he was an alcoholic, Dean memorized Alcoholics Anonymous' 12 steps so he could help Ford get sober.

Ford still lives in the area and has a son at UNC. So he comes by a lot to sit with Dean. "He knows I'm there somewhere," Ford says. "Sometimes you can see in his eyes, he's so close to coming back. Somewhere in the back of my heart, I believe it."

Ford brings up old games, and every once in a while, Dean will smile. Sometimes they just sit there in silence.

*

Lord, how the other schools hated him. Saint Dean, they called
him. Fans of the other ACC teams united under the ABC ban-
ner: Anybody But Carolina. When the NCAA tournament came
around, schools around the country crowded into the tent. Some-
one in every group had a Dean impression, that accent as dry and
flat as the Kansas prairie: *It might have looked like luck to you, but
we practice making those 40-footers off the backboard. That's the Carolina
Way.*

They grumbled about how Dean subtly baited the refs, how he
planted seeds with the media that other teams played dirty. They
were furious when he pulled out the Four Corners and stalled his
way to a win. They couldn't stand how he acted all humble but still
gave off that whiff of we're-better-than-you. They smelled it every-
where. One year the Heels beat Wake Forest after a five-second
call when Wake couldn't get the ball in bounds. "We did play *six*
seconds of good defense there," Dean said after the game. See, the
ABCers said. Even when he won, a little dig.

When Mike Krzyzewski took over at Duke in 1980, he chal-
lenged Dean like no one else had. At Duke in '84, Dean sent a sub
to the scorer's table, but the horn didn't sound at the next break,
and the refs didn't wave the sub in. Dean ran down to the table
and tried to sound the horn himself. Instead he banged the scor-
ing button, and 20 points popped up on the Tar Heels' side of the
scoreboard. The Duke fans went nuts. Dean somehow avoided a
technical. Carolina won. Afterward, Krzyzewski complained about
"the double standard that exists in this league."

There was also a double standard in Dean's head. He preached
process instead of winning and losing. But it was easy to say that
when he recruited so many great players that winning was a natu-
ral by-product. The process worked so well, it hid the coal of desire
that burned in his gut.

"Was Michael Jordan competitive on the court?" Dave Hanners
says. "That's how competitive Coach Smith was. People just didn't
see it in the same way."

Now, as Dean has declined, the bitterness among his rivals has
melted. When Lefty Driesell was at Maryland, he wrote Dean a
letter to inform him they wouldn't be shaking hands after games
anymore. Now Driesell frequently calls to check in. In June 2011,
Krzyzewski and Dean were co-winners of the Naismith Good

Sportsmanship Award. Krzyzewski keeps a photo in his office of the two of them sitting together at the ceremony in Raleigh. He told the *Charlotte Observer* last year: "I felt it was like two generals now at peace."

He came out onto the court one last time. It was 2010, and UNC had put together an alumni game as part of the celebration of 100 years of Tar Heel basketball. They planned to honor Dean at halftime. They didn't tell him. They worried he wouldn't show if they did.

There was a full house at the Dean Dome. At halftime, a tribute video played on the big screens. Dean couldn't see it. He was down in the tunnel with Williams, Guthridge, and Eddie Fogler—his assistants on that championship team from '82. They had told him they'd walk onto the court together as part of the ceremony. He could hear an announcer, and cheers. But in the tunnel, the sound was muffled.

What are they talking about out there? he asked.

Well, they're talking about North Carolina basketball, Williams said. *You and North Carolina basketball.*

Can't we just go stand out there now?

Wait just a second, Coach. Just a second.

The video ended and Williams, Guthridge, and Fogler led Dean onto the court. Just as they got to the center, the three assistants stepped back. Dean stood alone in the light.

Then his old players surrounded him. They hugged him and shook his hand and cried. Bobby Jones, who played for Dean in the early '70s and went on to be an NBA All-Star, wasn't sure Dean would remember him. "So I just said, 'Coach, it's Bobby Jones. Thanks for all you've done for me. We all love you.' He looked up. I could tell he certainly recognized me, and said, 'Hey, Bobby.' That was a good feeling."

The players lingered. The fans would not stop cheering. Dean waved to the crowd but did not speak. Then he walked back into the tunnel.

There are still moments. Dean works out three times a week with exercise physiologist Kevin Kirk at Functional Fitness in Chapel Hill. Once he entered middle age, Dean didn't exercise much;

for years he lived on pot roast and cigarettes and the occasional scotch. So he wasn't happy about the workouts. Sometimes he'll do a few leg presses and stretch the exercise bands. Other times Kirk just helps him flex his arms and legs.

One day they were working with a rubber ball about the size of a volleyball. Kirk stood a few feet from Dean and they bounced it back and forth a while. Then Kirk noticed Dean was glaring at him, and pointing to a spot a few feet away.

Kirk moved over there. Dean bounced him the ball. Dean pointed him to another spot, and another.

It took a minute for Kirk to catch on. Then it hit him: *We're running a drill. I'm running a drill with Dean Smith. I'm on his team.*

There is no way to tell when the curtain will part. There is no way to know what you will remember. You can only hope for moments worth remembering.

Kirk hustled around the floor, at Dean Smith's direction, and the old coach passed him the ball.

Last year, after a fan nominated Dean for the Presidential Medal of Freedom—the nation's highest civilian honor—UNC officials lobbied Washington to make sure he got it. The president can award the medal to people who, among other things, "have made especially meritorious contributions . . . to cultural or other significant public or private endeavors." Dean had a case beyond the wins and the titles. Ninety-six percent of his lettermen graduated. Dean was active in politics—he fought for a nuclear freeze and against the death penalty. And he nudged his part of the world forward when it came to race.

In the late '50s, Dean and Bob Seymour—his pastor at Binkley Baptist Church—took a black theology student to Chapel Hill's finest restaurant, a segregated place called The Pines. Dean was just an assistant coach then, but the managers knew him—the Tar Heels ate team meals there. None of the staff said a word. The three men sat down and ate dinner.

Dean also recruited Charles Scott. Among UNC players, Jordan is the best and Phil Ford is the most beloved, but Scott is the most important. He came to campus in 1966 as UNC's first black scholarship athlete. He became the ACC's first black star. The maddest anybody remembers seeing Dean was a night at South Carolina

when a fan called Scott a "black baboon." Dean headed into the stands before a coach pulled him back. All the way through college, and all the way through Scott's 10-year pro basketball career, fans and writers called him Charlie. He always preferred Charles. Dean called him Charles.

"He is basically the cornerstone of how I measure myself," Scott says. "To give you a story about what he has done is to give you the outline of my life."

These days Scott lives in Columbus, Ohio, where his son Shannon is a junior guard for Ohio State. His son's full name is Shannon Dean Scott.

The Medal of Freedom ceremony was at the White House in November. The 16 honorees ranged from two Nobel Prize winners to Loretta Lynn and Oprah. President Barack Obama noted that Dean couldn't come "due to an illness that he's facing with extraordinary courage." (He also brought up the old line that Dean was the only man in history who held Michael Jordan under 20 points a game.) Linnea took Dean's place, sitting next to Gloria Steinem on the stage, and accepted the medal and a hug from the president. She and Dean had been to the White House before, back in '98, when the Clintons held a state dinner for President Kim Dae-jung of South Korea. Kim's son was a Tar Heels fan.

They make sure the house is full of music. The satellite radio is tuned to the big-band and jazz stations. Linnea has a stash of videos of old variety shows with Sinatra and Dean Martin. One time a couple of the kids came by with an iPod and stuck the earbuds in his ears. He grinned and belted "Satin Doll" while they wheeled him around outside. Linnea brought in a concert harpist. A music therapist got Dean singing the old Wilbert Harrison number "Kansas City." Dean spent part of his childhood in Topeka, so they changed the lyrics: *I'm goin' to Topeka, Kansas / Topeka, Kansas here I come.* He rarely sings now. But music still seems to be the best connection. So they keep trying to connect.

It's a simple routine most weeks: office, church, exercise, home. Dean and Linnea live on a quiet wooded lot just outside town. Nothing says a basketball coach lives here. Dean didn't keep much memorabilia, and he gave most of it to the university after he retired. The paintings in the living room are landscapes. The books

are theology and philosophy. The back deck looks down a slope to a creek. Dean used to grill steaks out on the deck for the parents of recruits. Linnea marveled at how he got them just the right doneness and always remembered who wanted what.

Two dogs have the run of the house—a wary Goldendoodle named Lila and a sweet Chinese Crested named Eddie. Dean tolerates them. He was never much for froufrou dogs. He loved his two big dogs, a golden retriever named Mayzie and a black mixed named Kona. He'd walk them all over the property. Now they're buried out back.

He played golf for years with three of his closest friends: Chris Fordham, who joined the medical school faculty the same year Dean arrived and who later became chancellor; Simon Terrell, who ran high school sports in North Carolina; and Earl Somers, a Chapel Hill psychiatrist. They played from Hilton Head to Pebble Beach, and once went to Scotland to play Muirfield. The other three are gone now; Fordham, the last, died in 2008. By then, Dean wasn't playing golf anymore.

Linnea wishes she could know for sure if the trips to the office and the Sundays in church are doing any good. She wishes she and Dean had been able to talk it through. There was no way to prepare. Nobody knew until it had already happened.

"If you have cancer," she says, "you can process it and come to resolution in areas that you need to, or make sense or meaning of your life, and meaning of what's going on, and express your wishes."

She looks out the window.

"And we didn't have that."

The phone rings every few minutes. Linnea lets it ring. There hasn't been much new to say lately. There's no cure for dementia. But people keep calling, checking, hoping. "I'm sure they think," Linnea says, "*Is this going to be the last time? Is this my good-bye?*"

She wonders the same thing, of course. People can live with dementia for decades. They also can die from complications out of the blue. In between, most of the time, there is a vast and disconnected space. But the ones who care about Dean work for those few brief moments of connection, a smile or a song or a bouncing ball.

The dogs start barking. The door opens. And there he is.

The caregiver wheels him in. Dean is back from his trip to the office. He is wearing a white UNC ball cap and a Carolina blue windbreaker. His chin rests on his chest, and his eyes are closed.

Linnea will turn on some music later, to see if it connects. But for now the house is quiet. The caregiver wheels him around the corner, out of sight.

DON VAN NATTA JR.

Jerry Football

FROM ESPN THE MAGAZINE

"I had a fan come up, pretty adamant, put his finger in my face, and say, 'You know what a rut is?'

"I said, 'No.'

"And he said, 'It's a casket with both ends out, laying in an open grave. You'd just as soon be dead as that rut you're in. You'd better change that, Jones.'"

—Jerry Jones on August 9

ON AT&T STADIUM'S revolving stage ablaze in blue light, country music legend George Strait is crooning the encore of his final concert. A capacity crowd of 104,793—the largest audience at an indoor concert in North American history—sways and swoons and sings the anthem Strait made famous: *All my exes live in Texas, And Texas is the place I'd dearly love to be . . .*

Up in the darkened owner's suite, Dallas Cowboys owner Jerry Jones is dancing with Kate Bosworth, a 31-year-old blond actress and model. Their hands clasped, they shuffle their feet along the suite's top step, giggling when they momentarily go cheek-to-cheek. What Jones may lack in rhythm, he more than makes up for in enthusiasm. Clad in a black cocktail dress, Bosworth sashays with her back to the action. With a lopsided grin, Jones, in a black suit and salmon-colored shirt, peeks over her right shoulder at the oval stage. Standing a few feet away are Tony Romo and Jason Witten, Cowboys veterans who steal sideways glances at this unlikely duo's jagged two-step. As Strait sings the final stanza, Jones guides Bosworth through a mini-twirl that careens into a hit-and-run half-hug. It all looks innocent—or as innocent as 71-year-old Jones looks doing anything.

"Soooooooo awesome—thank you, Mr. Jones," Bosworth says before scampering down the suite's steps to rejoin her husband. Winking, Jones retrieves a tall plastic cup—emblazoned with the Cowboys' iconic star, filled with his usual drink this summer, Johnnie Walker Blue Label (always on ice)—and savors a swig of the smoky-smooth whiskey.

Jones's last dance is the perfect capstone to a glittery, boozy celebration of the $1.25 billion pleasure palace that he built for his mediocre football team. Inside the owner's spacious suite, Jones's star-studded concert party offers all the trappings of a corporate retreat—calligraphy name cards, a barbecue buffet, and an open bar—but it soon degenerates into something resembling a barnyard square dance.

"We knocked down a fifth in about 30 minutes already," Jones tells onetime billionaire Tom Hicks. "So we are ready to dance tonight."

"Good," says Hicks, the former owner of the Texas Rangers and Dallas Stars. "I've never seen this many people spendin' so much money."

Jones winks. "This broke the Super Bowl record for money spent . . . this concert—biggest gate in the history of this stadium," he says.

It's June 7, the final concert of George Strait's last tour, dubbed "The Cowboy Rides Away." Always keeping score, Jones confides the concert's highlights to a few select guests: *Didja know 77,000 tickets sold in just 15 minutes? . . . These tickets got up to where they were sellin' for $10,000—the parking close to the stadium was $1,000 a space . . . This gate is $13 million—after I get mine, I'm laughin' . . .*

Standing 6 feet, ½-inch tall, Jones is, like his stadium, modernized by creative vision and formidable resources—his face lifted, his scalp fortified, and his teeth capped to gleam. His blue eyes are still icicle-clear, full of mirth and the hint of trouble. It's been nearly a half-century since he played college football, but he still moves with an athlete's gait, as effortlessly as a man 20 years younger. Stepping forward heels-first, he appears to glide, even lope, despite a slouch that's most perceptible when he's immobile and feeling agitated, which happens most often when his team is playing.

Exactly three months from now, the Cowboys will open the regular season here against the San Francisco 49ers, the start, most

likely, of another season stuck in that rut. But for the Cowboys' owner, president, and general manager, tonight is a guaranteed winner.

"This is fun, isn't it?" Jones asks Romo, the Cowboys' hard-luck starting quarterback. "They will not kick a last-second field goal and kick our asses tonight. Everybody goes home happy."

On the living room wall of his estimated $20 million mansion in Dallas's posh Highland Park suburb is an original Norman Rockwell painting, *Coin Toss*. With a football cradled in his left arm, his right thumb raised, and his eyes aimed heavenward, Rockwell's pear-shaped referee, flanked by skinny football players, flips a coin that hangs in midair. The image was the cover of the *Saturday Evening Post* dated October 21, 1950.

"I bought this painting in 1989 right after buying the Cowboys," Jones says, admiring it late one night in June. "I had no money left—I mean, nothing . . . But Ross Perot collects Rockwells—he told me this one was too good to pass up . . . so I somehow scraped together $1.1 million." Recently, Jones says, auction house Christie's appraised *Coin Toss* at $18.5 million.

"Nothing I've ever owned has appreciated that much," Jones says.

On February 25, 1989, Jones, then a little-known oil and gas wildcatter from Little Rock, Arkansas, bought the Cowboys for $151 million, the highest price paid at the time for an American sports franchise. Still the NFL's most valuable franchise with annual revenues of $615 million, the Cowboys are now valued by *Forbes* at $3.2 billion. Jones is estimated to be worth at least that much, although likely much more. When told that the Cowboys' value has appreciated at a faster clip than his beloved Rockwell, Jones mulls the idea for a moment, then beams: "You know, that's probably true—I hadn't thought of that."

No team owner in American sports is more famous and infamous, more revered and reviled, than Jones. After the 2010 death of New York Yankees boss George Steinbrenner, Jones assumed the mantle of America's mercurial team owner, hell-bent on doing it his way and constrained only by a salary cap.

Although Jones has made nearly all the right moves as the Cowboys' owner, he has made just as many wrong moves as its general

manager, the job he gave himself when he bought the team. Since the start of the 1997 season, the Cowboys have established themselves as the NFL's masters of mediocrity, with a record of 136-136 and only one playoff victory. Each of the past three seasons, Dallas has finished 8-8, missing the playoffs by losing its final game ignominiously to a different division rival. Each subpar season further separates Jones's first flush of glory—three Super Bowl titles in just four years, the last Lombardi Trophy raised in January 1996—from front-office dysfunction and fans' impatience stretching nearly two decades now: the litany of blown draft picks and trades, hapless head coaches, overpaid and underachieving free agents, and squandered on-the-field chances.

It's become a preseason rite that this question is posed in Dallas: why hasn't owner Jerry Jones fired general manager Jerry Jones? Every summer, Jones gamely parries the question, always acknowledging the team's past futility but never leaving any doubt that nothing will change.

"We would have thought that, with Romo as our quarterback, with a coach, a young coach, like Jason Garrett, that we should have been in better shape to compete," Jones says at Valley Ranch. "So I'd be highly critical.

"On the other hand, I would have to look at what the GM has been—what he's been in the past and, I would like to think, capable of what he can do in the future."

When speaking of his role as GM, Jones often refers to himself in the third person, as if doing so might keep his shoddy performance at a safe distance.

Asked to grade his performance as GM, he says, "I'd give a C. If we had won a half a game more a year, we would be in the top five winningest teams in the NFL . . . We've been in a rut. Now, that stops with me. But the best person to get us out of the rut is me."

"More than anything," columnist Randy Galloway wrote in the *Dallas Morning News* a generation ago, Jones "wants to be known as a 'football guy.'" Of all the barbs Jones has endured, this one still cuts the deepest: His millions purchased a seat at the football guys' table, an accusation akin to saying a country bumpkin used new money to buy his way into the country club on a hill.

"He's the luckiest guy I've ever seen—in business and in life," says Larry Lacewell, one of Jones's closest friends and the Cow-

boys' head of scouting from 1992 until 2004. "His football team has been the unluckiest thing I've ever seen. How can you be that unlucky that long?"

Says Jason Witten, the Cowboys' All-Pro tight end drafted by Jones in the third round in 2003: "People can misunderstand the passion for something else—an ego—and that couldn't be further from the truth. I believe when he wakes up every morning, the first thing that comes into his mind is, 'I'm gonna make this football team better.'"

Year after year, however, Jones hasn't.

"Jerry Jones has become one of the biggest jokes in north Texas," says Dale Hansen, a venomous, 34-year veteran sportscaster on WFAA in Dallas and the critic Jones most despises. "He has one of the most important jobs in all of American sports, maybe in the world: he is the general manager of the Dallas Cowboys. And based on his record, there is not a single team in the NFL, Major League Baseball, NBA, or the NHL that would hire him to be their general manager. Hell, he couldn't get a job in Major League Soccer as the general manager . . . It's almost tragic that he has allowed it to happen—not only to the Dallas Cowboys but to himself."

Beyond the team, Jones is one of the NFL's all-time leading visionaries, always devising ways for the league and his fellow owners to "grow the pie." Commissioner Roger Goodell and many owners often call Jones, on his AT&T flip phone, seeking his counsel. Like Goodell, Jones wants an 18-game regular season, noting it would add $1 billion to the NFL's annual revenues. Like his protégé Dan Snyder, the Washington owner, Jones believes that the Redskins name should not change, calling it "a term of respect." Jones says the owners will stand behind Snyder.

Back in 1961, riding a team bus as a player on the University of Arkansas football team, Jones was thumbing through *Life* magazine when he stumbled on a profile of Art Modell, the new, fresh-faced Cleveland Browns owner. "I looked at it," Jones says, "and I said, 'Ya know . . . this is kind of what I'd like to think about doin'.' And what a great way to spend your days, spend your life." He wanted not only to own a team but also to call the football shots, do everything but the X's and O's.

But that wouldn't be enough. After a quarter-century as Cow-

boys owner, general manager, and the architect of the stadium that has become a spit-shined monument to every Texas-sized aspiration, something big is still missing for Jones, as elusive now as it was then: to be widely regarded as a smart football man. Winning a Super Bowl trophy now, on his terms and without the help of Jimmy Johnson, his college teammate, the first man he hired to coach the Cowboys and his longtime nemesis, is all that's left. To show them: *this was—and still is—a smart football man.*

"I've never wanted anything as much as I want to win the next Super Bowl," Jones says, smiling. "You wouldn't want to see the size of the check that I would write if it would for sure get the Dallas Cowboys a Super Bowl."

The one thing he wants most is the only thing he can't buy.

Happy hour, the bar inside Atlanta's Ritz-Carlton, on a Tuesday afternoon in late May: Jones sits hunched at a table just outside the men's room. Sporting a sky-blue sport jacket, a Cowboys star pinned to his lapel, and a loosened, midnight-blue tie, he's nursing a tumbler of whiskey, which on closer inspection looks like a bowl of whiskey.

I came to this hotel for the NFL spring league meeting to try to meet Jones and persuade him to cooperate with a man-in-full profile for this magazine. For several weeks, Rich Dalrymple, the Cowboys' longtime PR man, had not returned my calls to gauge Jones's interest. When Dalrymple finally called back, he sighed heavily at my request and promised nothing. "Believe it or not," he told me, "Jerry doesn't really like doing these things."

So I crash the owners' meetings with the hope of cutting out the middleman and pop my invitation directly. Throughout the afternoon, I hang around the hotel but catch only glimpses of Arthur Blank, John Mara, and Zygi Wilf in the lobby and Roger Goodell slipping into the men's room. After the meeting ends, I watch Jones's older son, Stephen, and his daughter, Charlotte—both senior Cowboys executives—march to their airport-bound Town Car. Still no Jerry Jones. Before leaving, I duck into the brightly lit bar. Imagine my surprise and relief when I see Jerry Jones sitting at a square table for four. Sipping his whiskey. Alone.

After I introduce myself, he smiles and launches into a rollicking soliloquy about the NFL's long-ago first TV contract negotia-

tions with ESPN. Then he asks whether I'd like to join him for a drink. Are you kidding? And for the next three and a half hours (he repeatedly postpones a dinner engagement), he's charming, self-deprecating, hilarious, and curious, every drawled word slow-roasted in that Arkansas molasses. This is Maximum Jerry.

Instantly, I'm reminded of another unstoppable life force, Bill Clinton. Jerry and Bill: two Arkansas good ol' boys who've made good and know just how to work ya.

Not only did he agree to cooperate with this profile—"This is gonna be some fun," he tells me—he goes all-in. I spend much of the summer with Jones, from hitching a ride on his Gulfstream V jet from Dallas to Fayetteville, Arkansas, to watching a team practice from his tower above the Cowboys' training camp fields in Oxnard, California. The Jones treatment isn't just excessive fun, it is *exhausting:* nearly every question I posed, he answers—a gusher of words and no filter—with only one main exception. He declines to discuss the cell-phone photos of him with two young women taken in a Dallas restaurant bathroom in 2009 that were published on several blogs in early August before they made national news. In Oxnard, he tells me he had been advised not to talk about the photos or the alleged extortion plot linked to them. Then the very next day, he tells reporters the photos "misrepresented" what had happened but declined to say more. A week later, at Dallas's first preseason home game, he again refuses to discuss the matter with me.

His no-comment is noteworthy because the photos reminded the public that Jones has long had a reputation for womanizing. Jones was dubbed "Honky Tonk Man" in a chapter title in Jim Dent's 1995 biography about this aspect of Jones's life. "It'll take an act of God to stop it," Lacewell told me. ". . . Jerry loves to party and dance. He has been known to pick up the tab for the whole bar. Needless to say, good women won't leave him alone."

Another reason Jones's no-comment is noteworthy is that more than any other owner in the NFL or any other sport, Jones loves being quoted and adores the spotlight. A brilliant entrepreneur, genius brand builder, marketing wizard, and Tasmanian devil of a pitchman who has sold shoes, insurance policies, and oil and gas, Jones is a master promoter of his team, his stadium, the league, and himself. The cost of the attention—not to mention all the high-profile entertaining he hosts on not one but *two* Cowboys

party buses—is that Jones catches more arrows than any other executive in sports except perhaps Goodell.

A hard-charging, egomaniacal, but larger-than-life owner named Norman Oglesby, obviously based on Jerry Jones, is a character in the celebrated 2012 novel *Billy Lynn's Long Halftime Walk* by Ben Fountain. "A king of self-esteem," Oglesby is called, and Jones is certainly that. Oglesby oozes likability; so, too, does Jones. Both men share a sunny optimism in the face of subpar seasons. Oglesby's winning personality is betrayed by "a faint arthritic creak in every smile and gesture," while Jones punctuates every off-color quip and daggered remark with a just-kidding grin chased by a maybe-not wink.

By hour three of our Ritz-Carlton introduction—deep into my second round and his third—it is obvious that Jones is more irresistible than his fictionalized self. A waitress delivers a cocktail napkin from a female admirer with a scribbled message: *J—I'm over at the bar. Hurry your ass! X C.* Jones reads it with a smirk, folds the napkin, and leaves it on the table next to his glass of whiskey. The note has no impact—he keeps rolling.

"I am still so damn mad," he snaps. "I get madder, every day, about missin' him."

Him is Johnny Football.

At the 2014 NFL draft two weeks earlier, Johnny Manziel, the freshman Heisman Trophy winner and Instagram antihero, had fallen to the first round's 16th slot owned by the Cowboys. Twitter nearly imploded: anything bigger than Johnny Football, the Texas A&M Aggie, becoming the future quarterback of the Dallas Cowboys?

Among the organization's football minds, only Jerry Jones wanted Manziel. Jones's son Stephen, the Cowboys' executive vice president in charge of player personnel, had lobbied hard against choosing Manziel—"I'm still so damn mad at Stephen," Jerry tells me—but Jones's younger son, Jerry Jr., told me, "I'm the head of sales and marketing—where do you think I came down?"

Everyone else had strongly advised against picking Manziel: Coach Jason Garrett, his staff, and the team's scouts. After all, Romo is entering the second year of a seven-year, $119.5 million contract with $55 million guaranteed. But Romo is also 34 years old and coming off his second back surgery in less than a year. The inevitable quarterback controversy—not to mention the three-

ring circus of Romo, Manziel, and Jones in Big D—would have distracted everyone and could have provided enough TNT—and TMZ—to blow up the team.

On draft night, fans and haters watched, enthralled, when Manziel had fallen in Jones's lap, their partnership looking preordained. On the clock in the Cowboys' draft room, Jones appeared anguished as he ground No. 2 pencils in his right fist. But Jerry Jones always gets what he wants, right?

No. Heeding everyone's advice, Jones selected offensive tackle Zack Martin of Notre Dame, picking a player to protect Romo over a player who would have made Romo hear footsteps. "I can't believe that Ringling Brothers and Barnum Bailey Circus didn't buy the biggest elephant of all time," Lacewell says later.

In his suite during the George Strait concert, Jones introduces me to Romo, who asks the subject of this story. Jones answers for me: "Passin' on Manziel for Romo." The surprise decision reveals something not widely understood about his boss, Romo says: he selected a sound fundamentals player needed to improve the offense, not the high-risk matinee idol of the draft. "More than anything," Romo explains, "it just shows a lot of people that we're here to win—not just be a flashy program."

Jones is beaming. He returns the sell: "And what is amazing," Jones says, "if there's anybody on this planet that could've handled Manziel competin' with him . . ." Jones drapes his left arm on Romo's right shoulder. "This guy could handle any damn thing—this is your fighter pilot. This is your fighter pilot. This is the guy you want goin' in, droppin' and winkin' at 'em, and comin' out, and drinkin' beer. This is him. So he could handle it. It wasn't a question of not handlin' it." The analogy, such as it is, puts a smile on Romo's face. He takes a long pull on his Miller Lite bottle.

But during our initial conversation at the Ritz-Carlton several weeks earlier, Jones spoke longingly about Manziel's potential benefits to the Cowboys long-term. "If we had picked Manziel, he'd guarantee our relevance for 10 years," Jones says.

America's Team needed Johnny Manziel to be . . . *relevant?*

"When we were on the clock, I said, if we pick the other guy— any other guy—it would be a ticket to parity, more 8-8 seasons," Jones says. "The only way to break out is to gamble—take a chance with that first pick, if you wanna dramatically improve your team.

That's why I wanted Manziel, but I was the only guy who wanted him. I listened to everybody . . . and I'm . . . not . . . happy . . ."

Jones likens himself to a riverboat gambler whose success depends on a well-honed "tolerance for ambiguity." It's a fancy way of saying that when a big bet goes south or the accumulated risks outweigh the potential rewards, he can still function at a high level.

"The riverboat gambler can be his most charmin', he can be his most clever, the smartest, and not know it's all gonna end on the next card and he's gonna be thrown overboard if it's the wrong card," Jones says. "And a part of havin' a tolerance for ambiguity is looking for the more positive and bein' able to handle the negative because you've got more goin' on."

On the Radio City Music Hall stage, as Martin donned a Cowboys baseball cap and hugged Goodell, Jones seethed back in the draft room. "There's only one thing I wanna say—I'd have never bought the Cowboys had I made the kinda decision that I just made right now," Jones whispered to Stephen. "You need to drive across the water rather than lay up. And we laid up for this one . . . We just didn't get here makin' this kind of decision."

By choosing to listen to everyone's advice, Jones had not just gone against his gut but, worse, had let slip another chance to test his tolerance for ambiguity. And what fun is that?

Sometimes a riverboat gambler doesn't need to be smart. He just needs to be lucky.

Long after George Strait's last bow after his final song, Jones is behind his suite's long bar, splashing Johnnie Walker Blue (about $200 per bottle) into a few of his guests' plastic Cowboys cups. It's coming up on midnight. Tipsy and waving his arms, he begins gushing about the stadium's splendor: *Five years now, can ya believe it?* He points at the floor. "Go downstairs—you'll see the floors are clean . . . pristine." He lets that last word hang there a moment. "They'll pick up garbage—that's how much people love this place."

Then a man taps Jones on the shoulder, says Adrian Peterson wants to say hello, and hands over an iPhone. Jones says hi to the Minnesota Vikings' star running back and listens, nodding but not smiling. "Well, I understand, Adrian," he says into the phone. The slanted smile returns. "I'd like that too . . . Well, I love your story.

I love your daddy's story. I've always respected what you've been about. I've always been a fan of yours."

Listening to half the conversation, it is obvious Peterson is telling Jones he wants to play for the Cowboys. Peterson, 29, is in the fourth year of a seven-year, $100 million contract that will pay him $11.75 million this autumn to play for the Vikings.

"Well, we'll see what we can do, if we can make that happen," Jones is now saying. "Hmm-hmm. . . . I'd like that too. . . . Well, we're talking pig Latin here, but let's see if we can do that." Jones listens, nods, and says again, "We're talking pig Latin here, but let's see what we can do about that. Okay, Adrian, thanks."

Jones returns the phone to its owner, who turns out to be a Morgan Stanley money manager who is a friend of Peterson's. Jones's conversation with the league's marquee running back occurs about a month after Jones decided to pass on Johnny Football.

Adrian Peterson would make one helluva consolation prize.

Long before Jerral Wayne Jones Sr. gambled on drilled holes and draft picks, he worked as a salesman. At age nine, he began learning the art of the sale inside his father's grocery store in the Rose City area of North Little Rock, Arkansas. Jerry's mother, Arminta, dressed her son in a black suit and bow tie and positioned him inside the store's front door. "Can I help you find something, ma'am?" young Jerry would ask.

His father, J. W. "Pat" Jones, was a natural-born salesman who knew how to attract customers, learn their names, and keep them coming back. At local parades, young Jerry, dressed as a cowboy, rode a pony with a sign advertising Pat's Grocery Store. "He was very good at selling himself," Jones says of his father, who died in 1997 at age 76.

Every evening after football practice and every weekend, Jerry was required to restock the shelves, sweep the floors, make homemade ice cream, whatever his father had asked. Often working into the wee hours, Jerry collected a few nickels and life lessons.

Jones brought those lessons with him to Fayetteville. During his first full day on the University of Arkansas campus in August 1961, he met Eugenia "Gene" Chambers, a Miss Arkansas USA beauty queen from a wealthy northwest Arkansas family. Jones and his Razorbacks teammates attended a mixer with the young women of the freshman dorm. After dinner, they all went to the county

fair. For hours, Jerry played the midway's games, tossing footballs through tires and baseballs at milk bottles to try to win Gene a stuffed prize worthy of his affection.

"Well, he wasn't having that much luck winning," Gene recalls. "So suddenly he just disappears. And I'm askin' his friends . . . 'What happened to Jerry?' All of the sudden, we see him come marching down the aisle, and he's got this huge teddy bear." She laughs. "He had slipped off and bought this big teddy bear—'cause he couldn't win it!" (Jerry had told Gene, "I finally won one," but didn't fess up until a year later; by then, they were engaged. They married in January of their sophomore year and have been married for 51 years.)

Jones began as the Razorbacks' fullback but moved, before his junior year, to offensive guard and played on the 1964 Arkansas team that went undefeated. On the road, players were assigned roommates based on the team roster's alphabetical order. So Jones roomed with Jimmy Johnson, a fireplug kid from Thomas Jefferson High School in Port Arthur, Texas. Johnson and Jones played for Frank Broyles, one of America's most innovative collegiate head coaches and who, at 89, remains an Arkansas legend. "He wanted to play and win more than just about anybody," Broyles says. "So did Jimmy—well, they had that in common, at least." Not much else in common, really, except a hardheaded nature and a love of the spotlight. But those things never mattered in Fayetteville.

In college, Jones continued to sell—first shoes, from a catalog, then life and educational insurance policies, on commission, for his father's newly founded insurance company in Missouri. "He was interested in making money," says Barry Switzer, a Razorbacks star who was then an assistant coach, "while the rest of us were out at the Shamrock Club or the Tee Table, enjoying the weekend with the sorority girls."

On the team bus, Jones had read the *Life* magazine article about young Art Modell and dreamed about owning a pro football team. (As evidence of his ambition, Jones wrote a business school master's thesis titled "The Role of Oral Communication in Modern-Day Football.") This was an audacious goal—after all, Jones was making only $1,000 a month drawn against commissions—that greatly displeased his father. Become an NFL owner? Jerry had the same chance of buying a damn casino.

Without telling anyone, Jones scraped together airfare to fly to

Houston to attend American Football League owners' meetings. His hope was to meet and impress Lamar Hunt, Ralph Wilson, and Bud Adams, the top team owners of the upstart league then attempting to challenge the mighty National Football League. "I'd do nothing but hang around the lobby," Jones recalls. "And just sit there and wait for those guys to come out of meetings, just to get to go up and talk to 'em or say hello to 'em. And just maybe thinking something might drop on the floor, I guess."

When hotel magnate Barron Hilton announced in 1966 that he was selling the AFL's San Diego Chargers, Jones, then 23, tried to buy the team—with someone else's money. Hilton's asking price was $5.8 million. With far more chutzpah than cash, Jones managed to put together a group of wealthy investors (mostly bankers) who extended him a $1 million letter of credit to land a meeting with Hilton, who was stunned that a recent college graduate wanted to buy his team.

Jones had met with Kansas City Chiefs owner Lamar Hunt, who explained that, without substantial TV revenues, the league would continue to struggle in its bid to compete with the NFL. Still, Jones could have secured a 120-day option to purchase the Chargers, for $50,000.

So Jones told his father about his desire to roll the dice despite the grim financial prospects. "This is my lifelong dream," Jones told his father.

"You aren't old enough to have a lifelong dream," Pat Jones replied. He then explained to Jerry that the sale's massive debt would put him "behind the eight ball." Financial recovery would be nearly impossible.

"The truth is," Jones says now, "he talked me out of it."

Shortly after Jones withdrew his interest, the AFL announced it was merging with the NFL. Instantly, the Chargers' value nearly doubled to $12 million. It was a story Pat Jones would tell for the rest of his life: how he talked his son out of making $6 million.

Despite the missed payday and opportunity, Jones insists he never felt even a momentary pang of resentment or bitterness toward his father. "I knew how much he loved me," he says, his voice cracking with emotion. "And so he was giving me advice selfishly as a father. I guess we're all selfish as fathers. But he certainly was doing it for my best interests."

*

Soon enough, Jones traded the insurance racket for a far riskier game—oil and gas wildcatting, forming the Arkoma Production Company in 1981. Initially with borrowed money, Jones drilled holes across Arkansas, Texas, and Oklahoma. He often tells stories about nearly drowning in $50 million of red ink, using guile and moxie to juggle the banks' notes, as well as dealing with the indignity of watching a Dallas car-rental agent cut his credit card into pieces for failing to pay a bill.

The gushers came soon enough; in one stretch, Jones hit 17 in a row. Thanks to Arkoma's spiraling profits—and savvy investments in real estate and banking—Jones amassed a personal fortune of tens of millions of dollars. Wealth buys influence, and Jones flexed considerable muscle in Arkansas politics, although he did it quietly enough to remain largely invisible.

That changed in 1982 after Jones struck a highly lucrative and politically toxic deal with Arkla, the Arkansas state utility. Headed by Jones's old pal and hunting partner, Little Rock lawyer Sheffield Nelson, Arkla agreed to buy nearly all the natural gas produced by Jones's company, an arrangement that smelled to some like the mother of all sweetheart deals. By the mid-'80s, the public utility was buying from Jones at a locked-in rate that was as high as $2.74 despite a glut that had dropped the market price to 16 cents.

A lengthy investigation concluded the companies had done nothing illegal. Arkla ended up settling a massive lawsuit filed on behalf of ratepayers for a $13.7 million refund. (The lawyer who filed the lawsuit later marveled that Jones had struck "a very shrewd business deal.") During the 1990 Arkansas gubernatorial race, the Arkla deal became a rancorous campaign issue, and Bill Clinton used it to help defeat Nelson.

In 1988, Jones sold his interest in the Arkla deal for $140 million, a windfall that would soon come in handy. Both Jones and Nelson deny that Jones's Cowboys purchase was financed, indirectly, by Arkansas's gouged utility ratepayers. "We didn't get Jerry the money he needed for the Cowboys," Nelson now says. "He wasn't some poor peddler on a street corner before he came to us."

It has become football lore that Jerry Jones was inspired to buy the Cowboys after waking up with a five-alarm hangover during a fishing vacation in Cabo San Lucas, Mexico. After downing too

many margaritas with his then-23-year-old son, Stephen, the night before, Jones stayed behind at the hotel and, in a day-old newspaper, stumbled upon a brief story: "Bum Bright to Sell the Dallas Cowboys."

"Well, I wasn't up to par," Jones says. He called the office of Cowboys owner H. R. "Bum" Bright and said, "You don't know me from Adam. My name's Jerry Jones. But if I live, I'm gonna come straight back to Dallas and buy the Dallas Cowboys."

Jones returned home on the next plane and quickly became the team's top suitor. A fierce negotiator, Bright decided the final $300,000 separating him and Jones on a price would be decided by a coin flip. (Jones called tails and lost.) The morning after they shook hands on the $151 million price tag, Bright called Jones at home and told him a group had just offered to buy the Cowboys for $10 million more. Jones said no to flipping the team for a quick $10 million profit. "I don't think Jerry would have sold the Cowboys for $100 million more," Nelson says. Bright had come to despise Tom Landry, the legendary first Cowboys coach who had won two Super Bowls in 29 years and almost always had the team competitive. But in 1988, the Cowboys finished an embarrassing 3-13, and many despondent fans were convinced the game had passed by the 64-year-old Landry. Bright offered to fire Landry before selling the Cowboys to Jones. Jones insisted he do it himself because, he says, "I needed to man up."

Hours after firing Landry, Jones introduced himself to the Dallas media as the team's new majority owner. "This is Christmas to me," Jones, then 46, told reporters. "The Cowboys are America. They are more than a football team." He spoke far more about hiring his old friend Jimmy Johnson, the University of Miami coach with a 52-9 record and a national title — "the best football coach in America," Jones called him — than about the legacy of the just-canned Landry. "I intend to have a complete understanding of contracts, jocks, socks, and TV contracts," he said. Now Jones admits that his tin-eared exuberance and lack of proper respect paid to Landry and original Cowboys president and GM Tex Schramm, who stood during the news conference while Jones sat behind a microphone, were unbecoming. The performance helped him stumble with practically everyone in Texas, and first impressions are hard to break. "Jones was completely lost," Galloway, the *Dallas*

Morning News columnist, wrote then. "Every time he opened his mouth, he got deeper into trouble."

Aghast at the criticism, Pat Jones (who, this time, had not attempted to talk Jerry out of buying a pro football team) called his son. "Jerry, I had no idea," he said. "I don't care if it works or not, you gotta make it look like it does. You use mirrors, smoke screen, or something, because if you don't, you'll be known as a loser the rest of your life."

On a shelf behind a couch in Jones's long office at Valley Ranch, the Cowboys' five Super Bowl trophies are arrayed in a straight line. In the center is the last trophy won by the Cowboys in Super Bowl XXX on January 28, 1996, in Tempe, Arizona, by a team built by Johnson/Jones but coached by Barry Switzer, Johnson's successor. This is the Lombardi Trophy Jones tells me he cherishes the most, by far. "Because when we were handed it," Jones says, "Barry said, 'We did it our way, baby!'"

We. Jerry Jones is all about the We. In fact, he values that lone Super Bowl he won with Switzer "10 to 1 . . . 1,000 to 1" more than the two he won with Johnson, he says angrily aboard his plane. "Just simply because I guess I am still that damn frustrated with the way everything happened with Jimmy."

This is two-decades-old history now, but the question still burns hot and fresh in Jones: why can't the owner/GM and the head coach share equally in their team's success? The question is as important as ever to Jones because the answer helps determine his legacy as a smart football man.

Jones's first two Super Bowl trophies were won by teams coached by Johnson. But Jones didn't have much fun, obsessing over Johnson's "backbiting, undermining, and whispering" to the media about his lack of football smarts ("My girlfriend knows more about football," Johnson told them). In March 1994, two months after the Cowboys won their second straight Super Bowl trophy, Jones and Johnson parted ways, which stunned and angered fans.

In the end, there just wasn't enough glory for the two men to share.

In my time with Jones this summer, Jimmy Johnson was a constant topic of conversation. That's because back in March, on the 20th anniversary of his departure, Johnson chatted with Tim

Cowlishaw, the *Dallas Morning News* columnist, and stuck a jagged shiv into Jones's ego.

"What anniversary is this one?" Johnson asked, laughing. "They're always having some kind of anniversaries down there . . . I guess because they don't go to Super Bowls anymore."

Their falling-out was pure pettiness: Jones wanted a piece of the adulation, wanted Cowboys fans to know he had helped build those Super Bowl–winning teams. Wasn't he the day-to-day general manager, after all?

Johnson insisted that he made all of the personnel moves, a claim angrily disputed by Jones then and now.

After their second consecutive Super Bowl, Jones and Johnson appear on camera to be playing tug-of-war with the Lombardi Trophy. Jones had achieved a lifelong dream, but he had never been more miserable (he infamously told reporters, "Any one of 500 coaches could have won those Super Bowls"). Aboard their plane in June, Jones's wife, Gene, reminds him, "You had to let people say so many bad things the first two years you were there because they suddenly loved Tom Landry and you were Darth Vader. And then suddenly you win, and that's supposed to be the time of joy. And instead, they made that into a negative."

Despondent, Jones visited his mother and father in Hot Springs, Arkansas, in early 1994 to seek their counsel. Johnson was threatening to bolt for the new franchise in Jacksonville, and most Dallas columnists were in the coach's corner. "It's eatin' on me, it's botherin' me, it's changin' me," Jones told his folks. Pat Jones just said, "Come on, Jerry—be a man, live with it." His mother echoed that advice. And a longtime business partner, Mike McCoy, told Jones, "Are you getting what you want from Jimmy?" The answer, on the field, was yes. "Then live with it," Jones says McCoy told him. "Forget it. Use him."

But Jones couldn't do it. In a matter of weeks, Johnson was gone, sent home with a $2 million check. In the end, Jones said, he felt like a phony, and his father would eventually agree he needed to "clear up" the angst he was feeling. "When I would be with him and we'd be charming and all that stuff, I just—I just couldn't stand it," Jones now says. "And I was just thinking—it's false."

Gene Jones told me, "What makes it fun to own a team if you have that?"

This summer, as he rehashed those days of sudden triumph and lasting hurt, Jones teetered between rage and sorrow, sometimes blaming himself for their falling-out. "I should have exercised tolerance and patience," he told me at the Ritz-Carlton. "I did not."

Other times, Jones blamed Johnson's covert acts of disloyalty, skullduggery, and pettiness for their breakup. "There was just an undermining that went on," Jones says. "It's subtle. It's smart . . . I lost my tolerance of having an associate, a friend, not be loyal. I've been told, 'That's trite. You should be bigger than that.' I mean, really—am I so dumb that I don't know you don't fire a coach after y'all just won two straight Super Bowls?"

"When I went to the Cowboys, Jerry told me he'd handle the marketing and money and I'd handle the football and we'd make history," Johnson said in an email after declining to speak or meet with me. "That changed after the first Super Bowl. I appreciate the opportunity he gave me and I'm proud of what we were able to accomplish."

Johnson's statement irritated Jones, who on Tuesday said: "Jimmy came from college and dealt in scholarships. This is pro football. You don't separate the money from pro football when you are physically and mentally there and up to your ears in it every day. That's a difference of opinion I have with him. Since I have owned the team—from day one Jimmy was here—I made or approved of every football decision that required a dollar."

Johnson is not in the Cowboys' Ring of Honor, among the 20 team legends such as Landry, Roger Staubach, Troy Aikman, Emmitt Smith, and Michael Irvin, each name emblazoned in big, capital letters inside AT&T Stadium.

At the Ritz-Carlton, I first asked Jones why he had not honored Johnson; after all, he had coached the Cowboys to two Super Bowl titles in five years, while it took Landry 29 years to win the same number. Jones responded with a convoluted explanation about Johnson failing to meet the standards favoring players established long ago by Tex Schramm, whom Jones himself had put in the Ring of Honor in 2003. (Jones had honored Landry in 1993.) Weeks later, Jones struggled to answer the same question during our on-camera interview at Valley Ranch, insisting that his decision is not personal.

But it is.

Onboard his plane, with Gene sitting in a leather chair across

from us, Jones spits out the reason Johnson isn't in the Ring of Honor: "Disloyalty . . . I couldn't handle the disloyalty. Whether it was right or not, by every measurement you can go, I had paid so many times a higher price to get to be there than he had paid, it was unbelievable . . . By any way you wanna measure it, wear and tear, pain, worry, butt kickin', the criticism—everything in the book!"

Jones wants to win another Super Bowl for many reasons. But one of the biggest is it would prove to the world he can do it without Johnson.

"It certainly has been more of a negative for me than it was for him," Jones says of Johnson's firing, his voice rising. Gene's eyes narrow—she knows where this is headed—and she shakes her head to warn him. Too late. Johnson's firing "caused him to never have won but two Super Bowls!" Jones says, practically shouting. "I don't give a s—t what it is, but it caused one thing for him: he'll never win but two! I've won three—and I may get to win five more!"

It's hard to miss that the Cowboys' era of mediocrity coincided with Jones's decision to build a new stadium. A decade ago, Jones decided he'd replace antiquated Texas Stadium. A new stadium's projected price tag was $650 million, but as Jones shopped for its home—and kept adding to its design's bells and whistles—the price tag ballooned, eventually nearly doubling but also looking like a billionaire owner's overcompensation for continuing on-the-field disappointments. After the city of Dallas didn't offer enough tax incentives (as a consolation prize, Jones says then-Dallas mayor Laura Miller offered to name a bridge after him), Jones decided to build his stadium in Arlington in a neighborhood of pawn shops, chicken joints, auto repair garages, and the Texas Rangers' ballpark. He needed—and eventually won—approval from taxpayers to kick in $325 million. At the same time, Jones hired Bill Parcells, a Hall of Fame coach who won two Super Bowls coaching the Giants. The timing of Parcells's arrival was hardly coincidental, critics say: Jones needed Parcells to regain credibility with fans to help win approval of Arlington's stadium tax referendum.

Jones had promised Parcells nearly complete control. They began with mutual trust. At Parcells's first training camp in 2003, he called the shots—or so it looked to the beat reporters surprised

that Jones had, finally, ceded control to his coach. Parcells established a defense employing big, physical players. And by getting his way most of the time in the draft room, Parcells quickly began rebuilding the Cowboys.

But Parcells and Jones would soon clash. Jones moved the training camp from Oxnard, California, where it's cool in summer, to San Antonio, where it feels like a blast furnace. Parcells was furious; Jones explained that Ford, the team's top training camp sponsor, was far bigger in Texas than California and that another sponsor, Dr Pepper, was more popular with San Antonio's Hispanic community. "Let me get this straight," Parcells told Jones. "We got a multibillion-dollar corporation, and we're worried about selling f—ing soda?"

Far more harmful to their relationship was Jones's decision to sign free-agent wide receiver Terrell Owens. After the 2006 season—and the disastrous Romo bobble of a snap on a 19-yard field goal try that would all but clinch a victory over the Seahawks in a wild-card playoff game—Parcells quit. With a Cowboys coaching record of 34-32, he left Dallas (and soon ended up in Miami) with a nice payday and, apparently, no bad blood between him and Jones.

"I found Jerry to be a very, very straight-talking, forthright person, whose word was good," Parcells says. "We got along very well."

Parcells's successor, Wade Phillips, coached teams built primarily by Parcells and won 33 games in three seasons. After going 13-3 in 2007, the Cowboys lost to the eventual Super Bowl champion New York Giants in a divisional playoff game. Jones's best shot to erase the Johnson stigma was lost. Friends of Phillips told me he felt undermined and second-guessed, repeatedly, by Jones, who denies this. When I reached Phillips by phone, he agreed to meet with me in Dallas, but a few hours later, he called back to cancel, saying he didn't want to say anything bad about Jones. "He's been good to me," Phillips says. (Jones had lent his private jet to Phillips's wife to attend her father's funeral.) *He's been good to me:* I heard this refrain from other former players and dismissed coaches who declined to discuss Jones on the record.

Jones's Cowboys and stadium businesses are truly family-run: Stephen, 50, is Jones's right-hand man on player-personnel matters (and sits to the right of his father during games); Charlotte Jones Anderson, 48, the executive vice president and chief brand

officer, leads the Cowboys' charity efforts; Jerry Jr., 44, is in charge of sales and marketing and is executive vice president. Jerry brags that Gene has attended every home and away Cowboys game since he bought the team, including preseason. "A 100 percent attendance record," he says. They are a close-knit family and fiercely protective of one another. Even so, while Jerry Sr. consults with his children on a moment's notice, I didn't see them palling around much in Jones's suite, at Valley Ranch or at training camp. All business. Jones is in good health; he beat back skin cancer and was diagnosed with an irregular heartbeat at the age of 46, shortly after buying the Cowboys. "A good-time heart," Jones calls it.

Fans can recite Jones's personnel misses and flops: passing on Randy Moss in the 1998 draft (Jones apologized for this a dozen years later); trading four draft picks for 28-year-old wide receiver Joey Galloway, who never caught a pass from Aikman, in 2000; drafting QB Quincy Carter in the second round despite coaches' and scouts' warnings about his problems; choosing RB Felix Jones over Chiefs star Jamaal Charles and Coach Phillips's choice, Titans star Chris Johnson. When I ask Jones for a decision he wants back as GM, he doesn't hesitate. "I think when we traded two number ones for Roy Williams," he says of the 2008 trade for the Lions receiver who was released in 2011.

Except, well, Jones gets it wrong. The Cowboys didn't actually trade two first-round picks for Roy Williams. They gave up a first-, third-, and sixth-round pick in 2009 and got a seventh-rounder in 2010. It seems a bit unfair to correct Jones like this—the man has been GM for 25 years and shouldn't be expected to know the particulars of every transaction carried out under his name. Or perhaps the three picks the Cowboys gave up just *felt* like two first-rounders. But at the same time, this is his biggest regret as GM— and he can't get the details right.

The rut Jones is in is littered with bad choices and busted gambles, and he knows it. He also knows there are fewer chances to reverse that view.

In early June, Jones flew on his G-V to Paradise Valley Country Club, in Fayetteville, Arkansas, to salute Frank Broyles, his college coach, and donate $100,000 to a foundation created by Broyles's daughters devoted to educating caregivers of those who have Alzheimer's.

Standing next to Broyles in the jammed clubhouse on a muggy afternoon, Jones talked about his old coach's life lessons. A half-century ago, Broyles always raised four fingers on the football field, a reminder for his players to try to preserve their energy for the game's most critical time—the fourth quarter.

Jones said, "I never dreamed that when he was talkin' the fourth quarter to us the night before a ballgame in Eureka Springs . . . we'd be standin' here right now, 2014, and him coachin' us in how to be in life in the fourth quarter, how to handle the stuff that comes to us in life in the fourth quarter. And boy, have you coached us up, Coach."

"Thank you," Broyles said.

"You showed us how to do it," Jones told him, his eyes moist. "You showed us what stickin' and stayin' and lovin's all about—keeping that enthusiasm and that stature and pushin' right through. Now that's the fourth quarter. Yep."

Back in Dallas, it's time for supper: Jones's personal security chief, Roosevelt Riley, is behind the wheel of Jones's black Lexus LS 460 and pulls up to my Dallas hotel. The boss is riding shotgun. I slide into the backseat and we head to Al Biernat's, one of the city's favorite steakhouses. When Jones and I walk into the bar, every head turns our way and you can feel the electrons in the room become supercharged, in that way they do anytime a famous person enters a public space. We settle into a low-slung booth for four, opposite the bar and adjacent to a hallway leading to the bathrooms.

Jones orders Johnnie Walker Blue for both of us. Years ago, Jones gave up alcohol for about a year to lose weight, but he became so ornery that his mother told Lacewell to persuade her son to start drinking again. "He's no fun," Jones's mother said. More than once, Jones asked me, "You still working?" as a way to invite me to join him for a Blue. (Dale Hansen, the WFAA sportscaster, recalls a famous story: He and Jones were drinking heavily in Austin one night and stumbled into a dance club at 2:30 a.m. when the bartender told them that last call had long passed. "Either you start servin' drinks," Jones said, "or I buy the bar and you're the first son of a bitch I get rid of." Ten minutes later, Jones tells Hansen, "Go to the bathroom." Inside, Hansen discovered a bartender sitting behind a hastily assembled but fully stocked bar; Jones,

Hansen, and another 10 pals enjoyed mixed drinks until 5:00 a.m. Hansen was shipwrecked with a hangover until late the following afternoon. "Jones was on *Good Morning America* at 7:00 a.m.," Hansen says in awe.)

We discuss his family's commitment to turning AT&T Stadium into a mecca for sports and entertainment, a venue for everything from this past April's Final Four and the January 2015 College Football Playoff championship game to dirt-bike races and high school proms. The stadium gave Jones another way to apply his sixth sense of monetizing every imaginable aspect of something he owns. He has forged 200 corporate sponsorships and alliances for the Cowboys and AT&T Stadium; nearly every one of AT&T Stadium's 347 luxury suites is locked into a lucrative, 20-year lease, and the seat licenses are worth $1 billion. There's practically no debt. The place has become a humming cash factory.

When I ask Jones how he settled on AT&T for the stadium naming rights, he says he fell in love with the name: "It just sounds like America—and the future." He then confides he considered investing $300 million in Chanel or Cartier, becoming partners with one of the companies and slapping its name on his stadium. Jones loved the idea that his team might have been married to one of those luxury brands. "Can you imagine—the Chanel Cowboys?" he asks. "Or the Cartier Cowboys? Now that has a nice ring, a lovely ring. Pure class."

This idea never went very far, and besides, the AT&T deal was sealed in July 2013 by the telecommunications giant's mind-boggling offer, an estimated $500 million over 25 years. "I was a whore!" Jones growls, with that just-kidding smile chased by that maybe-not wink.

His real estate company, Blue Star Land, owns vast property holdings totaling more than 2,000 acres worth more than $2 billion, with much of it located north of Dallas. In Frisco, Texas, the Cowboys will move to a new, modernized training facility in 2016. In the early '90s, Jones began buying the parcels, anticipating the growth that has marched north of Dallas–Fort Worth.

Two hours into our dinner, our menus remain untouched. When we talk about the Cowboys' chances this fall, Jones expresses guarded optimism—he has bought into Romo's enthusiasm for the offense, aided by a revamped, though young, offensive line.

But he acknowledges that the defense, the third-worst in NFL history last year based on total yards allowed, must radically improve for the Cowboys to have any hope of making a playoff run. Of this prospect, he sounds less certain. Coach Garrett is in the final year of his contract, and Jones says Garrett's future likely will depend on what happens on the field this season. Of course Jones's future, as GM, never depends on what happens on the field in any season. After all, what person, in any profession, could manage to keep a job if he hadn't succeeded in nearly 20 years?

"Trying to do too much," Lacewell told me. "It's his biggest fault, I'd say." So I raise this prickly issue again, asking Jones whether his attempts to rebuild the Cowboys were hampered by his business obligations and corporate commitments, particularly the decade-long campaign to get the stadium designed, approved, financed, built, and, now, earning.

Jones acknowledges the difficulty of trying to juggle so many responsibilities, confessing, "It's my devil." However, he estimates he spends 80 percent of his time working as a GM and the rest managing the team's business affairs and his personal investments.

Win or lose, America's Team is still, to use Jones's word, relevant. And likely always will be. Jones takes great satisfaction in the Cowboys' entrenched popularity beyond the Dallas–Fort Worth metropolitan area, extending to places such as Mexico and Europe. The Cowboys are the only NFL team to market and distribute its own merchandise. The blue-starred jerseys, hats, and caps (and a wide selection of women's attire) bring in $250 million annually. After each season, Jones brags that the highest Nielsen-rated games featured the Cowboys, who will play at least five games in prime time this fall. For Jones, the sales and ratings appear to help mitigate the on-the-field mediocrity.

"And if we're not the most popular team," he says, "we're always the most hated team." Is being the most hated team the second-best thing to being the most popular team? "I think I'd trade second-most popular for . . . the most hated."

Three hours after sitting down, we finally order salads and T-bone steaks, although not the hubcap-sized $65 Cowboy cuts. As we tuck into our meals, a stunningly beautiful woman in her 40s stops by our table. "You don't remember me," she tells Jones, mentioning a decade-ago meeting, but this doesn't jog Jones's mem-

ory. A few more hints, still nothing. She stomps off. Jones shrugs
and smiles. Then winks at me.

After dinner, Jones invites me to join him for a nightcap at his
house, a buttery-lit 14,044-square-foot "villa." Inside the vast foyer,
Jones asks a home security guard to bring us two glasses of Blue on
ice. On the gleaming marble floor of his living room are covered
works of art, new purchases waiting to be unwrapped. Jones ex-
plains that he and Gene have become avid collectors of Rockwell
and other artists. AT&T Stadium's dazzling collection of modern
art has been showered with critical praise; Gene selected most of
the pieces.

Jones and I carry our drinks into his two-story library. Here on
the walls is a stunning mix of six woods including cherry, walnut,
and Macassar ebony and shelves lined with candy-colored antique
books and framed photographs of Jerry and Gene cavorting with
their children, grandchildren, politicians, and celebrities. Above
us, the black ceiling glitters with the constellations of Jerry's and
Gene's zodiac signs, hand-painted in gold leaf. Jones marvels over
a 40-pound Tiffany crystal commemorating the Switzer-led Super
Bowl win. On an antique end table is a silver-framed photo of a
beaming Jones and a grinning Bill Clinton at the White House.
On the wall is a small dinner guest list, inked in cramped script by
Thomas Jefferson. One of the invited guests is Betsy Ross.

Jerry and Gene Jones have helped the Library of Congress re-
place the books lost in an 1851 fire that destroyed two-thirds of
Jefferson's library. What Jones doesn't say is that he and Gene rou-
tinely write checks, quietly, to people in need with one request:
don't tell anyone where you got the help. Publicly, they also do-
nate millions of dollars to an array of charities in Texas, Arkansas,
and beyond.

I follow Jones downstairs to his pub room, with two taps (Miller
Lite and Miller, the stadium's $15-million-a-year exclusive beer
sponsor) and a gargantuan projection flat-screen. "It's fun," he
says. Next is the billiards room, fortified with painted footballs
from the Cowboys' glory years and framed photos. You can't miss
Troy, Emmitt, and Michael doing their thing, but I don't see Jimmy
(apparently there's one). Over there is the wine cellar stocked
with 1,300 vintages. Down a long hallway I notice a framed photo
of Jerry, Gene, and Kevin Costner, all looking at least a decade

younger. "Look at her," Jones says, deadpan. "I've never seen Gene looking happier as she is right there looking at that other man."

We end up outside at the edge of the drive, gazing at the immaculately groomed gardens stretching far into the darkness. Jones points out the guest house, shielded by a stand of tall oak trees. His mother lived there until her death, in 2012, at age 90. For a few quiet moments, we stand side by side—me imagining what it must be like to have your mother living in a guest house in your backyard and Jones recalling, perhaps, the reality of that arrangement. As I begin to ask about his mother, Jones interrupts, saying, "Well, Don, I enjoyed this very much. But tomorrow is another day." Over my shoulder, I see Roosevelt Riley standing down the circular driveway, the engine of Jones's Lexus purring, as if my exit was arranged by some invisible force.

"Take your drink with you," Jones says and pats me on the shoulder.

"Thanks for everything, sir." I move down the circular driveway for the ride to my hotel. I stop, turn, and watch Jerry Jones walk back into his lit-up mansion. Tomorrow is another day, another season. His head down, his stride a beat slower but still purposeful, his right hand swaying his nearly drained tumbler. In that light, I'd swear, the glass of Blue is half full.

TIM GRAHAM

Broke and Broken

FROM THE BUFFALO NEWS

ORLANDO, FLA. — Those closest to Darryl Talley are terrified. His wife, daughters, and former teammates openly cry for him. They lament what has befallen him. They dread what his future might hold.

Talley's life is in tatters. Loved ones say his mind is deteriorating. He's begrudgingly starting to agree.

He's 54, but his body is a wreck and continues to crumble. He suspects collisions from playing linebacker for 14 NFL seasons, a dozen with the Buffalo Bills, have damaged his brain. He's often depressed beyond the point of tears.

He's bitter at the National Football League for discarding him and denying that he's too disabled to work anymore. He says the Bills have jilted him too.

He learned after he retired that he'd played with a broken neck.

He had a heart attack in his 40s.

He lost his business. The bank foreclosed on the Talleys' home of 17 years. Against her husband's pride, Janine Talley has accepted money from friends to pay the bills.

He contemplates killing himself.

"I've thought about it," Darryl Talley flatly said last month on the patio of the house he and Janine rent. "When you go through the s—t that I've gone through, you start to wonder: Is this really worth it? Is it worth being here, worth being tortured anymore?

"It would be just as easy to call it a day. But there are two reasons

why I won't. First of all, my parents didn't raise a coward. The most important is I want to be around for my grandkids."

Bruce Smith is among those most frightened for Talley.

Although they thrived alongside each other during the franchise's glory days and consider themselves brothers forever, Smith isn't willing to trust Talley's rationalizations.

"A moment of weakness, a moment of darkness, a moment of hopelessness," Smith said from his home in Virginia. "Those are pretty powerful things that can come into play that makes one forget about how we were raised or what state we would leave the rest of the family and friends in."

Talley, like Smith and the rest of their mates from the Super Bowl era, maintain a mythological presence with Bills fans. They're like superheroes leaping off the pages of a Marvel comic book. One of Talley's trademarks was the Spider-Man ski suit he wore under his uniform.

Buffalo's football legends, however, are not indestructible cartoon characters. They are mortals, as we've been reminded through Jim Kelly's cancer ordeal or 50-year-old Kent Hull's death from liver failure in 2011.

Talley is the first Bill from the Super Bowl years to disclose ominous mental, physical, and financial difficulties seemingly rooted in playing football.

"I never thought this would be our life, but this is the reality of it," Janine Talley said. She met Darryl at West Virginia University; they've been together 34 years. "I don't see it getting any better. This'll kill him one way or the other.

"His mental issues have accelerated a lot in the last year. I don't know what the future holds for either one of us. I don't know if in a few years dementia will set in. I don't know if I'll be able to care for him."

Gabrielle Talley, the younger of their two daughters, said through tears, "Hope is not in abundance right now."

Other teams have suffered tragedies linked to chronic traumatic encephalopathy (CTE), a degenerative brain disease caused by repeated head trauma.

San Diego Chargers linebacker Junior Seau, Chicago Bears safety Dave Duerson, Philadelphia Eagles safety Andre Waters, New Orleans Saints safety Gene Atkins, and Pittsburgh Steelers

guard Terry Long are among Talley contemporaries who committed suicide and were found afterward to have CTE.

"We're talking about real tragedies of life," Smith said. "Through Darryl, the Bills and their fans can actually identify a face with the problem now. It's an ugly problem.

"Hopefully this will never happen with Darryl, but we know what path Junior Seau went down. There are a number of other players that chose to take that route and not endure or get back on track."

The CTE Center, an independent academic research center at Boston University, explains on its website the disease "is associated with memory loss, confusion, impaired judgment, impulse-control problems, aggression, depression and eventually progressive dementia."

West Seneca native Justin Strzelczyk, a retired Steelers lineman, was in CTE's early stages. He was only 36 when he died in September 2004 at the end of a high-speed police chase on the Thruway. Strzelczyk's pickup truck collided with a tractor-trailer and exploded. He had been hearing voices.

Talley has not been diagnosed with CTE. That can be determined for sure only through an autopsy, although advancements give researchers hope it can be detected in the living. A pilot study last year at UCLA indicated Bills Hall of Fame guard Joe DeLamielleure's brain carried the abnormal protein characterized by CTE damage.

There are dark clues surrounding Talley.

"I'm not convinced that I'm dead yet," Darryl Talley said. "But the future doesn't look bright. People say these are supposed to be the twilight years of your life. When are they coming? The stars aren't twinkling.

"It's the damnedest thing to think . . . to think that . . . it's over? Not yet, but it's close. I'm not ready to call it quits yet or phone it in.

"But it's just an unbelievable fight to deal with the pain."

A Warrior Laid Bare

Talley's street is under construction. He and Janine live in an area of Orlando called Doctor Phillips, about 14 miles from Walt Dis-

ney World's Magic Kingdom. From the main road, barriers and heavy equipment prevent a quick turn toward their home.

Instead, you must take a detour down Bittersweet Lane.

All of this reads like a poetic metaphor, but it's the truth.

"You never had to worry about Darryl when we played," former Bills linebacker Cornelius Bennett said. "He just threw caution to the wind and did whatever he had to do to play on Sunday.

"I worry about him now."

Talley's family and friends know how serious his issues have been. They've advocated for him. They've encouraged him to come forward and admit he needs support.

A significant hurdle, though, is one of the undeniable traits that made Talley such a remarkable player, a two-time Pro Bowler despite an astounding list of injuries.

Pride has kept Talley from speaking up, from accepting his circumstances, from seeking relief.

Talley remained his typical, stubborn self until agreeing to sit down with the *Buffalo News* last month for an exclusive interview about his hardships.

When told her father was hosting a reporter, Gabrielle Talley thought, *There's no way Daddy's going to go for it.* The 21-year-old predicted he would back out. Alexandra Talley, 27, didn't want to discuss her father because she was too distressed over him.

Bennett broke down in tears and called it "a shock" when informed Darryl Talley finally wanted to talk.

"This . . . this . . . this . . . this just took me by . . ." Bennett said, his voice breaking. "For Darryl to talk about it and get help, to hear him say, 'I want to get help, and I want to talk about it,' that is the most . . . that is what it's about."

The Talleys are nervous how people will react to their situation. Darryl is particularly uneasy about revealing that his brain isn't working as well as it should, that his body won't let him be the man he wants to be, that his business failed.

Most of all, it has been difficult for him to concede the delicate spot his family is in.

"I've struggled with the idea of speaking out," Talley said in his favorite wicker chair, which allows him to sit for longer than a few minutes. His neck was rolled back and his legs fully extended, almost as if lying down.

"If you tell people you've been concussed so many times and forget what you've walked into a room for, they're going to go, 'Oh, there's a scarlet letter!'"

His hope is to salvage a more tolerable future and to shine a light on the truth many former players face long after they have served their purpose to the NFL.

Talley received the NFL's total-permanent disability B plan, which pays $50,000 a year. The league ruled he didn't file his paperwork in time to qualify for the A plan, which pays $120,000 a year. The Talleys contend he applied for his disability benefits in accordance with the collective-bargaining agreement that he played under.

"When you're done playing," Darryl Talley said, "you're like a piece of meat. They treat you like, 'None of what you say is our fault. None of these injuries happened from playing football.'

"They tell you whether or not you hurt. Ain't none of them son of a bitches took a hit . . . took a knife cut.

"None of us playing this game is normal. To compare an NFL player's pain threshold to the average person who's never done it? They're going to tell me I don't hurt?"

Without naming names, Talley claimed to know several retired players who tanked their disability exams or lied throughout the process to gain full benefits.

The doctor who evaluated Talley's disability case ruled he was capable of working at a job where sitting or standing was required. A significant problem, Talley insisted, is that his body can do one or the other for only a few minutes at a time. He wondered aloud if some company would hire him to be a staggering receptionist.

"I want to let everybody know what this has done to me," Talley said. "A lot of people don't have a voice. There are a lot of guys that didn't say anything before they died.

"Somebody's got to ring the bell."

Behind Closed Doors

A visitor to the Talleys' ranch home wouldn't detect anything amiss. Darryl and Janine reside in a prim gated community dotted

with gorgeous palm trees. The front lawn is thick. Their backyard is on a golf course.

Theo, their Shih Tzu–Maltese mix, rambunctiously trots around with a golf ball in his mouth, eager to play.

Janine Talley confessed they don't own this house, which is half the size of the one they were evicted from last year.

The Talleys are tenants now. They've had to move twice in the past 17 months. Their credit is so nuked from the foreclosure and the failed business that their landlord required them to pay three months' rent in advance. They didn't have the money.

Darryl Talley used to own superb credit. On just a signature, banks would lend him whatever money he needed for his business or personal needs.

To move into their home, three old friends—Smith, Bennett, and Thurman Thomas—gathered the rent deposit and gave it to Janine without Darryl's knowledge because they knew he would be too proud to accept it. When Darryl learned where the money came from, he cried.

The Talleys are convinced their lives would be different if the NFL institution took proper care of its own.

"It's the most disappointing thing ever to go out and play and to stand up for that shield and then to have them f—k you the way they do," Darryl Talley said. "I put team and league in front of everything, in front of my family.

"Where are the team and league to back me up now?"

Darryl Victor Talley's toughness is unquestioned.

He was a 146-pound linebacker with a 28-inch waist at Shaw High in East Cleveland. He played much larger, a sideline-to-sideline berserker.

His nickname was Big Chief from his Native American bloodlines and resemblance to the *One Flew over the Cuckoo's Nest* character. Both front teeth were knocked out when he ran into a telephone pole to catch a football in his neighborhood.

Scholarship offers were limited because he played only 10 varsity games. A broken ankle kept his senior season to three games.

Even so, West Virginia was amazed by Talley's tenacity.

He became WVU's first consensus All-American in nearly three decades. The College Football Hall of Fame inducted him in 2011.

The Bills drafted him 39th overall in 1983. He missed one game

in 12 years for the Bills (not counting the three-game NFL strike in 1987) and five his entire career, which included one-year stops with the Atlanta Falcons and Minnesota Vikings before he retired in 1997.

"The league is full of tough guys," former Bills special-teams coordinator Bruce DeHaven said. "But if I had to go down a dark alley and could pick one guy to go with me, it'd be Darryl Talley.

"I don't know if he's the best fighter, but I know two things: he'd have my back, and he'd stay there until they killed him."

Early in the 1990 offseason, Talley underwent surgeries on each elbow and one knee on the same day. He then had surgery to repair a torn meniscus two weeks before starting in the season opener.

He recalled resetting his own mangled right ring finger after it got entangled in Miami Dolphins guard Keith Sims's jersey and breaking his left middle finger so he could remove it from Los Angeles Raiders fullback Steve Smith's face mask.

Then there was the time Talley, while with the Vikings, walked six snowy blocks back to the hotel after knee surgery.

Talley emits his infectious, warbling laugh when he blithely explains how he handled myriad injuries and 14 surgeries.

But he and his wife were dumbfounded to learn during a 1998 postretirement NFL Line of Duty disability examination that years earlier he'd suffered a broken neck.

He can remember only two major neck injuries: versus Washington in 1987 and Pittsburgh in 1991. Each time, the Bills' medical staff cleared him for the next game.

On the drive home from his Line of Duty exam, the Talleys phoned the Bills to request medical records pertaining to his neck. The Talleys said the Bills told them those files no longer exist.

The Bills declined to respond to the Talleys' allegation about missing medical records.

"Our alumni play a very important role in the Bills organization, and each individual is unique in his own way," the Bills said in a statement to the *News* for this story. "Darryl Talley has always been one of our favorites throughout our storied history, but we believe, respectfully, that some of the accounts for this story are factually incorrect.

"Additionally, the Bills organization is very proud to have as-

sisted many former players, either personally or with their various endeavors, that dates back to the 1960s. The fact that our organization currently employs three of Darryl's former teammates should also be noted."

The Bills' statement didn't impress the Talleys.

"The Bills' response is disappointing and comes off to me, Darryl, and our daughters as dismissive," Janine Talley said. "We were specific, but they're not specifying what they debate to be inaccurate.

"Why would we lie?"

Darryl Talley noted an NFL team wouldn't draft a college prospect with X-rays that showed he once had a broken neck. Yet he's convinced he played for Buffalo with that serious injury.

"He loved being the person nothing could stop," Gabrielle Talley said. "That man wasn't stopping until a doctor or a coach told him he wasn't allowed. Nobody ever did.

"It's the NFL culture. As much as I resent my dad for not having his own well-being in mind when he played, that's what medical professionals are there for. Trainers and doctors went to school for that, to be the responsible voice of reason."

Only five players in Bills history played more seasons or games than Talley. He's on their Wall of Fame and was voted to their 50th anniversary team in 2009.

Trouble Sleeping

But for years he hasn't been able to flip his shirt collar down or fashion a necktie. His arms can't rise up and bend that way.

He rarely sleeps longer than 90 minutes, frequently climbing onto the floor with his legs propped on an ottoman for back relief.

He sometimes must use his knees to steer his pickup truck because of wrist pain from jamming linemen and tight ends.

"This is not what he signed up for," Gabrielle Talley said. "My dad is one of the toughest people you'd ever meet. He'd walk through a wall for you.

"But nobody would sign up to put their brain and their body through that if they knew what the risks were."

Janine Talley was asked what she felt the biggest points were to make about her husband's story.

She looked up from her laptop and studied her husband. She thought for a few moments.

Janine: "What I want people to know is how much he loved being a Buffalo Bill and how difficult it was to leave the team."

Darryl: "Oooooooo . . ."

Janine: "Darryl offered to play for the veteran minimum wage."

Darryl: "Because I didn't want to leave. The man is dead now, but [former Bills general manager] John Butler said he offered me a contract, and he didn't."

Janine: "The separation was awful for him and awful for me to watch."

Darryl: "That sent me into a deep depression. There's nothing in this world that I've seen or heard that will replace that void of playing in front of those fans."

The Talleys agreed that it took him at least four years to get over his 1995 Bills departure.

Within that gloomy period, Janine Talley started to get frightened for her husband. One particular incident confused and scared her.

She woke up at about 3:00 a.m., and Darryl wasn't in bed anymore. She searched the house yet couldn't figure out where he was. She saw no lights on.

Eventually, she opened the door to their recreation room. In pitch blackness, Darryl sat cross-legged in front of the pool table, a glass of Jack Daniel's in his hand, staring at the framed jerseys of his former teammates: Andre Reed, Hull, Smith, Thomas, Bennett.

She asked what he was doing. He didn't answer.

Upon hearing his wife recount that story, Darryl Talley muttered, "I've felt that way a number of times: 'I'm just lost.'"

He never was diagnosed with a concussion, but he's no fool. Seau and Strzelczyk didn't have documented concussions either.

So how many concussions would Darryl Talley guess he suffered? He emitted that warbling laugh again.

"Too many to count," Talley replied. "I've hit people, got up, felt like my eyes were bouncing back and forth, or I'd see mini lights. I'd have to say at least 75 times I saw little lights. I'd have to say it's got to be more than 100 concussions."

Dr. Julian Bailes is the former neurology department chair at

the Talleys' alma mater. They have not met, but Bailes knows those flashbulbs Talley described.

Bailes is codirector of the NorthShore Neurological Institute in Evanston, Illinois. He has conducted brain autopsies on NFL players, oversaw DeLamielleure's living CTE exams, examined Strzelczyk's brain, and sits on several sports safety boards. Bailes is chairman of the Pop Warner medical advisory committee.

"Every time you get hit and see flashing lights and you feel it in your head," Bailes said, "that's probably a significant subconcussion blow."

Subconcussions are brain injuries that might not rise to the level of a diagnosed concussion. Players don't necessarily wobble off the field or experience memory loss with a subconcussion. But the damage from repeated subconcussions can accumulate exponentially and may contribute to CTE.

The Talleys have lived in the same area for the past 17 years, but Darryl cannot remember the garbage is collected every Monday and Thursday. He cannot remember their ATM identification number, which hasn't changed since his rookie year.

On a visit to Gabrielle Talley's home in Birmingham, Alabama, he tried to make repairs to her SUV. Each time he needed a tool, he went to her second-floor apartment to retrieve it rather than get the toolbox.

"He just doesn't make the simple connections that come easily for the rest of us," Gabrielle Talley said.

Depression and suicidal thoughts are common CTE characteristics.

"It's horrible, and it has to be taken seriously," Bailes said. "Junior Seau played football for 30 years. You think of his style of football and how he played his position. He drove off a cliff two years before he shot himself in the chest.

"It's an extremely terrible and poignant part of the emerging CTE profile. We always worry that prior brain injury can be associated with an increased incidence of suicide later in life."

Seau shot himself in the chest two years ago, preserving his brain for examination. A year earlier, Dave Duerson killed himself the same way and left directions in a suicide note for his family to donate his brain.

Seau and Duerson had experienced failed businesses, memory

loss, abrupt mood swings, angry outbursts, and other issues the Talleys can identify.

Darryl Talley admitted an especially dark moment while a guest at the 2002 Pro Bowl. Miserable over how much he missed football, he considered jumping off the balcony at the Hilton Hawaiian Village hotel.

In explaining why he wouldn't kill himself now, Talley emphasized over and again that he's not a "coward." Upon reflection, he regretted using that word and took it back. He didn't want to disparage anyone's memory or offend their families.

"I think he needs to look at suicide prevention," Duerson's widow, Alicia Duerson, said from her home in the Chicago area. "If he's ever done some study on that or dealt with anybody who's lost a loved one, it's not about being a coward.

"It's someone who's in agony and pain and can't deal with it anymore. I don't think people realize how hard it is to take your own life."

Alicia Duerson paused for a moment before rushing off the phone.

"People who commit suicide are not cowards," she said. "I just . . . I don't know. I'm sorry. I can't talk right now. I have to go."

Failure and Denial

Darryl and Janine Talley tried to prepare for NFL retirement the prudent way. They saved money while he played. Their goal merely was to keep working, make enough money to exist, send their daughters to private school, and then pay for their college educations.

"I didn't play golf every day, chase hos up and down the street, or do drugs," Darryl Talley said.

What he initially wanted to do was serve as a Bills assistant coach. He said he called owner Ralph Wilson to inquire about an entry-level job but was told the Bills don't hire former players. Alex Van Pelt and Pete Metzelaars later became Bills assistants while Wilson was alive.

Darryl Talley in August 1999 purchased Sentry Barricades, a business that handled traffic signage and detour control for emergencies, construction sites, road closures, and the like.

Even though Talley was coping with depression and physical decline, Sentry Barricades grew to 17 employees.

The economy ravaged Sentry Barricades in 2008. Some clients went bankrupt. Not only did those contracts evaporate, but so too did the money they owed Talley's company.

Janine Talley said he tapped his 401(k) and bought out his NFL pension at 25 percent value to salvage Sentry Barricades, but they still couldn't honor their vendors or make payroll.

"My dad's work ethic and perseverance is what you see in children's books and people tell myths about," Gabrielle Talley said. "But he couldn't do anything to save the business even though he kept trying.

"He couldn't get it to work and feels that he's let everyone down."

Most heartbreaking to Darryl and Janine was cashing in their daughters' college funds.

"Do you know how humbling that was?" Janine Talley said. "At this point in our lives, we thought we probably would be retired, golfing, and have enough financial security to travel, visit our girls, be able to buy a vehicle when one broke down.

"That's not the way it's played out. I don't see at our age where things are going to get any better."

The Talleys couldn't afford to attend Reed's induction into the Pro Football Hall of Fame last August. Just as Smith, Thomas, and Bennett helped with the rent and some of Gabrielle's college, they picked up the tab to get the Talleys there.

Smith is paying for the Talleys' health insurance through the Affordable Care Act.

The NFL's all-time sacks leader has reached out to the Bills to get Talley some help but came away disillusioned with the team's indifference.

"I've had a conversation or two, and I'll just leave it at that," Smith said. "I was somewhat optimistic, but there was no follow-up. That was the disappointment."

Smith declined to divulge names or specifics about the Bills' lack of response.

"For someone to be so loyal to his previous employer," Smith said, "for someone who gave his all to their organization, to see the lack of support is just very concerning. It's sad.

"There should have been a lot more help than is being pre-

sented to him. It's imperative we do whatever we can to make sure this does not end up as a tragic story of someone who was beloved by players, coaches, fans."

The Bills declined to comment on Smith's frustrations. Smith conceded the Bills could be in an awkward spot by assisting one former player but not all of them.

Then Smith rattled off a handful of times when Talley played hurt or came back from surgery seemingly faster than possible for the Bills.

"If that doesn't show your allegiance and commitment to the organization, I don't know what does," Smith said. "Darryl wanted to help the team win.

"Once a player is done playing, the team pretty much washes their hands clean so they don't have issues with retired players. From my standpoint, though, there's something that should be done in this circumstance."

Darryl Talley isn't a fan of all this sympathy and charity.

He doesn't want it, but he knows his family needs it.

"To rely on somebody else to help you? It hurts like you don't want to believe," Darryl Talley said. "You can lay in the bed and cry thinking about it. It drives at you. It eats at you.

"Not to be able to do whatever you want to do mentally or physically, you have a dignity . . . It's very disheartening. But I want to see my kids get old. That's the only reason I'm here. Other than that, there's nothing."

His hands cradled his forehead then slumped hard onto the wicker chair's armrests. Janine Talley watched from the couch across from him.

"I've used up most of my useful life," he continued. "The part that hasn't been used up doesn't look like it can be too useful.

"It's going to be a pain in the ass. Getting old is not for sissies, but what drives me nuts is the NFL doesn't think it has anything to do with it."

GREG HANLON

Sins of the Preacher

FROM SPORTSONEARTH

I. Kayla

> "I'm uncomfortable but I don't say anything, 'cause in my head
> I'm going through all the talks he gave in class about how he was
> such a Christian guy, and so I was like don't—you know—don't
> think there's something happening here that's not. You know,
> don't offend him."

ADRIAN, MICH.—Chad Curtis didn't tell his lawyer that he's do-
ing this interview, he admits with a sly smile. Obviously, she'd be
angry, because he's appealing his conviction, and talking to a re-
porter is likely not in his best interests. But Curtis is still upset that
he didn't get to take the stand at his trial. He sees himself as a man
for whom telling the truth trumps calculated self-interest.

That's why, he believes, he has sat in prison since October on
a seven-to-15-year conviction for molesting three teenage girls at
the rural Michigan high school where he volunteered. Curtis, 45,
says he could have taken a misdemeanor plea, served a year and a
half in county, and been home with his wife and six kids by now.
But he's an innocent man in his own mind, so he couldn't bring
himself to swear on the Bible—which he quotes frequently and
encyclopedically during our two-hour interview at the Harrison
Correctional Facility—and admit to a crime he didn't commit.

As a major league baseball player, he wore a bracelet that said,
WHAT WOULD JESUS DO? Now that he's a prisoner, he tells me,
"Jesus lived the perfect life, and that got him crucified." By this,
he means there's historical precedent for the harsh judgments of

human beings to be 180 degrees wrong, and that he's in good company.

He asks if I'm familiar with the show *Pretty Little Liars*. He says he prays daily for his teenage accusers, all of whom had similar athletic builds and All-American good looks. He says all he was doing in that locked, windowless, dungeon-like training room was helping those girls recover from sports injuries. He says he took the same all-out approach to treating sports injuries as he did to playing baseball—"whether it was running into an outfield wall or breaking up a double play."

As for why the girls thought otherwise, and accused him of touching their rear ends, breasts, and, in one case, genitals, he doesn't want to speculate: "I've been really discouraged by how often and how wrong people have assumed my motivations, so I'll extend them that same courtesy," he says.

He doesn't mention that not a single boy testified to having gone down to the trainer's room for similar treatment.

We're sitting in a side room off the main visitors' room of Gus Harrison Correctional Facility in Adrian, Michigan, which is roughly equidistant between Ann Arbor and Toledo. Curtis's hair is a graying version of the same 1950s-style flattop buzz cut he wore as a player, and his broad shoulders fill out his prison uniform perfectly. He cuts a similarly classic figure in state blues as he did in Yankees pinstripes. His job now is to administer sports games (setting up cones, etc.) and he says he's made a lot of good friends. Despite the stories about child sex offenders in prison, he says he hasn't been attacked. He keeps busy by reading the Bible and by "work[ing] out like crazy," even though the weight pit is outside and the Michigan winter has been brutal.

Yes, religion and discipline have always been his calling cards: he told his students at one high school that he went years in the majors without once eating dessert or drinking soda. He never drinks alcohol, and he never swears: "Rid yourselves of . . . filthy language from your lips," Colossians 3:8 says.

He also says he has never cheated on his wife, walking the straight and narrow path of a Godly man while countless teammates acted like kids in a candy store. (He considers himself a "Bible-believing Christian" and eschews denominational titles.) If his teammates were doing the wrong things—missing chapel, not playing the game the right way, or even listening to explicit rap or

watching *Jerry Springer*—Curtis would call them out, for their own good. He was the ultimate God Squadder, noble to some but insufferably pushy to others, which might help explain why he played for six teams in his 10-year career. But no matter to Curtis: "You adulterous people, don't you know that friendship with the world means enmity against God?" states James 4:4.

Now, however, his bearing—the burdened gestures, the heavy sighs—bespeaks a martyr's pained awareness of the fallibility of others. People have let him down.

Like Andy Pettitte. The two were good friends, regulars at Bible study with the Yankees. When Pettitte was waffling back and forth on whether or not to retire several years ago, Curtis was on the phone with him at 5:30 in the morning giving him spiritual guidance. But since the allegations? Crickets.

And Kayla. Of all his accusers, this one hurts him most. The two were close, so close that Curtis approached her one day and said they were getting too close: "We could have a relationship within the bounds of the law if we chose to do that. But that wouldn't be good for you and that wouldn't be good for me," he says he told her.

But he is not bitter, he says. He has faith that God will use this tragedy for good. He believes that one day, Kayla will admit to falsely accusing him, that "she'll wake up, throw up her hands and just say, 'I can't do it anymore.'

"And when that happens, I have every intention of forgiving her."

The western part of Michigan, in the area around Grand Rapids, doesn't conform to the popular notion that the state is firmly in the blue column. The airport is named after Gerald Ford, and Barry County, where Lakewood High School is located, went heavily for Romney. It's across the state from Detroit and Ann Arbor and much further away culturally, its religious conservatism dating back to the 19th century, when Dutch Calvinist separatists settled in the area so they could freely practice their strict brand of Protestantism. Several people described the area to me as "The Bible Belt of the Midwest."

At Lakewood, a consolidated public school drawing its students from four tiny towns, roughly 35 minutes east of Grand Rapids, religion and sports are pillars of identity. And no teacher could

validate such an identity quite like Mr. Curtis, who had grown up in the area. He was clean-cut, handsome, and charismatic, his eyes framed by a perpetual furrow that conveyed his moral seriousness. He was happily married to his college sweetheart. They and their six children all had first and last names starting with the letter "C."

Discipline and undeviating faith in God had led him all the way to a 10-year career in the majors, to Yankee Stadium. In 1999, he hit a game-winning home run in the World Series against the Braves, then, in the next game, caught the last out of the last World Series of the 20th century. He gave away half of his earnings to nonprofit organizations—groups like Focus on the Family and anti-abortion crisis pregnancy centers, he tells me. After he retired, instead of going someplace warm or exotic, he decided to come back to western Michigan, the area that made him who he was, the area perfectly aligned with his sensibilities.

During the 2010–11 school year, he was living in Lake Odessa (pop. 2,018) and had begun substitute teaching and volunteering in the Lakewood weight room. The community considered itself lucky to have him; he would later be hired as football coach. He had a key card to the school and keys to the athletic department rooms.

Kayla was 15 going on 16 that year, a sophomore, and was new to the area. Interested in church, livestock, and playing sports, she was the type of teenager who earnestly worked to improve herself in every area of endeavor. Before that year, a family friend told her that if she wanted to prepare for sports, she should talk to Mr. Curtis, the former major leaguer.

She did, and soon Curtis had drawn up a workout regimen for her and was opening the gym in the early mornings for her and her brother. The two became close. She became friends with Curtis's second-oldest daughter, who was her age. The family was so welcoming of her, and she was so grateful, that she invited them to her basketball banquet her sophomore year.

That following summer, between her sophomore and junior years, Kayla, who had been training for cross-country in the Lakewood weight room with other athletes, began having problems with her hip flexors. Curtis offered to do manual resistance hip flexor exercises with her in the weight room, in the company of his two eldest daughters, with whom he did the same exercises. A

little intimate? Perhaps, but if Kayla was uncomfortable about what was happening, she would have had every reason to think she was the only one who was.

The exercises continued over the following days and weeks, but the venue moved: first to a room adjacent to the weight room, and then downstairs to the windowless trainer's room. The sessions were now one-on-one and out of the view of other students. In the trainer's room, Curtis worked her muscles in ways that began to make her feel uncomfortable: "He'd touch all around my leg, and he'd touch up near my hip bones and inside of my hip bones," she would testify.

But she didn't say anything, instead convincing herself that the problem wasn't that Curtis was crossing lines, but that she held those lines to begin with. To be the best athlete one can be, one has to overcome self-imposed limitations and break out of comfort zones. So when Curtis asked to give her an athletic massage—no, he wasn't a physical or massage therapist, but he had lots of experience with people at the highest levels of such things—she said yes.

He laid her down on the trainer's table on her stomach and started with her hands—"Relax, you're too tense," she testified he said. Then he progressed to the shoulders. Then he removed her shirt, leaving her in just a sports bra.

"I'm uncomfortable, but I don't say anything 'cause in my head I'm going through all the talks that he had talked in class, and how he was such a Christian guy. And so I was like don't—you know—don't think there's something happening here that's not. You know, don't offend him," she testified.

It unfolded increment by increment; Curtis made small talk the whole time. First he flipped her over on her back, exposing her front, and began massaging her stomach. Then, abruptly, he vaulted onto the table, and was suddenly straddling her.

"And once again I tell myself, 'Well, he's just trying to have a better angle at massaging my abdomen,'" she testified.

She said Curtis asked her, "Are you sure you're okay with this?"

She didn't say no. So Curtis removed her sports bra and began massaging her bare breasts. Kayla stared at the ceiling.

"I try to rationalize why he could think that it was okay to do that," she testified. "I was trying to figure out how it could better me as an athlete, 'cause that was the idea of this massage. And I

couldn't figure out like how that could make sense. And I wanted to say something, but I couldn't even open my mouth to say anything."

Later in the trial, John Cottrell, vice president of counseling services for the Grand Rapids YWCA and an expert witness for the prosecution, told the jury about "tonic immobility": "a neurobiological process that essentially paralyzes the body in a defensive way so that pain is not felt and resistance isn't even possible."

Child victims rarely fight back, Cottrell would say. Far more common is for children "to acquiesce, to follow instructions if instructions are given, and to endure things pretty much silently."

Eventually Curtis pulled her sports bra back down, covering her. He finished massaging her shoulders, and dropped a bead of sweat on her. Then he reached down and swiped his hand over her crotch, on top of her spandex.

Shortly after coming to Lakewood, Kayla had been taught by a teacher to shake the hand of adults after each encounter. It would make her look more professional, and would benefit her as she got older. It had become a habit, one she was proud of. After it was over, she shook Curtis's hand, and went home.

In 1999, Baltimore rapper SisQó put out his first solo album, *Release the Dragon*. Its sales were moderate until January 2000, when the novelty single "Thong Song" was released. Propelled by its catchy, goofy refrain—"Let me see that thong!"—it shot up to number three on the *Billboard* charts. By that spring, it had reached terra firma of American mainstream tastes: the major league baseball clubhouse.

Under late manager Johnny Oates, the Texas Rangers of the era had a policy that children were welcomed in the clubhouse. The administration of that policy was hands-off: Oates trusted his players to sort out the particulars of etiquette. Until one day in April, when Royce Clayton, the team's African American shortstop, was playing the song, and Curtis walked over to the stereo and turned it off. Clayton turned it back on; Curtis turned it back off. The two got in each other's faces and nearly came to blows.

"This shit happens 20 times a year in a major league clubhouse," Clayton told me recently. The difference this time, he said, was that reporters saw the confrontation and took an interest—and Curtis took an interest in explaining his side.

"He decided to keep talking about it," Clayton said. "He decided to go to the media and self-promote about how good a Christian he is. And the media bought into it, and I knew why: it was because we're in the Bible Belt, and here was a black dude he could go after, saying, 'He was listening to profanity in front of kids.'"

The incident was one of many during a career in which Curtis was known more for his aggressive proselytizing and capacity for moral reprobation than anything he did on the field. In Texas, his teammates complained that he'd turn off *Jerry Springer* when they watched it in the clubhouse before games: "We'd be like, 'Whoa, what are you doing?' And he'd be like, 'This isn't good for you to watch,'" former teammate Frank Catalanotto said.

In New York, Curtis would throw away the porn some players kept stashed in the bathroom. When management suggested that Curtis keep an eye on second baseman Chuck Knoblauch, who they feared was partying too hard, Curtis took the assignment to its mall-cop extreme, yelling and banging on Knoblauch's hotel room door to make sure he was there. He clashed with Derek Jeter, chastising him in front of reporters for fraternizing with then-friend Alex Rodriguez during a bench-clearing brawl between the Yankees and Mariners, and offending him by persistently soliciting him to attend chapel after Jeter had already turned him down.

"Chad just couldn't stay around any longer because that act gets tired," one Yankees official told author Ian O'Connor. "Once he became comfortable here, he became a preacher, and it ran its course."

For his part, Curtis told ESPN's *Outside the Lines,* "If I have something that I believe is the truth and it's necessary for other people to come to some type of a recognition or grip of that truth, then I want to share it."

Curtis was conscious of how public perception could advance his reputation for morality. He somewhat famously snubbed NBC's Jim Gray for an interview after hitting his walk-off home run in the 1999 World Series, in retaliation for Gray's aggressive line of questioning to Pete Rose earlier in the playoffs, though the decision to boycott Gray had been made ahead of time by the team. He became a go-to quote for reporters on performance-enhancing drugs for his strongly reproving stance. To him, baseball and the rest of the world had become too wishy-washy. If Curtis's firmness got him labeled as "intolerant," then so be it: "We live in a soci-

ety that practices tolerance and acceptance, which at the root is a good idea," he told the *Los Angeles Times*. "But, you step back sometimes and say, 'What is it that we tolerate? What is it that we are accepting? Is anything acceptable?' My answer to that is, 'No. Not everything will be tolerated.'"

At the same time, he used the media to project an impossibly wholesome image of himself. He recounted getting married in his minor league uniform so as not to be late for batting practice. (His wife and kids still believe he's innocent, by all accounts.) He told the *Dallas Morning News* that he began each morning by charting which of his prayers from the day before had been answered. He confessed to the *L.A. Times* to cheating in a Sunday school card game and said, "That might have been my all-timer" in terms of moral depravity.

"Is it surprising to me that he's done what he's done?" Clayton said. "Absolutely not. People hide behind a lot of bullshit to do what they wanna do."

Kayla was no shrinking violet, no product of a broken home, not the sort of recourseless victim that predators are known for seeking out. The day after Curtis massaged her bare chest, she went to weightlifting, supervised by Curtis, with the aim of confronting him after everyone left. But Curtis beat her to the punch: "Kayla, we need to talk. Something went terribly wrong," she testified that he told her.

Out came a rambling quasi-apology. There were compliments (she's a hard worker, she's a moral person, she reminds him of his daughters), quoted Bible verses, and acknowledgments tinged with a self-serving air (he said it was the most unfaithful he'd ever been to his wife). He made frequent use of the conspiratorial "we" when discussing the incident, and framed it as a teachable moment for both himself and Kayla. "Like it was a lesson for the two of us," she testified. "He somehow worded it whereas it was wrong, but it wasn't too wrong."

He said he had "an angel on one shoulder and a devil on the other," according to Kayla. "He said it was an inner struggle and [that] he needed to take these thoughts captive and just throw 'em out." In the midst of all this, he asked Kayla if she was a virgin.

Still, Kayla accepted his apology and believed that it would never

happen again "with my whole heart," the phrase itself indicating how badly she wanted to believe him. Normalcy quickly returned. They resumed doing hip flexor exercises together. Nothing inappropriate happened. Until several weeks later—when the two found themselves back in the trainer's room on Labor Day, when Lakewood's most dedicated athletes didn't skip their workouts.

More hip flexor work. More poking and prodding: "Does this hurt, does that hurt?" Kayla lay still as Curtis worked her shirt and shorts off incrementally, leaving her in a sports bra and spandex. All the while, he was moving side to side around the table, seemingly engaged with giving a strenuous massage, acting as if removing Kayla's clothes was an incidental by-product. Then he removed her sports bra.

Kayla tried not to look at him, but she caught a glimpse of his eyes: "They looked animalistic, or demonic," she testified.

He leaned down over her and kissed her breast. At the same time, he took one finger, reached underneath her spandex, and penetrated her vagina.

It lasted only several seconds, but it was long enough for Kayla to realize that she was in danger, and to react. Slowly, gingerly, she pushed him off of her, and said, "No."

It was making eye contact with Curtis, and seeing a man she had once revered as a moral authority shamefully slink down into a chair "like a little kid when you slap their hand," that sent her into convulsions of bawling. It was the hardest she had ever cried.

It was too horrible to face head-on, so she scrambled for alternate explanations. The first that came to her mind was that what had happened was some sort of test—of her own morality, of her friendship with Curtis's daughter—and that she hadn't passed. At trial, Cottrell would testify that 95 percent of sexual assault cases with children involve a known relationship, and that for the child to blame themselves is common: "Because they hold this person in esteem and because [children] are vulnerable, they will assume this person wouldn't hurt them, so if something bad happened, it must be the child's fault," Cottrell testified.

Kayla hysterically vocalized this sentiment to Curtis. At that, Curtis reassumed the role of the calm, poised authority figure. He put his hand on her thigh and said, "Kayla, you're wrong. You did pass. You have to understand that."

Another lecture followed, and it confused Kayla. On one hand, Curtis accepted responsibility and said he was sorry. On the other, he put in Kayla's mind what would happen if she told anyone.

"He's like if you go to the police, he's like I will lose my job . . . [His wife] will be extremely hurt, and I probably won't see my kids again," she testified. "'But Kayla, that's not your fault. I made this decision, and these are the consequences I have to deal with. If that's what you need to do, go to the police, then that's what you need to do.'"

Kayla asked Curtis what he was going to do, and he said he was going to talk to God, and keep it between himself and God. Then, just as Kayla was getting ready to leave and ponder the most difficult decision in her life, a decision with nothing but horrible outcomes on both sides, Curtis asked her to pray with him. "I didn't want to say no," she said. "Prayer is always good."

After the prayer, and after he told her that her confronting him was a "step in the right direction" for him, and that it would never happen again, she turned again to leave. He again called her name.

"Did you enjoy any of that?" he asked her.

She said no.

"And he turns it into a lesson, and he goes, 'Well, good, now I know that if you ever get into a situation with a boy, you'll be able to make an excuse or go home or something like that.'"

She listened to Christian music on the car ride home, went through the motions of helping to clean up after her family's Labor Day party, jumped in the shower, and resumed bawling uncontrollably.

At trial, Cottrell testified that child victims "try to maintain a sense of normalcy as much as possible," as both a denial mechanism and a way to exert control. That's what Kayla did in the months following the incident. She continued to banter with Curtis in the weight room, though there would be no more trips to the trainer's room. Her friendship with Curtis's daughter, who she couldn't bring herself to hurt, actually deepened, and she found herself going over to the Curtis house regularly.

"I decided I was gonna pretend," she testified. "And if I was going to make this commitment to pretend like nothing happened, then I had to make it look like nothing changed much."

II. Jessica

> "He told me he didn't think that we should text anymore because
> he didn't want his wife to be mad."

Teaching was a natural second career for Curtis for several rea-
sons, among them that his father had also been a teacher. The
family moved around to accommodate his jobs: Curtis was born in
Indiana, raised in Middleville, Michigan—30 minutes from Lake-
wood High School—and went to high school in Arizona.

But his teaching career, like his playing career, would be marked
by short, contentious stints. After getting his teaching certificate at
the evangelical Cornerstone University, he lasted only two years
at his first job, as a phys ed teacher and coach at Caledonia High
School, just outside of Grand Rapids. As he had in the major
leagues, he immediately began irking his colleagues, who felt he
imposed himself, in this case by disregarding preexisting weight-
room teaching techniques. "Mr. Curtis thinks his way is the right
way," one teacher told me. "It was his way or the highway. We'd
been teaching it one way and the baseball legend wasn't buying
in."

The superintendent who had brought Curtis to Caledonia, a
friend of Curtis's, wound up being imprisoned for embezzlement.
With that, Curtis's position was eliminated.

His next stop was NorthPointe Christian School, a fundamen-
talist Baptist school in Grand Rapids whose rigid handbook ex-
plicitly bans clothing with "graphics and words of secular musical
groups," "extreme hairstyles" like dreadlocks and mohawks, and
low-cut tops for girls. On paper, the place was right up Curtis's al-
ley, and he excelled at first, becoming the school's athletic director
and creating a football program. But the relationship soured, and
he was gone after two years. Principal Todd Tolsma would not tell
me why Curtis was dismissed, but he said, "Chad Curtis's separa-
tion was unrelated to any issue that has been publicized with the
charges and trial."

I asked Curtis why he was dismissed, and he demurred at first.
But then he said that he butted heads with the administration over
its laxity about enforcing the strict guidelines in the handbook.
When I pressed him for specifics, he cited the ban against low-

cut tops: a girl had been revealing cleavage in class, and when a teacher (not Curtis) complained to the administrator in charge of dress code, the administrator let the matter slide.

"My take was, you either have to take the rule out or you have to enforce it," Curtis told me.

That Curtis had two short tenures at two different schools before he was accused of molesting children invites the obvious question: did he do anything untoward at the previous schools, and did the schools, by getting rid of him without contacting law enforcement, look the other way?

The prosecutors looked into this and couldn't find anything they could introduce at trial, though Barry County prosecutor Julie Nakfoor-Pratt stressed to me that "the door is always open." Lake Odessa superintendent Michael O'Mara said that Lakewood's review of Curtis complied with proper background check protocol, including fingerprinting.

"He had explanations [for leaving those schools], and they were viable. We thought we knew what we were getting as a person," O'Mara said.

However, the mother of a male Caledonia athlete told me that rumors of Curtis's lecherousness were openly discussed among parents at the time. And a former Caledonia athlete told me that it was an acknowledged joke among his group of friends that Curtis took a disproportionate interest in attractive girls when supervising the weight room.

"He would always be encouraging the girls to stay after," the student said. "He would be like, 'All athletes stay,' and we'd all stay, but he'd pretty much just focus on the girls. He literally would spot girls [on weights] all the time. And looking back, that's where we were like, 'Holy shit, did we see this coming?'"

Several years later, at Lakewood, a student named Kaleb Curry and his friends had a similar ongoing joke. Mr. Curtis, it seemed, had a thing for Jessica, then a 15-year-old sophomore. According to Curry's testimony, Curtis would pull her out of gym class at least once a week for 20-minute periods to work with her in the trainer's room. When Jessica broke her pinkie, Curtis did one-on-one resistance work with her in lieu of a barbell bench press, leaning over her with their hands together and having Jessica push up. Curry

said that Curtis even remarked to him once that Jessica had a "nice athletic butt."

"I kinda feel like he paid more attention to Jessica . . . than any other person in there," Curry testified. Of the 20-minute disappearances during class, he said, "It was kinda suspicious. It didn't seem right."

One day, on a lark, Curry and a friend headed down to the trainer's room to scope out what was happening. After seeing Jessica emerge from the room, they started teasing her. Soon after, according to Curry's testimony, "Mr. Curtis approached me and Anthony and asked us if we were giving her a hard time about anything. And he said if you are, you need to stop."

What Curry didn't know was that Curtis and Jessica had exchanged 115 text messages between late February and late April of 2012. Many of these concerned weight room scheduling, which is what Curtis told me and what the defense said at trial. But many concerned Jessica's boyfriend and tensions in their relationship. Curtis would tell her that she was too good for her boyfriend's immaturity, that she was a pretty girl.

This made Jessica trust Curtis and feel flattered, and perhaps it also played to her awareness of her burgeoning sexual power. In the weight room one day, she once playfully asked Curtis to tell her boyfriend to stop staring at her. She also once texted him, "I would have a thing with you." She was a kid playing with boundaries and roles. "Like I had a crush on him, but it wasn't anything that I would ever take," she testified.

Curtis's response to that text was, "I don't want my kids to see me in jail," according to Jessica. The next day, she said, "he told me he didn't think that we should text anymore because he didn't want his wife to be mad."

Most of the texts from that period were gone by the time detectives obtained a warrant for Curtis's phone. Between February 21 and March 2, 85 consecutive texts between Curtis and Jessica had been deleted, investigators testified.

The texts between Jessica and Curtis were actually sent *after* the incidents when Jessica said Curtis touched her inappropriately. The defense portrayed this as proof that the so-called incidents were harmless by-products of athletic training methods. The prosecution portrayed a predator who opportunistically capitalized on

a teenager's experimentation with boundaries and who couched his true motives in the guise of legitimate athletic massage.

The first incident occurred in August 2011: Jessica reported a problem with her rib area and asked Curtis to wrap her with an Ace bandage. He began wrapping, with Jessica's shirt up so that the bottom of her sports bra was exposed. Then he asked her to lift the bra up a little bit, exposing the bottom of her breast, so he could get the wrap underneath it: "Is this okay?" he asked, similarly to how he had asked Kayla.

Jessica, like Kayla, didn't say no. So Curtis lifted the bra up all the way, exposing her breasts. When Jessica instinctively covered herself up, Curtis didn't flinch: he stared straight ahead and continued to wrap her rib, as if the whole thing was purely clinical. The man who couldn't abide porn in the bathroom and cleavage on a female student was trying to convince both a teenager and himself that there was nothing wrong with what he was doing.

He finished wrapping Jessica, then pulled her bra down. This forced Jessica to remove her hands momentarily and expose her chest again. Curtis stared directly at her the whole time.

The wrapping thus completed, she went off to volleyball practice. She later told her mother that Curtis had wrapped her, and then texted Curtis that the wrap had solved her rib problem.

In the ensuing months, Curtis regularly pulled her out of class to give her massages, which Jessica says progressed up her thighs to her underwear line. Curtis, in a statement he made after he was convicted but before he was sentenced, said Jessica would come to him with "fake-type injuries because she wanted to talk to me."

But Jessica says the opposite, and that the ostensible hip injury for which Curtis took Jessica to the trainer's room one day in the winter of 2011–12 was a figment of his imagination.

Jessica lay on her stomach, and Curtis peeled her sweatpants down, exposing her underwear. Then he moved her underwear to the side, exposing her bare rear end. Then he started massaging her there, continuing for several minutes.

"I wasn't so much scared. I was uncomfortable. But I trusted he was doing his job, so . . ."

Jessica wasn't the only person who reflexively believed Curtis was just doing his job. Just minutes after he was finished rubbing her bare rear end, the school's principal, Brian Williams, came

looking for Jessica on an unrelated matter and was told by the regular gym instructor—from whose class Curtis routinely pulled Jessica—that she was getting ice in the trainer's room. Williams walked in to find exactly that: Jessica on the trainer's table, clothed and with ice, and Curtis seated on a chair. It was not a suspicious sight.

Williams testified at trial, "I've been asking myself, you know, since I found out all this going on, why I wasn't alarmed. And the only thing I can come to is Mr. Carpenter [the weight room instructor] said, 'They went to get ice.' And she was there with ice."

The incident raised the obvious question of whether Lakewood was at all responsible for its female students being molested in the school building. O'Mara, the district superintendent, said that if he knew Curtis had been massaging girls even for the medical reasons Curtis purported, he likely would have fired him on the spot: "You can't put yourself in that position," he said. But Curtis called that assertion "baloney," and claimed what he was doing was widely acknowledged. Curtis's take on this seems to jibe with the fact that he often pulled students out of other teachers' classes for the one-on-one sessions.

A report by O'Mara, issued to the Lakewood School Board in early March, said, "Existing school policies and procedures were adhered to by school personnel." Soon after the accusations broke, Lakewood installed a window on its training room.

Curtis told me that he has heard grumblings through his lawyer about a lawsuit against both the school district and himself, but no suit has been filed as of yet.

III. Alexis

> "I no longer enjoy going to school . . . I hear the gossip and I had to quit volleyball because [tryouts] were the same week as the trial, and the coaches didn't show support for my decision."

Curtis tells me that the first accusation against him broke on his three-year-old's birthday. The second came on his 11-year-old's. He was arrested on the day of his 19-year-old's graduation.

"Now, is that coincidental? Or is that someone looking at your personal file and deciding to mess with you?" he says to me.

Looked at one way, it's a laughably grandiose delusion of a man whose persecution complex is in proportion to his Jesus complex. But in person, in real time, Curtis is more compelling than he is after the fact. Like any charismatic person, he pulls you in and makes you want to go along with what he's saying. He has the convincingness of someone who has thoroughly convinced himself of his own innocence.

This helps explain why, in the aftermath of the initial allegations, much of the local public outrage was directed at the accusers. The comments section of an early news report summed up this line of thought:

"I bet you some girl tried to seduce him and he turned her down," read one comment. "He's a former MLB player with two world titles. There's no teenage girl he would ever go after. Use common sense."

"I agree it has to be bogus!! All we can do is pray!" read another.

Curtis had a list of some 40 character witnesses he wanted to call at trial, though only a handful of them got to testify. One said, "Chad's integrity is the highest of any man I've ever met." Another said, "He is flawless."

The defense also called a psychologist who cited the "post-event information effect," when outside sources can cause someone to alter their interpretation of events, and who alluded to the daycare sex abuse hysteria cases of the 1980s. The defense's other star witness was an athletic massage therapist who said the rear end is a repository for lactic acid buildup from all kinds of leg injuries.

Even after his conviction, a sizable percentage of area residents still believe that Curtis got railroaded, either by trumped-up charges promulgated by overzealous investigators or by a *Mean Girls* gang-up against a deep-pocketed target. However, this notion seems to be undermined by the fact that the five girls who eventually accused Curtis were not friends with each other and ranged three and a half years in age. There's also the fact that Curtis is currently being sued by the state of Michigan to pay for his own incarceration, and he told me he's largely tapped out of money.

Still, there are believers. Kelly Stein-Lloyd, a close friend of the Curtis family and the director of the Caledonia Chamber of Commerce, believes Curtis was doomed in court by his stone-faced expression in comparison to the girls' outward emotion. "I've coached girls for 15 years. I know teenagers. And girls can be

pretty convincing. They can be pretty conniving and pretty believable. And that played to their benefit this time," she said.

When word got around that Alexis, a 15-year-old freshman, had accused Mr. Curtis of molesting her, she became persona non grata at Lakewood.

"I got really depressed because like everyone started treating me differently," she testified. Her volleyball teammates "wouldn't talk to me. I—I would always have to find my own partner."

She had come to Curtis's attention after injuring her knee in the most childlike way imaginable: a sledding accident. Subsequently, Curtis, in the same persistent manner as he had solicited his teammates to attend chapel, asked her repeatedly if he could help her rehab it. She turned him down several times but eventually relented, "'cause I was sick of him asking me," she testified.

Soon enough, they were down in the trainer's room, Curtis rubbing her knee, then her thigh, then her upper thigh, then her groin, up to her underwear. He flipped her over on her stomach and went through the same progression, ending with rubbing her rear end, with both hands, in a circular motion. All the while, he lectured Alexis, who was also very religious, about how to prove to an atheist that God exists. During his major league career, his sermons had often been met with exasperation and dismissal. In the Lakewood trainer's room, he had a captive audience.

After it was over, Alexis wondered: had she just been molested? She didn't know. She described to her youth pastor that night what had happened and was told "to be careful."

The next day, Curtis took her down to the trainer's room again, but she felt okay about it because another girl, Rachel, went down with them. But then Curtis told Rachel to take the medicine ball upstairs, and now it was just the two of them again, and he began to touch her in the same progression as the day before.

His hands were on the side of her rear end, over her pants, when they both heard the jangling of keys in the door lock. It was another student, who had been sent by a teacher to fetch something. The student didn't see anything notable, but Alexis caught a glimpse of Curtis's face frozen in panic.

"I was uncomfortable the whole time, but when I saw his reaction, that's when I knew that something was wrong," she said.

The next day, a Thursday, she spoke to authorities, and she took

off from school until Monday. Among the many things that would be different in her life when she returned was that Curtis was no longer at Lakewood, having been suspended immediately.

Detective Jay Olejniczak spoke first with Alexis, and then to Rachel, the girl Curtis had taken to the trainer's room with Alexis but then sent upstairs with the medicine ball. Olejniczak had sought out Rachel simply to investigate Alexis's claims, but it turned out she had her own stories to tell.

She was a family friend of the Curtises who, as an eighth-grader, had gone on vacation with them to babysit their younger kids. During this vacation, she said that Curtis rubbed suntan lotion on her and slid his hand underneath her bra. Also on that trip, she said that on one early morning, he lay in bed with her, over the covers, while his daughter slept in the next bed over. To his defenders, this was proof that the charges had been trumped up to implausible proportions. To those who believed the girls, it was evidence that Curtis had lost any sense of boundaries and judgment.

Rachel was one of two accusers who took the stand but whose accusations were not prosecuted. The other was Brittany, a recently graduated Lakewood student who also babysat for the Curtis kids. She testified that one day at the Curtis house, after she had gotten a sunburn while sitting outside, Curtis had insisted on rubbing suntan lotion all over her body, including on the top of her breasts.

Curtis was contrite afterward, Brittany said. "He said that it couldn't happen again, that we couldn't do it again," she testified, remembering his conspiratorial use of "we," just as Kayla had.

He also told Brittany that "that was as close as he's ever come to cheating on his wife." Several months later, after penetrating Kayla with his finger, Curtis said it was the "most unfaithful he's ever been to [his] wife." The prosecution pointed to this progression—touching the top of Brittany's breasts maybe wasn't *technically* cheating, but penetrating Kayla definitely was—as evidence both of Curtis's escalating behavior and the girls' truthfulness. It was too specific, prosecutors said, to make up out of thin air.

Much of Curtis's MO involved creating the perception of a gray area between legitimate massage and molestation. Given this, it makes sense that when Olejniczak questioned him about touching

Rachel in Curtis's one and only interview with police, he said, "I don't think she's a liar, and I don't think I'm a liar either."

What really tripped his mental wiring was a question about lotion. When Olejniczak mentioned the word "lotion," Curtis announced that he was nauseous, got up out of his chair, and lay on the floor for close to two minutes.

"It was a really awkward silence, didn't really know what was going on," was how Olejniczak described it.

Curtis's first words when he composed himself were, "I guess you can just say that I'm—I'm hurt and confused. I try to pour my time and energy into helping kids."

At the time Olejniczak interviewed Curtis, only Alexis and Rachel had accused him. In the 14 months between that interview and the trial, Kayla, Brittany, and Jessica would come forward.

It was a trying period for the girls, and by all accounts still is. They were bullied in the hallways and on social media. Rachel said that after coming forward, "No one liked me. They were all against me 'cause he was a great guy and this would never happen, so we were all lying."

Some of the girls and their family members accused Curtis and his family of fomenting a campaign against them. Tensions got so bad that Curtis's oldest daughters—one of whom graduated, one of whom transferred—were barred from Lakewood functions.

Kayla transferred her senior year too, and saw her close friendship with Curtis's daughter severed. She had planned to go to college but had not done so as of the trial. "She's not able to sleep by herself," her father said in court. "This week she's crawled in with her mother three or four times."

Alexis couldn't play volleyball her senior year because tryouts conflicted with the trial. She said in court that "the coaches didn't show support for my decision."

The toughest part was the trial itself. Curtis stood accused of criminal sexual conduct in both the third and second degree, the latter of which, the most serious charge, was for penetrating Kayla with his finger.

Every day of the weeklong trial, the 131-person courtroom was packed, evenly split between supporters of Curtis and supporters of the girls. In front of all of those people, the girls recited the intimate details of how they were violated, and then reaffirmed those details under cross-examination.

"These girls, they were rocks," said Nakfoor-Pratt, the prosecutor. (Nakfoor-Pratt's assistant prosecutor, Chris Elsworth, was the one who tried the case.) "Particularly when they have school, sports, family, everything. This was a long road for these young ladies to hang in there, and I was amazed by how strong they were."

Meanwhile, Curtis didn't testify, on the advice of his lawyer. Now that Curtis is behind bars, he has a new lawyer. One of the grounds for his motion for a new trial is that he received incompetent counsel, he told me.

The jury deliberated for around three hours and found Curtis guilty on all six counts. The victims and their families addressed him at sentencing.

Kayla said, "There was a time I believed you to be a man of high morals and integrity. That time is long gone. Now, a little over two years later, I have a better view of who you really are. You are a manipulator and a perpetual liar."

Kayla's father said, "You used her devout faith against her. You blasphemed. Your self-serving actions included using God as your shield, allowing you to garner support from other Christians."

Alexis said, "You know what you did, but you let us girls be put through the embarrassment of a trial and be humiliated on the stand. We didn't ask for this. You chose to put us through this. We shouldn't be treated like outcasts because of your selfish actions."

Finally, it was Curtis's turn. He had been sitting in the Barry County Jail for the previous several weeks after his conviction. Whatever denial mechanisms had cracked during his interview with Olejniczak had sealed back up. He spoke for 55 minutes. During this time, he became lightheaded and asked for a glass of water before continuing. Nakfoor-Pratt would tell reporters afterward that it was "the most selfish, self-serving, victim-blaming statement I've heard in my career as a prosecutor."

He said he prayed for the girls, the prosecutor, and the judge. He said he was "a servant as opposed to a selfish person." He said he wakes up every day and asks, "'God, what would you have me do? And God, how can I be a positive influence on others and be about building your kingdom?'"

He began to address his victims' claims one by one. He said Jessica invented "fake-type injuries" and added, "I didn't touch Jes-

sica for my sexual purposes. I tried to touch Jessica mentally and emotionally for her benefit and physically for her benefit."

Jessica left the courtroom at hearing this. Curtis said after her, "I hope that's hard for her, and I hope that from that hardness she says what is true."

"I hope it's hard for you, you ass!" an onlooker shouted back, who was then escorted from the courtroom.

Curtis continued. When he began to address Alexis, she left the courtroom too, and was followed by her mother, and Kayla, and Brittany.

When Kayla returned, Curtis said that in order to maintain proper boundaries between the two of them, he had recruited her older brother to coach a sixth-grade football team with him. "Having [him] around a little bit more would be good accountability for her and myself," he said. "It was something that needed to be controlled. We came to the conclusion that we needed to stay out of a situation where we could be tempted to fall into a situation that wouldn't be good for either one of us."

Curtis continued, saying he hoped he and Kayla "could write a book together some day, and it would be to the positive benefit of millions of people."

It was this statement, in the context of the 55-minute speech, that most people point to as the signature moment of this sad episode: Curtis was delusional, and still sought connection with his accuser.

Was he aware that people thought he was crazy? I asked him several months later.

Of course he was, he said, smiling. The judge had told him so. His lawyer even told him so. But he was proudly unfazed: to be the only one in the room who believed in what he did was a familiar role for him, a role he relished.

"That's what people told me when I said I would make the big leagues," he said.

FLINDER BOYD

Run and Gun

FROM FOX SPORTS

Prologue

I STAND IN the center of a busy strip mall parking lot just off
Pico Boulevard in Los Angeles, wiping the sweat from my brow. It
is unseasonably hot for February, and my pulse is racing. How do
you address a gang leader?

Soon a flashy, late-model car pulls up and he gets out slowly.
He can't be more than an inch taller than me, but his presence
radiates across the parking lot. He wears designer jeans and a well-
fitted gray polo shirt that struggles to contain his muscular shoul-
ders.

He recognizes me by the notebook under my arm. We slap
hands, then exchange tense small talk about mutual friends.

His phone vibrates in his hand, he glances down, then back up.
"I know you got a story to write," he says in a distinct L.A. drawl.
"So tell me what you want to know."

What I want to know is why Javaris Crittenton, the former first-
round pick of the Los Angeles Lakers, a quiet Bible-touting honor
roll student and much-loved son of Atlanta, is now in jail facing
charges of murdering a 22-year-old woman, attempting to murder
two others, running huge quantities of drugs across state lines,
and being a member of the Mansfield Family Gangster Crips—
the street gang that is the pulsating heart of this three-square-mile
area.

I grew up not far from here, and in the past three weeks I had
contacted old high school friends with loose connections to the

Mansfield Crips to see if anyone would talk to me. Each response
was similar.

"Stay away from this."

"They know you're asking questions."

"Leave it alone."

And I did, initially. I wasn't naive about gang culture. But then
a couple days before our meeting, I got a text from T-Locc,[1] a
Mansfield OG, who owed a friend a favor.

Now, T-Locc stands looking at me, awaiting my response, his lip
partially curled. The sun fights through the lone cloud in the sky
and I cup my hand over my eyes. Cars drive around us, curiously
staring back as they pass. "I was hoping you could tell me some-
thing about . . ." — I pause, avoid his eyes and take a deep breath —
"Tell me about Javaris."

Part 1

Once upon a time there was a factory for tiny basketball players —
a place on the Westside of Atlanta where boys would bring their
short attention spans and passion for basketball, a haven from the
harsh world around them that seven- and eight-year-olds shouldn't
yet know about. It was run by Tommy Slaughter, although his dis-
ciples called him PJ. He was brash and energetic, and would pull
up to practice in a new shiny SUV with music blaring out of the
windows and a smile laden with gold teeth sparkling in the sun.
When practice started he would jump on the court with his mini
players to demonstrate the right way to play, the PJ way.

When Sonya Dixon, Javaris's mother, was looking for a place to
drop off her rambunctious eight-year-old son, she was told about
this program at the old, run-down Adamsville Recreation Center,
just a 15-minute drive from their home in the Cleveland Avenue
area in Southeast Atlanta. She had given birth when she was a ju-
nior in high school, and with Javaris's father rarely around and
suffering from acute liver disease, the parenting was left to her. In
many ways, she and Javaris were growing up together.

In PJ, she found someone who could harness Javaris's bursts of
boyish anger. PJ saw talent and pushed him harder than any of his
other players. If he asked someone to make five layups in a row,
Javaris would have to make every single shot without touching the

rim. The discipline appealed to Javaris, and over time they established such a tight bond that PJ began referring to him as his son.

In small-time, local youth tournaments, little Javaris was making a name for himself and soon word reached Wallace Prather Jr., known to many as the godfather of Atlanta hoops. A quiet but stern man with sharp eyes and a graying goatee who oversaw the development of nearly the entire area, Prather valued mentorship and coaching for its own benefit and enlisted others with the same philosophy. He then streamlined the most talented and respectful players into one organization: the Atlanta Celtics.

With various summer teams made up of players ranging in age from nine to 18, the Celtics were the pride of the local youth sports scene and were run with the efficiency of a city-state. Practices were crisp and diligent and coaches taught life skills as much as they taught fundamentals. By the early 2000s, Prather was presiding over the golden age of Atlanta basketball. Never before, or since, has there been so much talent or so much local attention paid to high school basketball in the area.

In the summer after Javaris's eighth-grade year, Prather, who admired his young protégé's fierce competitive streak, asked Javaris to join his top traveling team that included future NBA stars Josh Smith and Dwight Howard, in the hopes they would help mentor him. But from Javaris's first game with the Atlanta Celtics, a marquee matchup against LeBron James's summer team in a tournament in Houston, Javaris refused to be a sideshow.

PJ, meanwhile, had been diagnosed with colon and rectal cancer, and for weeks he had kept it secret, embarrassed by his decaying appearance. Knowing it might be the last chance he'd get to see Javaris in action, PJ traveled to Houston to see his disciple play.

Late in the game, as the story goes, LeBron James switched onto Javaris, who had just been inserted into the lineup. LeBron had been decimating the Celtics players, but Javaris demanded the ball when he saw LeBron guarding him. Javaris cleared out his teammates, faked left, and paused. LeBron, who was already touted as the greatest high school player of all time, bit on the fake. Javaris dribbled toward the hoop, then as he rose up, LeBron, his 17-year-old arms ripped with muscles, came from behind intent on not just blocking the shot but exploding it off the face of the glass. At the last moment, the lanky Javaris switched hands and reversed it in off the other side of the backboard while LeBron flew by. The

crowd erupted, college scouts scribbled in their notebooks, and PJ grinned, clenching his fist.

In the coming months, every high school in Atlanta with a decent program was after Javaris. He was set to enroll at Douglass High, the trendy school where many of his friends were going, until he got a call from Dwight Howard Sr., the athletic director at tiny Southwest Atlanta Christian Academy. He offered Javaris a scholarship and believed he could team up with his son to form a nationally recognized program.

Under head coach Courtney Brooks, Javaris was taught the importance of details, both during games and in his everyday life. Together with PJ, who had begun to slowly recover, and Prather, Javaris was encircled by mentors and father figures who fenced off outside influences. As a result, Javaris flourished. He had a singular goal of playing in the NBA, and he absorbed everything they taught him.

He transformed from a kid with baggage into an intensely focused young man in everything he did. He was the class president in school, had a 3.5 GPA, and scored almost 1400 the first time he took the SAT. If there was Bible study, Javaris had to memorize more and know more than anyone else, and even his school tie and jacket had to be pristine.

Nowhere was his drive more evident than on the court. His exploits became the stuff of legend. There was his performance in the state championship his sophomore year (and Dwight Howard's senior year) when he single-handedly took over the game despite playing alongside the best high school player in the country. There was the time he scored 30 against O. J. Mayo in a double-overtime loss and couldn't eat after the game.

The stories abound, but no game encapsulates Javaris more than the Wallace Prather Jr. memorial game before his senior season.

On June 17, 2005, 51-year-old Wallace Prather Jr. stepped in the shower and collapsed, dying of a heart attack. The tight-knit Atlanta basketball world was devastated and did the only thing they knew would honor the man who had done so much for the community. They organized a basketball game in nearby Suwanee with many of the nation's best players. For most of the participants, it was a glorified all-star game, a chance to show off their dunking skills in front of a packed gym full of scouts and fans. Javaris,

however, would never disrespect Prather by treating the game as a showcase. He picked up full court on defense and dove on the floor for loose balls. His passion bounced off the walls of the stuffy gym; he attacked the basket with the full force of his pain, and called out his teammates if they didn't hustle. He was unguardable and sensational and was named the MVP of the game.

By the end of his senior year in high school, Javaris was considered one of the top players in the country, but it was inside Atlanta, within the interstate highway, 285, that encircles the city and separates it from the suburbs, where he was most revered.

"He was the symbol for the original Atlanta area," says Jonathan Mandeldove, his teammate with the Atlanta Celtics. "He was the backbone and the entire city was behind him."

When it came time to choose a college, Javaris bypassed the recruiting process entirely. He never even thought of leaving his city, or his people. He enrolled at Georgia Tech, leading the Yellow Jackets to the NCAA tournament his freshman year. At six-foot-five and with the rare combination of power and speed, Javaris was a pro scout's dream. He immediately applied for the NBA Draft, and true to his loyal nature, hired Wallace Prather Jr.'s son, Wallace III, as his agent.

On June 28, 2007, over 200 people, including the chief of Atlanta Police, fought through a torrential downpour and packed into a private room at the FOX Sports Grill in downtown Atlanta to experience the moment their local hero wrapped his arms around a childhood dream.

As each pick in the draft was called, the tension inside the room increased. Greg Oden went first, then Kevin Durant to Seattle, then Al Horford to Javaris's hometown Hawks, later Joakim Noah to the Bulls. When the Hawks, desperately in need of a point guard, were on the clock again with the 11th pick, everyone in the room held their breath. The moment seemed too perfect.

Atlanta, however, selected Acie Law from Texas A&M.

Perhaps, in retrospect, that was it—the first twist down the spiral. But at the time, it was only a momentary lull. Eight picks later, all eyes looked up at the giant screen as David Stern stepped to the podium: *With the 19th pick in the 2007 NBA Draft, the Los Angeles Lakers select . . . Javaris Crittenton from Georgia Tech.*

The place exploded. It was delirium—high fives, hugging, embracing. Someone screamed, "He's going to Hollywood!"

"There was so much joy around that," Atlanta Celtics coach Horace Neysmith said. "Everybody expected Josh, Dwight, Randolph [Morris] to be pros. Javaris, they knew he was good, but when he got there and got to that point, it was like, 'Wow, this is really happening for the kid.'"

Twenty minutes later, Javaris, dressed in a newly tailored brown suit, walked in with his tall and beautiful high school sweetheart Mia. He hugged his mom tight, then worked his way around the room, looking each person in the eye, smiling as he shook hands, and thanking each of them for their support.

PJ stood back, allowing Javaris to soak up the moment and admiring the man he had become. When the restaurant closed, PJ walked into the stormy night struggling to fight back tears.

"To be a parent, because Javaris was like my son, to be a parent and see your son drafted, it's like the biggest thing going. It's a life changer," he said.

Part 2

For a kid from Atlanta, Los Angeles had a mystique—like a newly polished Ferrari glittering under the sun. Before the season, Javaris settled into an apartment a half a mile from Venice Beach and was the guest of honor at a Hollywood nightclub welcoming him to L.A. He was new royalty in a town that worshiped the Lakers. Not even a week after his introductory party, though, he caught a glimpse of the corrosion just below the sheen.

While leaving to head home after a night out, according to Mia, Javaris was walking to his parked car—he never paid for valet, if he could avoid it—when two men approached him and snatched off the chain around his neck at gunpoint, then calmly walked back into the network of alleyways that surround Hollywood Boulevard.

Over the next few months, Javaris rarely ventured out as he put all his focus into basketball. Yet during games in the first few months of the season, he was becoming increasingly frustrated with his lack of meaningful minutes. The same quality that got him to the NBA—his relentless competitive streak—was now restricting him. In practice, Javaris would not only try to match up against the all-world Kobe Bryant but he would also try to take some of his minutes.

"The best player on the planet is Kobe, and [still Javaris] thought he should be playing," PJ said.

Javaris was drafted as a long-term project, a prototypical Phil Jackson point guard, tall, intelligent, and defensive-minded, who could contribute down the road.

"He's got to be patient and he's not a patient young man," Jackson told the *Los Angeles Times* in January 2008.

By the time Javaris turned 20, on New Year's Eve 2007, he had only appeared in 12 games. Despite his frustrations over the last few weeks, he had rebuilt his community in L.A. and slowly had begun to settle in. Mia had moved in, two of his cousins, Scooter and Woody, came to stay for long stretches, while teammate Kwame Brown, who grew up not far from Atlanta, lived across the street. Together in one tiny corner of L.A., they reconstructed Georgia.

To celebrate his 20th, Javaris and Mia went to a nearby bowling alley, as the clock neared midnight. It was quiet and simple, and for a moment he could look back and see just how far he'd come.

"It was beautiful," Mia remembers. "He was happy, and things were beginning to work out."

In the next game, Javaris led the Lakers with 19 points, his career high. But less than a month later, the Lakers decided to strengthen their frontcourt and so shipped Javaris, along with Brown, to the Memphis Grizzlies for Pau Gasol. Javaris was surprised by the news, but he immediately packed up his belongings and left his apartment. As he got on the plane to Memphis, he handed Mia a Bible and a handwritten note that read: *You can't make plans, only God can.*

Part 3

"You see all this," T-Locc says, waving his open hand out in front of him as cars pull in and out of the parking lot around us. "From Olympic to Pico to Venice on down. That's all Mansfield." His gruff voice fills with pride.

The rigid boundary of the Mansfield Crips sits along the Pico corridor where the conflux of Korea Town, South Central, Hollywood, and the outer reaches of Beverly Hills flow together into a basin that's colloquially called the Deep West Side. It's a neighborhood that both geographically and historically connects the

various subcultures of the city. Everything you need to understand L.A. is written into these streets. It's where the utopia and the dystopia collide.

The Mansfields, whose neighborhood was in the crosshairs of the burgeoning drug trade in the 1980s, made millions from drug sales[2] while brutally protecting their prime West L.A. real estate.

"The police feared us so much, because we were ruthless," says T-Locc, recounting the days of gang warfare with a tinge of nostalgia. "Everything was done with precision and done right and thought about.

"We're the smartest gang around."

The Mansfield Crips are an anomaly for an L.A. street gang. Members, who are born from this middle-class neighborhood, are well educated and crisply dressed. Comedian Alex Thomas, who grew up near Pico, calls them "gangsters with two parents."

As a result of their upbringing, members can often blend into any situation. So when a record label opened a residence to house visiting East Coast artists some 25 years ago within the Mansfield territory, members were easily able to mingle and befriend some of the early luminaries of the rap world.

As hip-hop and R&B erupted into the mainstream in the mid-'90s, Atlanta became a hub, and many of the Mansfields followed their famous friends to help with security detail or in the studio. Some even stayed in Atlanta but still raised their kids loyal to the streets of West L.A.

In the summer of 2008, after Javaris finished his rookie season in Memphis, he returned to Los Angeles for a few weeks to work out and see Mia. One evening while he was out at a club, according to sources, he was introduced through an Atlanta connection to an Atlanta-raised rapper, whose mother had grown up along Pico Boulevard. The rapper went by the moniker "Dolla." A magnetic personality, with striking amber eyes and MANSFIELD tattooed on the inside of his right index and middle finger, he was already recognizable for his modeling work with Sean John and his top 100 single with T-Pain that was playing nationwide.

Javaris, who rarely went out or drank alcohol at the time, was drawn to Dolla and others in this tight-knit group, including Asfaw Abebe, or "K-Swiss," whose brother lived in Atlanta. The group were mostly L.A. kids in their early to mid-20s, who had gone to decent schools like Fairfax High School or Los Angeles High

School, or, like Dolla and his brother, were new transplants from Atlanta. The connection was immediate.

"Javaris saw the glamour," T-Locc says. "The way we move, people are attracted to that. That's the powerful part. We got a lot of people associated with us and they got genuine love for us, and not on some bully, gangsta sh*t. Legitimate, like a family."

Part 4

In March, a short drive from the Atlanta airport, where the city begins to peter out into the wooded countryside, I meet PJ at a Red Lobster restaurant, just off the I-285.

He greets me with a soothing smile and firm handshake. After recently completing his third round of chemotherapy in the last 10 years—this time for 14 months, including four straight months in the hospital—his eyes look worn and battered. But his long, thick dreadlocks have grown back, and his magnetism, which all great coaches have, still lingers.

He reclines slightly along the booth, and I can sense his mind racing, flashing back to the days when he once stormed up and down the sideline coaching future NBA players like Dwight Howard, Toney Douglas, and Josh Smith.

"Javaris. Man, he was different," PJ says. "He was special, he has a good heart."

When Javaris was 14 he invited PJ to watch him play, but when PJ arrived, Javaris was clowning around. A strict disciplinarian, PJ was furious.

"Javaris felt so bad, he wrote me a 13-page handwritten letter the next day," he recounts, the edges of his lips curling upward and the gold teeth sparkling under the soft yellow lighting. "He told me he was sorry, and he loves me, and he promises to make me proud and he said he'll never let me down again."

He tells me more stories of Javaris's youth exploits; then, as he takes another bite of the steak in front of him, his tone changes. "You try to think about what went wrong," he says. "Once he got in the league, maybe he started second-guessing things?"

When Javaris returned to the Grizzlies for his second season, they didn't have a place for him, so he was shipped off to Washing-

ton for a draft pick early in the season. He played sparingly until the last month of the season, when he finally got a chance. And he capitalized, averaging 10 points and shooting over 50 percent from the floor.

PJ, in the midst of his second battle with colon and rectal cancer at the time, was struggling to reconcile his own frailty and possible death and pulled away.

"For a while, I let him go," PJ says. "I wanted him to find himself and I needed to do the same thing."

But things took another bad turn. When Javaris's third season began, he ruptured ligaments in his left ankle and was sidelined indefinitely. He withdrew inward and soon began peeling off the layers of his youth. He fired his agent, Wallace III, and broke up with Mia. But he still needed his mentor, and his mentor needed him.

For Javaris's 22nd birthday, PJ traveled to D.C. to see his "son."

"We hung out and had a good time that night," PJ says. "The next morning I wake up and turn on the TV and I said, 'What the hell?'"

Thirteen days earlier, Javaris and Wizards teammate Gilbert Arenas got into a heated argument over a card game. It was widely reported that Arenas, known for his macabre sense of humor, placed three guns in front of Javaris's locker two days later next to a sign that read PICK ONE. Javaris, who had been carrying a gun ever since he was robbed in L.A., was wary of Arenas and brought his own black-and-silver pistol to the gym. They were both summoned to the general manager's office, reprimanded, and all involved assumed the entire episode was being handled in-house and had blown over . . . until the details were plastered all over sports channels on New Year's Day.

The NBA cracked down hard, suspending both Javaris and Arenas for the remainder of the season, and Javaris was also charged with a misdemeanor possession of a firearm. (Arenas was charged with a felony.)

Javaris, who Mia says "really felt bad" about the incident, returned to Atlanta but could feel the disappointment from the people closest to him. Embarrassed, he then gravitated back toward the anonymity of L.A.

A year earlier, Dolla had been killed,[3] and the Mansfields had

been in a state of mourning since. Dolla's group of friends bonded tighter, and when Javaris was in L.A., he spent more time with K-Swiss and his best friend, "Lil Swiss," or "Flaco," a Latino small-time weed dealer.

Javaris would stop by K-Swiss's place often, where they would watch TV, or they would go out to clubs and talk to girls. The Mansfields helped insulate Javaris, they didn't judge him or feel disappointed by his suspension. To Javaris they were just his friends, he didn't think of them as "gang members." He began to feel a part of the Mansfield family and soon got a tattoo of a hand twisted into a "C" for "Crip" on his abdomen.

"He had a fence around him in Atlanta," says Mia. "When he came to a different city it was harder. [In L.A.] he thought he was building a white picket fence, but he was building a black barbed-wire one."

On July 21, 2010, Javaris got his first taste of the gang lifestyle. Seven months after his suspension, two LAPD detectives appeared at Javaris's front door and held their badges up to the peephole. They were let in and then quickly began interrogating Javaris about his relationship with K-Swiss and Flaco, and his possible involvement in a double homicide.

A surprised Javaris mumbled through his answers, downplaying his friendship, and claiming he had no connection to a murder. Two and a half months earlier, according to authorities, K-Swiss and Flaco parked their rented Jeep on Corning Avenue, just west of La Cienega Boulevard. They reclined their seats all the way back and waited for a member of the Playboy Gangster Crips[4] who had shot K-Swiss in the torso during an argument three weeks earlier.

When the target and his wife got into their car that morning, Flaco allegedly jumped out of the Jeep, raised his gun, and fired into the car, missing his target but hitting his target's wife, killing her and her unborn baby.

Once back in safe territory, Flaco and K-Swiss allegedly stashed the gun and kept it quiet.

When Javaris came by the following day, Flaco asked him if he could buy him a ticket to Atlanta. It was urgent, Flaco said, "family matters," and he didn't have a credit card. Javaris was frugal and refused, telling Flaco to ask someone else. Eventually Javaris relented and bought Flaco a one-way ticket to Atlanta on his Ameri-

can Express card. The day before Flaco left town, he handed Java-ris the cash.

A few days later, K-Swiss was arrested, but Flaco remained on the lam. By tracking Javaris's credit card receipts, authorities eventu-ally arrived at his front door.

Javaris, still reeling from the embarrassment of his NBA suspen-sion, didn't tell PJ, or any of his close confidants from Atlanta, about the police investigation. Instead, he sought advice from his new family.

"He was scared to death about the whole incident," T-Locc said. "I told him, 'Talk to the police, just tell them what your involve-ment was.' He didn't have no involvement in it, but police kept sweating him to see if he knew anything."

With his close friends in jail, police questioning him about his role in a double murder, and a war about to kick off between the Mansfields and the Playboys, Javaris decided he needed to get out of L.A. Without a contract, he had a brief tryout with the Bobcats but wasn't offered a spot on their roster. With no NBA teams call-ing, Javaris got on a plane with his cousin Scooter and went just about as far as he possibly could.

They landed in Hangzhou, China, a city of eight million, two hours southwest of Shanghai. Javaris's ankle had fully recovered and through five games, he dominated the league. But China wasn't just 12,000 miles from home, it was also on the other side of the world from his NBA dream. He terminated his six-figure con-tract and headed to the D-League for a fraction of that. He had to be close when the NBA called.

In January 2011, Javaris arrived in Bismarck, North Dakota, to play for the Dakota Wizards, the D-League affiliate of the NBA's Wizards and Grizzlies. His cousin, meanwhile, returned to At-lanta. Without a girlfriend around, and without his mentors or his friends, Javaris was alone for essentially the first time, looking out across the snowy prairie at all the directions his life could go, at all the possibilities.

He was only 23 years old, but after struggling with consistency through four professional seasons and owning the fourth-longest suspension in NBA history, Javaris had to know that this was maybe his final chance.

Despite having a far superior basketball pedigree to anyone on

his team, Javaris didn't play up to expectations. When the final game of the season ended, in which he'd scored just nine points with five turnovers, he was as far from the NBA as he'd been.

Less than a week later, Los Angeles district attorneys summoned him as a witness to testify against his friends, K-Swiss and Flaco, in a preliminary hearing to confirm Javaris did in fact buy the plane ticket. Javaris, facing his shackled friends, answered questions meekly, his voice rarely climbing above a whisper.

When he got out of the courtroom, he stood for a moment as the sun beat down on him. Everything was going wrong. He needed to go home, back to Atlanta, to the comfort of the city that loved him.

Part 5

On a cool, damp Georgia evening on April 21, 2011, after Javaris had returned from L.A., he picked up his cousin Scooter and drove toward the barbershop in their old neighborhood on Cleveland Avenue.

After they got their hair cut, the pair stayed inside for hours talking. When it was nearly 11:00 p.m. they noticed another man, known as "Big Boo," the leader of the Raised on Cleveland street gang, or ROC, had left the barbershop just before them.

As the cousins walked outside toward Javaris's black Porsche, two men emerged from the dark shadows and rushed towards them. One looked Javaris in the eye and raised his gun. Javaris never told police the alleged perpetrator's name, but it is widely reported that he thought it was "Lil Tic," or Trontavious Stephens, who was just 17 at the time. (Stephens has denied his involvement.) Along with his two brothers, Lil Tic had been for years a menacing figure in the neighborhood where Javaris grew up, as a member of the ROC.

Javaris bit his lip and handed over a reported $55,000 worth of jewelry. He thought he'd been set up. When police arrived, they asked Javaris to identify the thieves, but he was livid and refused. His car had been stolen just two weeks earlier in the Cleveland Avenue area, and he felt he was being targeted. He ignored the lineup photos and reportedly told police: "I'll handle it."

But Javaris's temper cooled, and over the next few weeks he stayed away from the area. He spent much of his free time with his mom and his two young sisters. They attended church weekly and he sought to rebuild his reputation. He even attempted to reconcile with his father. "He's a family type of guy," PJ said. "When he was back he was real focused, trying to get back on track."

Javaris, however, was going broke. He was paying two mortgages, various lawyer fees, and had no income coming in. He asked PJ, who is well respected in the community, to call Big Boo to negotiate the return of his jewelry.

The Atlanta Police Department, however, was investigating witness tampering during the murder trial of a bartender in Grant Park, and had begun tapping calls between Big Boo and his close associates, according to a source. When PJ called, in conversations overheard by police, Big Boo refused to hand over the merchandise. Soon, pictures of Javaris's jewelry were being sent between ROC members, then spider-webbing out across the digital landscape, mocking Javaris. He seethed. *How could this happen here? In Atlanta. In my city.*

Javaris was working out obsessively, furiously blowing on the dying embers of his NBA career. He called his college coach for practice tips and hired a new trainer, while shooting thousands of shots a day. In July, three months after the initial barbershop robbery, after leaving a nightclub, Javaris and Scooter allege they were robbed yet again, at gunpoint, and sought to have the jewelry replaced by insurance. Authorities, however, according to a source, were skeptical, and when Javaris contacted his appraiser, he was told his insurance had just expired.

Javaris was now spiraling into a free-fall.

On August 14, 911 operators got a frantic call from an anonymous tipster that "Crittenton, the basketball player," had shot and missed Lil Tic's brother (who bears a resemblance to Lil Tic) from a black Porsche, just a few doors from where Javaris had spent most of his childhood.

As police were beginning to collect evidence, there was another tragic shooting in the same neighborhood later in the week.

On Friday, August 19, what is known is this: Javaris and his cousin Scooter rented a black Chevy Tahoe Hybrid SUV in Fayetteville for Scooter's birthday. Scooter, who didn't have a credit

card, reserved the car using Javaris's card. Later that day, Javaris headed to Buckhead in North Atlanta, to watch some of the King of Hoops tournament he'd be playing in later that weekend.

Fifteen miles south, meanwhile, Julian Jones, or "Pee-Pie" as her family affectionately called her, was giddy with excitement. At 22, she already had four children between the ages of seven years and 10 months, and this was the one night a month her two aunts would watch all her kids.

At 9:30 p.m., she sat outside with Lil Tic on Macon Drive waiting for friends before heading to a barbecue. Outwardly Lil Tic tried to maintain a hardened exterior, but around Pee-Pie he was a doting play brother. He adored her. Tall and slender with a permanent smile, Pee-Pie was often seen skipping and singing along the sidewalks. She was the light of the neighborhood.

A quarter-mile away, a black SUV with dark tinted windows quietly crept up Macon Drive. At the apex of the hill, according to court documents, as Pee-Pie handed Lil Tic a lighter for his cigarette, the back window of the SUV rolled down, and a high-powered rifle thrust out into the clear night. Four sharp blasts ripped through the air, echoing down the hill. Lil Tic hit the ground. Someone shrieked. Neighbors scattered. The SUV peeled off, then came back to check who was hit, then sped back down the hill.

On the ground lay Pee-Pie, in a circle of her own blood. Two bullets had shredded through her thigh, across her pelvis, exploding the femoral artery.

Fifteen minutes later, sirens came screaming up the street. Inside the ambulance, Pee-Pie started complaining of surging pain in her chest. Her breathing became labored. She vomited violently, then again. At the hospital, nurses and doctors rushed into action, performing emergency surgery, tying the artery, squeezing it shut, and pumping her with blood. She passed out. They pumped her with more blood. Doctors looked over at her monitor—the pulses were slowing down. A lifetime was floating away.

At 11:34, just over two hours after Pee-Pie had been shot, a doctor walked into the waiting room, stood in front of her aunt, June Woods—who had cradled Pee-Pie from birth—and broke the news.

June's voice shuddered. "My baby," June whispered. "My baby."

The next day was Saturday. Javaris woke up around 6:30 a.m.

and drove to Buckhead for the 9:00 a.m. pro-am game for the King of Hoops tournament. It was the first time he'd played in a meaningful game in Atlanta in a long while, and he was eager to play his best.

"He wanted to get back in shape, reclaim his name," said Mandeldove, his former Atlanta Celtics teammate and teammate that game. "He looked really good, he looked like the old Javaris I know."

Javaris's team advanced to the next round, but Javaris unexpectedly didn't show up for that game, or the championship game the next day.

On Monday, Scooter returned the rental car and asked to remove Javaris's name and credit card info from the rental contract, then paid with a money order from Flash Foods. That night, police arrived in Fayetteville at Javaris's front door with a search warrant. They canvassed the house and found an AK-47, a black-and-silver pistol, and a shotgun, but no high-powered rifle, and as police reported, "nothing of evidential value." They searched the ponds, the surrounding forests, still nothing.

Meanwhile, rumors began circulating around Cleveland Avenue about Javaris's involvement in the murder. Soon his Twitter feed was filled with threats and subtweets and he dashed back to L.A. Detectives, meanwhile, found the black SUV rental car and began tearing it apart, peeling every inch for evidence of fingerprints and gun residue.

When Javaris arrived in L.A., he seemed upbeat. He saw the movie *The Help*, ate at the trendy Berri's Café on Third, worked out, and tweeted how happy he was to be back in L.A. He didn't tell anyone about the police investigation, but he could hear the footsteps. He messaged a friend playing overseas and asked if he could send an immediate transfer of money. It never came. By Friday, a week after the shooting, his name was all over the radio and TV. Police had found gun residue on the backseat of the rental SUV and issued an arrest warrant for Javaris and Scooter.

Javaris's supporters in Atlanta came out in huge numbers. At his bond hearing, his lawyer brought a petition signed by 1,000 people asking the judge to grant bond and several character witnesses, including his college coach Paul Hewitt, his middle school teacher, and his ex-girlfriend Mia. All testified to how exceptional he was.

There were also missing pieces of evidence. No gun was found, and no witness could identify Scooter, the supposed driver. It was only Javaris, the alleged triggerman, who would have been firing at the witnesses, and who was already well known in Atlanta and to the residents of Cleveland Avenue.

Javaris was granted bond for an astonishingly low figure of $230,000, almost unprecedented for a murder case in Georgia. He walked out of Fulton County Jail less than a month after being arrested.

He headed to L.A. hopeful that the charges against him were falling apart, but his destruction was already coded into the spiral.

He became involved in a custody battle over a newborn son and needed money for a family lawyer. Through connections in Atlanta, according to a source there, he was put in touch with a man who, through two high-level suppliers, was shipping massive amounts of drugs around the country. This man set up Javaris as a runner, and linked him up with an accomplice who ran a car shipping business. Javaris, who was flying back and forth from Atlanta to L.A. and Washington, would have his car shipped full of weed; then when he landed, he would pick up the car and hand its contents to the proper distributors. Unbeknownst to Javaris, federal agents had been tapping the man's phone for months.

On Wednesday, January 15, 2014, at 6:00 a.m., DEA agents, federal marshals, and local police descended on Javaris Crittenton's home in Fayetteville. Guns were raised, and there was loud banging at his door to wake him up. The boy who once had the world at his feet was then handcuffed, paraded outside, and led to a waiting police cruiser.

Epilogue

Draw a line roughly equidistant from Cleveland Avenue to Adamsville to Fulton County Jail and you'll find once promising lives strewn across the Atlanta landscape.

It's February, and I'm sitting in June's living room. Her niece's presence is everywhere, framed pictures of Pee-Pie above the TV and across the house. June recently had open-heart surgery and a jagged scar runs down her chest. Her face lights up when she recalls her niece dancing to her favorite song, or the outpouring

of emotion from the neighborhood when she was killed—around 400 people attended her funeral. Soon Julian's oldest son, now 10, pokes his head around the corner.

"What do you remember about your momma?" June asks him. His features are strikingly similar to the pictures of his mom—a long face, with a large glowing smile. He looks over at me, holds his gaze a few seconds. We lock eyes, then he darts back into his room.

At Fulton County Jail, Javaris talks to his visitors through closed-circuit TV. His mom, Sonya Dixon, comes by often, and many continue to defend him. They point to the lack of direct evidence, but mostly they hold on to the memory of the kid they once loved. Javaris counts the days until the murder trial, currently scheduled for September, where he'll be prosecuted by an old familiar face who once watched him win a Georgia state title—the Fulton County district attorney, Paul Howard, Dwight's uncle.

Across town, PJ and I finish our desserts at Red Lobster and get into my car and drive back toward his home in Adamsville. He excitedly points out where the old rec center once stood, the place where he first met Javaris and poured his soul into teaching basketball. The nostalgia seems to change him.

He looks out of the window, and lets the pain fill the chasm between what could have been and what is.

"I'm more hurt than anyone can imagine and feel," PJ says. He no longer coaches basketball, the seemingly never-ending bout with cancer has sapped his energy. He's trying to recover and clings on to hope that Javaris will be exonerated.

"The only thing I can do is believe in him," he says.

We pull through a gate and I stop in front of his place. He opens his door, then turns back to me and shakes my hand. "You know," he says, "sometimes I just wish he could go to sleep and it was all just a dream."

Notes

1. Name has been changed.
2. T-Locc: "You take a whole kilo and chop it up into rocks and sell it on the block, and make 2K off of each ounce and there were 36 ounces in each one. That was serious money, and you selling that in a day."
3. On May 18, 2009, an unarmed Dolla was shot in the back and shoulder in broad daylight in the ritzy Beverly Center parking lot in L.A. by a

man he'd had a scuffle with a few days earlier in Atlanta. The perpetrator was found not guilty by reason of self-defense.

4. It's sometimes mistakenly assumed there is one large-scale war between Crips (blue) and Bloods (red), but often the most violent rivalries are between various subsets or "cards," within the same overarching alliance to Crip or Blood. The Playboys and Mansfields are both West L.A. gangs from the same Crip subset—"Trays" (others include "Neighborhood Crip," "Deuces," and "Blocc Crips")—and have lived in harmony for years. K-Swiss and Flaco likely knew their intended target well.

KATIE BAKER

Those Kansas City Blues: A Family History

FROM THE DAILY BEAST

THE ROYALS HAVE made it to the World Series. Those true blue underdogs, the down-on-their-luck little guys of the American League, have made it—after what I'm told is one of the longest postseason droughts in all of baseball history, 29 years on the sidelines—to the championship. And two games in, they're holding steady.

Kansas City natives will say that the Royals are a team that could only have come from their Midwestern mecca, their riverine cattle town, where the stockyards and the packing houses down in the West Bottoms used to move three million cows a year and where the American Royal livestock show and rodeo has taken place every autumn since 1899. My mother used to watch the animals marching down the parade route alongside the Future Farmers of America, all those cornflower boys in bright blue jackets. Kansas City natives will also say that there was a time when the greatest steak joints were located down in the West Bottoms—like the Golden Ox, where a century-old set of steel horns still hangs above the grill and where you can order 12 different cuts of Grade-A beef—and that the stockyards never quite recovered from the great flood of '51, when the swollen waters of the Missouri crested its banks and eddied over the tops of the slaughterhouses.

Of course, the Royals (and here I mean the baseball team, not the cowhands) came late to the history of Kansas City. Before them, the A's were the hometown heroes, playing in the old Mu-

nicipal Stadium down near 18th and Vine. My grandfather used to dress up smartly in a suit and tie and take my dad to watch talents like Roger Maris and Hector Lopez, who were both quickly traded to the Yankees. After Charlie Finley bought the team, he brought all sorts of entertainment to town—including the Beatles, who performed on a stage set up behind second base during their tour of '64.

My father had no great loyalty to the A's, though he adored the Royals and the Chiefs, whom he watched every Sunday. After we moved to the Pacific Northwest, he adopted the Seahawks—and so 2014 was shaping up to be a banner year indeed, long before the Royals had aced their wild-card game. My dad needed a heart operation in the spring, but he wouldn't risk it before the Super Bowl. When the 'Hawks won big, he danced around the house for days.

This sheer ebullience—his expansive elation that his team had finally triumphed, that the odds turned out in his favor, that his number came up lucky—it was something I would cling to when, two months later, he had the surgery and did not survive it.

And now his Royals are in the World Series. And millions of baseball fans are watching the television cameras pan over the wide boulevards and the Spanish-style Plaza, over the curving fountains and the railroad tracks, and thinking about what a pretty city Kansas City must be. I want to tell you a story about those wide boulevards and those fountains, about the Plaza and the Paseo and about the railroad tracks and what they once led to. I want to tell you how Kansas City sits at the center of my family's history and of our national psychogeography, the nexus where north meets south in uneasy conflagration, where the east expands onto the grassy vistas of the western prairie, where vices are indulged and industries built. It is the omphalos, this city that straddles two steamboat rivers at the continental crossroads. There, pioneers embarked on their perilous journeys. There, militias fought in feverish abolitionist wars. It's the place where my parents grew up and where they fell in love. The place where jazz and barbecue and mob bosses and the blues flourished. The place where our past bleeds into the present, where you can and can't go home again—and where the muddy Missouri flows ever onward, winding slowly toward its distant manifest destiny.

*

When we talk about Kansas City, what we're talking about is a certain state of mind, a bricolage of bootstrap can-do-ism and ingrained suspicion of the more lawful authorities. The town's character is a product of the kind of attitude reflected in favorite Missouri phrases like "The buck stops here" (from native son Harry Truman) and the "Show Me State," in outposts with names like Independence and Liberty and Agency. It is also a product of generations of vagabonds looking to hide out from the Pinkertons or the Feds, hucksters and scoundrels who could vanish out onto the open plains or into the city's smoky underbelly. To put it another way: the same city that nurtured all-American sweethearts like Ginger Rogers and Walt Disney also spawned Jesse James, Big Boss Pendergast, and the Mafioso "Willie the Rat."

The first pioneer to reach the riparian tributary where Kansas City now shimmers was, in fact, on the lam himself. An illegal fur trader by the name of Étienne de Veniard, Sieur de Bourgmont, he was fleeing French authorities after deserting his military post at Fort Detroit. Monsieur le Sieur slunk into the fertile lands of the Sioux and settled down with his Native American wife (he also had a bride back in France) to swap pelts with mountain men, trappers, and local tribes. Later, back in the graces of the French crown, he was appointed commander of the Missouri and built Fort Orleans in 1723. From there, he led groups of Kansa and Osage to scout for Spanish garrisons. After securing the region in the name of the House of Bourbon, he took a few favorite chiefs back to Paris, where they hunted with Louis XV and palled around Versailles. Whether the warriors enjoyed their time in Europe, it is not said, although one version of the story has it that when they returned—without Bourgmont, who had tired of the New World—they slaughtered all the soldiers who remained at his fort.

A century later, Lewis and Clark rowed up the Missouri on the first leg of their journey to find the Northwest Passage and reach the Pacific. Within a few decades, hundreds of thousands of pioneers and gold seekers were flooding into Kansas City—they called themselves, romantically and perhaps fatalistically, "Argonauts"—to stock up on staples at the Pike's Peak Express Company, which ran the fabled Pony Express. Three trails led out of Independence, just east of town—the California, which trekked up and over the treacherous Sierras; the Oregon, which tracked across the buffalo-rich plains to the Rockies and the thundering Columbia;

and the Santa Fe, which wound through Comanche country on its way south to Mexico. For every few wagons that left, another one straggled back—during one Gold Rush bust, the Kansas Historical Society notes, "the roads were strewn with culinary utensils . . . and oxen, teams and wagons were sold for a song."

My great-grandmother's grandparents would have passed through Kansas City en route to farm in Iowa, probably taking the Oregon Trail up the river to Omaha, then turning east along the Platte tributary. By the time my great-grandmother, Katie, was born, railroads raced across the land where wagon ruts still cut deep into the dry earth. It was an era when social reformers like Frederick Douglass and Sojourner Truth toured through the territories and Arabella Mansfield was sworn in as America's first female lawyer at Mount Pleasant. Meanwhile, Buffalo Bill's Wild West circus vamped off an idea of the plains that was already fast disappearing. Katie's family still traveled by covered wagon in the last decade before rail became king, roaming around Nebraska and the Dakotas as her father homesteaded outside of Deadwood and worked on the Burlington line. He never laid the tracks beyond Wyoming; one night, crossing a railroad trestle, he suffered a mortal fall into the Cheyenne River.

With younger siblings to feed, Katie—14, industrious, impossibly shy—was sent to work at a hotel owned by the Lamb family, a clan of backwoods warriors who had migrated down from the dark northern forests around Prairie du Chien and Bad Ax. The patriarch, Josiah, had fought with the 42nd Wisconsin Infantry, marching all the way to Kentucky to battle the Confederates. After the war's end, he took advantage of the boosterism campaigns to resettle in Nebraska. His youngest son, Orange Scott, was a rough-and-tumble trickster and a terrible tease. When he left to join the Spanish-American War, Katie kept a picture of him on a locket around her neck. After two years in the Philippines, he returned and they married, moving "back east" to Iowa, and then to Kansas City. There, Orange Scott ran the interurban, a turn-of-the-century electric trolley line that connected the boomtown with its exurbs. The cars had plush green upholstery and stained-glass windows and were faster and cheaper than a horse-and-buggy. "It could run 80 miles an hour," remembered one passenger long after the interurban had vanished. "You could hear the wires sing as it went down the road. They just sang you a song."

That song would soon morph from the jaunty clip of the light rail to the siren sounds of jazz. Under the protection of political boss Tom Pendergast, who ensured that Prohibition never infiltrated Kansas City, the '20s and '30s saw the town christened "The New Storyville," after New Orleans's scandalous red-light district. Down in the clubs around 18th and Vine, players like Charlie Parker and Count Basie developed a hard, bluesy style and jam sessions at the Hi Hat, the Hey Hey, and the Chocolate Bar went on late into the night. When police raided the joints (which rarely happened, since the federal prosecutor was in Pendergast's pocket), "the Boss man would have his bondsmen down at the police station before we got there," recalled Big Joe Turner, who worked at the time as a "singing barman" at fixtures like the Kingfish Club at The Sunset. "We'd walk in, sign our names, and walk right out. Then we would cabaret until morning."

Thanks to the jazz scene, the city fostered a thriving African American culture. "Kansas City, I would say, did more for jazz music, black music, than any other influence at all," the blues musician Jesse Stone once remarked. "Almost all their joints that they had there, they used black bands. Most musicians who amounted to anything, they would flock to Kansas City because that's the place where jobs were plentiful." Out at Municipal Stadium, the Kansas City Monarchs showcased Jackie Robinson and the great pitcher Satchel Paige; around the same time, Langston Hughes—raised in Joplin and Lawrence while his mother worked in Kansas City—wrote his first and most famous poem, "The Negro Speaks of Rivers," while studying at Columbia in New York. "I've known rivers ancient as the world and older than the flow of human blood in human veins." He was talking about the golden Mississippi, but he could have easily been describing the Missouri, flowing thickly through the aorta of his childhood home.

This image of Kansas City—the jazz, the booze joints, the levantine nightlife—is the one that Hollywood so loves, as do those of us drawn to noirish decadence and a concupiscent sort of decay. Gatsby and his West Eggers may have been tailored to New York's Roaring Twenties excess, but Kansas City could hold its own when it came to crime and sin. Pendergast's political machine ran all sorts of corrupt sidelines—it was no coincidence that the city's newest buildings were constructed with Pendergast Readi-Mix Concrete—and sewed up elections with bought votes. (Pen-

dergast's early patronage of Harry Truman would almost cost the Democrat the presidency.) Gangsters with ties to City Hall, like "Pretty Boy" Floyd and Eddie Richetti, littered the streets with bodies, casualties of their underworld wars. When Eddie and Floyd decided to bust the bank robber Frank Nash out of FBI custody, they ended up killing him and four unarmed agents in the 1933 Union Station massacre. Their handler for that gig, "Brother John" Lazia, ran the city's biggest gambling resorts, as well as illicit nightclubs, loan-shark operations, and bail bond companies. By 1934, he'd made enough enemies that someone decided to mow him down in the street with a sawed-off shotgun. His last words, or so they say, were woefully self-indulgent: "Why me, Johnny Lazia, who has been the friend of everybody?"

Yes, Kansas City was a city of chancers whose luck could turn on a dime—and this is where my father's side of the family comes in. My grandfather, Horace, arrived in town in the early '30s along with a passel of siblings searching for work (and apparently dodging a few warrants). The kids were descendants of Southerners who had fought in the Seminole Wars and founded Baptist parishes high on the Alabama plateau, where they quaked for Jehovah and prayed fervently for deliverance from the North. The family had grown up dirt-poor, sharecropping the 20,000 acres of cotton that stretched out below Sand Mountain. Horace was athletic and clever, known, probably apocryphally, as the fastest cotton picker in Clay County. He won a ticket to college on a basketball scholarship but had to drop out to support his siblings. At some point, the brothers decided to head up to Kansas City and found jobs at Armco, still known locally as Sheffield Steel. At its peak, the mill employed more than 4,500 workers as it churned out ironworks for FDR's war effort.

At the steel mill, Horace operated the overhead cranes and fell for one of the bookkeepers, the daughter of a small-town sheriff turned Kansas City cop. Margaret was straight-laced and churchgoing but her background was a bit wilder—her ancestors had lived way out on the prairie, in the same remote region where Jesse James fled after robbing the Kansas City fairgrounds and where Bleeding Kansas's border wars resulted in grisly trading post massacres. Her grandfather had been a physician and healer who—according to family lore—married a descendant of the Osage or Pawnee tribes. This may have accounted for Margaret's dark eyes

and her raven hair, or perhaps her features were from the Sephardic ancestors whose names we have lost but who show up in our DNA. In any case, she was a looker and Horace—with his blue eyes and his sweet-talking ways—won her over.

Old pictures of the couple show Horace decked out in a three-piece suit and diamond rings and Margaret swaddled in furs. My grandfather lived fast and large—he liked his liquor and his tobacco, and he was also an ace gambler. Gin rummy was his big game and he fraternized with high rollers like Minnesota Fats and Dean Chance. Anywhere there was a backroom card game or pool hall, from Los Angeles to Colorado Springs, Horace could be found—he supported the family off his winnings. One morning, when my uncle was in high school, he remembers waking up and seeing a large hearse parked outside the house. Horace had been playing poker with a mortician, who had put the car up as collateral. My grandfather was wickedly funny, with round cheeks and an infectious laugh, which usually indicated he was up to something naughty. Fortune laughed along with him—he won at all sorts of things, not only cards but raffles and games of chance. I guess you could say he was just a very lucky guy.

For his bride, Horace built a little brick house on Sixth Street, in Kansas City's Northeast quadrant, and that's where my father was born. One year later and 10 blocks away, my mother came into the world, the granddaughter of those pioneers who had roamed the prairie. Her mother, Virginia, was wry and hardy, just like her Nebraska ancestors; her father, Carl, was serious and civic; he studied law at Northwestern and the University of Missouri before losing his life savings in the stock market crash—a stroke of ill fate that left him forever cautious. During the Depression, his clients paid him in tea sets and fresh eggs; when he could no longer afford to stay in business, he joined the Chamber of Commerce. He was the type of man upon whom it weighed heavily that he had been too young to join the First World War and too old to join the Second.

Their neighborhood in Northeast was a place where kids played wiffle ball on streets lined with elms so broad they made a canopy over the passing cars, and where milkmen dropped daily deliveries on the back porch. It was also strongly Italian—Margaret learned to make meatballs and marinara from her neighbors, who had nicknames like "John-John" and "Uncle Charlie." No one will tell

me if this was one of the corners where the powerful Kansas City mafia took root; the question elicits ellipses. "They were wonderful cooks and had beautiful daughters," says my uncle. "Everyone was nice," says my mother, blithely, "and we all felt very safe."

Maybe the mob wasn't there, after all. Or maybe it just didn't fit into the neat narrative that postwar Kansas City liked to tell about itself—one where, in the words of Ernest Hemingway (who worked briefly for the *Kansas City Star*), the "food [was] good" and people spoke "the purest American." The best of the good food was barbecue, of course—slow-smoked ribs smothered in a thick tomato and molasses sauce at Arthur Bryant's, out near the A's stadium, or the lighter and tangier brisket across town at Gates. My grandfather also favored DiMaggio's deli, which peddled dishes that smacked of the Deep South, like sow's ear sandwiches and pickled pig's feet. Over at the Plaza, the architect J. C. Nichols was busy constructing that "purest American" myth, driven by a belief in the supremacy of leafy subdivisions. It was the age of consumption—TWA, based in Kansas City, made the metropolis a hub for traveling salesmen and women shopped at Harzfeld's, with its famous Thomas Hart Benton mural, while the men wore Woolf Brothers suits. That luxury store had been founded years earlier by Herbert Woolf, a relative of the British writers Leonard and Virginia. Their Kansas City cousin raised prizewinning ponies on 200 acres outside of town, and threw extravagant Jazz Age parties for the likes of Pendergast and Teddy Roosevelt—a lifestyle of excesses and vice, the type of thing that 1950s Kansas City preferred to leave behind.

It was in this buoyant baby boom atmosphere that my parents grew up. While they knew each other distantly as children (my mother remembers my dad as the one trying to kiss all the girls in Sunday school), they didn't really meet until they attended Northeast High. How do I begin to describe my father to you? Smart, so smart, and darkly handsome; a practical joker, large-hearted and fun. A wide-ranging curiosity. An inventive mind. That huge, voracious lust for life. Of course he would go for my mother—warm, friendly, with her Natalie Wood looks and her glass-half-full optimism. They started out dating each other's best friends, but soon my dad was driving my mom around in his little red Karmann Ghia. He took her to the Savoy Grill to eat lobster, and to his favorite Mexican joint for hot enchiladas. Occasionally, they'd head out

to the Starlight Theatre to catch a show, and to skateboard in the parking lot, my mother standing on my father's feet as he steered.

My father also had Horace's sense of flair. He was a fashionable dresser ("Madras was big in those days," says my mother) and collected unusual jewelry, like black sapphire rings. He was an excellent pool sharp and quick at poker and bridge. That's not to say he wasn't industrious—in college, after a full day of biology classes, he would work nights on the railroad or at the labs. But he also indulged in games on the side—he could deal a deck so fast that it would look like he'd cleanly cut the cards, when in fact he'd placed them strategically so. He and his best friend developed a racket where they would pretend to be strangers and clean up with the bets, my dad dealing his pal the winning hand. My father, who had a rich tenor, loved to sing songs from *Guys and Dolls,* especially "Sit Down, You're Rocking the Boat" ("I dreamed last night I got on the boat to heaven/And by some chance I had brought my dice along"). He, too, was a very lucky guy.

One summer, early in their relationship, my parents took jobs as camp counselors with the city. They'd drive around in a large bus, picking up kids from the poorest neighborhoods and taking them to play archery and other sports in the wooded parks. The children teased my parents about their budding romance and my parents, in turn, fell in love with their tiny wards. After they'd drop the children off at home—on blocks where the houses had no doors, where windows were covered with thin sheets to keep out the wind—my parents would go out on a date, then buy ice cream cones to take back to the kids at the end of the evening. Kansas City was still segregated at that point, and the old downtown around 18th and Vine suffered from terrible and endemic poverty. Racial inequalities simmered; in '68, they exploded. My parents watched the city burn from the roof of their college dormitory; elsewhere on campus, kids were burning their bras and their draft cards. Change was necessary—and when it came, it was violent, and it engulfed Kansas City's heart in transmutative flames.

By the time the Royals came to town in 1969, my father was growing restless. He wanted to see the world. In many ways, Kansas City is a leaving town, a place for pioneers and rovers with an eye on the distant horizon. And so, in 1972, when he got an offer to do his PhD in New England, my dad and my mother packed up and

moved east—truly east, original-colonies east. My father didn't go back to Kansas City much after that. He said it was because he hated the Midwest humidity, those sticky evenings that smother the lungs and send lightning storms racing across the plains. Now, I think he avoided it because of something that happened a few months after he left. One night, my grandfather Horace was driving home. Maybe he had been at a card game—wherever he was, it was late and he was speeding in the rain. A cop pulled him over; the rookie had his gun cocked; the gun went off. It was a terribly inauspicious accident. My father had to fly back to town to keep his uncles from enacting vigilante justice over the death. Margaret, in the blasted shock of sudden loss, sold most of her possessions and moved to Florida. And just like that, my father no longer had a home to go home to.

Perhaps this was the beginning of the end of my parents' Kansas City. Horace was gone; my mother's father soon followed. Her mother moved to the suburbs, her brothers moved to California. The trees that lined the spacious boulevards began dying from Dutch elm disease. Meanwhile, urban blight took over the downtown area. The mob ran wild, using the local Teamsters to run casinos in Las Vegas and bombing buildings along the River Quay. The FBI's bid to bust the Kansas City bosses for their involvement in the Tropicana Casino, dubbed Operation Strawman, eventually took down most of the Civella crime family. At the city's methadone clinics, addicts could run into William Burroughs, the once-great Beat, whose counterculture lifestyle had gone from glamorous to infirmly grim. And the Royals, after a brief run on top—reaching the championships in 1980 and winning the whole shebang in the "Show-Me Series" in '85—started their three-decade-long losing streak. The story of Kansas City that my relatives told, when I was growing up and would visit in the summers, was one in which a glorious yesterday had slid, perhaps irrevocably, into blighted decrepitude.

I don't know if that story is still true. Lately, the city has enjoyed something of a renaissance—the downtown is full of art galleries and food trucks, and even some hipsters; a new concert hall curves across the skyline. What has happened to the families who had to make way for the food trucks and the hipsters, I do not know; their story is not part of the tourism brochures. This new Kansas City, this shiny millennial town, is not my parents' city. This

city belongs to other people, a generation who may not know and may not care about the pioneer tracks that start in Independence, about the crime bosses and the Sunset Lounge, about the kids who used to play wiffle ball on Chelsea and Van Brunt, and the kids who couldn't afford wiffle balls down on 18th and Vine. Already, these things take on the air of fable. We are already at a degree of remove—it was my father who drove that convertible out to the Starlight, my mother who watched the holiday shoppers on the Plaza, not me, and assuredly I have gotten the details wrong, assuredly there are things that I will never know, already the past is slipping away. The gulf grows wider even as I write this. How many details are needed, after all, before one can say to oneself, "This is what I have lost"?

This inexorable change, time's riparian flow, is neither good nor bad, in the way that death is neither good nor bad—it just is.

The last time I visited Kansas City, it was the Fourth of July. We sat on the grass, in the hot twilight, watching the fireworks burst in patriotic showers of light over Independence. My mother called my father to let him hear the sounds of the cicadas singing their dying songs. A cousin took me to the National Frontier Trail Museum, where I jotted down dutiful notes. ("Before starting on the Oregon Trail, a typical family would need 600 lbs. of flour, 120 lbs. of biscuits, 400 lbs. of bacon, 200 lbs. of sugar . . .") I had no idea where we were headed that I would need this information, but maybe I could absorb a bit of where we came from. One thinks of the opening lines from a Hemingway short story: "In those days the distances were all very different, the dirt blew off the hills that now have been cut down, and Kansas City was very like Constantinople. You may not believe this. No one believes this; but it is true."

Before my father had his surgery, my brother wanted to get down all the stories about his Kansas City childhood. But for reasons that remain obscure, my dad refused. A week later, after so many bad breaks in the hospital, after so many things had gone unthinkably wrong—including a delirium in which my father dreamt the nurses were trying to break his spirit, a delirium that precipitated a heart attack and a Code Blue, a delirium we knew had broken when my dad made feeble jokes through his oxygen mask and tried to talk about Texas Hold'em with the orderlies—my father told me he wanted to record his early memories. "That's

a good idea, Daddy," I said. Instead, we held hands and I let him rest. I thought there was time. Twenty minutes later, the surgeons told us they needed to start on the 12-hour operation to save his arteries. He fought for two days, and I remember a moment when it seemed our luck was finally turning. Leaving the OR that night, I looked up at the clear sky, at the flocks of white seagulls and a sliver of crescent moon. It felt like a new beginning. That was the night my father died.

At the funeral, one of the hospital's nurses sent us a card. She had been there as my mother and I sat with him around the clock, sleeping by his bedside, anxiously checking his vitals. She said that whenever she came into the room, she had felt the radiation of a vast and unseen force. It was a force, she said, of tremendous love.

I think of this love, of my parents' love—for each other, for us— when I see the couples kissing in front of Kansas City's fountains, which now gush the color of Royals blue. My father used to swim in these fountains, to cool off from the heat and to make my mother laugh. Always the risk-taker, he would dive through the subterranean tunnels in the fountains in front of the art gallery, the ones with the beggars and the angels. My mother waited up above at the water's edge. Around them, Kansas City glowed in the midsummer dusk; ahead of them glimmered the future. And my father swam, down into the blue water to impress my mother—and beyond them the Missouri impassively flowed—and my mother stood by the water's edge, waiting for him to surface.

BRIAN PHILLIPS

The Sea of Crises

FROM GRANTLAND

The White Bird

WHEN HE COMES into the ring, Hakuho, the greatest *sumotori* in the world, perhaps the greatest in the history of the world, dances like a tropical bird, like a bird of paradise. Flanked by two attendants—his *tachimochi*, who carries his sword, and his *tsuyuharai*, or dew sweeper, who keeps the way clear for him—and wearing his embroidered apron, the *kesho-mawashi*, with its braided cords and intricate loops of rope, Hakuho climbs onto the trapezoidal block of clay, two feet high and nearly 22 feet across, where he will be fighting. Here, marked off by rice-straw bales, is the circle, the *dohyo*, which he has been trained to imagine as the top of a skyscraper: one step over the line and he is dead. A Shinto priest purified the *dohyo* before the tournament; above, a six-ton canopy suspended from the arena's ceiling, a kind of floating temple roof, marks it as a sacred space. Colored tassels hang from the canopy's corners, representing the Four Divine Beasts of the Chinese[1] constellations: the azure dragon of the east, the vermilion sparrow of the south, the white tiger of the west, the black tortoise of the north. Over the canopy, off-center and lit with spotlights, flies the white-and-red flag of Japan.

Hakuho bends into a deep squat. He claps twice, then rubs his hands together. He turns his palms slowly upward. He is barechested, six-foot-four and 350 pounds. His hair is pulled up in a topknot. His smooth stomach strains against the coiled belt at his waist, the literal referent of his rank: *yokozuna,* horizontal rope.

Rising, he lifts his right arm diagonally, palm down to show he is unarmed. He repeats the gesture with his left. He lifts his right leg high into the air, tipping his torso to the left like a watering can, then slams his foot onto the clay. When it strikes, the crowd of 13,000 souls inside the Ryogoku Kokugikan, Japan's national sumo stadium, shouts in unison: *"Yoisho!"— Come on! Do it!* He slams down his other foot: *"Yoisho!"* It's as if the force of his weight is striking the crowd in the stomach. Then he squats again, arms held out winglike at his sides, and bends forward at the waist until his back is near parallel with the floor. Imagine someone playing airplane with a small child. With weird, sliding thrusts of his feet, he inches forward, gliding across the ring's sand, raising and lowering his head in a way that's vaguely serpentine while slowly straightening his back. By the time he's upright again, the crowd is roaring.

In 265 years, 69 men have been promoted to *yokozuna*. Just 69 since George Washington was a teenager.[2] Only the holders of sumo's highest rank are allowed to make entrances like this. Officially, the purpose of the elaborate *dohyo-iri* is to chase away demons. (And this is something you should register about sumo, a sport with TV contracts and millions in revenue and fan blogs and athletes in yogurt commercials—that it's simultaneously a sport in which demon-frightening can be something's official purpose.) But the ceremony is territorial on a human level too. It's a message delivered to adversaries, a way of saying, *This ring is mine,* a way of saying, *Be prepared for what happens if you're crazy enough to enter it.*

Hakuho is not Hakuho's real name. Sumo wrestlers fight under ring names called *shikona,* formal pseudonyms governed, like everything else in sumo, by elaborate traditions and rules. Hakuho was born Mönkhbatyn Davaajargal in Ulaanbaatar, Mongolia, in 1985; he is the fourth non-Japanese wrestler to attain *yokozuna* status. Until the last 30 years or so, foreigners were rare in the upper ranks of sumo in Japan. But some countries have their own sumo customs, brought over by immigrants, and some others have sports that are very like sumo. Thomas Edison filmed sumo matches in Hawaii as early as 1903. Mongolian wrestling involves many of the same skills and concepts. In recent years, wrestlers brought up in places like these have found their way to Japan in greater numbers, and have largely supplanted Japanese wrestlers at the top of the rankings. Six of the past eight *yokozuna* promotions have gone

to foreigners. There has been no active Japanese *yokozuna* since the last retired in 2003. This is a source of intense anxiety to many in the tradition-minded world of sumo in Japan.

As a child, the story goes, Davaajargal was skinny. This was years before he became Hakuho, when he used to mope around Ulaan-baatar, thumbing through sumo magazines and fantasizing about growing as big as a house. His father had been a dominant force in Mongolian wrestling in the 1960s and '70s, winning a silver medal at the 1968 Olympics and rising to the rank of undefeatable giant. It was sumo that captured Davaajargal's imagination, but he was simply too small for it.

When he went to Tokyo, in October 2000, he was a 137-pound 15-year-old. No trainer would touch him. Sumo apprentices start young, moving into training stables called *heya* where they're given room and board in return for a somewhat horrifying life of eating, chores, training, eating, and serving as quasi-slaves to their senior stablemates (and eating). Everyone agreed that little Davaajargal had a stellar wrestling brain, but he was starting too late, and his reedlike body would make real wrestlers want to kick *dohyo* sand in his face. Finally, an expat Mongolian *rikishi* (another word for sumo wrestler) persuaded the master of the Miyagino *heya* to take Davaajargal in on the last day of the teenager's stay in Japan. The stablemaster's gamble paid off. After a few years of training and a fortuitous late growth spurt, Davaajargal emerged as the most feared young *rikishi* in Japan. He was given the name Hakuho, which means "white Peng"; a Peng is a giant bird in Chinese mythology.

Hakuho's early career was marked by a sometimes bad-tempered rivalry with an older wrestler, a fellow Mongolian called Asashoryu ("morning blue dragon"), who became a *yokozuna* in 2003. Asashoryu embodied everything the Japanese fear about the wave of foreign *rikishi* who now dominate the sport. He was hot-headed, unpredictable, and indifferent to the ancient traditions of a sport that's been part of the Japanese national consciousness for as long as there's been a Japan.

This is something else you should register about sumo: it is very, very old. Not old like black-and-white movies; old like the mists of time. Sumo was already ancient when the current ranking system came into being in the mid-1700s. The artistry of the *banzuke,* the traditional ranking sheet, has given rise to an entire school of cal-

ligraphy. Imagine how George Will would feel about baseball if he'd seen World Series scorecards from 1789. This is how many Japanese feel about sumo.

Asashoryu brawled with other wrestlers in the communal baths. He barked at referees—an almost unthinkable offense. He pulled another wrestler's hair, a breach that made him the first *yokozuna* ever disqualified from a match. *Rikishi* are expected to wear kimonos and sandals in public; Asashoryu would show up in a business suit. He would show up drunk. He would accept his prize money with the wrong hand.

The 600-pound Hawaiian *sumotori* Konishiki launched a rap career after retiring from the sport[3]; another Hawaiian, Akebono, the first foreign *yokozuna,* became a professional wrestler. This was bad enough. But Asashoryu flouted the dignity of the sumo association while still an active *rikishi.* He withdrew from a summer tour claiming an injury, then showed up on Mongolian TV playing in a charity soccer match. When sumo was rocked by a massive match-fixing scandal in the mid-2000s, a tabloid magazine reported that Asashoryu had paid his opponents $10,000 per match to let him win one tournament. Along with several other wrestlers, Asashoryu won a settlement against the magazine, but even that victory carried a faint whiff of scandal: the Mongolian became the first *yokozuna* ever to appear in court. "Everyone talks about dignity," Asashoryu complained when he retired, "but when I went into the ring, I felt fierce like a devil." Once, after an especially contentious bout, he reportedly went into the parking lot and attacked his adversary's car.

The problem, from the perspective of the traditionalists who control Japanese sumo, was that Asashoryu also won. He won relentlessly. He laid waste to the sport. Until Hakuho came along, he was, by an enormous margin, the best wrestler in the world. The sumo calendar revolves around six grand tournaments—*honbasho*—held every two months throughout the year. In 2004, Asashoryu won five of them, two with perfect 15–0 records, a mark that no one had achieved since the mid-1990s. In 2005, he became the first wrestler to win all six *honbasho* in a single year. He would lift 400-pound wrestlers off their feet and hurl them, writhing, to the clay. He would bludgeon them with hands toughened by countless hours of striking the *teppo,* a wooden shaft as thick as a

telephone pole. He won his 25th tournament, then good for third on the all-time list, before his 30th birthday.

Hakuho began to make waves around the peak of Asashoryu's invulnerable reign. Five years younger than his rival, Hakuho was temperamentally his opposite: solemn, silent, difficult to read. "More Japanese than the Japanese"—this is what people say about him. Asashoryu made sumo look wild and furious; Hakuho was fathomlessly calm. He seemed to have an innate sense of angles and counterweights, how to shift his hips a fraction of an inch to annihilate his enemy's balance. In concept, winning a sumo bout is simple: either make your opponent step outside the ring or make him touch the ground with any part of his body besides the soles of his feet. When Hakuho won, how he'd done it was sometimes a mystery. The other wrestler would go staggering out of what looked like an even grapple. When Hakuho needed to, he could be overpowering. He didn't often need to.

The flaming circus of Asashoryu's career was good for TV ratings. But Hakuho was a way forward for a scandal-torn sport—a foreign *rikishi* with deep feelings for Japanese tradition, a figure who could unite the past and future. At first, he lost to Asashoryu more than he won, but the rivalry always ran hot. In 2008, almost exactly a year after the Yokozuna Deliberation Council promoted Hakuho to the top rank, Asashoryu gave him an extra shove after hurling him down in a tournament. The two momentarily squared off. In the video, you can see the older man grinning and shaking his head while Hakuho glares at him with an air of outraged grace. Over time, Hakuho's fearsome technique and Asashoryu's endless seesawing between injury and controversy turned the tide in the younger wrestler's favor. When Asashoryu retired unexpectedly in 2010 after allegedly breaking a man's nose outside a nightclub,[4] Hakuho had taken their last seven regulation matches and notched a 14–13 lifetime record against his formerly invincible adversary.

With no Asashoryu to contend with, Hakuho proceeded to go 15-0 in his next four tournaments. He began a spell of dominance that not even Asashoryu could have matched. In 2010, he compiled the second-longest winning streak in sumo history, 63 straight wins, which tied a record set in the 1780s. He has won, so far, a record 10 tournaments without dropping a single match. When I arrive in

Tokyo, in early January 2014, Hakuho has 27 championships, two more than Asashoryu's career total and within five of the all-time record. That he will break the record is a foregone conclusion. He is in his prime, and since winning his first *basho* in May 2006, he has won more than half of all the grand tournaments held in Japan.

Watching Hakuho's ring entrance, that harrowing bird dance, it is hard to imagine what his life is like. To have doubled in size, more than doubled, in the years since his 15th birthday; to have jumped cultures and languages; to have unlocked this arcane expertise. To be followed on the street. To be a non-Japanese acting as a samurai-incarnate, the last remnant of a fading culture. At the time when I went to Tokyo, there was one other *yokozuna* in Japan, Harumafuji, another Mongolian. He was widely seen as a second-tier champion, and when I arrived he was out with an ankle injury. Hakuho is everything. How do you experience that without losing all sense of identity? How do you remember who you are?

But it's time, here at the Kokugikan, for his first match of the *hatsu basho,* the first grand tournament of the year. *Rikishi* in sumo's top division wrestle once per day during the 15-day derby; whoever has the best record at the end of the final day wins the Emperor's Cup. Hakuho opens against Tochiozan, a Japanese *komusubi*—the fourth-highest ranking, three tiers below *yokozuna.* Tochiozan is known for outmuscling his opponents by gripping their loincloth, the *mawashi.* The wrestlers squat at their marks. The referee stands between them in shining purple robes, holding his war fan up. The crowd calls Hakuho's name. There's a roar as the fighters lunge for one another. Nothing Hakuho does looks difficult. He spins slightly out of the way as Tochiozan grabs, unsuccessfully, for his *mawashi.* Then he uses his rotation as a windup to smash the other wrestler in the chest. Tochiozan staggers back, and Hakuho presses the advantage—one shove, two, three, and now Tochiozan is over the barrier, the referee pointing his war fan toward Hakuho's side to indicate victory. The entire match lasts four seconds.

He doesn't celebrate. He returns to his mark, bows to Tochiozan, and squats as the referee again points to him with the fan. Win or lose, sumo wrestlers are forbidden from betraying emotion. That was the sin Asashoryu used to commit; he'd raise a fist

after winning or snarl a happy snarl. Hakuho is not so careless. Hakuho is discreet. There are many crimes a *sumotori* can commit. The worst is revealing too much.

The Disappearing Sword

Some Japanese stories end violently. Others never end at all, but only cut away, at the moment of extreme crisis, to a butterfly, or the wind, or the moon.

This is true of stories everywhere, of course: their endings can be abrupt or oblique. But in Japan, where suicide is historically woven into the culture,[5] where an awareness of life's evanescence is the traditional mode of aesthetics,[6] it seems truer than in other places.

For instance: my second-favorite Japanese novel, *Snow Country,* by the 20th-century writer Yasunari Kawabata. Its last pages chronicle a fire. A village warehouse where a film has been playing burns down. We watch one of the characters fall from a fiery balcony. The protagonist runs toward her, but he trips in the crowd. As he's jostled, his head falls back, and he sees the Milky Way in the night sky. That's it. There is no resolution. It's left to the reader to discover how the pieces fit together, why Kawabata thought he had said everything he needed to say. Why he decided not to give away more than this.

The first time you read a story like this, maybe, you feel cheated, because you read stories to find out what happens, not to be dismissed at the cusp of finding out. Later, however, you might find that the silence itself comes to mean something. You realize, perhaps, that you had placed your emphasis on the wrong set of expectations. That the real ending lies in the manner of the story's turning away from itself. That this can be a kind of metamorphosis, something rich and terrifying and strange. That the seeming evasion is in fact a finality, a sudden reordering of things.

For instance: In January I flew to Tokyo to spend two weeks watching sumo wrestling. Tokyo, the city where my parents were married—I remember gazing up at their Japanese wedding certificate on the wall and wondering what it meant. Tokyo, the biggest city in the world, the biggest city in the history of the world, a galaxy reflected in its own glass. It was a fishing village barely

400 years ago, and now: 35 million people, a human concourse so vast it can't be said to *end*, only to fade indeterminately around the edges. Thirty-five million, almost the population of California. Smells mauling you from doorways: stale beer, steaming broth, charbroiled eel. Intersections where a thousand people cross each time the light changes, under J-pop videos 10 stories tall. Flocks of schoolgirls in blue blazers and plaid skirts. Boys with frosted tips and oversize headphones, camouflage jackets and cashmere scarves. Herds of black-suited businessmen. A city so dense the 24-hour manga cafés will rent you a pod to sleep in for the night, so post-human there are brothels where the prostitutes are dolls. An unnavigable labyrinth with 1,200 miles of railway, 1,000 train stations, homes with no addresses, restaurants with no names. Endless warrens of *Blade Runner* alleys where paper lanterns float among crisscrossing power lines. And yet: clean, safe, quiet, somehow weightless, a place whose order seems sustained by the logic of a dream.

It's a dream city, Tokyo. I mean that literally, in that I often felt like I was experiencing it while asleep. You'll ride an escalator underground into what your map says is a tunnel between subway stops, only to find yourself in a thumping subterranean mall packed with beautiful teenagers dancing to Katy Perry remixes. You will take a turn off a busy street and into a deserted Buddhist graveyard, soundless but for the wind and the clacking of *sotoba* sticks, wooden markers crowded with the names of the dead. You will stand in a high tower and look out on the reason-defying extent of the city, windows and David Beckham billboards and aerial expressways falling lightly downward, toward the Ferris wheel on the edge of the sea.

All that winter I had been forgetful. No one who knew me would have guessed that anything was wrong, because in fact nothing was wrong. It was only that things kept slipping my mind. Appointments, commitments, errands. My parents' phone number. Sometimes, and for minutes at a time, what city I was in. There is a feeling that comes when you open a browser window on a computer and then realize you have lost all sense of what you meant to do with it; I felt that way looking out of real windows. Some slight but definitive shift in my brain had separated me from my own thoughts. The pattern had changed and I could no longer read it; the map had altered and I could no longer find my way.

There was a reason for this, but instead of confronting it I was evading it, I was refusing to name it to myself. I would come up to the point and then trail off in the middle of the sentence. I kept myself in the margins of a safe semi-oblivion, around whose edges things kept erasing themselves. Of course I would go to Tokyo, I said when I was asked to write about sumo wrestling. Inwardly, I was already there.

I drifted through the city like a sleepwalker, with no sense of what I was doing or why. Professionally, I managed to keep up a facade of minimum competence, meeting with photographers, arriving on time for the first bell at the Kokugikan, taking notes. (I have: "arena French fry cartons made of yellow cardboard with picture of sumo wrestler printed on it." I have: "bottle openers attached to railings with string, so fans can open beer." I have: "seat cushions resting on elevated platforms, so fans can slide their shoes underneath.") Early one morning I stood in a narrow side street between a bike rack and a pile of garbage bags, spying on a sumo practice through windows steamed over from the heat of the bodies within. Occasionally a wrestler would come out and stand in the doorway (it was a sliding glass door, motion sensitive), sweat-slick and naked but for his brown *mawashi,* to let the winter air wash over him. We would look at each other, and not smile.

I wandered through Ryogoku, the neighborhood near the Kokugikan, past run-down *chanko* joints peddling the high-calorie protein stew that *rikishi* guzzle to gain weight. I followed wrestlers who were out running errands, crossing the street on the way to or from their stables: soft kimonos and wooden sandals, working their iPhone touchscreens with big thumbs or bopping their heads to whatever was playing in their earbuds. One afternoon I spied on a young *rikishi* who was sitting alone on a park bench, 375 pounds if he was an ounce, watching some tiny kids play soccer. He was sitting on the left side of the bench, and he was very careful not to let his kimono spread onto the other half of the seat, as though he were conscious that his bulk might impose on others. Every once in a while a mother would approach and give him her child to hold, and he would shake the little baby, very gently.

Most of the time, though, I was lost in Tokyo, and if I wound up anywhere I was supposed to be, anywhere I had agreed to be, it felt like a fortuitous accident. The disorientation I had experienced all winter latched onto Tokyo's calm madness and found a home in

it, like one of the silent water buses—glass beetles from a science-fiction film—that glide up the Sumida River.

Part of this had to do with another Japanese story, one I found myself increasingly preoccupied with, even though it had nothing to do with the wrestling culture I'd come to Japan to observe. This story fit into mine—or maybe the reverse—like the nesting sumo dolls I saw one afternoon in a *chanko* shop window, the smaller fighters enclosed in the larger, tortoises in a strange shell. It was a distraction, but unlike almost everything else during those weeks, I couldn't get it out of my mind.

On the flight to Tokyo, I brought a novel by Yukio Mishima. *Runaway Horses,* published in 1969, is the second book in his *Sea of Fertility* tetralogy, which was the last work he completed before his spectacular suicide in 1970. What happened was that he sat down on the floor and ran a dagger through his abdomen, spilling 20 inches of intestine in front of the general whom he had just kidnapped, bound, and gagged. He had taken the general hostage in his own office in the headquarters of the Japan Self-Defense Forces (SDF) in a failed attempt to overthrow the government of Japan. If you tour the building today, you can see the gouges the writer's sword left in the door frame when he fought off the general's aides.

Mishima was a contradiction. Handsome, rich, a perennial contender for the Nobel Prize, he was at 45 a national celebrity, one of the most famous men in the country. He was also possessed by an increasingly charismatic and death-obsessed vision of Japanese culture. After its defeat in the Second World War, Japan had accepted severe restraints on its military, had turned away from martial values. The SDF was the shadow of an army, not really an army at all. Mishima not only rejected these changes but found them impossible to bear. As a child, he had been sickly and sheltered. Now he worshiped samurai and scorned the idea of peace. He fantasized about dying for the emperor, dying horribly: he posed in an artist's photo shoot as the martyred St. Sebastian, his arms bound to a tree, arrows protruding from his sides.

In 1968, horrified by the scale of left-wing protests in Tokyo, Mishima founded a private army, the Tatenokai, advertising for soldiers in right-wing student newspapers. A married father, he had long haunted Tokyo gay bars. He fell in love with the Tateno-

kai's second-in-command, a young man called Masakatsu Morita, and began to imagine a coup attempt that would double as a kind of erotic transfiguration, an all-consuming climax of the sort that sometimes fell at the end of Kabuki melodramas.

And so in 1970 Mishima made an appointment to visit the head-quarters of the Self-Defense Forces accompanied by four young Tatenokai officers. He wore his brown Tatenokai uniform, sword in a scabbard at his belt. When the general asked to see the blade, a 17th-century weapon forged by the Seki no Magoroku line of swordsmiths, the writer requested a handkerchief to clean it. This was the signal for the four Tatenokai officers to seize the general and barricade the door.

Here is what I see when I picture this scene: the orange tassel hanging from the hilt of Mishima's sword. The twin rows of me-tallic buttons on the brown tunics of the Tatenokai officers. The polite smile on the general's face in the moment before he felt himself grabbed from behind.

Mishima went onto the general's balcony and delivered a fiery speech to the soldiers, around 1,000 of them, assembled below. He urged the members of the SDF to take their place as a true na-tional army, as warriors devoted to the emperor—a move that, had it succeeded, would have shattered the social structure of postwar Japan. He was asking the men to stage a coup. The soldiers jeered him. There is broad consensus among scholars that Mishima never expected the coup to succeed, that his only aim was to die glori-ously. But he had planned to speak for half an hour, and he gave up after seven minutes. "I don't think they even heard me," he said as he climbed in through the window. Back in the general's office, he unbuttoned his uniform jacket. The young officers could hear helicopters circling outside, police sirens wailing. Mishima sat down. He screamed. Then he drove the dagger with both hands into his stomach.

Here is what I think about when I envision this scene: the mo-ment earlier that morning when the Tatenokai officers, none older than 25, stopped to wash their car on the way to Mishima's house. Mishima joking on the drive about what sort of music would play in a yakuza movie at that moment. (He began to sing a song from the gangster flick *A Lion Amid Peonies;* the younger men joined in.) The gagged general's eyes bulging as one of Japan's most cel-ebrated writers committed seppuku on his floor.

"Please," Mishima gasped, "do not leave me in agony too long."
He was speaking to his lover, Morita, the student leader of the
Tatenokai, whose role in the ritual was to cut off Mishima's head.
In a formal seppuku, the *kaishakunin* decapitates the dying man,
sparing him the prolonged anguish of death by disembowelment.
Morita hacked at Mishima's neck but missed, slicing into his shoul-
der. He tried again and left a wound across his back. A third stroke
cut into the neck but not deeply enough. Finally another Tateno-
kai officer, a law student named Hiroyasu Koga, took the sword
from Morita—the writer's sword, the sword with the orange tas-
sel—and beheaded Mishima in one blow.

Morita, as planned, then knelt and tried to commit seppuku.
He was too weak. At his signal, Koga beheaded him too.

In the confusion afterward, as Koga and the other officers sur-
rendered, as reporters struggled to piece together the sequence of
events,[7] Mishima's sword was taken into custody by police. Some-
time later, it went missing.

Here is what I wonder when I try to imagine this scene: *What did
this feel like for Koga?* To have followed Mishima into that place, and
then, unexpectedly, to have been called on to cut off his head? To
have lived the rest of his life with that memory?[8] To have drifted
out of the center of the story, drifted into obscurity, carrying those
moments with him? At his trial, where he was sentenced to four
years in prison for (among other things) "murder by agreement,"
Koga said that to live as a Japanese is to live the history of Japan,
that the experience of each Japanese person is the experience of
the nation in microcosm. What a history he must have conceived,
I thought, to have said that, having done what he had.

On my third day in Tokyo I discovered that he was alive.

The Floating World

Watch the slow, sad figure of the *yobidashi* with his broom, end-
lessly sweeping the edges of the ring. For the long minutes be-
tween bouts, while the wrestlers move through their preparations,
this slight man circles gravely and patiently, smoothing sand, eras-
ing footprints. No mark can be allowed beyond the line because
the judges must be able to tell, from a glance, whether a toe has
landed outside the *dohyo,* whether a heel has slipped. Each *rikishi* is

called into the ring by a singer, then announced over the stadium loudspeakers by a voice that sounds strangled and furious, like an oboe filtered through the dive alarm on a submarine. Through this, the *yobidashi* sweeps.

The wrestlers face off at their marks, not once but twice, three times, squatting and flexing, glaring intimidation at each other. Then they break and walk to their corners, where they scoop salt out of a bowl and hurl it across the clay—another Shinto purification ritual. The *yobidashi* sweeps the salt, mixing it into the sand. Tall silk banners, representing sponsors' bonus prizes—extra money guaranteed for the winner of the bout—are carried around the ring on poles. The *yobidashi* sweeps around the banners. The wrestlers slap their bellies, slap their thighs, signaling massiveness to their enemies. The spectators, who know the routine, chat lightly, snap pictures, reach out to receive bags of snacks from the tea-shop waiters who circulate through the aisles. At the center of the ring, the referee poses and flits his fan, a luminary in silks; the hilt of his knife, which he wears as a reminder of the days when one wrong decision meant his immediate seppuku, peeks out from the sash at his waist. Through all this, the *yobidashi* sweeps.

Then the atmosphere changes. The crowd grows quiet. The *rikishi* toss one last handful of salt and stamp back to their marks, fat torsos shining. The referee's fan hangs in the air between them. And in the last split second before the combatants launch at one another, the *yobidashi*, who has never changed his pace, who has never at any point moved without perfect deliberation and slow, sad care, lifts his broom and steps down from the *dohyo.*

And here is something you should register about sumo: how intensely hierarchical it is. It is not only the *sumotori* who are ranked. Referees are ranked too. So are *yobidashi.*

Hakuho glides through his first five matches. On day 2, he lets the diminutive and root-vegetable-like Toyonoshima—five feet six inches tall and maybe five-foot-eight from rump to navel—push him almost to the edge of the ring, only then, when Toyonoshima lunges in with what looks like the winning shove, Hakuho just *isn't there;* Toyonoshima does an arms-flailing slapstick belly flop over the line. On day 3, Hakuho gets a grip on the *mawashi* of Okinoumi, a wrestler known for his movie-star looks. Okinoumi outweighs the *yokozuna* by 20 pounds, but Hakuho lifts him half off the clay and guides him out of the ring; it's like watching someone

move an end table. On day 4, against Chiyotairyu, a wrestler whose leg he once snapped in a match, Hakuho slams his adversary with the first charge, then skips aside; Chiyotairyu drops; the bout lasts one second. On day 5, he grapples with Ikioi, a physically strong wrestler known for controlling his opponent's *mawashi*. Hakuho ducks out of Ikioi's grasp, plants a hand on the back of his adversary's neck, and thrusts him to the floor. It takes a sumo novice perhaps 10 seconds of match action to see that among the top-class *rikishi*, Hakuho occupies a category of his own. What the others are doing in the ring is fighting. Hakuho is composing little haiku of battle.

There is a feeling of trepidation in the crowd over these first five days, because the Yokozuna Deliberation Council has come to the stadium to observe Kisenosato, a wrestler of the second rank, *ozeki*, who is being considered for promotion. This is a rare event. Unlike a *sumotori* of any other rank, a *yokozuna* can never be demoted, only pressured to retire, so the council must make its recommendation[9] with great care. It has 15 members, all sumo outsiders, professors and playwrights, dark-suited dignitaries from various backgrounds. For five days they tilt their heads back and scrutinize the action. They are austere and haughty, their lips as shriveled as bacon. The crowd is anxious because Kisenosato is Japanese, his country's best hope for a native-born *yokozuna*, and he has already failed in one promotion attempt.

After sumo's scandal-torn recent past, the desire for a native-born *yokozuna* is palpable.[10] The council has recently announced that if Kisenosato wins 13 matches here, he could be promoted even if he does not win the tournament. In fact, Kisenosato has never won a tournament, and the number of *yokozuna* of whom that could be said at the time of their promotion is very small.

The hope of Japan is sour-faced and prim, a six-foot-two, 344-pound maiden aunt in a crimson loincloth. His stomach protrudes inflexibly straight in front of him; his soft breasts hang to either side. When he enters the *dohyo*, his posture is erect. When he swings his arms before the fight, he does so with a strange, balletic slowness. On the first day, with the council looking on, he wrestles Toyonoshima, the root vegetable.

The crowd is afraid because Kisenosato is thought to be weak under pressure. The smack as their bellies collide is thunderous. Toyonoshima drives his stubby legs into the clay, trying to force

Kisenosato backward. Kisenosato gets a right-handed grip on Toyonoshima's pale green *mawashi*, but he fails to lift Toyonoshima, his hand slips off, and his fallback attempt to throw his opponent also fails. Now he is in trouble. Toyonoshima is a little locomotive, churning forward. The wrestlers' guts grind together. Muscles leap in their thighs. With a huge effort, Kisenosato grunts his way back to the center of the *dohyo*, gets Toyonoshima in check. Toyonoshima twists his torso hard to divert the larger man's momentum, and the throw works; Kisenosato's knee folds, and he goes over onto his back, then rolls over the edge of the clay platform and into the photographers' trench. He rests on his hands and knees, defeated, surrounded by flashbulbs.

On the fifth day, Kisenosato goes over the edge again, this time battered out by the frenzied shoves of Aoiyama, a gigantic Bulgarian. The frowns of the Yokozuna Deliberation Council go right to the pit of your stomach. There is talk later that Kisenosato has suffered a toe injury. Regardless, he will lose more than he wins at the *hatsu basho,* finishing 7-8, falling to Hakuho on day 13, and there will be no Japanese *yokozuna* in the sport that most embodies the history of Japan.

I thought about Hiroyasu Koga.

The drummer in the tower outside the Kokugikan started pounding his *taiko* at eight o'clock each morning of the grand tournament, but the elite wrestlers, like most of the crowd, didn't arrive till late afternoon, when the *makuuchi* division made its formal ring entrance. For a day or two it was fun to watch the skinny teenagers and midlevel hopefuls who wrestled first. But if I spent all day in the stadium, I started to feel like the *yobidashi* was sweeping around the edges of my brain rather than the edges of the *dohyo*.

So I wandered, lost, around Tokyo. I went to the shrine of Nomi no Sukune, the legendary father of sumo, who (if he lived at all) died 2,000 years ago. I went to the food courts in the basements of department stores. I thought I should look for the past, for the origins of sumo, so early one morning I rode a bullet train to Kyoto, the old imperial capital, where I was yelled at by a bus driver and stayed in a *ryokan*—a guest house—where the maid crawled on her knees to refill my teacup. I climbed the stone path of the Fushimi Inari shrine, up the mountain under 10,000 vermilion gates. I vis-

ited the Temple of the Golden Pavilion, rebuilt in 1955 after a mad monk burned it to the ground (Mishima wrote a novel about this), and the Temple of the Silver Pavilion, weirder and more mysterious because it is not actually covered in silver but was only intended to be. I spent 100 yen on a vending-machine fortune that told me to be "patient with time."

As of 2005, I learned from Wikipedia, Koga was a practicing Shinto priest on Shikoku, the smallest of Japan's main islands. I pictured him in his white robes, standing in a cemetery behind a dark gate.

Back in Tokyo, I thought the city was a river, the urban element somehow changed to liquid form. In New York, the storefronts come and go but the shape of things stays relatively stable, which is why you can, say, lay a photograph from the 1940s over a neighborhood scene from today. You marvel at the difference, but the edges connect. War, earthquakes, fire, and human ingenuity have annihilated Tokyo over and over again; the city never stops building because it never stops rebuilding. Change comes like a crash, like a wave, the crowd parting and then re-forming around whatever new reality has fallen from the sky. We were shopping for sunglasses, now we're eating ice cream, let's listen to music, let's take pictures with our phones.

The way you remember things in a dream is not precisely like remembering, yet anything you've experienced can come back to you in a dream. Under the shoguns, sumo wrestlers often appeared in *ukiyo-e*—meaning "pictures of the floating world"—woodblock prints from the pleasure districts whose other great subjects were courtesans and Kabuki actors, musicians and fishermen, archers and demons and ghosts. I went to a *ukiyo-e* exhibit and noted the wrestlers intermixed among the geisha, among the snarling samurai. Their bellies were rendered with one or two curved brushstrokes, their navels cartoon X's. Their eyes were oddly placid and I thought: *It will be a miracle if I can ever finish a thought.*

And I thought about Koga. I'm not sure why. I didn't know how I'd find him. I didn't know how I'd speak to him. But I priced tickets to Shikoku. I looked at the sumo schedule to figure out when I could get away. To be honest, Mishima's suicide had always struck me as somewhat absurd—in bad taste, at the very least. But I thought: *It is a small island. If I can get to the train station, I can walk to the shrine, and I will find him there.*

Then I looked at a map of Shikoku. "The smallest of Japan's main islands" covers 7,300 square miles, is home to 4.1 million people, and contains dozens of Shinto shrines. I gave up.

But I found that I couldn't give up. Whenever I stepped onto a subway train, whenever I rode an escalator up into the light, the idea came back, and I thought: *If I can track down the shrine, I will find him there.* I tried to locate a directory of Shinto sites on Shikoku—but how to make contact with one, how to ask for him?

Hello, yes, are you familiar with this celebrated author? Wonderful. Now, did one of your priests by any chance decapitate him in the early 1970s using a 400-year-old samurai sword that has since vanished?

It was an impossible question to imagine putting in English, much less Japanese. And I spoke no Japanese. I pictured the look on the face of whomever I roped into being my interpreter.

One thing struck me, though: the only source for the "Shinto priest in 2005" line on Wikipedia was a copied-and-pasted *Sunday Times* article that mentioned Koga only in passing. Even that article was hard to find online. What if it was misinformation? Perhaps Koga was no longer in Shikoku, or had never gone there. Perhaps he was a priest someplace else.

Finally I wrote an email to my friend Alex, a college professor who studies Japanese literature and film. "WEIRD JAPAN QUESTION" was the subject line. I asked if he had any thoughts about how I could track down Mishima's *kaishakunin*. I hit Send. And I waited for an answer, wandering through the city, lost. I listened to jazz in blue doorways. I pulled my coat a little tighter. I watched the setting sun float in pale high glass.

The Mandarin Ducks

In the Kokugikan there are stories of ghosts, sounds with no sources, invisible hands that seize you from behind. Security guards are reluctant to enter a certain hallway at night. A reporter from the *Asahi Shimbun* recalls being shoved in the back by something large and round, "like a volleyball," only to turn and find that "no one was there." A clerk is pulled from behind while using a urinal. The clatter of sumo practice comes from an empty dressing room. Somewhere under or near the stadium is said to be a mass grave containing victims of the great fire of 1657, which

razed two-thirds of Tokyo and killed 100,000. The shogun built a temple to commemorate the dead; the temple became the site of sumo matches whose popularity led to the construction of the first national arena in 1909.

Even to die in this country, you might say to yourself, is somehow to live the history of Japan. But this thought does not seem to weigh on the fans streaming through the gates under banners of watery silk, nor on the *gaijin* tourists lined up in the entrance hall to buy the little glitchy radios that offer audio commentary in English. The tourists talk about being tourists, and about the 1,000-yen deposit for the radios: Is it refundable or not? It is refundable. No one talks about ghosts.

Hakuho is frictionless, devastating. He wins his next eight matches. On day 10, Hakuho hits his fellow Mongolian, the 39-year-old Kyokutenho, so hard that the older man practically rolls out of the ring. On day 13, he wrestles Kisenosato, the Japanese *rikishi* who has flubbed his chance to be promoted to *yokozuna* and is fighting only for pride. The match is furious, Hakuho thrusting his open hand repeatedly into Kisenosato's neck; neither man can get a grip on the other's *mawashi*, so they simply bash one another, tactically berserk. Little violent nasal exhalations, the sound of a spray bottle's trigger being squeezed. Finally, with his foot braced on the edge of the rice-bale circle, Kisenosato twists to throw Hakuho and fails. The *yokozuna* loses his balance and lurches forward but Kisenosato also stumbles backward; Kisenosato's foot touches out of bounds a fraction of a second before Hakuho's hand. The *yobidashi* sweeps up the marks.[11]

On day 14, Hakuho wrestles Kotoshogiku, an *ozeki* from Fukuoka who specializes in bodying his opponents with his torso. Kotoshogiku seems to have grappled Hakuho to a standstill, the two men bent at the hips and clinging to one another in the middle of the *dohyo,* and then Hakuho slaps his left hand against Kotoshogiku's knee. Kotoshogiku crumples; the move is so unexpected and counterintuitive—and the end so sudden—that the match almost looks fixed. Hakuho shows no emotion. On the second-to-last day of the tournament he is 14-0 and one win away from a perfect championship—a *zensho yusho.*

His body is strange, Hakuho's. It's smooth, almost unformed, neither muscled like a boxer's nor bloated like that of many *rikishi.* Gagamaru, the Georgian wrestler who is currently the larg-

est man in top-division sumo—440 pounds and a little over six feet tall—looks like a canyon seen from the air, all crevasses and folds. Hakuho, by contrast, is a single large stone. His face is vague, broad so that his eyes look small and rimless, but also inexpressive, self-contained. Once in a while he will glance to one side with what looks like critical intelligence. Then he blurs again. The sources of his strength, whether physical or psychological, are almost totally hidden from view.

Another Mongolian, the *ozeki* Kakuryu, has fought his way to a 13-1 record, making him the only *rikishi* with a chance to tie Hakuho and force a playoff. Kakuryu is the son of a university professor who, unlike Hakuho's father, had no background in Mongolian wrestling. With the championship at stake, he and Hakuho are scheduled to meet on the tournament's final day.

"Re: WEIRD JAPAN QUESTION" dinged into my inbox in the middle of the night. "Sounds like a cool piece," Alex wrote. He had looked into the Koga question, and as far as he could tell, Shikoku was a red herring. Koga had never lived there. Nor was he a Shinto priest. He had indeed joined a religious group, but it was Seicho-no-Ie, "the House of Growth," a spiritual movement founded in the 1930s. Seicho-no-Ie fuses Christianity with Buddhism and Shintoism. After prison, Koga became the head of its branch in Hokkaido, the snowy island in northern Japan where he had been born and raised. He married the daughter of the group's leader and changed his name to reflect that he'd been adopted into her family: Hiroyasu Arechi. "Arechi" was an unusual Japanese name, formed from characters that meant "wild land" or "barren ground." "If you want to get really literary," Alex told me, "Arechi" was also a Japanese translation of the title of T. S. Eliot's poem "The Waste Land." But that was only a coincidence.

Seicho-no-Ie struck a chord, so I looked it up in one of the Mishima biographies. There it was: the writer's grandmother had been a member. When Koga said at his trial that to live as a Japanese is to live the history of Japan, he was quoting one of the group's teachings.

Then Alex sent me a link that made me cover my mouth with my hand. Koga/Arechi retired in 2012 and moved to the other end of the country, to the city of Kumamoto, on the southern island of Kyushu. The link led to a video from the website of an

apartment complex in Kumamoto. In it, a 65-year-old man named Hiroyasu Arechi answers questions about being a new resident. He mentions at the beginning that he is from Hokkaido. He wears a black V-neck sweater over a red-and-white gingham sport shirt. His features match those of the young Koga in a photograph I'd seen of him posing with fellow Tatenokai conspirators, looking fierce in their ridiculous faux-military uniforms.

The older man in the video has warm eyes. As he speaks, we see a bit of his apartment in the background. Flowers hanging on a light-flooded balcony. A cream-colored curtain, tied back. An inset picture on the website shows a console table that holds framed photographs of what look like children and grandchildren. A couple holding hands in front of a landscape. Young people at a wedding. A man or woman in a parka, smiling, surrounded by snow.

He does not mention decapitation or suicide or Mishima. He says that the bus is very convenient to the building. The sales representatives are compassionate and polite. The park nearby is a good place to take walks. There is a MaxValu store across the street, open 24 hours, a handy place to shop. There is a roof garden. He has a wide balcony. There are beautiful views at night.

I remember the auditorium of the Kabuki-za Theater, warm and high and tinted by lights reflecting off the lavish pictorial curtains—herons in a stream, Mount Fuji, a hummingbird breaking out of a tangle of cherry blossoms. Tiny old ladies in surgical masks sat with bento boxes resting on their knees, looking pleased; packs of theater kids sprawled in fishnet tights. Old men slept in their chairs with both hands balanced on their canes. The Kabuki play I had come to see was about sumo, or involved sumo; I was not entirely sure. The English-language audio guide I had rented was unclear about the details. The play's story was fantastically complex, and was itself only a tiny peripheral fragment of a larger story about two brothers seeking revenge for the murder of their father, a revenge that spanned decades and flowed inexorably from an equally long backstory. The story when the curtain opened, however, was simple. It was a story about love.

A beautiful young woman was adored by two men. She herself loved the handsome youth with the impossibly sad white face, but the burly cross-eyed villain with the orange-red face was determined to win her hand. The villain (I learned from the voice in my

ear) had never lost a sumo wrestling match. So the youth with the sad white face and the wrestler with the orange-red face wrestled to decide who would marry the woman. They danced this, spinning slowly and not quite touching their hands. At last the youth with the sad white face won the match. But the cross-eyed villain explained in an evil aside to the audience that he would yet betray the lovers. Spotting a pair of Mandarin ducks in the lake, he threw his dagger and killed the male (a little wooden duck turned upside down, like a prop in a parking-lot carnival). The villain explained that if he could trick the youth into drinking the duck's blood, it would drive him mad. And he did so.

But the Mandarin duck is a symbol of marriage, of fidelity, and now, in some mystical way, the two young lovers began to swirl. They swirled until they became the ducks. They became, by magic, the souls of the ducks. They took to the air on bright wings. They had become transcendent, timeless. On the same ground where the sumo match was fought, the duck-souls attacked the wrestler. They danced this, darting and bending their backs. The ducks drove the cross-eyed villain to the ground, making him even more cross-eyed. Then the lovers' costumes turned inside out, revealing brilliant plumage, plumage like an illustration in a children's book, feathers as vivid as fire. Then they all froze in place and the curtain dropped.

The Reconstructed Castle

Yukio Mishima's novel *Runaway Horses* tells, in part, the story of a samurai rebellion. In 1868 the reign of the shoguns ended and power reverted back to the emperor of Japan, or (because nothing is ever as simple as the official story) to a group of powerful men acting in his name. One of the consequences of this event, which is called the Meiji Restoration, was that the large samurai class that had governed Japan for hundreds of years[12] was stripped of its power and dissolved. Imperial edicts forced members of the former warrior caste to stop styling their hair in topknots, to stop carrying swords.

In 1876, a group of 200 reactionary ex-samurai called the League of the Divine Wind launched a surprise nighttime attack on the castle in the city of Kumamoto, on the southern island of Kyushu.

As the barracks burned, they drove back the conscript soldiers of the Imperial Army, wounding hundreds and killing the wounded. Fires broke out everywhere. "Even his garments, drenched in enemy blood, glowed crimson in the flames," Mishima writes of one samurai. At last the soldiers regrouped and reached their guns and ammunition. The League, whose aim was to eradicate all traces of Westernization and return Japan to its feudal past, had chosen to fight with swords. With no firearms, the samurai were decimated. The leader of the attack, gravely wounded, called on a follower to cut off his head. Most of the survivors committed seppuku.

Old buildings in Japan are seldom really old. A country that builds with wood instead of stone runs the constant risk of losing its monuments to fire. Ancient shrines are really copies of ancient shrines. The Imperial Palace in Kyoto has been rebuilt eight times, and its current layout would make no sense to any emperor who lived there. The main keep of Kumamoto Castle, which burned to the ground in another samurai uprising in 1877, was reconstructed from concrete in 1960. The forms return again and again. They end violently, and they never end at all. To live as a Japanese, Koga said, is to live the history of Japan.

His building is there. Koga's, I mean. In Kumamoto. Just down the hill from the castle. I found him a few hundred yards from the scene of the battle in the book that made me think of him in the first place.

A trip on the Shinkansen train from Tokyo to Kumamoto takes about six hours. You change in Osaka. The train passes just below Mount Fuji at the start of the trip and stops near the end at Hiroshima, where it looks out on the baseball stadium. As it hurtles south, you pass into a misty country where hills drift toward you like ghost ships. If it's raining when you get out at Kumamoto Station, you can buy a clear plastic umbrella for 350 yen from a bucket in the station shop. If you have time and don't mind getting wet, you can walk into town along the river, the Shirakawa, which lies in a wide, ugly basin.

The castle is on a hill in the center of the city. There is a tiny parking lot at the base of the hill with a vending machine that sells Boss-brand hot coffee. The castle's fortifications merge with the hillside just behind the parking lot, a tortoiseshell of large, dark stones too steep to climb.

His building is down the hill. A five-minute walk, if that. Come

around the slope and you will see the complex, a series of squat, identical gray blocks, each maybe 11 stories tall. Cars speed by on a busy street. A security guard in a gray jacket and white motorcycle helmet stands beside the gate, near some orange traffic cones. The complex's sign, printed in English on a black stone fence, is intersected at intervals by purple neon bars.

There is a bus stop very convenient to the building. There is a MaxValu just across the street.

So this is where I am. I am standing in the parking lot of the Max-Valu. It is four o'clock in the afternoon. The air is drizzly and cool. The cars that turn in to the lot are blunt, compact hatchbacks, little modern microvans in gold and pale blue and white. They are shaped like sumo wrestlers, I think, and it hits me that sumo is essentially a sport of refusing to die, refusing to be swept away, refusing to accept the insolidity of the dream. It was a street entertainment, really, until the early 20th century. Then the samurai tradition burned down and had to be rebuilt.

And soon I will think about this while I watch Hakuho wrestle Kakuryu on the TV in my hotel room, on what is supposed to be the last match of the last day of the tournament: Hakuho missing his chance to seize Kakuryu's *mawashi* just as Kakuryu wins a two-handed grip on his. Kakuryu literally leaping forward with spasmodic sliding jumps, backing the *yokozuna* to the edge of the rice-bale circle, where Hakuho's knees and then his ankles will flex frantically, until he goes toppling, the greatest wrestler in the world, off the edge of the clay, twisting onto his stomach as he falls. When he gets to his feet, Hakuho will offer no reaction. A few minutes later, in the playoff match to break their identical 14-1 records, he will grapple Kakuryu in the middle of the ring and then drop his hips and lift Kakuryu halfway off the sand and force him backward. They will both fall out of the ring at the same moment, but Kakuryu's foot will touch first, giving Hakuho the Emperor's Cup and his 28th tournament championship. The *yobidashi* will sweep the marks away.[13] Hakuho will smile slightly, not a smile that is meant to be read.

But that will happen later. Now I am leaning on a railing in the parking lot of the MaxValu, thinking about endurance at four o'clock in the afternoon. I am looking across a busy street at the apartment complex of the man who beheaded Yukio Mishima and

then lived a whole life afterward, lived another 40 years. I think: *He is in there.* I think: *It is time to decide what to do.*

I get up and move toward the crosswalk. The wind is damp. It's January, so I don't see any butterflies. It is a cloudy day, so I do not see the moon.

Notes

1. Japanese mythology, like many aspects of early Japanese culture, was heavily influenced by China.

2. There are two additional *yokozuna* who supposedly practiced before 1749, but it's only with the ascension that year of Maruyama Gondazaemon, the third holder of the title, that we reach a point where we can be pretty sure about names and dates and whether people actually existed outside folklore, etc.

3. Sample lyrics: "Built to last, like an Energizer bunny/Pushin' 700, and still makin' money."

4. After chasing him into the street and into a taxi, allegedly.

5. The extent of Japan's suicide problem is sometimes overstated by the media, but Japan may be unique in the way that suicide has been historically celebrated and seen as an honorable rather than a shameful act.

6. E.g., the concept of *mono no aware*, which translates into something like "a pleasing sadness at the transience of beautiful things." The literary scholar Motoori Norinaga coined this idea in the mid-18th century to describe *The Tale of Genji*, the great Heian-period novel whose author—perhaps deliberately—left it unfinished. When the protagonist dies late in the book, his death is never mentioned directly; instead, it's marked by a blank chapter called "Vanished into the Clouds."

7. There had been no public instances of seppuku in Japan since the war era; incredulous editors concluded that their writers were getting the story wrong. One newspaper's late-afternoon edition ran with the headline "Injured Mishima Rushed to Hospital."

8. Koga, too, was prepared to commit seppuku—all the young men were—but shortly before the coup attempt, Mishima ordered them to live, charging them to explain his actions to the world.

9. The advice of the Yokozuna Deliberation Council carries immense weight, but the Japan Sumo Association has final say in all promotions.

10. Although in fairness, Japanese *rikishi* have been involved in their share of controversy; of Hakuho's first five opponents, two were among the more than a dozen wrestlers suspended in 2010 for illegally betting on baseball.

11. In the four tournaments since his losing effort in January, Kisen-

osato has gone 9-6, 13-2, 9-6, and 9-6. He has yet to win a championship and has not been promoted to *yokozuna*.

12. The 20th-century Western idea of the samurai as an armored warrior, a kind of Japanese knight, is not particularly accurate. Some samurai were warriors, and samurai were licensed to carry swords. But by the 19th century the samurai class had evolved into a kind of hereditary government bureaucracy. Many were officials whose roles had nothing to do with war.

13. In the Osaka tournament two months later, Kakuryu beat Hakuho, won the championship, and earned a promotion to *yokozuna*. Hakuho being Hakuho, however, he won the next three tournaments, including last month's fall *basho* in Tokyo. He now has 31 championships, one short of the record.

In Deep

FROM THE NEW YORKER

ON HIS 13TH day underground, when he'd come to the edge of the known world and was preparing to pass beyond it, Marcin Gala placed a call to the surface. He'd traveled more than three miles through the earth by then, over stalagmites and boulder fields, cave-ins and vaulting galleries. He'd spidered down waterfalls, inched along crumbling ledges, and bellied through tunnels so tight that his back touched the roof with every breath. Now he stood at the shore of a small, dark pool under a dome of sulfurous flowstone. He felt the weight of the mountain above him—a mile of solid rock—and wondered if he'd ever find his way back again. It was his last chance to hear his wife and daughter's voices before the cave swallowed him up.

"Base camp, base camp, base camp," he said. "This is Camp Four. Over." His voice traveled from the handset to a Teflon-coated wire that he had strung along the wall. It wound its way through sump and tunnel, up the stair-step passages of the Chevé system to a ragged cleft in a hillside 7,000 feet above sea level. There, in a cloud forest in the state of Oaxaca, Mexico, lay the staging area for an attempt to map the deepest cave in the world—a kind of Everest expedition turned upside down. Gala's voice fell soft and muffled in the mountain's belly, husky with fatigue. He asked his seven-year-old, Zuzia, how she liked the Pippi Longstocking book she'd been reading, and wondered what the weather was like on the surface. Then the voice of Bill Stone, the leader of the expedition, broke over the line. "We're counting on you guys," he said.

"This is a big day. Do your best, but don't do anything radical. Be brave, but not too brave."

Gala had been this deep in the cave once before, in 2009, but never beyond the pool. A baby-faced Pole of unremarkable physique—more plumber than mountaineer—he discovered caving as a young man in the Tatra Mountains, when they were one of the few places he could escape the strictures of Communism. When he was 17, he and another caver became the first people to climb, from top to bottom, what was then the world's deepest cave, the Réseau Jean Bernard, in the French Alps. Now 38, he had explored caves throughout Europe and Ukraine, Hawaii, Central America, and New Guinea. In the off-season, he was a technician on a Norwegian oil platform, dangling high above the North Sea to weld joints and replace rivets. He was not easily unnerved. Then again Chevé was more than usually unnerving.

Caves are like living organisms, James Tabor wrote in *Blind Descent,* a book on Bill Stone's earlier expeditions. They have bloodstreams and respiratory systems, infections and infestations. They take in organic matter and digest it, flushing it slowly through their systems. Chevé feels more alive than most. Its tunnels lie along an uneasy fault line in the Sierra de Juárez mountains and seethe with more than seven feet of rain a year. On his first trip to Mexico, in 2001, Gala nearly died of histoplasmosis, a fungal infection acquired from the bat guano that lined the upper reaches of a nearby cave. The local villagers had learned to steer clear of such places. They told stories of a malignant spirit that wandered Chevé's tunnels, its feet pointing backward as it walked. When Western cavers first discovered the system, in 1986, they found some delicate white bones beneath a stone slab near the entrance: the remains of children probably sacrificed there hundreds of years ago by the Cuicatec people.

When the call to base camp was over, Gala hiked to the edge of the pool with his partner, the British cave diver Phil Short, and they put on their scuba rebreathers, masks, and fins. They'd spent the past two days on a platform suspended above another sump, rebuilding their gear. Many of the parts had been cracked or contaminated on the way down, so the two men took their time, cleaning each piece and cannibalizing components from an extra kit, knowing that they'd soon have no time to spare. The water here

was between 50 and 60 degrees—cold enough to chill you within minutes—and Gala had no idea where the pool would lead. It might offer swift passage to the next shaft or lead into an endless, mud-dimmed labyrinth.

The rebreathers were good for four hours underwater, longer in a pinch. They removed carbon dioxide from a diver's breath by passing it through canisters of soda lime, then recirculating it back to the mouthpiece with a fresh puff of oxygen. Gala and Short were expert at managing dive time, but in the background another clock was always ticking. The team had arrived in February, three months before the rainy season. It was only mid-March now, but the weather wasn't always predictable. In 2009, a flash flood had trapped two of Gala's teammates in these tunnels for five days, unsure if the water would ever recede.

Gala had seen traces of its passage on the way down: old ropes shredded to fiber, phone lines stripped of insulation. When the heavy rain began to fall, it would flood this cave completely, trickling down from all over the mountain, gathering in ever-widening branches, dislodging boulders and carving new tunnels till it poured from the mountain into the Santo Domingo River. "You don't want to be there when that happens," Stone said. "There is no rescue, period." To climb straight back to the surface, without stopping to rig ropes and phone wire, would take them four days. It took three days to get back from the moon.

The truth is they had nowhere better to go. All the pleasant places had already been found. The sunlit glades and secluded coves, phosphorescent lagoons and susurrating groves had been mapped and surveyed, extolled in guidebooks, and posted with Latin names. To find something truly new on the planet, something no human had ever seen, you had to go deep underground or underwater. They were doing both.

Caving is both the oldest of pastimes and the most uncertain. It's a game played in the dark on an invisible field. Until climbing gear was developed, in the late 19th century, a steep shaft could end an expedition, as could a flooded tunnel—cavers call them terminal sumps. If an entrance wasn't too small or a tunnel too tight, the cave could be too deep to be searched by torch or candlelight. In the classic French caving books of the 1930s and '40s, *Ten Years Under the Earth*, by Norbert Casteret, and *Subterra-*

nean Climbers, by Pierre Chevalier, the expeditions are framed as manly jaunts belowground—a bit of stiff exercise before the lapin chasseur back at the inn. The men wear oilskins and duck-cloth trousers, carry rucksacks and rope ladders, and light their way with a horse-carriage lantern. At one point in *Subterranean Climbers,* a sweet scent of Chartreuse fills the air and the party realizes, with dismay, that their digestif has come to grief against a fissure wall. Later, a rock tumbles loose from a shaft and conks a caver named François on the head, causing some discomfort. The victim, Chevalier notes with regret, was "poorly protected by just an ordinary beret."

Chevalier and his team went on to map more than 10 miles of caverns in the Dent de Crolles, outside Grenoble. Along the way, they set the world depth record—2,159 feet—and developed a number of caving tools still used today, including nylon ropes and mechanical ascenders. Casteret may have done even more to transform the sport. In the summer of 1922, he was hiking in the French Pyrenees when he noticed a small stream flowing from the base of a mountain. He shucked off his clothes and lit a candle, then wedged himself through the crack and waded in. The tunnel followed the stream for a couple of hundred feet, then dipped below the waterline. Rather than turn back, Casteret set his candle on a ledge, took a deep breath, and swam ahead, groping the wall till he felt the ceiling open up above him. He went on to explore many miles of tunnels inside the cave, culminating in a pair of large, airy galleries. The first was covered in spectacular limestone formations. The second was smaller and drier, with a dirt floor. When Casteret held his candle up to its walls, the flame flickered over engravings of mammoths, bison, hyenas, and other prehistoric beasts—the remains of a religious sanctuary some 20,000 years old.

Casteret and Chevalier helped turn caving into a heroic undertaking, and the search for the world's deepest cave into an international competition—a precursor to the space race. "Praise Heaven, no one can give France lessons in this matter of epic achievement," Casteret wrote, in his preface to Chevalier's book. "The race of explorers and adventure-seekers has not died out from our land." By combining lighter, stronger climbing gear with scuba tanks, cavers went deeper and deeper into the earth, more than tripling Chevalier's depth in the next 60 years. The record

would bounce between France, Spain, and Austria (where one of Gala's teams went below 5,300 feet at Lamprechtsofen in 1998), before settling in the Republic of Georgia, in 2004.

A cave's depth is measured from the entrance down, no matter how high it is above sea level. When prospecting for deep systems, cavers start in mountains with thick layers of limestone deposited by ancient seas. Then they look for evidence of underground streams and for sinkholes—sometimes many miles square—where rain and runoff get funneled into the rock. As the water seeps in, carbon dioxide that it has picked up from the soil and the atmosphere dissolves the calcium carbonate in the stone, bubbling through it like water through a sponge. In Georgia's Krubera Cave, in the Western Caucasus, great chimneylike shafts plunge as much as 500 feet at a time, with crawl spaces and flooded tunnels between them. The current depth record was set there in 2012, when a Ukrainian caver named Gennadiy Samokhin descended more than 7,200 feet from the entrance—close to a mile and a half underground.

The Chevé system is even deeper. Drop some fluorescent dye into the stream at the entrance, as a teammate of Stone's did in 1990, and it will tumble into the Santo Domingo eight days later, 11 miles away and 8,500 feet below. No other cave in the world has such proven depth (though geologists suspect that some caves in China, New Guinea, and Turkey go even deeper). But that isn't enough to set a record: cave depths, unlike mountain heights, are inherently subjective. Everest was the world's tallest peak long before Edmund Hillary and Tenzing Norgay scaled it. But a cave is only officially a cave when people have passed through it. Until then, it's just another hole in the ground.

Deep caves rarely call attention to themselves. Like speakeasies and opium dens, they tend to hide behind shabby entrances. A muddy rift will widen into a shaft, a crawl space into a vaulting nave. Krubera begins as a grave-size hole full of moss and crows' nests. When local cavers first explored it, in 1960, they got less than 300 feet down before the shaft leveled off into an impassable squeeze. It was more than 20 years before the passage was dug out, and another 17 before a side passage revealed the vast cave system beneath it. Yet the signs were there all along. The bigger the cave,

the more air goes through it, and Krubera was like a wind tunnel in places. "If it blows, it goes," cavers say.

Chevé has what cavers call a Hollywood entrance: a gaping maw in the face of a cliff, like King Kong's lair on Skull Island. A long golden meadow leads up to it, bordered by rows of pines and a stream that murmurs in from the right. It feels ceremonial somehow, like the approach to an altar. As you walk beneath the overhang, the temperature drops, and a musty, fungal scent drifts up from the cave's throat, where the children's bones were found. The stream passes between piles of rubble and boulders, their shadows thrown into looming relief by your headlamp. Then the walls close in and the wind begins to rise. It's easy to see why the Cuicatec felt that some dark presence abided here—that something in this place needed to be appeased.

Like Krubera, Chevé starts with a precipitous drop: 3,000 feet in less than half a mile. But then it levels off to a more gradual slope: to go another vertical mile, you have to go 10 miles horizontally, at least half a mile of it underwater. Although the water eventually gathers into a single stream, the cave's upper reaches are full of oxbows and tributaries, meandering and intertwining through the rock, paralleling one another for a stretch, then veering apart or abruptly ending. It's tempting to imagine the system as a giant Habitrail, with cavers scurrying through it. But these tunnels weren't meant for inhabitants. They're geological formations, differentially eroded, their soft deposits ground down to serrated edges or carved into knobs and spikes that the body has to contort itself around. A long squirm down a tight shaft will lead to an even longer crawl, a slippery descent, and so on, in a natural obstacle course, relentless in its challenges. Near the main entrance, there's a 30-foot section known as the Cat Walk, where a caver can hoist his pack and stroll forward without thinking. It's the only place like it in the system. "Every other piece of this cave might kill you," Gala told me.

Bill Stone has led seven expeditions to Chevé in the past 10 years, all but one of them with Gala. In 2003, his team dove through a sump that had thwarted cavers for more than a decade, then climbed down to nearly 5,000 feet, making Chevé the deepest cave in the Western Hemisphere. But there was no clear way forward: the main passage ended in a wall of boulders. The only

option was to try to bypass the blockage by entering the system far-
ther downslope. The following spring, Stone sent teams of Polish,
Spanish, Australian, and American cavers bushwhacking across the
cloud forest in search of new entrances. They found more than
100, including a spectacular cliff-face opening called Atanasio.
The most promising, though, was a more modest but gusty open-
ing labeled J2 (the "J" was for *jaskinia*—Polish for "cave"). It was
wide open at the top, but pinched tight as soon as you went down.
The Australians called it Barbie.

The J2 system runs roughly parallel to the main Chevé passage
and about 1,000 feet above it. The water's exact course through
the mountain is hard to predict, but cave surveys and Stone's 3-D
models suggest that the two systems eventually merge. If Gala and
Short could get past the sump beyond Camp Four, their route
should join up with Chevé, drop another 2,500 feet, and barrel
down to the Santo Domingo. "Imagine a storm-tunnel system in
a city," Stone told me. "All these feeders connect to a trunk and
then go out to an estuary. We're in the back door trying to get into
that primary conduit." This is it, he said. This is the big one. "If
everything goes well, we'll be as far as anyone has ever been inside
the earth."

Deep caving demands what Stone calls siege logistics. It's not so
much a matter of conquering a cave as outlasting it. Just to set up
base camp in Mexico, his team had to move six truckloads of mate-
rial more than 1,200 miles and up a mountain. Then the real work
began. Exploring Chevé is like drilling a very deep hole. It can't be
done in one pass. You have to go down a certain distance, return to
the surface, then drill down a little farther, over and over, until you
can go no deeper. While one group is recovering on the surface,
the other is shuttling provisions farther into the cave. Stone's team
had to establish four camps underground, each about a day's hike
apart. Latrines had to be dug, ropes rigged, supplies consumed,
and refuse carried back to the surface. Divers like Gala and Short
were just advance scouts for the mud-spattered army behind them,
lugging 30-pound rubber duffel bags through the cave—sherpas
of a sort, though they'd never set foot on a mountaintop. Stone
called them mules.

Two months earlier, in Texas, I'd watched the final preparations
for the trip. Stone's headquarters are about 15 minutes southeast

of Austin, on 30 acres of drought-stricken scrub. There is a cor-
rugated building out front that's home to Stone Aerospace, a ro-
botics firm he started in 1998, and a two-story log house in back,
where he lives with his wife, Vickie, a fellow-caver. (They met at a
party where Stone overheard her talking about tactical rigging.)
The trucks were scheduled to leave in two days, and every corner
of the house had been requisitioned for supplies. One room was
piled with cook pots, cable ladders, nylon line, and long under-
wear. Another had dry suits, diving masks, rebreathers, and oxy-
gen bottles. In the basement, eight long picnic tables were stacked
with more than 1,000 pounds of provisions. Shrink-wrapped flats
of peanuts, cashews, and energy bars sat next to rows of four-liter
bottles filled with staples and dry mixes: quinoa, oatmeal, whey
protein, mangos, powdered potatoes, and broccoli-cheese soup.
Stone had tamped in some of the ingredients using an ax handle.

"In the past, I'd lose 25 pounds on one of these trips," Stone told
me. "We can burn as many calories as a Tour de France rider every
day underground." Ascending Chevé, he once said, was like climb-
ing Yosemite's El Capitan at night through a freezing waterfall. To
fine-tune the team's diet, he'd modeled it on Lance Armstrong's
program, aiming for a ratio of 17 percent protein, 16 percent fat,
and 67 percent carbohydrates. In Mexico, the supplies would be
replenished with local beans, vegetables, and dried machaca beef.
"What you aren't going to find is candy," Stone said. "Stuff like
Snickers—that's bullshit." When I looked closer, though, I found a
bottle of miniature chocolates that Vickie had hidden among the
supplies.

Cavers, even more than climbers, have to travel light and tight.
Bulky packs are a torture to get through narrow fissures, and every
ounce is extracted tenfold in sweat. Over the years, caving gear has
undergone a brutal Darwinian selection, lopping off redundant
parts and vestigial limbs. Toothbrushes have lost their handles,
forks a tine or two, packs their adjustable straps. Underwear is
worn for weeks on end, the bacteria kept back by antibiotic silver
and copper threads. Simple items are often best: Nalgene bottles,
waterproof and unbreakable, have replaced all manner of fancier
containers; cavers even stuff their sleeping bags into them. Yet the
biggest weight savings have come from more sophisticated gear.
Stone has a PhD in structural engineering from the University of
Texas and spent 24 years at the National Institute of Standards

and Technology, in Gaithersburg, Maryland. His company has worked on numerous robotics projects for NASA, including autonomous submarines destined for Europa, Jupiter's sixth moon. The rebreathers for the Chevé trip were of his own design. Their carbon-fiber tanks weighed a fourth of what conventional tanks weigh and lasted more than four times longer underwater; their software could precisely regulate the mix and flow of gases.

Stone's newest obsession was a set of methanol fuel cells from a company called SFC Energy. Headlamps, phones, scuba computers, and hammer drills (used to drive rope anchors into the rock) all use lithium batteries that have to be recharged. On this trip the cavers would also be carrying GoPro video cameras for a documentary that would be shown on the Discovery Channel. In the past, Stone had tried installing a paddle wheel underground to generate electricity from the stream flow, with fairly feeble results. But a single bottle of methanol and four fuel cells—each about the size of a large toaster—could power the whole expedition. The question was whether they'd survive. High-tech gear tends to be fragile and finicky. While I was in Texas, one of the rebreathers kept shutting down for no apparent reason (it was later found to have a faulty fail-safe program), and this was the sixth generation of that design. The fuel cells weren't nearly as robust. Stone would keep them in shockproof, watertight cases, but he doubted that would suffice. "We're going to take them down there and turn them into broken pieces of plastic," he said.

Stone knew what it meant to be a battered piece of hardware: he'd turned 60 that December and had spent more than a year of his life underground. His gangly frame—six feet four, with a wingspan nearly as wide—was kept knotty by free weights, and he could still outclimb and outcarry most 25-year-olds. But he was getting old for an extreme sport like this, and he knew it. He had the whiskered, weather-beaten look of an old lobsterman. "I think it's a little surprising to him how hard the caving is on his body these days," one of the team members told me. "I won't say that he's feeling his age, but he's realizing that he isn't at the pointy end of the stick anymore."

As a leader, Stone models himself on the great expeditionary Brits of the past century. He has an engineer's methodical mind and an explorer's heroic self-image. He's pragmatic about details

and romantic about goals. His teammates often compare him to Ernest Shackleton, another explorer who felt most alive in the world's most unpleasant places. But Shackleton, despite shipwreck and starvation, never lost a man under his direct command. ("I thought you'd rather have a live donkey than a dead lion," he told his wife, after failing to reach the South Pole.) Cave diving is less forgiving. Stone has lost four teammates on his expeditions, including Henry Kendall, the Nobel Prize–winning physicist. Kendall failed to turn on the oxygen in his rebreather while cave diving in Florida. Others have succumbed to narcosis or hypoxia, fallen from cliffs or had grand-mal seizures, lost their way or lost track of time. They've buried themselves so deep that they couldn't come back up.

Stone's single-minded, almost mechanistic style can sometimes raise hackles. He can be inspiring one moment and dismissive the next. "Bill has problems identifying people's emotions," Gala told me. "So he doesn't always react to them well." Then again it's hard to avoid tension in a sport that takes such a mortal toll. Stone's mentor, the legendary cave diver Sheck Exley, retrieved 40 corpses from diving sites in Florida alone, then drowned in a Mexican cenote in 1994. "When cavers become cave divers, they usually die because of it," Stone's friend James Brown told me. In 1988, Brown and Stone were called in to help remove the body of a female diver from a cave near Altoona, Pennsylvania. When they found her, she was tangled in rope at the bottom of a sump, arms so stiff that, Brown recalled, Stone suggested they cut them off for easier transport. "Nobody liked that idea much," Brown said. "But after a while her arms softened up, and we were able to fold them down."

It took them two days to get her out, with Stone pushing from behind. "He kept saying, 'Don't leave me back here if she gets stuck!'" Brown said. If there's one rule of caving, Stone told me, it's that you never leave a person behind. Especially if they're alive, he added. "If they're dead, it's another matter."

By the time I arrived at base camp, in mid-March, the team had settled into a soggy routine. A week underground followed by 10 days on the surface. Five days of drizzle followed by one day of sun. They'd spent most of the first month hauling gear up the mountain—a muddy three-hour hike from a farmhouse in the val-

ley—loading the heaviest items on burros and the rest on their backs. They'd set up tents and dug latrines, strung lights and cut trails to the cave. The camp was spread out beneath pines and low-hanging clouds, on a rare stretch of relatively flat ground. To one side, the Discovery crew had erected a geodesic dome with two full editing stations inside. To the other, the cavers had hung a giant blue tarp, sheltering a long plywood table, stacks of provisions, and a pair of two-burner camp stoves. On most expeditions, base camp is a place to dry out and recover from infections acquired underground—cracked skin and inflamed cuts and staph bacteria that burrow under your fingernails till they ooze pus. But this forest was nearly as wet as the cave.

"Welcome to Hell," one of the cavers told me, when I joined him by the campfire that first night. "Where happiness goes to die," another added. There was a pause, then someone launched into the colonel's monologue from *Avatar:* "Out there, beyond that fence, every living thing that crawls, flies, or squats in the mud wants to kill you and eat your eyes for jujubes. . . . If you wish to survive, you need to cultivate a strong mental attitude." It was a favorite conceit around camp: the cloud forest as hostile planet. But, looking at all the gleaming eyes around the fire, I was mostly reminded of the Island of Lost Boys. Beneath all the mud and gloom and dire admonitions, there burned an ember of self-satisfaction—of pride in their wretched circumstance and willingness to endure it. As Gala put it, "It's just one continuous miserable."

Fifty-four cavers from 13 countries, 43 of them men and 11 women, would pass through the camp that spring. The team had a core of 20 or so veteran members, reinforced by recruits from caving groups worldwide. On any given day, the cave might be home to a particle physicist from Berkeley, a molecular biologist from Russia, a spacecraft engineer from Washington, D.C., a rancher from Mexico, a geologist from Sweden, a tree surgeon from Colorado, a mathematician from Slovenia, a theater director from Poland, and a cave guide from Canada who lived in a Jeep and spent 200 days a year underground. They were a paradoxical breed: restlessly active yet fond of tight places, highly analytical yet indifferent to risk. They seemed built for solitude—pale, phlegmatic creatures drawn to deep holes and dark passages—yet they worked together as a selfless unit: the naked mole rats of extreme sport. As

far as I could tell, only two things truly connected them: a love of the unknown and a tolerance for pain.

Matt Covington, a 33-year-old caver from Fayetteville, was a typical specimen. A professor of geology at the University of Arkansas, he had earned his PhD in astrophysics but switched fields so that he could spend more time underground. He had a build best described as Flat Stanley. Six feet four but only 150 pounds, he could squeeze through a crevice six and a half inches wide. "My head isn't the limiting factor," he told me. "It's my hips." Covington was a veteran of seven Stone expeditions as well as caving trips to Sumatra, Peru, and other remote formations. Five years earlier, he was climbing up a cliff face in Lechuguilla Cave, near Carlsbad Caverns, when an anchor came loose from the rock. Covington's feet caught on the cliff as he fell, tumbling him onto his left arm, causing compound fractures. Rather than wait for rescue, he spent the next 13 hours dragging himself to the surface. "The crawling was fairly uncomfortable," he allowed. "There was a lot of rope to climb."

When I first met Covington, late one night, he'd just slouched back into camp after five days underground. His eyes were bloodshot, his blond hair clumped and matted, his skin as blanched and fuzzy as moldy yogurt. He was so tired that he could barely stand, and his clothes reeked of cave funk. Yet he seemed fairly content. "A good caver is one who forgets how bad it really is," he said. There was more to it than that, though. Covington didn't feel claustrophobic underground; he felt at home. The rock walls, to him, offered a kind of embrace. As a boy, he told me, he used to flop around so much in his sleep that he often fell on the floor. Rather than climb back up, he'd crawl under the bed and stay till morning. He felt better there, beneath the springs, than he did looking up at the ceiling in his big empty room.

It was an instinct almost everyone here seemed to share. One of the cavers remembered staring at a slice of rye bread as a child, fascinated by all the air bubbles beneath the crust. He wanted to go down there. Gala was so comfortable in caves that he sometimes felt as if they were made for humans. "The passages are exactly the right size for my body to fit in," he told me. And his wife, Kasia, who worked as a photo editor in Warsaw, was nearly as happy underground as he. They took turns exploring the cave and tak-

ing care of their daughter, Zuzia, up on the surface. Zuzia had spent much of her life watching people disappear into holes and reemerge weeks later. She traversed her first cliff face at the age of four, in Spain's Picos de Europa mountains, and kept a map above her bed with pirate flags pinned on all the countries she'd visited. When she first came to Mexico, in 2009, she would sometimes cry out in frustration, "It's so uncomfortable here!" Now she flitted between tents like a forest sprite, half naked in the cold, fencing with corncobs and setting traps for mice. Life at camp had built up her immune system, Gala assured me, and had taught her the "skills of dynamic risk assessment."

I wished that I could see Chevé through her eyes. Before her father went underground with Phil Short, for their long hike beyond Camp Four, he'd read to Zuzia from *The Hobbit*. Chevé was no Lonely Mountain. Yet it had glistening caverns and plummeting boreholes, stalagmites tall as organ pipes and great galleries draped in flowstone, deeper than any goblin lair. And they were right beneath her feet. "When you squeeze through these small holes into these big halls, you feel like you're the only person on the earth," Gala said. "It's like the kingdom of the dwarves."

Gala had been exploring Chevé with Stone so long that he could nearly navigate it blindfolded. After a while, he said, you start to create a map of the system in your mind, to memorize each contortion and foothold needed to climb through a passage. On the steepest pitches, certain rocks almost seemed to smile and wave at him, and to reach for his hand. He would grab them, thinking, Old friend! And yet the deeper he went the more unfamiliar the territory became. By the 13th day, the escalating uncertainty— the risk of a careless stumble or a snapped limb so far from the surface—was starting to weigh on him. "The further in you go, the more you begin to doubt and question yourself," he told me. "What the fuck am I doing here?"

The sump beyond Camp Four was like nothing Short and Gala had seen before. The three sumps higher up in this system were relatively shallow and less than 500 feet long. This sump was more than 30 feet deep, and it seemed to go on and on. And something more rare: it was beautiful. The water was a luminous turquoise, flowing over pure-white sand; the limestone was streaked with

ocher and rust. Most sumps are cloudy, tubelike passages carved by underground streams, but this one had been a dry cave not long ago. The stalactites on its ceiling could only have been formed by slow drip. With its lofty chambers and limpid water, it reminded Gala of the blue holes of Florida and the caves of the Yucatán. Finning through it felt like flying.

The hazards of cave diving are inseparable from its seductions. Wide-open tunnels can fork into a maze; white sands swirl up to obscure your view. You think that you know the way back only to reach a dead end, with no place to come up for air. "People think that cave diving is an adrenaline sport, but really it's the opposite," Short told me. "Whenever you feel your adrenaline racing, you have to slow down. Stop, breathe, think, act, and, in general, abort. That's the rule in cave diving."

Short is one of the sport's premier practitioners, with experience as far afield as the Sahara and shipwrecks off Guam. His body is a testament to its rigors: long and arachnid, skin taut over bone, head shaved to shed its last encumbrance. With his rapid-fire talk and glasses that seem to magnify his eyes, he could pass for a street preacher or a pamphleteer. But his absurdist wit was a great gift around a campfire, and his diplomacy often took the edge off Stone's blunt directives. Gala and Short were a good match: one quiet, the other loquacious; one expert at climbing, the other at diving. Just as Gala could pick his way through Chevé by memory and internal gyroscope, Short could divine a sump's path from half-conscious clues: the flow of current and its fluctuating temperature, the shape of the walls and ripples in the sand. Still, he took no chances. As they swam from chamber to chamber, the beams of their headlamps needling the dark, he unspooled a three-millimeter line behind him, like Theseus in the Labyrinth.

An hour later, he signaled for Gala to stop. Below them in the sand was the line they'd laid down 15 minutes earlier. The tunnel had led them on a loop. They'd expected the sump to be about 1,000 feet long, but they'd already gone twice that distance, and time was running out. Cave divers like to ration their air supply by a rule of thirds: one part for the way in, another for the way out, and a third in reserve. On a four-hour rebreather, that left them less than half an hour for exploring. The cave was a honeycomb, they realized, with tunnels angling off in every direction

and hardly any current to guide them. "There were passages ev-
erywhere, everywhere," Gala recalled. "It was so complex we could
spend a year looking."

In the end, they just picked a tunnel and hoped for the best.
When they'd backtracked around the loop, reeling in their line,
they came to a kind of four-way intersection. One passage led back
to the beginning of the sump, another to the loop behind them,
a third to a dead end they'd explored earlier. That left one un-
explored passage. It took them up a short corridor, along a ris-
ing slope of terraced mustard-colored flowstone, and into a small
domed chamber. There was an air bell at the top about the size
of a car trunk, so they swam up and took off their helmets and
neoprene hoods to talk. They seemed to be at a dead end. They
were cold, tired, and disoriented, and their air ration had nearly
run out. There was no choice but to head back. "We were just a
little overwhelmed by this dive," Gala told me. Then they heard
the waterfall.

A mile above them, at base camp, Stone was waiting impatiently
for their call. This was the pivotal moment in the expedition—the
day for which he'd spent four years perfecting gear, recruiting cav-
ers, and raising money. (The total budget for the trip was roughly
$350,000, most of it paid for by equipment sponsors and the Dis-
covery Channel.) He had expected Gala and Short's reconnais-
sance trip to take less than six hours—two hours to dive the sump,
two hours to look around and find a camp site, and another two
to swim back and call in—yet nine hours had passed. "There are a
bunch of scenarios that could be going on right now," he told the
Discovery cinematographer, Zachary Fink. "Even a one-kilometer
swim with fins would take only about an hour. And that was way
beyond our limit."

Stone looked haggard and thin, his mustache drooping over
sallow skin. Weeks of shuttling supplies into the cave had taken
a toll on him. He was a strong climber and diver, but he wasn't a
"squeeze freak" like some of the others. His broad, bony shoulders
weren't built for these tunnels. In the tightest fissures he had to
take off his helmet just to turn his head, or strip down to his dry
suit and wriggle between walls for hundreds of feet. (They called
one passage the Contusion Tubes.) "It's hypothermic as hell down
there," he told me. "The wind is whipping through, the water's

in contact with the rock, and you can just feel the calories being sucked out. It can be more dangerous than a high-altitude peak at 25 below." By the time he'd resurfaced a few days earlier, he was coming down with a flu. Then it rained for three and a half days.

It was late evening when the call finally came: "Base camp, base camp, base camp!" Stone rushed over to the phone and hit the Talk button. "Tell us what happened," he said. There was a blast of static, then Short's clipped British accent came crackling over the line. "We have good news and we have complicated news," he said. "From a point of view of future exploration, complicated is today's understatement."

The waterfall could mean only one thing, Short and Gala knew. They'd reached the end of the sump and the river was flowing nearby. How to get there? When Gala ducked his head underwater and looked around, the chamber looked sealed off. But when he looked again his headlamp picked up an odd texture in the wall to his right. There was a gap in it just below the waterline—wide enough for a person to squeeze through. Gala could tell that his rebreather wouldn't fit, so he handed it to Short, along with his mask, helmet, and side tanks. "I left him holding all these things with his teeth and both his hands," he recalled later. Then he held his breath and dove through.

When he resurfaced on the other side, he was in a fast-flowing canal of clear water. The walls were formed by ancient breakdown piles, their boulders napped in calcite; the low ceiling was hung with stalactites. As he swam, a wide, airy passage opened up ahead, with a large pool in the distance. It glimmered in his headlight. He hiked over to it and swam across, feeling light and buoyant without his rebreather. He could hear the roar of the waterfall growing louder as he went, but an enormous stalagmite blocked the way, with only a thin gap to one side. He stretched an arm and a leg through the opening and shimmied around, thankful again to be rid of his gear. When he was through, he found himself in a great chamber filled with mist and spray, its floor split by a yawning chasm. The river ran into it from the right and fell farther than his light could follow. Across the chamber, 30 or 40 feet away, a huge borehole stretched into the darkness. *This is it,* Gala thought, the breakthrough they'd imagined. With any luck, it would take them straight to Chevé's main passage.

Stone wasn't so sure. "Is there any place at all over there that

you saw that would be suitable for a camp?" he asked Short over the phone, when the story was done. "Negative. There is not a single flat surface other than the surface of the river." Stone clutched his head and frowned. The sump was too long. Two thousand feet! They didn't have enough line down there to rig that distance. Without rigging, most of the team couldn't dive the sump safely, and without their help Gala and Short couldn't resupply for the next push. "The whole game had changed," Stone told me later. "Just diving through wasn't the game. The game was to get all the support material to the other side. It was like running a war: if you don't get the food and fuel and ammo to the front line, you're going to stall out."

Only a few dozen people in the world had both the caving expertise and the scuba skills to go this deep in the cave. Of those, 12 had originally agreed to join the expedition. Then the number began to drop. Three died before the expedition began: one on a deep dive in Ireland, another in an underwater crevice in Australia, the third from carbon monoxide poisoning in Cozumel. Three had left early or had not yet arrived. And three had physical limitations: James Brown had gimpy knees, a Mexican diver named Nico Escamilla had a pulled groin muscle, and a veteran diver named Tom Morris had torn a rotator cuff. "It was like getting hit in the head with a two-by-four," Stone told me. "Oh, crap! We've lost most of our divers! The three that are qualified to dive the sump are the two that are down there and me—and, God bless them, Phil and Marcin want to see daylight."

It was too late to recruit new divers to the team. The best candidate, a veteran British caver named Jason Mallinson, had joined another expedition, across the river at a cave system called Huautla. "He's one of the best divers in the world," Stone told me. "But he has a certain personality—it's abrasive, and what I really wanted this year was harmony, and I got it." Stone had planned to join Gala and Short for the last leg of the expedition, to see the very deepest regions of the cave. But without more divers to support them he wasn't sure it was safe to continue. "They did a fantastic thing there, but it may also be the end of that route," he said, after Short got off the line. "There is no glory in rushing into something like that and losing a friend. It just is not worth it."

*

Word of Stone's misgivings filtered down to Gala and Short as they worked their way back up the cave, camping with the support crews. It seemed a kind of betrayal. The yo-yo logistics of deep caving required that they return to the surface to rest and reprovision, but they had every intention of going back down. Yes, the sump was longer than expected, the conditions more challenging. But they'd found exactly what they wanted on the other side. How could they stop now?

"My thinking was that Bill is just tired with this cave—that this is just an excuse not to come back," Gala told me. "I think that he spent too much time preparing this expedition, making all these tools, all these deals." But Stone insists that his reluctance was just a matter of safety and logistics—an equation like any other, balancing risk and reward. On Gala and Short's first evening back at base camp, the scene around the campfire got so tense that Stone shouted at Zachary Fink to turn off his camera. "It's always like that at some point in an expedition," Gala told me. "There's always a shouting match between Bill and me, with someone almost crying." But over bourbon that night and coffee the next morning, they slowly hashed out a plan. They would have to work fast, resupplying the camps themselves and exploring the new tunnels without backup divers. If they hung hammocks from the wall beyond Sump Four, they could bivouac there and explore the cave for another three weeks before they ran out of rope. With any luck, they'd reach the Chevé juncture before they were done.

Stone went underground the next day. Short took five days to rest and heal—half the usual recovery time, after three times the usual stay underground—and by the morning of March 21 he was leading a ragtag team down the mountain. This was just a five-day trip to help prepare the cave for the final push. But with the expedition so undermanned, Short had no choice but to lead the team and to bring two novices along: Patrick van den Berg, a hulking information-security specialist from Holland, and David Rickel, an emergency medical technician from Texas. Van den Berg was a weekend caver in relatively poor shape ("I get most of my exercise moving a mouse around," he told me). Rickel was the team medic. He had a rock climber's ropy build, but the closest he'd come to deep caving was working in an iron-ore mine in Australia.

Short was of two minds about taking them. He knew that one

injury could derail the whole expedition, and that the cave ahead would test even the fittest athlete. "You can lift weights and go wall climbing and run a few miles every day, but it's not the same," he told me, as we wound our way down the slope. "When you're 19 days underground, in the cold and wet without a bed, with a 40-pound pack on your back, crawling on your hands and knees or climbing up and down cliffs or diving through sumps, and then you come back and resurface, and four days into your 10-day break some sadist wants to send you back down under, and you end up volunteering to go—most people hear that and they think you're stark raving mad." Yet Short was an optimist at heart and an experienced teacher—he gave scuba and cave-diving lessons in England—and he'd seen even novices accomplish unimaginable things. "It's not the body that breaks, it's the mind," he said. "If you compare this to what the British infantry were lugging in the Ardennes in World War I, or what Shackleton's team did in the Antarctic, this shit is easy. They were trudging up those slopes with old-fashioned ropes and no oxygen, and I'm sitting here complaining about the hole in my antibacterial underwear."

Whether van den Berg took any comfort in this wasn't clear. Less than an hour from camp, he was already red-faced and wheezing, sweat streaming down his chest. The altitude was getting to him, he told me. Hiking at 7,000 feet made him feel like he was breathing through a straw. When the team set down its packs for a brief rest, Short came over and crouched beside him. "I'm a little concerned that you're as tired as you are after just walking down a hill," he told him. "Your pulse was up to 160, which David tells me is pretty high." Van den Berg shook his head and insisted that he was fine. He wouldn't have a problem going down the cave. "But you have to come back out too," Short told him.

We were headed toward a cave entrance known as the Last Bash, about a mile from base camp. Discovered in 2005, it was a side entrance to the J2 passage, an hour or so down the slope from the original entrance. It would allow the team to bypass a sump and cut 12 hours out of the trip down, but it was tighter and more punishing than the other entrance—just a crack in the rock 10 feet above the trail, flanked by boulders and elephant-ear vines. If Short hadn't pointed it out, I would have passed right by it.

Short's team peered up at the opening for a moment, then slowly put on their gear. They stepped into their waterproof caving suits

and climbing harnesses, attached special ratchets for rappelling down cliffs, and strapped on their helmets and headlamps. "This is not going to be some macho-driven bullshit," Short assured them. "It's going to be a slow bumble down the cave, with double dinners when we get to camp." They made a quick snack of crackers and energy bars, while Rickel checked van den Berg's heart rate again. It had dropped to 120. "How did you end up here?" van den Berg asked him when he'd finished. Rickel laughed. "A long sequence of poor life choices," he said. Then they crawled into the crack one by one and disappeared.

The rains were getting to be a serious concern now. The tunnels below the Last Bash weren't known to flood, but neither were the tunnels above it before 2009. Then some gravel got clogged in a fissure at the bottom of a pool, flooding the chamber behind it and trapping seven people in the cave below. Five were able to dive out, but the other two, Nikki Green and David Ochel, had to sit and wait, not knowing if the tunnel would clear. "We had no food for five days, just watching the water," Green told me. In the end, the rain abated long enough for them to climb out, and then the cave flooded for the rest of the season. "We stayed too long," Green said.

A neighboring cave, known as Charco, had an even more un-pleasant history. In 2001, a team of six cavers was heading back to the surface there, after a week of surveying, when they noticed the underground stream starting to rise. It had been raining for two days by then, and the tunnel was so tight that it began to flood. Charco is a place to make even cavers claustrophobic: the first camp is a 12-hour crawl from the surface, mostly on your belly. By the time the last team member neared the entrance, the water in the tunnel was inches from the ceiling. As he treaded water, lifting his face up to breathe, bits of soft white debris drifted toward his mouth and got caught in his hair. But it wasn't debris, as it turned out. A cow had died in the entrance that spring. Its belly was in-fested with maggots and the rains had washed them into the cave.

If there was an advantage to going deep, it was that the cave was fairly sterile. In the lower reaches of J2, the only signs of life were a few translucent crustaceans and bits of refuse that washed down from above. (In the Huautla system, teams sometimes found Pop-sicle sticks a mile belowground.) By early April, the camps were

reprovisioned, Rickel and van den Berg were safely back on the surface with Stone, and Gala and Short were alone once again at Camp Four. The sump beyond it, once the dark side of the moon, now seemed comfortingly familiar. Short had discovered a larger opening in the chamber at the end, which allowed them to dive out with their rebreathers and equipment. When they had swum down the canal on the other side and followed the tunnel to the misty chamber with the waterfall, it was as if they'd arrived at another beginning. "Now we were in truly dry, unexplored cave," Short told me. "Our lights were the first light that had fallen on this place since it had been created."

Two promising passages lay ahead: the fossil gallery where the river had once flowed, and the canyonlike fissure where it now fell. They took a moment to gather themselves at the top of the falls and to make a pot of hot chocolate. But Gala couldn't bear to wait. While Short tended the stove, he free-climbed the 40 feet to the other side of the canyon—ropes would come later. Then he shouted at Short to join him.

It was just as they'd hoped: a cavernous passage, perhaps 15 feet high by 30 feet wide, with a packed mud floor. There was even a flat spot ahead where they could set up a camp. The gallery followed the path of the tunnel behind them at first, then meandered left and right, up and down. Gala and Short took surveyor's notes as they went, one man walking ahead and holding up a saucepan lid while the other shot a laser at it to get the distance. They used a compass and a clinometer to measure the tunnel's direction and slope, marked the numbers with a Sharpie onto a waterproof sheet, then copied them onto a piece of colored tape and tied the tape to the reference point. (Back at base camp, Stone would enter the data on his laptop to create 3-D maps of the cave.) This was standard practice in new tunnels and could add hours to a trip. But not here: after 300 or 400 feet, the passage abruptly ended. Rather than drop down to rejoin the stream, it had circled back on itself like the oxbow in the sump, ending in a large chamber walled with flowstone. It would take them no farther.

Gala and Short trudged back the way they'd come, their spirits deflated. A dry fossil gallery is the caver's version of a superhighway: the fastest, safest way underground. But at least they had another option. "There was still the waterfall," Gala told me, "and it *had* to go further down." He and Short strapped on their climb-

ing harnesses and unpacked their rigging. The hammer drill had gone dead after the battery got wet—the fuel cells had all met the same fate—so Gala had to knot the rope around a rock to anchor it. But it held firm as they rappelled down the chasm. Forty feet below, the water thundered into a shallow pool, then slipped down a stair-step streambed to another, much larger pool below. They'd left their dry suits at the top of the falls to air out, so they had no choice but to swim across in their thermal underwear. The water here was a few degrees warmer than higher up in the cave, but still close to 40 degrees below body temperature, and the sopping cloth kept it close to their skin. Yet they kept moving forward. "Expedition fever had bitten us," Short says.

When they reached the far shore, the water cascaded down to yet another pool, 20 feet below. They rigged ropes for the descent, scrabbled down, and swam across, their limbs trembling as the cold sank into them. In the distance, the dusty beam of Gala's headlamp picked out a pile of boulders in their path, but this only quickened his pulse. It reminded him so clearly of a passage higher up, where a series of pools led to a breakdown pile along a fault line, and then a wide-open tunnel beyond it. "I had this feeling that we were almost done," he told me. "We will climb these boulders. We will find a huge borehole, and that will open the way to Chevé."

It was not to be. When Gala and Short arrived at the breakdown pile, it was just the back end of a small sealed chamber—another cul-de-sac. Its boulders were bound together with flowstone, the holes between them no larger than your hand. "There was no air, no anything," Gala recalls. As for the river, it had found a long crack in the floor less than an inch wide, and spooled through it like an endless bolt of turquoise cloth.

They stood there for a moment in shock, not quite believing that they'd reached the end. They knew that the cave kept on going below, gathering the waters of Chevé beneath them. Yet there was no way forward. Like the cavers in Krubera before the side tunnel was discovered, they had yet to unlock the system's secret door. Gala looked over at Short—he was shaking uncontrollably now, his wiry limbs lacking all insulation—and was grateful, once again, to have him at his side. "It's like a friendship during war," he told me. "So strong an experience, it ties souls together." He clasped Short's shoulder and told him to go make some hot drinks while

he finished surveying. Then they packed up their gear and began the long climb back to the surface.

Deep caving has no end. Every depth record is provisional, every barrier a false conclusion. Every cave system is a jigsaw puzzle, groped at blindly in the dark. A mountain climber can at least pretend to some mastery over the planet. But cavers know better. When they're done, no windy overlook awaits them, no sea of salmon-tinted clouds. Just a blank wall or an impassable sump and the knowledge that there are tunnels upon tunnels beyond it. The earth goes on without them. "People often misunderstand," Short told me. "All you find is cave. There is nothing else down there."

When I spoke to Stone recently, he was already planning his next trip to Chevé. His team had brought back some intriguing data, he said. Gala's survey showed that the end of J2 lies directly below a cave entrance discovered in the early 1990s. The tunnel beyond it is fairly cramped, but there's enough air blowing through to suggest that it leads to a larger passage—one that could bypass the blockage in J2. If Stone's team can connect the two tunnels, then drop down into the main Chevé passage, they might still stitch the whole system together. "Where did the water go a million years ago? That's what you have to ask yourself," Stone said. "As a cave diver, you have to think four-dimensionally." In the meantime, this spring, he was joining an expedition across the river to Huautla, where Jason Mallinson had managed to reach a depth of more than 5,000 feet—a new record for the Western Hemisphere. Huautla can never go as deep as Krubera, Stone said, much less the full Chevé system. But it could well be the *longest* deep cave in the world. Why not see how far it goes?

That was as good a reason as any. For most of the team, though, it wasn't the chance at a record that would bring them back, or even the lure of virgin cave. It was the camaraderie underground—the deep fellowship of shared misery. The camps down there were just a few damp tents on rubble, clustered around a propane flame. The food was the same dehydrated stuff they ate up top. A trip to the latrine could be a life-threatening experience—a squat on slippery rocks above a thundering chasm. But after weeks underground, even that smell could lift your spirits. It held the promise of dry clothes and hot coffee, black humor and noisy sex, drowned

out by sing-alongs. Gala and Short spent one very good night hollering "C Is for Cookie" until they were hoarse.

On their 21st day underground, when they finally emerged from the cave's rocky clutch, they blinked up at the sun like newborns. Their skin was ashen, their eyes owl-wide and dilated. "I had these mixed emotions," Gala told me. "I understood that this is the end of J2—nine years of my life, of the most beautiful exploration of my life. It was a sad story." Yet it had also been the longest and hardest trip he'd ever taken, and it made the return to the surface all the sweeter. The green of the forest, so luminous and deep, seemed nearly psychedelic after weeks of dun-colored earth and the pale wash of his headlamp. The smell of leaves and rain and the workings of sunlight were almost overwhelming.

"It is beautiful here, isn't it?" Gala had told me when we first met, on a gray, drizzly morning at base camp. "Listen to these strange birds! When I'm back on the surface, just by contrast, I enjoy every piece of my life. Everything is fantastic." He laughed. "Some people say that all this caving is just for a better taste of tea."

WELLS TOWER

Who Wants to Shoot
an Elephant?

FROM GQ

IT IS JUST before dawn at a hunting camp in Botswana's game-rich northern savanna, and Robyn Waldrip is donning an ammunition belt that could double as a hernia girdle. "You can't help but feel like sort of a badass when you strap this thing on," she says. Robyn, a Texan in her midthirties, seems to stand about six feet two, with piercing eyes of glacial blue shaded by about 12 swooping inches of eyelash. She's a competitive bodybuilder and does those tractor-tire and sledgehammer workouts, and there is no part of her body, from the look of it, that you couldn't crack a walnut on. In her audition video for a reality-television show called *Ammo & Attitude,* Robyn described herself as a stay-at-home mom whose "typical Friday-night date with [her] husband is going to the shooting range, burning through some ammo, smelling the gunpowder, going out for a rib-eye steak, and calling it a night."

Robyn Waldrip could kick my ass, and also your ass, hopping on one leg. Her extensive résumé of exotic kills includes a kudu, a zebra, a warthog, and a giraffe. But she has never shot a *Loxodonta africana,* or African elephant, so before she sets out, her American guide, a professional hunter named Jeff Rann, conducts a three-minute tutorial on the art of killing the world's largest land animal.

"You want to hit him on this line between his ear holes, four to six inches below his eyes," Jeff explains, indicating the lethal

horizontal on a textbook illustration of an elephant's face. The ammo Robyn will be using is a .500 slug about the size of a Concord grape, propelled from a shell not quite as large as Shaquille O'Neal's middle finger. About three feet of bone and skin insulate the elephant's brain from the light of day, and it can take more than one head shot to effect a kill. "If he doesn't go down on your second shot, I'll break his hip and you can finish him off."

"Anything else I need to know?" Robyn asks.

"That's it," says Jeff.

"Just start shooting when they all come at us?"

"The main thing is, just stay with the guns," Jeff tells the rest of the party, which includes Robyn's husband, Will Waldrip, two trackers, this journalist, a videographer who chronicles Jeff's hunts for a television program, *Deadliest Hunts,* and a government game scout whose job it is to ensure that the hunt goes according to code. The bunch of us pile into the open bed of a Land Cruiser and set off into the savanna, the guides and the Waldrips peering into the lavender predawn for an elephant to shoot.

If you are the sort of person who harbors prejudices against people who blow sums greater than America's median yearly income to shoot rare animals for sport, let me say that Will and Robyn Waldrip are very easy people to like. They didn't grow up doing this sort of thing. Robyn's dad was a fireman who took her squirrel hunting because it was a cheap source of fun and meat. Will's father was a park ranger. In his twenties, Will went into the architectural-steel business, and now he co-owns a company worth many millions of dollars. They look like models from a Cabela's catalog. They are companionable and jolly, and part of the pleasure of their company is the feeling that you've been welcomed into a kind of America where no one is ever fat or weak or ugly or gets sad about things.

The Waldrips arrived in Rann's camp on the eighth of July, and they've allotted 10 days for the hunt. But it is unlikely to take that long to find their trophy. Botswana contains somewhere in the neighborhood of 154,000 elephants, most of them concentrated in this 4,000-square-mile stretch of northern bushland where the Kalahari Desert meets the Okavango Delta.

In addition to airfare, ammo, and equipment costs (the antique double-barreled Holland & Holland rifle Robyn bought for the

trip typically sells for about $80,000), the Waldrips are paying Jeff
Rann $60,000 for the privilege of shooting the animal, at least
$10,000 of which goes to the Botswana government. In Septem-
ber 2013, a ban on elephant hunting goes into effect in Botswana,
making the Waldrips' hunt one of the last legal kills. It is a pre-
cious, expensive experience, and Robyn wants to take her time
to find big ivory, not to simply blast away at the first elephant that
wanders past her sights.

Through the brightening dawn, the Land Cruiser bucks and
rockets along miles of narrow trails socked in by spindly acacia
trees, camellia-like mopani shrubs, and a malign species of thorn-
bush abristle with nature's answer to the ice pick. No elephants
are on view just yet, though a few other locals have come out to
note our disturbance of the peace. Here is a wild dog, a demonic-
looking animal whose coat is done up in a hectic slime-mold pat-
tern. Wild dogs, among the world's most effective predators, are
the biker gangs of Africa. They chase the gentle kudu to exhaus-
tion in a merciless relay team. A softhearted or lazy dog who lets
the prey escape can catch a serious ass-kicking from the rest of
the heavies in the pack. What's that, Mr. Wild Dog? You're on the
endangered-species list? Well, karma is a bitch. Let's move along.

Now here is a pair of water buffalo. Charming they are not.
They scowl sullenly from beneath scabrous plates of unmajestic,
drooping horn. "Hostile, illiterate" are the descriptors I jot on my
notepad.

And there is the southern yellow-billed hornbill, and there the
lilac-breasted roller, which, yes, are weird and beautiful to look
upon, but if you had birds jabbering like that outside your window
every morning, would you not spray them with a can of Raid?

Say what? I'm unfairly harshing the fauna? Yes, I know I am. I'm
sorry. To the extent that I've discussed it with Jeff Rann and the
Waldrips and other blood-sport folk I know, I believe that hunt-
ers are being sincere when they say they harbor no ill will toward
the animals they shoot. Not being a hunter myself, I subscribe to
an admittedly sissyish philosophy whereby I only wish brain-pierc-
ing bullets upon creatures I dislike. I've truthfully promised Jeff
Rann that I'm not here to write an anti-hunting screed, merely to
chronicle the hunt coolly and transparently. But the thing is, I'm a
little worried that some unprofessional, bleeding-heart sympathies
might fog my lens when the elephant gets his bullet. So I'm try-

ing to muster up some prophylactic loathing for the animals out here.

Perhaps out of a kind of kindred impulse, Will and Robyn Waldrip are quick to point out the violences elephants have inflicted on the local landscape. And it's true, the *Loxodonta africana* isn't shy about destroying trees. We are standing in an acreage of bare earth ringing a watering hole Jeff Rann maintains. It looks like a feedlot on the moon. Where there is not a broken tree or a giant dooky bolus, there is a crater where an elephant started eating the earth.

"Man, [the elephants] have just destroyed the ecosystem," Will says. "People who oppose hunting ought to see this." Will is a bowhunter. Elephants aren't his bag. And while he has no reservations about Robyn shooting the elephant, he is doing, I think, some version of the hunt-justifying psych-up going on in my own head. He wants to feel like it's a good deed his wife is doing out here, a Lorax-ly hit in the name of the trees.

It's midafternoon before we spy a candidate for one of Robyn's Concord grapes. In the shade of a very large tree, a couple of hundred yards from the jeep trail, is something that does not at first register as an animal, more a form of gray weather. We dismount and huddle before setting off into the brush.

The elephant appears to be a trophy-caliber animal, but at this distance, it's hard to say for sure. "One thing," Jeff says to Robyn. "If it charges, we have to shoot him."

"If he charges, *I'm* gonna shoot him," Robyn says.

The entourage begins a dainty heel-to-toe march into the spiky undergrowth. As it turns out, it is not one elephant but two. One is the big, old, shootable bull. The other is a younger male. Elephants never stop growing, a meliorative aspect of which (elephant-hunt-misgivings-wise) is that the mongo bulls that hunters most want to shoot also happen to be the oldest animals, usually within five or so years of mandatory retirement, when elephants lose their last set of molars and starve to death.

For the record, this detail does not soothe me as the guns make their way toward the elephants under the tree. I have not yet figured out how to dislike elephants enough to want to see one shot. In private treason against my hosts, I am thinking, *Not now, not now. Let it please not get shot today.*

We near the creatures. The big bull shifts its ears, and it is a

significant event, like the hoisting of a schooner's rigging. Jeff lifts his binoculars. As it turns out, the bull is missing a tusk, probably broken off in a fight. So it will not be shot, its ultimate reward for the tusk-snapping tussle.

We creep back to the jeep. Robyn is electrified, breathing hard, her blue eyes luminous with adrenaline: "That was big!" she says to Will. "As soon as we got out of the truck, was your heart going?"

"Nah, but when he turned and his ears spread and he went from huge to *massive?* Yeah."

"Huge," says Robyn. "It could just mow us down."

"We'd be jelly," says Will. "But you wouldn't want to have shot him on your first day, anyway."

Fair warning: An elephant *does* get shot in this story. It gets shot pretty soon. Maybe that upsets you, as it did 100 percent of the people (hunters and nonhunters) to whom I mentioned this assignment.

Elephants are obviously amazing, or rather, they are obvious receptacles for our amazement, because they seem to be a lot like us. They live about as long as we do. They understand it when we point at things, which our nearest living evolutionary relative, the chimpanzee, doesn't really. They can unlock locks with their trunks. They recognize themselves in mirrors. They are socially sophisticated. They stay with the same herds for life, or the cows do, anyway. They mourn their dead. They like getting drunk (and are known to loot village liquor stashes in Africa and India). When an elephant keels over, its friends sometimes break their tusks trying to get it to stand up again. They bury their dead. They bear grudges against people who've hurt them, and sometimes go on revenge campaigns. They cry.

So why would you want to put a bullet in one? Well, if we are to take hunters at their word, it is because the experience of shooting an animal yields a thrill, a high that humans have been getting off on since we clubbed our first cave bear. And if you go in for this sort of thing, then it arguably stands to reason that the bigger the beast, the bigger the thrill when it hits the ground.

On the subject of hunting's pleasures, Robyn Waldrip has this to say: "It kind of taps into your primal instincts. I think everybody has it in them."

But an elephant?

"It was on my bucket list of hunting. It's the largest land mammal, and just to go up against something that big, it's exciting. I ran into this mom at the grocery store and she was like, 'What are you doing for the summer?' and I said, 'I'm going to Africa to do an elephant hunt.' And she said, 'Why in the world would you wanna do that?' and I'm like, 'Why *wouldn't* you?'"

Jeff Rann has a similar take: "Hunting's almost like a drug to people that do it." In his 38-year career, Jeff has presided at the shootings of around 200 elephants, and he has never had a trophy get away from him. It is Jeff Rann whom King Juan Carlos I of Spain calls when he wants to shoot an elephant, as he did in April 2012. (King Juan Carlos likely will not get the hankering again. He broke his hip on the safari—in the shower, not on Rann's watch— and amid the general outrage sparked by leaked photos of the king posed alongside his kill, Juan Carlos was booted from the honorary presidency of the World Wildlife Fund and compelled to issue a public apology.)

Rann is the most perfect exemplar I have ever met of Hemingway's speak-softly-and-shoot-big-things-without-being-a-blowhard-about-it masculine ideal. He is lethally competent and incredibly understated and cool, even when he's telling swashbuckling stories, such as the time he nearly got killed by a leopard: "The leopard charged. I shot him. It was a bad shot. He jumped on me, and we just kind of looked at each other. I remember those yellow eyes staring back at me. He bit me twice and dropped to the ground. He also pissed all over me. For about a year, I'd wake up in the night and I'd smell that strong cat smell. But I don't think about it anymore." Or the time he led the Botswana Defence Force into a camp of poachers who'd been hunting in the land he leases from the government. "We went into camp, and there were two old guys and one kid about 16 years old. The agents just opened up on them. Killed the two old guys outright. The one they shot 11 times, the other they shot 14 times. The kid took off running, but they shot him a couple of times in the back."

Q. So you, like, saw three guys get shot and killed?
A. Yeah.
Q. Whoa. Wow. What was that like?

A. Didn't bother me.

Q. Wow, really? Weird. Do you think that's because maybe you've seen
 so many animals killed over the years that seeing the poachers get
 shot, it's, you know, just another animal?

[*Patient silence during which Rann seems to be restraining self from uttering the
word "pussy" in conjunction with visiting journalist.*]

A. I don't know. Hard to say. Those guys [illegally] killed a lot of ani-
 mals. It pissed me off.

In addition to million-acre leases in Botswana, Rann has a hunt-
ing concession in Tanzania and a 5,500-acre rare-game ranch out-
side San Antonio. The economic downturn did not put much of
a bite in Rann's business, a happy fact he credits to the addictive
nature of hunting's elemental pleasures: "Our clients might not
buy a new car as often, or buy a second or third home, but they're
still going to go hunting." But this new hunting ban is poised to
do to Rann's elephant-hunting business what economic calamity
could not.

There's been a regulated hunting industry in Botswana since
the 1960s. Before the ban took effect, the government was issu-
ing roughly 400 elephant-bull tags per year, of which Jeff Rann
was allowed to buy about 40. And counterintuitively, even in the
presence of an active bullet-tourism industry, Botswana's elephant
population has multiplied twentyfold, from a low point of 8,000 in
1960 to more than 154,000 today. These healthy numbers, as peo-
ple like Rann are keen to mention, mirror elephant populations
in other African countries where hunting is allowed. Despite a re-
cent uptick in poaching problems, both Tanzania (with 105,000
elephants) and Zimbabwe (with 51,000) have seen similar patterns
of population growth. Kenya, on the other hand, banned elephant
hunting in 1973 and has seen its elephant population decimated,
from 167,000 to 27,000 or so in 2013. Some experts predict that
elephants will be extinct in Kenya within a decade.

As the pro-hunting side has it, elephant safaris assist conserva-
tion by pretty simple means: a bull killed on a legal hunt is, in the-
ory, worth more to the local economy than an animal slaughtered
by poachers. In the most far-flung parts of the Botswana bush, the
hunting industry has been the chief employer, offering a paycheck
to people in places where there simply is no other gainful work.
When locals' livelihoods are bound to the survival of the el-

ephants, they're less likely to tolerate poachers, or to summarily shoot animals that wander into their crop fields. Furthermore, hunting concessions are uninviting to poachers. Hunters like Jeff Rann employ private security forces to patrol the remoter parts of the preserve.

Hunting's critics maintain that, in practice, the industry tends to fall short of these ideals. For every professional hunter who follows the rules, there are others who overshoot their quotas, or engage in illegal ivory trafficking, or cheat their employees of a living wage. In countries more corruption-plagued than Botswana, crooked officials commonly siphon off safari profits before they reach the elephants' rural human neighbors on whose mercy and financial interest the fate of the species ultimately depends. And lately, in Tanzania and Zimbabwe (where last year 300 elephants were poisoned in a single massacre), the hunting industry has proven no antidote to poaching. Citing "questionable management" and "lack of effective law enforcement" in Zimbabwe and Tanzania, the U.S. Fish and Wildlife Service, in April 2014, suspended the import of elephant trophies from both nations.

But Satsumo, the Department of Wildlife and National Parks employee who's tagging along on the Waldrips' safari, believes that Botswana's hunting ban may ultimately turn out badly for the elephants. "There will be more poachers," she says. "More elephants will get out of the reserve. They will go to people's crop fields. The hunters pump the water for them, but now they will have to move to the villages to find it. It's a bad thing. It's a very bad thing."

Abhorrent as the practice is to most Western, Dumbo-adoring sensibilities, elephant hunting occupies an awkward, grayed-out space in the landscape of conservation policy. Some nonprofits such as the World Wildlife Fund have quietly endorsed it as part of a conservation strategy but decline to discuss their position on record. The issue is such an emotional live wire, for people on both sides of the debate, and is so deeply laced with PR perils, that it's just about impossible to find a frank and disinterested expert opinion about hunting's efficacy as a means to help conserve the species. It's worth noting that I couldn't find anyone on the anti-hunting side who could convincingly answer this question: if hunting is so disastrous for the long-term survival of the species, why do the countries where it's legal to hunt elephants have so many more of them than those where the practice is banned?

With the next couple of tourist seasons, most of Botswana's elephant concessions will be converted to photographic-safari destinations, which many conservationists promote as an effective way to monetize the animals and thereby protect them. But according to Jeff Rann, photo safaris aren't all that difficult for poachers to work around. "[Photo tourists] are not armed. And they stick to a set, predictable routine, so the poachers just go kill animals in parts of the concessions where they know the photographics aren't going to go."

Obviously Rann's got a vested interest in this perspective. But looking at the case of Kenya, home to one of Africa's largest photo-safari sectors and a poaching problem of catastrophic proportions, you sort of have to give Rann his due. Of course, there's every possibility that some combination of public policy, private money, and anti-ivory market pressures will render hunting obsolete as a conservation instrument. But for now, if you are one of those people who chokes up at reports of poachers poisoning elephants by the herd, you may have to countenance the uncomfortable possibility that one solution to the survival of the species may involve people paying lots of money to shoot elephants for fun.

The hunt continues. We are not back in the truck 10 minutes before the tracker calls for a halt. Robyn and Will linger in the Land Cruiser while Jeff and the tracker go off into the bush to investigate. On the heels of our run-in with the monotusker and his pal, it feels as though the day has already coughed up a full lode of potential prey. So it registers as something of a surprise when Jeff returns with this news: "There's five bulls, all of 'em pretty good size." One of them is carrying at least 60 pounds of ivory, Jeff's threshold, I gather, for trophy viability. "It's a shooter," he says. "If we get a shot, we've gotta shoot it."

Robyn shoulders her rifle. Her eyes are incandescent. Off we troop over the sand.

The bush resounds with a din of timber destruction. The sun is making its descent, and perhaps a hundred yards off, through the brambles, tusks glow in the rich light. The animals are fanned out ahead of us, noisily munching. We come in closer, and the elephants begin to take note, though we register more as a mild irritant, not a mortal threat. The trophy animal is in a lane of dense shrubs, mooning us. Robyn could conceivably flank it and get an

of a magnificent organism that has been treading the savanna since the Kennedy administration, now scattered in pieces on the ground.

3. *Then, this retort: Yeah, but wasn't the leather your wallet's made from once the property of a factory-raised cow whose sole field trip from the reeking, shrieking bedlam of the factory farm was a terrified excursion to the abattoir? And don't you gobble bacon and steaks whenever you get the chance? And aren't "hypocrite" and probably also "pantywaist" accurate words to describe a person who gets queasy at an animal being flayed but who eats meat and/or dons leather shoes?*

4. *Right, but elephants are so smart, and old.*

5. *A caged chicken once beat you at tic-tac-toe. I don't hear you crusading for the pearl mussel, which can live for over a century.*

6. *But elephants are so splendid to look at.*

7. *Unlike a 10-point buck?*

8. *No, but okay, look: We can assume that most people, for whatever totally arbitrary reason, have an affinity for elephants over chickens and pearl mussels. Sure, it's the same illogical pro-mammal bigotry that lets people mourn the slaughter of dolphins and not mind so much the squashing of an endangered spider. BUT? Isn't it a little bit fucked, when the average person looks at an elephant and goes, "Aww, what an amazing animal," to be the one guy in a thousand who goes, "Yeah, cool, I want to shoot it"?*

9. *So it's bad to shoot elephants because other Westerners arbitrarily sentimentalize them? Consider your fantasies of grenading the deer who eat your gardenias. Multiply that by about 10,000 and you've probably got a good approximation of the feelings of the Botswana farmer who wakes up to find that elephants have munched a full year's worth of crops.*

10. *No, I mean I guess I just don't really understand the impulse behind wanting to shoot this big amazing animal, or how, after shooting one, you'd want to jump up and down.*

11. *So what's she supposed to do? Cry and drop into the lotus position and sing a song in Navajo? It's not terribly hard to understand why people go hunting. They go hunting because they find it exciting. As Robyn herself put it, you get a primal thrill. And whether or not you want to admit it, you had the thrill, the neurochemical bongload that hit you when the elephant died. It made Robyn Waldrip jump up and down and it made you go on a pompous, half-baked death trip, which is your version of jumping up and down. You were at the party, bro.*

12. *But I'm not the one who shot the elephant.*

13. *No, you're the one who came on this hunt so that you could ride the*

adrenaline high while at the same time reserving the right to be ethically
fastidious about it. I mean, what really distinguishes your presence here
from Jeff Rann's or the Waldrips'?

14. *Maybe only this: Though the harrowing intensity of the elephant's*
death will, in time, denature into a fun story to tell at cocktail parties,
right now I would trade all of it—the morbid high, the anecdote for my
memoirs—to bring this particular elephant back to life.

The elephant's skull is buried. Its flesh has been hung out to dry.
The Waldrips are booked at Jeff Rann's safari camp for eight more
days, but these folk are hunters, and the notion of spending a week
doing nothing but observing creatures of the wild holds little in-
terest for them. So tomorrow, they will go to South Africa, because
Will Waldrip Jr. wants to undertake something called a "springbok
slam," which involves shooting one of each of that species' four
subvarieties. Jeff has an extra elephant tag for his concession in
Tanzania. He offers this to Will senior, and Will declines.

Our last evening in camp, we go for sunset cocktails at a locally
famous baobab tree. The tree is craggy, Gandalfian, and 1,000 years
old. It has a crazed unruly spread of branches, which inspired the
folk saying, Jeff tells us, that "God pulled the baobab out of the
ground and stuck it upside down." A leopard sometimes hangs out
in the man-sized cave in its trunk. The leopard isn't home. The
only locals on the scene are a squadron of huge buzzards, resting
in the baobab's branches. The camp dumps its hunting refuse not
too far from here, and the buzzards, Jeff tells us, have likely spent
the day gorging on the remains of Robyn's elephant. At our ap-
proach, they take grudging flight in a storm of black wings.

While Jeff's wife is arranging the cocktail table, the party moves
in to have a look at the leopard hole. Suddenly the sounds of
shrieking pierce the quiet of the dusk. My first thought is that
the leopard was home after all and has mauled one of the chil-
dren. But it turns out that one last buzzard had been hiding in
the tree. The bird had gobbled so much of Robyn's elephant that
it couldn't take off. So, to attain flight weight, the buzzard started
puking on the safari group. Fran, the Waldrips' nanny, got the
heftiest portion of Robyn's elephant, on her shoulders and hair,
and Jeff Rann got speckled a bit. The elephant huntress herself
dodged the vomit entirely as the bird set a course for the sun.

ARIEL LEVY

Breaking the Waves

FROM THE NEW YORKER

THE FIRST TIME Diana Nyad tried to swim around Manhattan, in the fall of 1975, she was pulled out of the East River in the black of night after eight hours of nonstop swimming—"trembling uncontrollably, muttering an incoherent stream of monosyllables," she wrote in her 1978 memoir, *Other Shores.* She had contracted a virus in the contaminated water, and it took her 10 days to recover. Then she got back in the water and did it again. On her second try, she wrote, "the Hudson was rough, but the full force of the tide was with me and I almost frolicked in the waves." Nyad made it around in seven hours and 57 minutes, breaking the record by nearly an hour: "Manhattan Island was mine!"

There were pictures of her on the front pages of the New York papers the next morning. She was on *Saturday Night Live.* Woody Allen called her up for a date. (Nyad said yes, even though she's gay, and they became friends; at one of his birthday parties, Diana Vreeland asked where she got her little shorts.) Nyad was 26 and strikingly beautiful, with big brown eyes, a toothy smile, and freckles. Her looks and her pronounced confidence made her a natural for television: she made a dazzling appearance on *The Tonight Show.* Her friend Bonnie Stoll remembers, "She walked on to Johnny Carson's show as if it was her show—no fear whatsoever." Nyad was already an accomplished long-distance swimmer, having broken the women's world record for the 22-mile route from Capri to Naples and made the first north-to-south crossing of Lake Ontario. But after Manhattan she was a star.

For a follow-up, she decided, she would swim from Cuba to Flor-

ida: 111 miles, the equivalent of five English Channel crossings, and the longest open-ocean swim in history. (The closest comparable feat was a 60-mile crossing of Lake Michigan, performed by two men.) Nyad would have to contend with the strong currents and rough waves of the Gulf Stream, and with sharks and jellyfish. In an interview on *The Today Show,* Jane Pauley asked about her motivation. "The most difficult thing I know, mentally or physically, is swimming these great bodies of water," Nyad replied. But when she reached her destination, she said, she experienced "a moment of immortality."

The Cuba swim was instead an epic deflation. Nyad entered the water in Havana Harbor protected by a steel shark cage, and the weather soon turned horrid. She was attacked by jellyfish, and eight-foot waves slammed her against the walls of the cage. The current pushed her wildly astray, toward Texas. Nyad had swum 79 miles, in 42 hours, when her team pulled her out of the water and told her that a squall had sent them irretrievably off course. She was devastated. "I have never summoned so much willpower—I've never wanted anything so badly," she told a television reporter just after she returned. Fighting tears, she added, "And I never tried so hard."

A year later, on her 30th birthday, she broke the open-ocean world record for both men and women, swimming 102 miles from the Bahamas to Florida, unassisted and without a shark cage. She did not swim another stroke for three decades.

One morning in November, Nyad, who is 64, was at home in Los Angeles, where she lives with her dog, Teddy, in a rambling house in a neighborhood of green lawns and carefully pruned roses. Two ragged flags, American and Cuban, hung from a pole in her front yard.

When Nyad stopped swimming, she reasoned that 30 was a good age for an athlete to retire. She began a career as a television personality, on *Wide World of Sports* and CNBC, and as a radio commentator for NPR. Nyad's voice is deep and resonant, and she is a voluble, impassioned storyteller; she also found work as a motivational speaker. She stayed in shape, and took a 100-mile bike ride every Friday. "Part of the pleasure of these endurance activities is to be so engaged in your mind and in nature and just get away from the monkey chatter," she said. "But I'd get back to the house

and think, 'Oh, my God, I didn't notice a thing. I didn't look over and see if there were dolphins in the ocean.'" Her mind was monopolized by regret. "I was very engaged in examining the past: 'Why didn't I do it this way instead?'"

She thought about the dissolution of her decade-long relationship—her marriage, as far as she was concerned—with a television executive named Nina Lederman, who is now a close friend. She thought about injustices she'd suffered and how she wished she'd fought back. And sometimes she thought about how differently she would approach her sport now. "There's that French expression 'If only the young knew, and the elderly could still do,'" she said. "How many athletes have I interviewed who say, 'Oh, if only I could have my mind of this age and be back on the world stage' as a skater, golfer, tennis player . . ."

She first had the idea of swimming from Cuba to Florida, in the 1970s, when she was living on the Upper West Side. (She liked to gamble at the time—she used to meet her bookie at the cheese department in Zabar's.) "I went out and got all the nautical charts of the earth's surface, and I put them out on a big swath of the rug and got rid of the Antarctic Circle," she said. When her eyes reached Cuba, "I literally had a palpitation about it. I thought, It's *Cuba*. It's magic. It's that forbidden land we're not allowed to go to, and they're not allowed to come here. I thought of all the stories of the hundreds of Cubans who have tried to swim out on their own and not made it—they call it the Havana graveyard." When Nyad was growing up, in Fort Lauderdale, her mother used to take her to the Lago Mar beach club and, pointing off the shore toward Cuba, say, "It's so close you could actually swim there." "She meant it figuratively," Nyad said. "But I think somewhere, bubbling in my imagination, I was, like, 'It's right there.'" Around her neck, Nyad wore a pendant that Lederman had given her: a scrimshaw map of Cuba with ONWARDS engraved on the back.

Her mother died shortly before Nyad turned 60, and something shifted inside her. "I don't care how healthy I am—it's not like I'm going to live another 60 years," she said. "There's a real speeding up of the clock and a choking on, 'Who have you become? Because this one-way street is hurtling toward the end now, and you better be the person you admire.'" She didn't want to ponder her past anymore. "I used to be such a maverick in the 1970s," she said. "I was one of the few people—certainly one of the few

women—doing these kinds of extreme things." She wanted the "thrill of commitment": a magnificent goal that would consume all self-doubt. "Cuba, because the dream had been there before, I thought, 'Boy, that's a dream I could rekindle.'"

But it seemed impossible: you could never do at 60 what you did at 30, let alone what you couldn't do at 30. The body disintegrates every year, every hour. "In some parts one grows woody; in others one goes bad," the critic Charles Sainte-Beuve wrote. "Never does one grow ripe." And yet: Cuba. So close you could swim there.

"We usually know where each other is," Bonnie Stoll, who has been Nyad's best friend for more than 30 years, recalled. "Suddenly there'd be hours of time when she'd be all squirrelly—three, four hours at a time where I don't know where she is, because she's swimming." After Nyad revealed her plan, Stoll accompanied her on a training swim in Mexico and saw her in the water for the first time. "One hour in, I saw that she was meant to do it," Stoll told me. "She was one with the water. There was no difference; she was just part of it. That lasted six or eight hours. I said, 'Okay, let's go.'"

Nyad announced her intention to the rest of her friends at a party. "I feel powerful—I've got a lot of chi left in this life," she shouted, pacing poolside in a white bathing suit. "When I walk up on this beach this time, the whole world's going to see: 60 is the new 40!" Then she leaped into the water.

Nyad met Stoll playing racquetball; Stoll was once among the top 10 professional players in the country. The two dated briefly, and then settled into a jock friendship, working out together constantly. After Stoll, who has the demeanor of an exceptionally jovial drill sergeant, retired from racquetball, she became a trainer, and she helped Nyad prepare for Cuba. She wasn't particularly concerned about Nyad's age. "Endurance sports are very different from other kinds of sports: the mind is a large part of the endeavor," she said. "And Diana has a different kind of mind."

Steven Munatones, the director of the World Open Water Swimming Association, told me, "If you run, eventually your joints give out. In basketball, you can dunk at 22 but probably not at 42, and certainly not at 62." Munatones, who is a performance consultant for a variety of athletes (when we spoke, he was on the way to coach skiers for the Olympics in Sochi), said that swimming

is different: "If you are inclined to, you can do it until the day you die. Marathon swimmers aren't Michael Phelps. They are not being measured on aerobic capacity. If Diana's aerobic capacity decreases, she just slows down."

But the slower she swims the longer she has to stay awake, and to get from Cuba to Florida at any pace she would have to swim for days on end. Nyad has always operated without a lot of rest, though. In fifth grade, she wrote an essay called "What I Will Do for the Rest of My Life," in which she announced, "I want to play six instruments. I want to be the best in the world at two things. I want to be a great athlete and I want to be a great surgeon. I need to practice hard every day. I need to sleep as little as possible." Stoll told me, "Diana is the least lazy person I have ever met in my life."

After Mexico, Stoll began to gather information: "Let's figure out the nutrition; let's write to people. But nobody really knows." What they wanted to do had never been accomplished by anyone, male or female, at any age. Stoll said that she could "see the playing field: in endurance sports, you have to build up and then you have to taper down in order to peak at the right time." But they couldn't simply pick a date to begin the swim. They had to wait for a window when the currents and the wind would not make the journey impossible. Even then, at any moment—after, say, 40 hours of swimming—the weather could suddenly force them to stop.

They estimated that the expedition would cost about half a million dollars. Nyad needed a boat with a crew and an experienced navigator that she could follow. She needed a medic, in case she collapsed in the water. (In 1959, the Greek swimmer Jason Zirganos, attempting to cross the North Channel of the Irish Sea, suddenly stopped stroking after 16 and a half hours. The medic in his crew cut his chest open with a pocketknife and performed open-heart massage, but Zirganos died before they reached land.) Nyad would need handlers available the entire time she was swimming, calling her toward them every 90 minutes, so that they could feed her over the side of the boat. (In keeping with the rules of the sport, they would have to feed her without touching her, as if dangling fish into the mouth of a dolphin.) Finally, the entire crew would need plane tickets and paperwork to get to Cuba. They began raising money.

When Nyad wasn't working on logistics, she trained ferociously.

She spent the first half of 2010 going for 12-, then 18-, then 24-hour swims off of St. Martin, where there are rarely sharks to contend with. For the Cuba swim, Nyad and Stoll decided that they would employ shark divers and kayakers for protection: Nyad had bad memories of swimming inside the shark cage, and, furthermore, an Australian named Susie Maroney had made the swim in a cage in 1997; Nyad wanted to accomplish something unprecedented. She and Stoll found a company that produces a kind of shark shocker—a telephone-sized contraption with a seven-foot antenna that drags in the water and emits a shark-repelling electromagnetic field.

Early in the summer of 2010, Nyad and Stoll went to Florida and waited for the right conditions. "Ninety-one days in a row sitting in Key West—trained, ready, expedition paid for—looking at the winds, calling the meteorologists," Nyad remembered, shaking her head. "The winds never stopped coming from the east. And when they come from the east and the Gulf Stream's going east they hit and they form giant peaks. And you can't make it. Then the water temperatures get too cold by the end of September." In early October, she sent an email to friends and donors: "I got in better shape both body and mind than even in my twenties. It has been draining, ripping of the spirit to feel it all slip away from me."

"It's hard for me to remember even now—the heartache the day we went and packed up, after all the training, the fund-raising," she told me. "Now you're waiting until next July. And training again." Relinquishing the Cuba swim did not feel like an option. When she returned to L.A., she was "just looking up a *mountain* of knowing I was going to go back. Because there is no way I'm not going to do that fucking swim." The waiting and the training would be their own test of endurance.

A pronounced ability to tolerate pain is common among marathon swimmers. Agony in the sport is a given. The body suffers from being immersed for days in salt water: when a swimmer swallows water as she breathes, it abrades the soft tissue of the lips, the tongue, and the throat. The throat starts to swell shut; in one case, Munatones said, "they literally had to cut the person's throat to get air in." Salt water is nauseating, and swimmers, already seasick from being thrown by waves, vomit during marathons, losing valuable calories.

The water in the Straits of Florida, where Nyad wanted to swim,

is relatively warm. But even the balmiest seawater is colder than body temperature, and hypothermia is a grave danger. Blood flows to the body's core to protect the vital organs, and, as the condition progresses, the extremities fail. The victim becomes confused and can lose consciousness; in the worst case, her heart stops. Most swimmers tolerate a certain degree of hypothermia. The problem is that by the time a swimmer is dangerously hypothermic she has stopped feeling cold. "Every year, people get in trouble," Muna-tones said. "When their crew pulls them out, they seem catatonic, their blood pressure is low, their eyes roll back in the sockets."

Swimmers call the process of acclimating the body to cold and seasickness "hardening": the earned capacity to survive for long stretches underwater, where humans are not designed to be. People who excel at this tend to be exceptionally good at refocusing their minds when confronted with pain or danger. Recently, Nyad took part in an experiment with a psychiatrist at the University of California–San Diego, in which subjects' air supply was restricted for undisclosed intervals and their panic response measured, using MRIs. Nyad stayed as calm as Navy SEALs who participated in the experiment. Open-water swimmers tend to have "a survival mentality," Munatones said. "You literally have to go to the edge. With athletes in general, they say that, but normally that means jump high or run fast—it's not a matter of life or death.

"Every open-water swimmer I know, they make lists," he continued. "They remember their exact time, to the second, of a swim they did 20 years ago; they count their strokes." When Nyad takes a long flight, she buys a family-size pack of M&Ms. In her seat, she takes the candy out of the bag, counts it, and puts back an equal number of each color. (She eats the extras.) She divides the length of the flight by the number of remaining M&Ms and then eats them at even intervals, keeping track of what color she pulls out of the bag every time. "I want to finish them exactly when I land," she said. "Of course, if you don't land on time, then you're screwed, and your whole OCD personality is in crisis." On training swims for Cuba, if she got to her point of exit ahead of schedule, she would continue swimming around until she'd hit her planned duration to the second.

Open-water swimmers must be able to control their minds—it is all they can control, unlike the weather, the sharks, the currents. "They feel sick or cold or whatever, they have to be able to think of

something else to continue," Munatones said. "Open-water swimmers have to be able to compartmentalize."

Nyad's mother, Lucy Curtis, was born into a wealthy family, which made its money from a product called Soothing Syrup, and "used to live where Tiffany's is now," Nyad told me. But Lucy's mother didn't want her, and she was sent to France to be brought up by relatives "who knew Matisse and Gauguin" and lived "literally right next door to Gertrude Stein and Alice Toklas." She was 17 when the war came to Paris, and, with her American passport, she escaped. "She got together with a group of people and—by bicycle and by walking through the South of France—they got across the Pyrenees and into Portugal, where they took a boat to Manhattan."

Lucy married Aristotle Nyad, a Greek Egyptian who looked like Omar Sharif and was a wonderful dancer. Diana often does an impression of him in speeches. "He called me over when I was five years old, and he had the large Webster's dictionary open, and he said, 'Dahling, I am waiting for five years, till you are ready to hear this moment,'" she told a TED conference in Berlin. He pointed to the word "naiad," and explained that in Greek myth "these were the nymphs that swam in the lakes and rivers and the oceans to protect them for the gods! The modern definition says 'girl or woman champion swimmer.' This is your destiny, dahling!'" She started getting up at four-thirty or five every morning to swim for two hours before school, with an hour of sprints at lunchtime; after school she got in the pool for another two hours. "I would be so tired at night I couldn't eat dinner," she said.

Aristotle Nyad was a con man, and the family—Lucy, Diana, her sister, Liza, and their brother, William, who was schizophrenic—had to move frequently to keep ahead of the people he had lied to and stolen from. "My father, I always thought, was, you know, scary and fun," Nyad said. "Magnetic and terrifying." She adored her mother, but described her as weak. Aris, as he was called, had a violent temper, and several times Lucy had to go to the hospital after he attacked her. Diana became skilled at diverting her attention, focusing on the goals she set for herself at school and in the pool.

Her parents broke up when she was a teenager, and she did not see Aris for 20 years. One day, when she was living with Nina Lederman, on West 86th Street, he showed up at their apartment

at four in the morning. "He says, 'Dahling, please, I want to see you. I love you so much.' He's wearing a white dinner jacket. He's got a bucket of some incredibly expensive champagne. He's got fresh-squeezed orange juice. He says, 'Dahling, oh, I have thought of you every day for 20 years!'" He stayed that night and the next, when Nyad and Lederman were having a dinner party. "He makes a salmon with homemade risotto," Nyad told me. "Gets these expensive Greek wines. Comes back at night with flowers for every woman at the party. Shows the men card tricks. Dances. We stay up till dawn. Everybody calls me the next day and says, 'Your father is the most fascinating person alive, and his work with the UN is just incredible!' Then the next person calls and says, 'To be a professor of classics at the Sorbonne and to make it all the way over for this party was just amazing.' They're going to find out the truth when he's gone. But he's gone. And I never saw him again. Poof. Gone."

Throughout Nyad's childhood, Aris had disappeared and re-emerged, and once she reached puberty it was better if he was away. When she was 11, he took her to the beach one afternoon, and when they stopped after swimming to wash off the sand he put his hand between her legs. "Like he could grab my crotch and hold it in his hand and look at me, like, 'I *got* you—I got you right here. And I know how humiliated you feel, and this is *fun*.'" After that, Nyad strategized how to get to her room without crossing his path when she got home from school. She felt safest and most free underwater.

As a seventh-grader at the Pine Crest School, in Florida, Nyad found a mentor: Jack Nelson, her swimming coach, a former Olympian, who convinced her that with his help she could become a star. "Finally, there's somebody who truly is a leader and cares about me and thinks I'm going to capture the world," Nyad told me. Within a year, she had won state championships in the 100- and 200-meter backstroke. "I had him on a pedestal—he was *it*. I was just dying for some leadership and I selected him. And I told him a lot of those stories about the parents."

So it was devastating when he forced himself on her, when she was 14, one afternoon as she was resting at his house before a swim meet. Throughout high school, Nyad says, he persuaded her to meet him in hotel rooms, at his office, in his car, and molested her. She would never be a great swimmer without him, he said, and this was what he needed from her in return; he told her that she had

instigated the relationship by writing "I love Coach Nelson" on the cover of a notebook. Years later, Nyad disclosed the abuse to a former teammate, who said that she'd had the same experience. They reported him to the headmaster, and Nelson left at the end of that school year. He went on to become the swimming coach at Fort Lauderdale High School, and in 1993 Fort Lauderdale named him its man of the year. In 2007, Nelson made a statement to the Fort Lauderdale police denying the allegations of abuse; Nyad, he claimed, had told him once that she "wanted to be a writer, and wanted to have the ability to write things that were not true and make people believe them."

Nyad told me, "A lot of children who grew up with incest say, 'Oh, I love my father—it's very complicated.' With the coach, for me, it's not complicated. I've had all kinds of fantasies of being out in the woods and tying him to a tree and putting his penis on a marble slab and walking around with a hatchet and watching him cry and plead, and I'd say, 'Oh, remember me? Remember when I was crying? You didn't seem to care too much about my feelings.' And then leaving him to bleed to death."

When Nyad was in college, her mother revealed that Aris was her stepfather, and that her real father had left when she was three years old. By the time Aris died, in 1998, Nyad had already made peace with her memories of him. "People say, 'Where'd you get this drive?'" she told me. "Early on, I thought, 'I'm in this alone. I'm going to be taking care of myself.'"

On the evening of August 7, 2011, after a second year of nonstop training, Nyad and Stoll and their crew set out from Havana Harbor. "There was just no doubt in any of our minds, 'We're going all the way,'" Nyad said.

Distance swimmers spend most of their athletic life staring down into murky water, isolated by sensory deprivation. "You are swimming essentially blind and deaf," Munatones told me. "Imagine doing the New York Marathon and not being able to see around you. Most people would finish the marathon crazy—in fact, they wouldn't be able to finish at all." Nyad gets through the hours by singing songs in her head—Neil Young, the Beatles. She counts in sets of 100, first in English and then in German, Spanish, and, finally, French. She thinks about a one-woman show she wants to perform and fantasizes about appearing on *Dancing with the Stars*.

For the Cuba swim, Nyad followed an illuminated path in the water; her team had developed a streamer studded with LEDs that trailed off a support boat, so that she could swim above it. They couldn't shine a beam into the water to track her—light attracts animals—so she swam with a little red light attached to her swim cap.

By the end of the first night, she had excruciating pain in her right shoulder—"I feel like it's going to come out of the socket," she told Stoll from the water—and the current was pushing them backward. A few hours later, Nyad suffered a severe asthma attack, the first she'd ever had in the water, and every few strokes she had to roll onto her back to catch her breath. Her doctor got in the water to give her puffs from an inhaler, and she pushed on, swimming so slowly that she developed severe chills. "I'm just dead," Nyad called out to Stoll. "I'm dead."

At 29 hours, she got out of the water, dehydrated and vomiting. "I just can't see myself training and dragging everybody along again for another year," she told her supporters when the team pulled up onshore in Key West. She cried a little as she said, "I think I'm going to have to go to my grave without swimming from Cuba to Florida."

Six weeks later, she tried again. The weather and the water were flawless. "It was like glass the whole time," Nyad said. She had been reading Stephen Hawking, and, at dusk, as she was enveloped by the dark sea and sky, she thought about the limits of time and space. Suddenly, at about 8:00 p.m., she felt a pain like nothing she'd ever experienced—like being "dipped in hot burning oil and your body is in flames."

She had been stung by a swarm of box jellyfish, the most venomous creature in the ocean—an almost mythological monster with 24 eyes and three-foot tentacles that inject a poison that can cause cardiovascular collapse and cerebral hemorrhage. "I feel it in my back and then I feel it in my lungs," Nyad recalled. "Just frozen in agony." An emergency medical technician jumped in to wipe away the gelatinous tentacles and was stung in the process. He got back on the boat, injected himself with epinephrine, and collapsed on deck, able to take only three breaths a minute. Nyad stayed in the ocean, treading water, screaming and gasping for air.

After the worst of it dissipated, she picked up her stroke again. At five in the morning, a medical team from the University of Mi-

ami arrived to attend to her. "It was like an ICU in the water," she said. She was given prednisone and oxygen, and then she kept swimming. At dusk, she was stung again.

Nyad's nephew, Timothy Wheeler, who was working on a documentary about the swim, filmed her as she was pulled from the sea: her face is riven with terror, and then she closes her eyes and goes blank as the medical team administers oxygen. Stoll screams at her to keep breathing and not to fall asleep. Finally, air starts coming in and out of her nose, fogging the oxygen mask.

Nyad insisted on continuing after a few hours of treatment; if she returned to the precise GPS coordinates where she'd stopped, she could at least attempt a "staged" swim. But she was too weak to swim half the time she was in the water, and the team was being swept off course. After 37 hours, the navigators gave Nyad bad news. "They said, 'Do you want to go to the Bahamas?' And I said, 'No, I don't fucking want to go to the Bahamas!' And they said, 'Then it's over. We're done.'" Stoll told Nyad, "I watched you almost die last night. I really did. And I don't think I can do that again."

Still treading water, Nyad said, "Other people may go through this, but they're younger, and they're going to do other swims." She looked ruined, bereft. "This is the end of it. This is the end."

One afternoon during my visit, Nyad met with an accountant she was thinking of hiring. "All my life, whether I've had money or not had money, it's the one area where I've been disorganized, incompetent, and haven't done well by myself," she told him. (Minutes before, she had left her wallet behind on the counter at a Jamba Juice.) When she was hired as an announcer on *Wide World of Sports,* she made $350,000 a year. "In the 1970s, it was a lot of money," she said. "I gave it all away, took care of my friends—we went on some badass trips to Africa."

Nyad is capable of incredible discipline, but she can be surprisingly unheeding: she never opens her mail and rarely has anything in her refrigerator. Until 2006, she had a business manager, but things ended badly. One day, she went to the hospital for shoulder surgery, and was told that she hadn't had health insurance in years. Even now she seemed not to fully understand her own finances. She asked the accountant, "If I get paid $50,000 for a

speech, what tax bracket am I in?" He explained that it depended how many speeches she gave a year.

She was going to make some money soon, she said, writing an inspirational book about her life. "All the biggest editors and publishers are interested; they're all calling it probably the biggest memoir of the decade!" she said, with guileless wonder. "I'm 64 years old. I want to take care of myself and not be stupid this time around." The accountant asked if she had a spouse or a partner. "Not right now," she said, but explained she had friends she wanted to provide for, so that when they were old "we always have a place to live and a little money to travel."

Nyad has not had a serious relationship in decades. (She had an affair at the end of her time with Lederman, and, she says, "I think part of my not being with someone else all these years was because I deserved to punish myself.") But she and Bonnie Stoll are very much a team. They have matching tattoos that say ONE HEART, ONE MIND in Japanese. They talk and text constantly and see each other daily—Stoll lives 10 minutes from Nyad, in a modern house with a Leni Riefenstahl photograph of Jesse Owens, which Nyad bought for her, hanging in the living room. "She does as much for me as I do for her," Stoll told me. "I don't want to be on Diana's coattails; that's not my position."

After the near-fatal swim in 2011, Stoll and Nyad were deeply divided about whether to finally let go of the Cuba dream. Stoll had become convinced that there was something almost suicidal about persisting. She told me, "Sometimes Diana's not very evolved— and it pisses me off! She can react out of desperation. She can be desperate."

"My journey now is to find some sort of grace in the face of this defeat," Nyad told an audience a month after her third failed attempt. "Sometimes if cancer has won, if there's death and we have no choice, then grace and acceptance are necessary. But that ocean is still there. I don't want to be the crazy woman who does this for years and years and tries and fails and tries and fails, but I *can* swim from Cuba to Florida and I *will* swim from Cuba to Florida."

Nyad has always believed that a champion is a person who doesn't give up. (In high school, she hung a poster on her wall

that read, A DIAMOND IS A LUMP OF COAL THAT STUCK WITH
IT.) But another kind of person who doesn't give up is a luna-
tic. "I sort of thought, 'Oh, she's crazy'—and she *is* on some level
crazy," Nyad's friend Karen Sauvigne told me. Sauvigne, a former
triathlete who completed a 400-mile bike ride when she was 60,
said, "On some level I can approach understanding." But, after
Nyad's friends saw photographs of her face swollen and disfigured
by stings, Sauvigne said, "we were all, like, 'Give it *up,* girl.'" Can-
dace Lyle Hogan, a former girlfriend who has accompanied Nyad
on every Cuba swim since 1978, told me, "I'm afraid from day one
that she's going to die. That body of water is a wilderness still. It's
strange out there."

On August 18, 2012, Nyad made her fourth attempt. She swam
for 51 hours and was stung repeatedly by jellyfish. (At night, she
wore a protective mask that left only her nose and lips exposed:
she was stung on the mouth.) When her team finally pulled her
out, there were sharks in the water around her and a severe tropi-
cal storm above. Nyad resisted, "shaking her head angrily," accord-
ing to a live blog that Hogan kept on the boat, though there was
"lightning, thunder, and roiling winds tossing her tiny escort vessel
up and down on the waves." She relented only when they con-
vinced her that lightning might kill one of the kayakers.

Stoll told Nyad that she would not accompany her on a fifth
attempt at Cuba: she was increasingly disturbed by her friend's in-
ability to accept defeat. "It didn't matter how many people—ex-
perts!—told her that the Cuba swim couldn't be done," Stoll said.
Munatones told Nyad, "I don't think it is physically, humanly pos-
sible. There are just too many variables."

"By this summer," Nyad told me, "everybody—scientists, endur-
ance experts, neurologists, my own team, Bonnie—said it's impos-
sible." But Nyad was convinced that with each failed attempt she'd
learned something. She enlisted Angel Yanagihara, the world's
foremost box-jellyfish authority, and collaborated with a prosthet-
ics expert to produce a silicone mask, with eyeholes for goggles
and bite plates that secured the mask over Nyad's lips while still al-
lowing her to breathe. Munatones said that swimming in that pro-
tective gear would be like "wearing lead shoes to walk up Mount
Everest." Nyad, on her website, acknowledged that the mask "slows
me down, by about 0.3 mph. And it forces me to swallow much
more seawater than good for the stomach. But I simply need to

remember, when enduring the difficulty of the mask, that it protects me from stings . . . No other way." She had a simple plan for dealing with the weather this time. She emailed her team, "We will not, under any circumstances, interrupt the swim for storms this year . . . no matter how severe."

Stoll thought that no amount of preparation could suffice. "Something can always go wrong and something always will go wrong," she told me. But at the last minute she decided to go with Nyad, anyway. "I didn't want to have regret. If this is what Diana was going to do, then I'm with her."

In Havana, the night before the swim, Nyad felt a cold coming on. Hogan gave her a massage before she went to sleep, and she woke up 10 hours later "feeling fantastic," she told me. Before a swim, she forces herself to keep her adrenaline contained, so she has energy available to fend off crisis. "When something means a lot to me, I don't want to give it a lot of dispersed energy. I want to keep it within myself."

Her first night in the water, the mask was agony, abrading her mouth and forcing her to swallow so much salt water that she threw up constantly. On her second night, there was a storm, and the support boats had to move away to avoid hitting her. For two hours, Nyad treaded water, becoming severely chilled. "I really started hallucinating badly," she said. "I thought I saw the Taj Mahal. I saw all the structure of it and I was talking to the shark guys about it: I thought we got off course and we're over in India." Stoll told her that if she came across the Taj Mahal she just needed to swim around it.

"It was choppy out there, but who cared?" Stoll said. "Everything went our way—everything. No sharks, the currents, the wind. We were being pulled in the direction we wanted to go."

"I was cranking," Nyad said. "And, even with the rougher seas, we were moving with a good current and with me feeling well. And when I came to put on the mask at night Bonnie said, 'I want to tell you something. You're never going to have to put this mask on again.'"

The navigation team had calculated that the swim would take three nights—maybe four—but the current and the conditions indicated that they would arrive in Florida before sunset on the third day. Stoll told me, "It was like Mother Nature just said, 'You know what? Let her fucking *go*.'" In the water, Nyad recalled, "I'm start-

ing to think, 'Oh, my God, I'm going to make this thing.' Before
that moment, you have no idea when you're going to finish. Is this
going to be four days, and you're going to have to find a way not
through this night but through the next night?" When she lifted
her head to breathe, she saw light along the horizon, and a thrill
went through her: "I saw the sun was coming up. I saw this really
white light." But it was better than sunshine. "Bonnie said, 'Those
are the lights of Key West.' And I cried. I still had 14 or 15 hours
to go. But for me that's a training swim."

As Nyad approached land, the team on the boat saw it before
she did. "My vision's real bad now—my swim-clouded, hallucina-
tory vision," Nyad recalled. "But I see all the shark divers getting
in and Angel Yanagihara getting in, and I just felt like there were
a lot of people in the water all of a sudden." They were nearing
the reef just off Key West. "I started thinking of all the places I'd
trained and all the people who helped, all the fund-raisers," Nyad
said. "I remember the first attempt, and how it was so upsetting
to be told that you're so off course you're never going to make it.
Once we crossed the reef, it was not really a euphoric celebration
but just, 'You didn't give up. You fucking didn't give up.'"

At two in the afternoon, Nyad stumbled through the shallow
water onto the sand, where hundreds of people had gathered to
cheer her on. Her lips were as swollen as a clown's. She staggered
like a toddler taking her first steps. Stoll stood in front of her, a few
feet up the shore, urging her forward, until finally Nyad stepped
out of the water and fell into her arms. She managed to tell the
crowd, "You're never too old to chase your dream."

Late this fall, to raise money for charity on the anniversary of Hur-
ricane Sandy, Nyad had a two-lane pool installed in front of Ma-
cy's, in Herald Square, and for 48 hours she swam back and forth
through the calm, chlorinated water. Every 15 minutes, another
person joined her for a shift in the second lane—a high school stu-
dent from a local swim team, her friend Jacki from L.A., Richard
Simmons. During the day, there were throngs of people standing
and staring, but by four in the morning it was frigid and dark, and
the crowd had shrunk to a dozen spectators who couldn't believe
what they were seeing. "She's been in there for how long?" a wait-
ress getting off her shift asked.

It was Nyad's second night in the pool, and as she swam up to

the edge so that Stoll could feed her peanut butter she was starting to sound less coherent. (At one point, she asked when they were going to start using "the other pool.") "When she's been in the water for a long time, she turns into her mother, my grandmother," Timothy Wheeler said. Lucy had Alzheimer's disease at the end of her life, and there was a similar sense of disorientation and vulnerability. "Her voice, her facial expressions—everything."

At the edge of the pool, Nyad didn't look strong and confident, as she does on land. She looked weary and pickled and frail. She drank water through a straw that Stoll gently guided into her mouth, then started retching and threw up into a plastic garbage bin, which Stoll held out for her. Stopping to vomit made her cold, and she shivered in the water. It was hard not to wish that she would just stop swimming and get into bed.

Other people came and went from the pool, swimming beside her, in synch or not, sharing a little of her journey. The light started coming up, and the sky glowed purple for a while, then grew cloudy and foreboding. Sometimes, there were lots of people cheering her on, and it seemed as if Nyad were at the center of something exciting, and then there would be a lull, and the enterprise would seem dubious and isolated. There were long periods of dullness when time went by slowly, but it seemed to speed up toward the end. Diana Nyad did not stop swimming until her time was up.

CHRISTOPHER BEAM

The Year of the Pigskin

FROM THE NEW REPUBLIC

THE DAY OF the first game of American football ever played in Chongqing, China, Fat Baby held court in the locker room at the stadium of Chongqing Southern Translators College. "Stadium" would be generous, actually—it was a soccer field with stone bleachers. So would "locker room," in reality a pile of clothes and equipment strewn across the benches. Even "football team" was arguable, come to think of it, but that's what the Chongqing Dockers were there to prove.

Fat Baby and his teammate Bobo had just returned from a trip to Japan, where they'd bought matching Under Armour skullcaps. "You can't find these in Chongqing," he said proudly. One of the team's founding members, Fat Baby (his real name is Zeng Xi, but like most of the teammates he goes by his online nickname) juggled the roles of wise elder (he was 29) and class clown. He first got into football after watching movies like *The Longest Yard*—the 2005 Adam Sandler remake, not the 1974 original.

As game time approached, Fat Baby slipped on his favorite pink cleats. It didn't look easy—he called himself Fat Baby for a reason. Later, I asked if the pink cleats were meant to scare his opponents. "Yes," his wife, Yangyang, interjected, "they're scared he'll fall in love with them." Yangyang, tall and matter-of-fact, wasn't a football fan. "I hate sports," she told me. But as a nurse, she supported Fat Baby's passion to the extent that it would help him lose weight.

Marco, the Dockers' captain, scurried over, looking anxious. He was smaller than average, especially for a former personal trainer, and his facial expression tended to hover between pensive and

pissed off. When he got excited, his voice plunged from alto highs to baritone lows. He wasn't typical captain material, but he had mapped out a meticulous plan for the team's development, and media was key to his strategy. The more people knew about them, the more players they'd attract, the better they'd get. Today's contest, against the Beijing Cyclones, was their first home game, a chance to show everyone that they weren't just a bunch of posers in uniform, but an actual American football team in southwestern China. Unfortunately, a 6.6-magnitude earthquake had hit Sichuan Province that morning, so only a couple of news outlets had showed up to see them play.

Marco took the referee microphone out to the middle of the field to test its range and to show off his football English: "Holding, defense, number 27, first down." On the opposite fence, a red propaganda banner hung: UNITED, WE PROGRESS, BREAKING BOUNDARIES, WE INNOVATE, STRIVING TENACIOUSLY TO BE FIRST. Behind it, a strip of Chongqing skyline: identical-looking office buildings next to skeletons that would soon be identical-looking office buildings. From the air, Chongqing resembles a Sim City created by a 10-year-old off his meds. Perched between two rivers, fringed with ports, Chongqing has exploded economically in the past decades, with an urban population of seven million and the second-highest GDP growth rate in the country. All this development makes Chongqing the urban incarnation of China's modern identity crisis. It's a city where the Liberation Monument dedicated to the 1949 Communist victory is surrounded on all sides by Cartier, Armani, Louis Vuitton, Gucci, Starbucks, KFC, and Häagen-Dazs; where Bo Xilai, the former Chongqing party secretary, is both reviled for his corruption and beloved for his populist policies; where you can be late to dinner because, when someone said to meet at the Wal-Mart in your neighborhood, he meant the *other* Wal-Mart in your neighborhood.

Chris McLaurin, the team's 26-year-old American coach, wanted badly to win. He didn't let it show, exuding the air of calm authority the teammates had come to rely on. But ever since he had arrived in Chongqing the previous fall, the Dockers had dominated his life, nights and weekends spent coaching, planning, promoting, recruiting, all on top of a full-time job at a government-run investment firm. Without McLaurin, Fat Baby told me in English, "we would be a piece of shit."

The Beijing Cyclones rolled in an hour before game time, 50 Cent serving as unintentional entrance music. Mike Ma, a Cyclones captain and Beijing native who had spent his teenage years in Los Angeles, greeted McLaurin with a purposeful thug hug. "Damn, you guys are deep, dog," said Ma. Since many Beijing players couldn't make the trip, Chongqing outnumbered them almost two to one. This made McLaurin cautiously optimistic. Beijing had more experience and stronger athletes, including a professional parkour practitioner. But between their home-field advantage and numbers edge, he thought the Dockers had a shot.

Fans, mostly friends and family, gathered in the stands. I asked a student named Liu Zhiyue if he understood the game. "A little," he said. "The quarterback is the most important." Beyond that, he wasn't totally sure. By the sidelines, a small squad of refs, all expat friends of McLaurin, put on the pinstripes they'd ordered online. One, a densely built Californian named Jeff, who had played semi-pro football in Poland and had NEVER AGAIN tattooed in Hebrew on his shoulder, was getting nervous. "I don't know the rules, that's my thing," he said to the head ref. "You should have, like, taught us the rules before, dude."

Queen's "We Will Rock You" came on, the international sign that a sporting event is about to occur. The Dockers lined up along the sidelines and made war whoops, as McLaurin had instructed. A smiley player named Kang had affixed masking tape to his helmet to form 杀, the character for "kill."

Beijing kicked off. The ball sailed deep, spinning backward, and bounced off the Chongqing receiver's chest before he chased it down. If the crowd was already confused about the game of football, what happened next didn't clarify much. It almost looked like the Dockers were *trying* to lose the ball. The Chongqing quarterback, Seven, fumbled a snap, then recovered it just in time to get sacked. Not long afterward, he passed to a receiver who wasn't there.

"Settttt, *hut!*" growled Leo, the Beijing quarterback. As soon as he took the snap, a Chongqing tackle drilled through the line for the sack. "There you go! There you go!" shouted James "Fitz" Fitzgerald, another assistant coach. The euphoria was temporary. Second down, Leo saw an opening on the left side, threaded through it, and ran, as if alone on the field, all the way to the end

zone. He celebrated by chest-bumping one of his teammates and miming a graphic strip tease.

The Chongqing players looked at each other. They'd been practicing for months, running and sweating and studying the playbook, rebuilding their bodies and reprogramming their brains, learning this weird foreign game from scratch. For many of them, football had not only become the center of their social lives, it had become their identity: Fat Baby had a custom-made bumper sticker on his car that said CHONGQING DOCKERS FOOTBALL FATBABY. Marco wore his Dockers T-shirt everywhere. Football was already more than a game to them—it represented a whole set of stories and values and attitudes that these young Chinese men had hungrily absorbed and now wanted to project. And for what? So a Beijing quarterback could gyrate his crotch in front of their loved ones. Fitz shook his head: "We're about to get our ass kicked."

"American football in China" is a sport/location combo that at first sounds like a joke, like "Jamaican bobsled team." But according to the rule that, in a country of 1.3 billion people, everything is happening somewhere, the existence of Chinese football should come as no surprise. Unlike basketball, which missionaries brought to China in the late 19th century and which has long enjoyed government support (Chairman Mao was a fan), football is a recent import. It doesn't come close to breaking into the country's top 10 sports. Even the term in Mandarin—"olive ball"—sounds awkward. But it is here and growing fast. The NFL first set up a China office in 2007 and started a flag-football league that has grown to more than 36 teams. Meanwhile, a raft of amateur tackle clubs has materialized, including, as of summer 2012, the Chongqing Dockers.

The Dockers started when Fengfeng, a 19-year-old freshman at the Chongqing Electronic Engineering University, created a QQ group dedicated to American football. (QQ is one of China's most popular online chat programs and, along with WeChat, the way most of the players keep in touch.) He named the group "Rudy," after the 1993 movie about a five-foot-six-inch steelworker who dreams of playing for Notre Dame, which Fengfeng had seen 10 times. Marco saw the message and reached out. They and a handful of others, including Fat Baby, arranged to hold a practice. Marco

also invited a journalist friend, resulting in a full-length write-up in the *Chongqing Economic Times*. Marco received more than 200 inquiries, and 30 guys showed up to the next practice.

The problem was, they came expecting to learn how to play American football. Marco had studied some instructional videos he'd found online, but had never played himself. "It was truly terrible," Fat Baby recalled. That didn't stop them from accruing the trappings of a football team. They named themselves the "Dockers," a reference to Chongqing's armies of longshoremen. They bought jerseys before buying pads, designed a logo before getting a playbook, recruited cheerleaders before doing anything cheerworthy. Nana, the squad captain, choreographed a few routines based on scenes from the *Bring It On* movies, employing dance moves Chinese girls don't learn in school.

None of this translated into actual skill. One day in the fall of 2012, McLaurin showed up to a practice. "It was like a bunch of guys who'd heard of the sport trying their best to imitate what they'd seen on TV," he said. No one had pads, so hits were more like careful hugs. What had inspired them to pick up this strange game with an unwieldy ball that had no connection to local culture, he hadn't the slightest. But they were eager to learn, and McLaurin, who'd just arrived in Chongqing, needed friends.

McLaurin was immediately made head coach. He assigned positions based on size and speed. Quarterback was tricky, as the job requires a combination of height, athleticism, intelligence, and leadership ability. Seven was tall. He got the job.

At the first practice I attended, in February of 2013, the team was preparing for its debut game against Chengdu. In one drill, McLaurin told the linemen to hit him head on, but they kept slowing down just before making contact. "Really hit me," said McLaurin, who enjoyed the warm feeling that ran down his spine after a hard strike. "Don't think too much." But the players kept hesitating. After 30 minutes, they ambled over to the sidelines, where half the guys swigged water and the other half dragged on cigarettes.

The following Sunday at 9:00 a.m.—only in China are football practices scheduled for Sunday mornings—a few team members showed up after a late night of drinking and fiery Chongqing barbecue. "My asshole is burning," Fat Baby announced as he waddled onto the field. Rock, a railway employee who was wearing a Mi-

chael Vick jersey and a jock strap over his tights, put one teammate in a WWE-style figure-four hold. I asked if he knew that Michael Vick was famous for torturing dogs. "China has a lot of people like that," he said, grinning. McLaurin had Seven run a simple passing drill. Not a single throw reached its target, and McLaurin grew frustrated. He made everyone run sprints, which he won. As the players headed to their cars, McLaurin walked over to the benches, braced himself against a wall, and spilled the contents of his stomach onto the ground.

Coaching the Dockers was like coaching a peewee team, McLaurin told me, only harder. Sports aren't built into the average child's life in China as they are in the United States. Instead, athletics and academics are separate tracks. If a kid has potential, he gets siphoned into a special school dedicated to producing the nation's finest athletes. Most of the Dockers hadn't played organized team sports past grade school, and if they had, it was basketball or soccer. The core skills of football—throwing, catching, hitting—were as foreign to them as curling.

McLaurin, by contrast, was a specimen of the American scholar-athletic complex. Born outside Detroit to a white mother and a black father, both police detectives, he was a star football player at a Catholic high school that emphasized sports as part of a well-rounded character. He went on to play tight end for the University of Michigan and might have made it to the NFL if it weren't for a career-ending shoulder injury. He was able to fall back on a stellar transcript, going on to get a master's in social policy and planning at the London School of Economics and to score a White House internship. He eventually came to Chongqing on a Luce Fellowship. After years of competing, McLaurin couldn't *not* go 100 percent. Between drills, he'd coil up and jump high into the air as if clearing an invisible hurdle. When his players didn't match his intensity, he got annoyed.

But the greatest cultural gap between McLaurin and the team seemed to be the willingness to draw up every last bit of oneself and smash the person opposite. Size wasn't a problem; the Dockers were a strapping bunch. They just weren't willing to *use* their size. Part of it was fear of injury: in the Dockers' first six months, seven players had been hurt, including Bobo, who had broken his leg at practice. But habit played a role too. Life in China is plenty physical—just try riding the subway during rush hour—but you

don't often see kids roughhousing in the park. Figo had to get used to the idea of crushing another man. "The first time, I didn't dare tackle," he said. Fat Baby, too, was no natural destroyer. "You have to imagine the other guy is your enemy," he told me. "It's like in *The Waterboy* [the 1998 Adam Sandler movie], where you pretend they're the person who bullied you."

By the day of their first game, they'd at least learned to talk the talk. "Kill Chengdu!" the team chanted as their coach bus pulled away in the predawn light. Six hours later, they arrived at the soccer field of Chengdu Technology University, where bamboo poles tied to the goalposts served as uprights. "I'm very worried," Marco had confided to me. "I worry we'll fail. I worry our players will get injured. I worry about all these things."

On the field, everything that could go wrong, did. Chongqing's first three downs went nowhere. The Chengdu Mustangs scored twice early on. Seven threw a perfect interception. "That's why we don't throw the ball," McLaurin said to nobody in particular. The Mustangs scored again. When they went for an extra point, Chongqing blocked the kick. But instead of ignoring the dead ball, one of the Dockers grabbed it and started charging madly upfield. The Chengdu offense, not sure if this was allowed but not certain it *wasn't*, took off after him. The crowd on the Chongqing side screamed, "Go! Go!" The Chongqing player ran the ball all the way to the end zone and spiked it triumphantly. The coaches were laughing. "Just let them have this one," Fitz said to the ref. The final score: Chengdu 31, Chongqing 6.

On the sidelines after the game, Metal, the largest player on the team, still in uniform, took a knee and proposed to his girlfriend, who was one of the cheerleaders. She accepted. On the bus ride home, everyone hoisted bottles of watery Harbin beer. During one raucous toast, I noticed Marco sitting quietly at the front of the bus, eyes forward, unsmiling.

For McLaurin's birthday, two weeks later, a few of the players took him out to KTV—Chinese karaoke—in downtown Chongqing. To say that the team worshiped their coach is only a slight understatement. They repaid his dedication with free rides to and from practice, and regular invitations to dinner and drinks. One teammate even offered to pull strings to make his boss give him a raise. And they admired more than just his athletic skill. In their eyes, McLau-

rin was emblematic of some imagined urban American authenticity, with a love of hip-hop and a swagger that they'd previously seen only in movies. He looked good too. Marco described his first impression of McLaurin in English: "It's a pretty boy." Many of the cheerleaders agreed, as did the Chongqing women who on occasion walked up to him and wordlessly typed their numbers into his phone.

I was still struggling to understand why the teammates had chosen football, of all sports, and their admiration for McLaurin provided the first hint. When I asked them what they liked most about the game, the most common response was that it's "man"— a slangy use of the English word to mean "manly." "Violent," "aggressive," and "exciting" were all runners-up. In Chinese media, the masculine ideal tends to be smart and slim, with coiffed hair. Yet here these players were bumping chests and slapping asses like Skoal-dipping American males. I questioned Joker, the team's lothario, about what Chinese ladies look for. Physically, they want "clean, skinny" guys, he said. "Chinese girls aren't really interested in sports." Marco had a more cynical take. "Right now," he said, "they only like one kind of man: rich man."

When we got to the bar, the men were sitting on one side of the rented room, the women on the other. Soso, who worked at a design firm, crooned earnestly to a Chinese pop ballad, while her friend Tina, a saleswoman and the team's official photographer, told the story of how a creepy Russian client had tried to seduce her the night before. Fat Baby took the mic and launched into one of his favorite songs, "Ghetto Superstar," by Taiwanese rapper MC Hot Dog. The chorus: "I'm so, so, so, so ghetto/I'm so ghetto/I'm so ghetto."

For a lot of Chinese, such revelry would be an indulgence. But as McLaurin quickly discovered, these guys liked to party. On a typical day, Fat Baby would wake up, go to work—or, if he felt like it, not—at the government construction office where he was an assistant engineer, and meet up with friends for dinner (such as hotpot, Chongqing's blindingly spicy culinary staple) or a drink. Yangyang preferred to stay in and play games on her phone. Fat Baby's job wasn't especially strenuous, except for the occasions when an enraged citizen whose house was marked for demolition stormed into the office carrying a knife or, in one instance, a bowl full of feces. "These people just wanted more money," he explained.

As the son of a logistics officer at a military university, Fat Baby is on the comfortable end of the football team's economic spectrum. Marco explained that about a fifth of the teammates could be considered *wenbao,* which means "warmly dressed and well-fed," about three-fifths are *xiaokang,* or "comfortably off," and the top sliver might be called either "middle-class" or straight-up rich. After all, football requires at least 3,000 yuan ($500 or so) of imported equipment, as well as significant leisure time. Fat Baby has both, plus a Paladin SUV, a wide-screen television, and an arsenal of video games. In short, he is not especially ghetto.

But he is increasingly normal. China has no strict definition of "middle-class," partly because prices swing wildly from place to place and partly because the concept barely existed until recently. Under Mao in the 1960s and '70s, social classes were relatively equal, more because of a pushing-down of the elite than a lifting-up of the poor. After Deng Xiaoping's open-market reforms of 1979, earnings exploded, with a tenfold increase in per capita disposable income from 1980 to 2010. But the gap between rich and poor widened dramatically too, and in the early years of Deng's reforms, there was no strong "middle class" in the way Americans think of it: a basic level of comfort, plus the occasional vacation to Paris.

That is rapidly changing, particularly in the cities. A 2013 report by McKinsey projected that China's urban "upper middle class," defined as households that make between $16,000 and $34,000 a year, will grow from the current 14 percent to 54 percent by 2022. Alongside that growth comes an expanded view of the world and a taste for conspicuous consumption. Unlike Chinese over 50, who still save nearly two-thirds of their income, this new middle class is spending—on travel, consumer goods, or, in Fat Baby's case, an extensive collection of movie-star dolls, including Tom Cruise from *Valkyrie.*

This way of life differs, to say the least, from that of their parents. During the Cultural Revolution, Fat Baby's mother and father were among the "sent-down youth" who at the party's behest left the cities to work on collective farms. After returning to Chongqing, his father took a job at the military university where Fat Baby's grandmother worked, and his mother went to work at a factory that produced machinery. Others their age were assigned

jobs by the government. Most people lived in housing provided by their work unit and many met their spouses there. The country's *hukou* registration system imposed tight limitations on migration within the country and even within a province, to the extent that farmers could be arrested simply for entering a city.

That system has since been dismantled piece by piece. Fat Baby lives in a comfortable high-rise apartment that he owns, travels when he wants, and met his wife on a volunteer trip to Sichuan after the 2008 earthquake. In other words, he chose his life. There are still limitations, but young people in China today inhabit a universe of choices that is unrecognizable to their parents. What exactly they *do* with those choices, though, a lot of them haven't figured out.

Fat Baby handed the mic to Figo, who sported his trademark bandana-bead necklace/goatee combo and screamed along to "Smells Like Teen Spirit." Figo told me he regretted studying law instead of pursuing music. After graduating, he went to work for the local government's anti-corruption office — a stable job in Chongqing if there ever was one — before transitioning to more laid-back administrative work. (I once saw him field a call from his boss, who wanted him to check that his daughter's new license-plate number was sufficiently auspicious.) At 32, he still found time to strum his guitar at home on his parents' couch — he plays a mean "Tears in Heaven" — but he felt like he'd missed a calling.

Marco wasn't singing. He was thinking about football. Since starting the team, it had nearly consumed his life. He'd previously done marketing for China Unicom, one of the three national telecommunications companies, but quit once the Dockers got going. In college, Marco studied IT so he could learn to make video games (he took his name from a character in the *Metal Slug* series), but drifted away from it after graduating. He and a couple of friends had recently started a wedding photography business. He was hardly flush, but he worked constantly and made enough to live alone in a modest apartment. If football was his primary passion, second was Magic: The Gathering, the Dungeons & Dragons–inspired trading-card game obsessed over by children and man-children everywhere. Actually, the two hobbies weren't all that different, he said: "You have to use your brain to enter the brains of others." Like Figo, he wanted to get away from Chong-

qing, only farther. "I'd really like to go to northern Europe, like Sweden or Switzerland," he said. "A quiet place where I can buy a house, be with my wife, raise a dog."

As he sat nursing a Corona, I asked Bobo why he played football. "Life is too short," he said. "For our parents, every day was the same. They'd get married, have kids, and die." His own father died of cancer in 2012. Even before then, Bobo's goal had been to see as much of the world as possible. He kept using the word *tihui*, to "learn from experience." After graduating from art school in 2006, he started a design company. When that failed, he opened a barbecue restaurant. That went under too, so he and a couple friends started three hotpot joints. Success requires risk, even if that means breaking one's leg. Would he be more careful next time? I asked him. "Probably not."

Uncertainty doesn't seem as frightening as it once did; values that long dominated Chinese life—like filial piety, face, and financial stability above all else—have started to lose their grip. "I don't want to stay in one job forever," said Seven, the soft-spoken quarterback, who works at an IT company. "I want to explore, to focus on things that interest me."

Not all young people are so unorthodox, but football seems to filter for Chinese individualists. Part of the reason may be that many of the teammates have led relatively comfortable lives and can afford to have aspirations beyond eating a square meal. But for most of them, the source of this philosophy seems to be Western pop culture. After *Rudy*, Fengfeng's second-favorite movie is *Forrest Gump*. "The moral is perseverance," he said. "No matter what happened, he kept running." Fat Baby echoed this idea using a phrase common on the Chinese Internet that translates roughly as "revenge of the losers," but amounts to the American dream: "A person looks short, fat, ugly, but through hard work can become tall and rich," he said.

Until very recently, Americophilia wasn't an acceptable enthusiasm in China. Foreign powers have been resented for centuries, but during the Cold War, the United States became the main icon of imperialist villainy, depicted in Communist propaganda as a hook-nosed villain wearing aviator sunglasses. That attitude still lingers: in 2012, former President Hu Jintao wrote an essay warning his countrymen to resist Western attempts at "long-term infiltration" via popular culture. But talking to the Dockers, you realize

it's not a fair fight. I have rarely seen such pure delight as when Marco described a scene from the straight-to-video *American Pie Presents: The Naked Mile* in which a midget football player tackles the character Erik Stifler while yelling, "You're still my bitch, Stifler!"

Their parents may not actively approve of these obsessions, but they don't get in the way. "We don't understand America," said Figo's father, Jianguo, who was part of the Little Red Guards at age 12 during the Cultural Revolution and whose name means "build the nation." We were talking in Jianguo's apartment, a comfortable two-bedroom in a high-rise on Chongqing's southern outskirts, where Figo also lived with his wife and baby girl. Over a lunch of twice-cooked pork and eggs stir-fried with tomatoes, Jianguo, 60, poured us shots of his homemade date-and-walnut *baijiu* liquor, and then Figo showed off the skull-shaped bottle of German absinthe he'd just bought online. "Our cultural level is too low, our thinking too closed-off," Jianguo continued in his gravelly Chongqing accent. Since his parents retired, Figo has taken them to Hong Kong and Japan, but they draw the line at American movies.

Marco said he knows that the American movies he loves aren't realistic, but he likes what they represent, such as the idea that anyone can achieve their dreams. President Xi Jinping often talks about the "Chinese Dream," but has yet to define the phrase. Perhaps it's because, for a lot of Chinese, the dream is to be somewhere else.

The loss to Chengdu didn't hurt morale much. The Dockers had played a full game of American football; that's what mattered. But over the following weeks, their unity started to show cracks. "Our team has many problems," Fat Baby confided to McLaurin at a music lounge one night. Marco had initially enjoyed broad support as founder and captain, but lately he'd been alienating some teammates. His decision to start dating Nana, the head cheerleader, hadn't gone over well. Everyone knew that Marco cared about the team, but sometimes he cared *too* much: he often yelled at people during practice and bossed them around in the QQ group. Some teammates thought it was time for a leadership change. "Everyone wants to be *laoda*, the big guy," said Fat Baby.

In early April, the team made some organizational changes.

Whereas Marco had previously been in charge of everything, Figo would now handle outreach and PR, Tina would take care of the team's finances, and Soso would be manager. Marco would still lead practices, but that was it. The redistribution of responsibilities wasn't a straight-up ouster, but Marco got the message. "Every day, he is sad," said Fat Baby.

At the same time, discipline was slipping. When McLaurin woke up for day one of the two-day "training camp" he'd organized, it was pouring rain. Only 10 people showed up, and those who did show were only half there. During one drill, the guys walked unhurriedly from the huddle to the line, to McLaurin's annoyance. Next they ran a pursuit drill, in which the players had to try and catch McLaurin. "Marco, why are you stopping?" he yelled. Instead of push-ups at the end of practice, Seven did a limp version of the worm.

The problem was, the players were struggling to balance football and their obligations off the field. Fengfeng commuted as far as 90 minutes from school to practice and back. Figo and others had kids and parents to take care of. Marco was trying to open a Korean barbecue restaurant with a friend. An hour spent clobbering other men was an hour not spent schmoozing at a work dinner or keeping a marriage together. McLaurin didn't see it that way. Over the team's complaints, he pushed to bump practices up to three times a week. "It's no longer a democracy, that's how I see it," he told me.

And then came the game against the Beijing Cyclones—they of the triumphant mock strip tease. It ended with the Dockers getting trounced, 36–8. They'd been practicing for nine months, and they were still losing. Something had to change.

The chauffeured car arrived at McLaurin's apartment on time. He grabbed his giant equipment bag and helmet and climbed in. Weezy, a top-heavy, long-haired 20-year-old and the newest addition to the team, sat in the front seat. He told the driver how to get to the practice field, and put on his favorite new song, Drake's "Started from the Bottom." Weezy was from Xi'an, in the north, but had come to Chongqing since his dad started working for the city's light rail system. Hence the personal driver. He'd been enrolled at Rutgers as a freshman the previous year, but dropped out because, he told me, it was too dangerous. "I got robbed by a black

dude and he put a gun right to my head," he said in English. "I heard gunfire on the school bus. I was like so afraid I was gonna die someday." That must have been a tough decision, dropping out, I said. Weezy disagreed. "My life or my diploma?" he said. "Because you only live once. YOLO." He broke off to sing over a verse— *"I wear every single chain even when I'm in the house."*

When we arrived at the practice field, the Dockers were a different team. Not metaphorically—it was literally a new set of people. Over the summer, they'd recruited a dozen new players, including a few foreigners. There was Julian, a compact 38-year-old former boxer from Holland; Cherokee, 20, who had come to Chongqing after a tour in Afghanistan; and Eric, a 22-year-old Des Moines native with a goatee nearly as full as his mohawk. The new Chinese recruits showed promise too. Alien, a college senior in a black leather jacket and preworn jeans, was the fastest player on the team, and could catch a ball even if it was covered in Vaseline. Tong Er, a former People's Liberation Army soldier, loved getting hit almost as much as he loved hitting.

McLaurin, who had decided to start playing quarterback, gathered the offense together in a huddle. "I want a Pro-I Right blue 43 dive on 1," he said. Someone translated, somehow. The players lined up. "Blue 14, blue 14," McLaurin growled. "Set, *hut!*" McLaurin dropped back and launched the ball in a deadly accurate arc. Off to the side, Seven, demoted to backup QB, watched.

A lot had changed since the spring. The influx of talent brought a new energy to practices. The players were stronger and faster. "I lost 20 pounds!" Fat Baby told me. "You should lose another 20," Yangyang said. McLaurin had also imposed a strict attendance rule: if you wanted to play, you had to show up to a minimum number of practices. And on top of all that, McLaurin and Fitz had organized a league.

The American Football League of China would have eight teams in all, four in the south and four in the north. Each team would play four games during the regular season, with a championship held at the end between the winners of each conference. There had been a contentious debate over the number of foreigners who could play on the field at once, but the teams had settled on a limit of five. Thus McLaurin's new role. He wasn't a natural quarterback, by his own admission, but he was a lot more natural than anyone else.

The first contest of the new season was a home game against the Dockers' archrivals, the Chengdu Mustangs. At practice, McLaurin had the teammates line up and practice blocking. "Tell them this drill is about violence," Eric said to Kang. Kang's translation: "You need to use a little more power." But the idea was starting to get through. The players crashed into each other like cars, no brakes. "Now that's football," McLaurin said.

They had 48 hours to prepare, McLaurin reminded the team at the end of practice. "Don't eat hotpot," Cherokee said.

On game day, McLaurin wore his old Michigan helmet, which he'd covered with Dockers-orange masking tape. Fitz was psyching himself up for his first game since high school. He'd had two steaks for breakfast. "I'm ready to just smash into people until I injure myself," he said, grinning. Weezy took off his orange socks with a marijuana leaf design and put on regular orange socks.

The difference in the team was palpable from the whistle. At one point, Rock blew past two defenders, charged into two more, then dragged them along behind him, and flopped down just over the 10-yard marker. On a few downs, McLaurin just plowed through like a bowling ball.

Then the errors began: Kang fumbled the ball after a hand-off ("extremely tragic," said the announcer), Alien dropped a pass, and Rock, who hadn't slept the previous night because he'd been on duty, ran the wrong way on a play, which led to a turnover. "Rock, you don't know what you're doing, get off the field," McLaurin yelled. Later, as Chongqing was about to snap the ball, a whistle blew. The players looked around, confused. An old man had wandered onto the field for a better view.

At halftime, the Mustangs were up by a touchdown. "I know you have family and friends here," said Marcus, one of the coaches. "We don't wanna go home empty-handed. This is your house." Weezy summarized: "Don't play like a pussy."

Chengdu scored again in the third quarter, putting them up 12–0. If things were already wrong, they started to go wronger. During one play, Fitz jammed his finger. He jogged off the field, held still while someone tied on a splint, and jogged back on. Tina sighed in admiration. "In America, when this happens, is it normal to go back in?" she asked. Fat Baby, playing defensive tackle, got

in a fight—the most notable thing he did on-field all season. Rock got crunched and couldn't move his head. A couple of teammates grabbed his limbs and carried him off the field. "That is not how you move someone with a neck injury," McLaurin said under his breath.

It's hard to say what happened in the fourth quarter. Maybe the Dockers finally realized they were about to be humiliated by Chengdu on their home turf. Maybe Chengdu started getting tired. Maybe Chongqing started getting lucky. But with about 10 minutes left, McLaurin launched a bomb into the deep right corner. Somehow, Fitz was there, open. The ball fell right into his busted hands and he booked it into the end zone. "He got hurt and still got a touchdown?" Tina said. "He is perfect."

As the game wound down, McLaurin came off the field clutching his stomach, knelt down on the sideline, and, as was becoming tradition, vomited. Minutes later he was back in and Chongqing was pushing toward the end zone until there were three yards to go and less than a minute left. Eric subbed in at running back, and McLaurin handed him the ball, which he muscled through the hole Tong Er had created and over the line.

The Chongqing side erupted. The Dockers now led, 14–12, with less than a minute on the clock. Seven subbed in as quarterback for the final play. "Hut, *hike!*" he said for the first time in a long time. The next moment, he got leveled, and came up limping. Seven's season was over. And within seconds, the game was too.

The teams lined up and shook hands, and the Dockers took turns posing with the Sichuan Bowl. Heads were cradled, butts were slapped. "This game changed my life," Kang said in his first-ever post-win interview. "It made me more confident. Now I know that, in life, if I have some trouble, I should just push on and I can still make it better."

More than any other sport, the players told me, football takes teamwork. Sure, soccer and basketball require cooperation, but those sports favor stars. "Argentina has Maradona, he's the most *lihai*," the most badass, said Fat Baby. "If they didn't have him, they'd only have an okay team . . . Football isn't like that; you can't depend on one person."

Historians and sociologists have long theorized about why football overtook baseball post–World War II as the most popular

sport in the United States. Among the many explanations is that it emphasized cooperation and teamwork at a time when social ties were weakening. Now, China is navigating its own "bowling alone" moment, with an erosion of faith in public institutions and a sense that self-interest has replaced communitarian spirit. Not that the solidarity championed by the Communist revolution was by any means ideal. But some Chinese remember that time with nostalgia, compared with the market-worshiping, corruption-tainted era that emerged post-1979, even if they enjoy the spoils of the latter. A whole genre of national news story has emerged about passersby ignoring strangers in need, which only feeds the sense that China has lost its collective soul. At the same time that youngsters want to declare independence from the crowd, they also have a craving for communion. If anything, one intensifies the other.

And to hear the Dockers tell it, nothing strengthens social bonds better than football. In addition to practices and games, they'd started holding team dinners, movie nights, hiking trips, and swimming outings. "I think of them as my big brothers," said Fengfeng, who like most of the players, and most Chinese under the age of 35, is an only child.

The rest of the season flew by. Off the field, the players—to use Fengfeng's words—kept running. Marco's Korean restaurant opened. Figo and his wife moved out of his parents' place, with their financial help of course. Kang, Alien, and Weezy all got into academic programs abroad and planned to enroll in the spring. Fat Baby got a new SWAT-team doll.

And, at long last, they were actually playing football. In November, the Dockers traveled to Hong Kong to play the Warhawks and creamed them, 32–0. In December, they defeated their nemesis, Chengdu, in a game even McLaurin was proud of. They won not because of any spectacular runs or Hail Marys. They were simply finding the holes, getting the sacks, completing the handoffs, playing as a team. That win sealed it for the Dockers: they were going to the championship.

If you wanted to create a movie version of an evil Chinese football team, you couldn't do much better than the Shanghai Warriors. They were big, they were foreign (almost half were non-Chinese), and that season they'd devoured their opponents one by one. So I was surprised when, one day over all-you-can-eat

sushi, McLaurin said, "We'll win." Not *I think we have a chance:* "We'll win."

The Dockers cranked through into the new year, dialing the frequency of practices up to three times a week. This time, no one objected. McLaurin screened videos of Shanghai's games for the team, pointing out the Warriors' weaknesses.

When the team arrived in Shanghai, they dropped their bags at a cheap hotel, where escort services slipped business cards under the doors, and gathered at a sports bar downtown. Eric gave a short motivational speech, which Soso followed with her own dirty version of a Chinese children's song: "Drop, drop, drop the soap / Everyone go quickly tackle him / Go fuck him in the ass." In the cab back to the hotel, I asked Coach Marcus what he thought the championship game would be like. "Beautiful," he said. "It has to be. Anytime something happens for the first time, it's beautiful."

On championship day, the stands of Shanghai's Luwan stadium were empty—not because no one showed, but because the officials in charge of the venue were demanding an extra 11,000 yuan to open the bleachers. "Feel free to sit on the sidelines," said Frank Schipani, a New Yorker who coached the Warriors. Spectators stood along the fence instead.

Chongqing started strong: an interception on its first defensive possession, followed by a quick touchdown. Patrick, the American quarterback who'd been out drinking till late the night before, found McLaurin in the deep right corner of the end zone. The two-point conversion made it 8–0, Chongqing.

Shanghai answered with a long touchdown of its own, and it quickly became clear how evenly matched the two teams were. This was the most brutal, physical game I'd seen in China. The hits looked like they hurt; there were fights, even an ejection. Chongqing was able to pick up yards on the ground, thanks in no small part to Tong Er's formidable blocking. Shanghai was disciplined, with a speedy quarterback, who helped them amass an eight-point fourth-quarter lead.

But with only minutes left, Chongqing surged. First, a pass from Patrick nearly fell short but still found its receiver, who booked it into the end zone. "We make plays, we win this game now," McLaurin said, the score tied. A minute later, Fitz nabbed the ball after it bounced off a Shanghai receiver's hands, for the turnover. "That's

why I love you, baby!" Fengfeng yelled as he jumped on Fitz. A few plays later, another bomb delivered to the far corner clinched the game: Chongqing 24, Shanghai 16.

The post-championship celebration was like a million before it, but also completely different. A local TV station interviewed McLaurin, who could barely move his arm after a hard hit had popped his shoulder out of its socket. A little boy asked for his autograph. The Dockers sang, "We Are the Champions."

I found Marco changing back into his sweats, quietly satisfied. "My baby's grown up," he said, recalling their earliest practices. Weezy outsourced his postgame comments to Drake. "'We started from the bottom, now we here,' right?" he said. "'Started from the bottom, now my whole team fucking here.'" On the way to the airport, the Dockers joked about who would play who in the inevitable movie about their triumph. Fat Baby picked Daniel Wu, the Hong Kong actor. Marco? Kung-fu star Ashton Chen. What about Fat Baby's wife, Yangyang? "Sandra Bullock," Fat Baby said.

Soso said the team's story reminded her of the movie *Alexander*, in which Alexander the Great and his men were determined to "go east" at all costs: "'What is ahead, I know not,'" she said, paraphrasing a speech from the movie. "'I just want to go east. If some men want to return home, they may return home. The rest of us will continue east . . . We can't give our true hearts to everyone, but to give them to our compatriots is enough.' . . . I don't remember exactly, but it basically went like that."

This, it seemed, was the real appeal of American football to the Dockers. Figo would go back to his job at the local government office, and Soso would go back to working long hours at her design firm. Fat Baby would go back to not going into work. But now, whenever they watched *Any Given Sunday* or *Remember the Titans* or *Rudy*, these stories weren't just stories anymore.

The celebration continued in Chongqing the following week, but McLaurin had trouble enjoying it. He needed surgery on his shoulder, and his current job didn't provide health insurance. He was also applying for new jobs, in China and the United States, as well as law schools. Chongqing was fun, he said, but it was starting to feel small.

The Dockers were having their own issues. Two weeks after the championship, they met at a teahouse. Marco and others criti-

cized Soso for not doing enough to recruit new players. If they weren't happy, she said, they could start a new team. Fat Baby almost stormed out of the room. "Chinese people don't know how to come together," he told me. "It's deep in their bones."

Starting a Chinese football team might have been the easy part. From the beginning, it was never a question of if McLaurin would leave Chongqing, but when. "No one else can lead the team," said Fat Baby, and he included himself. That's the way things tend to go in China: It's simple to get a project off the ground. It's hard to build something lasting.

After the final game, Figo posted a note on WeChat. It was a photo of McLaurin in full Dockers regalia, face all serious. Figo had added a caption: "The person in this picture, Christopher J. McLaurin, joined us in September 2012, became our head coach, and made us understand what real football is. From the beginning, he told me countless times, 'I want to make you the strongest football team in China!' Every time, I said, 'Yeaaaaahhh!' But in my heart, I had doubts . . . Then in 2013, he said, 'I want to start a Chinese football league and play a tournament with the whole country!' Again I thought, 'That's too hard, so many cities, they're all amateur teams. There are rules, travel fees, so many other problems!' But he did it. He did everything. He organized the league and led us to become the national champions! This guy, who's six years younger than me, taught me: if you have a dream, you should protect it, work hard, and persevere to accomplish it." Fengfeng left the first comment: "I love him."

SCOTT EDEN

No One Walks Off the Island

FROM ESPN.COM

1. The Escape

JUST BEFORE DAWN one day in late April 2012, four young Cubans stood on an otherwise deserted beach, peering hard into the Caribbean darkness. They were trying to escape their native country, and they were waiting for the boat that would take them away. Thirty minutes passed, then 60. Still no boat. Three men and one woman, the group had arrived at the designated spot close to the appointed hour: 3:00 a.m. By design, the rendezvous point was located on one of the most isolated coastal stretches in a country famous for nothing if not isolation—so remote it could be reached only by foot.

They had spent the previous 30 hours hiking there, without sleep, and had reached varying levels of emotional distress; the stakes were high. Covert interests in Miami and Cancún had made the arrangements from afar. Their goal was to extract from Cuba a baseball player of extraordinary talent and propitious youth. Just 21 years old at the time, Yasiel Puig already was well known to both Cuba's millions of fervid baseball fans as well as officials high in the hierarchy of the Cuban state-security apparatus.

With Puig was Yunior Despaigne, then 24. A former national-level Cuban boxer and a friend of Puig's from their teens, Despaigne had spent the previous year recruiting Puig to defect, under the direction of a Cuban-born resident of Miami named Raul Pacheco. If caught and found out as an aider and abettor, Despaigne would inevitably face serious prison time. He and Puig had

together made four failed attempts to escape the island over the previous year. The authorities were almost certainly wise to their machinations. They needed this trip to work.

According to Despaigne, in the escape party were Puig's girlfriend and a man who, Despaigne says, served as a *padrino,* or spirit guide, a kind of lower cleric in the Afro-Catholic religion of Santeria. Sometime before this latest escape attempt, Puig and his girlfriend had sought out the *padrino;* a vatic ritual had revealed that their voyage would end in good fortune, Despaigne says. The couple decided to take the *padrino* along so as to improve their chances for safe passage.

From the start, the journey had seemed both hexed and charmed. Two days earlier, they'd hitched a ride from Cienfuegos, the city they all lived in, to a sleepy seaside hamlet called Playa Girón, where, around nightfall, they were supposed to meet the guide who would leave them to their smugglers. Instead, they spied what appeared to be a squadron of police milling around close to their planned meeting place. They drove past without stopping; they placed a few frantic cell-phone calls; they managed to reconvene with their guide 35 kilometers up the coast in the town of Playa Larga. But almost immediately, right near the beach, they ran into two policemen. Among the guide's first instructions: "Run!" They ran along the beach and then into the sea—it was tranquil and waveless there—and waded in water up to their necks. They could see police on land trying to pursue. Dogs barked, and the beams of flashlights played in the air and on the water. When they saw the lights range over the water, they dived. Eventually, the police gave up, but the Cuban coast guard did not. The guide's course took them along the edge of a fjord-like inlet that cuts deep into the country. On its western side stretches a vast Evergladian swamp—the Ciénaga de Zapata, one of the most prodigious wetlands on earth. It was slow going. During daylight hours, they picked their way through dense mangrove thickets, careful to keep their distance from the packs of crocodiles that lazed in the lagoons and among the marsh grasses, and careful not to walk on the beach, far easier though it would have been, and risk exposing themselves to the coast guard making regular patrols just offshore. At nights, they resumed hiking along the beach, occasionally plunging into the water up to their noses, driven there by swarms of mosquitoes.

Now, at the rendezvous point, dawn broke. In the gray morning light, the group came to a decision. Despaigne and Puig, veterans of the defection process, knew that the smugglers who helmed these vessels — *lancheros,* as they're known across Cuba — would almost assuredly not want to risk capture by attempting a daylight pickup. And so the group decided to give up. They would surrender. All were severely dehydrated, and starving, having ditched their provisions when they were forced to run from the police into the sea. They would start walking back toward the nearest settlement, some 40 kilometers in the direction they'd come, and in the meantime attempt to flag down one of the patrolling coast guard ships. Better to go to prison than die in the Ciénaga de Zapata.

They'd walked about 400 meters when the *padrino* stopped; he said he had to go back. At the rendezvous point, he'd left something important behind: the figurine of Elegua, a Santeria deity, Lord of the Crossroads, a powerful spirit in the faith's pantheon of them — in the words of Despaigne, also a believer, "the one who opens and closes the way." You don't leave Elegua behind. All four turned around and trekked back, except the guide, who at that point had had enough and abandoned the group. They found Elegua resting safely on the sand; Puig was the one who reached down and picked it up. That's when, raising their eyes to the Caribbean horizon one last time, they saw it. A vessel. It appeared to be approaching. At first they thought: coast guard. But as it drew nearer its details emerged: 40 or 45 feet, outboard engines of many growling horsepower — a long, lean, late-model cigarette boat, "like the ones you see," Despaigne recalls, "on Miami Beach."

"Are you Puig?"

"Are you Despaigne?"

The *lancheros* wanted ID confirmation, and before anyone knew it, Puig, Despaigne, Puig's girlfriend, and the *padrino* had waded out and climbed aboard to meet their ferrymen. As Despaigne and the rest would later learn, these men were the leaders of an alien-smuggling-and-boat-theft ring with links to the Mexican cartel Los Zetas. At least two were fugitives from American justice, their names on the wanted lists of several law enforcement agencies. The *lancheros* apologized for their lateness; they'd gotten lost.

As Cuba receded, the four defectors went quiet. The moment must have been bittersweet. They'd finally escaped, yes, but they

were leaving home, maybe never to return. None in the group made mention of the historical import of the body of water they'd spent the last two days circumnavigating, the place where they'd officially become traitors to their country and enemies of the Revolution. They'd fled their nation through the Bahía de Cochinos—more commonly known as the Bay of Pigs.

2. *Jilted and Afraid*

It was September 2013, 18 months after his escape, and Yunior Despaigne was recounting this story in the office of a Miami lawyer named Avelino Gonzalez. One of only four people in the world with complete, firsthand knowledge of Yasiel Puig's flight from Cuba, Despaigne was telling him a tale that had never been told, one that afforded a window into a dangerous and secretive Cuban smuggling underworld, and one that took many hours to relate in full: the Bay of Pigs adventure. The rivalrous bands of cutthroat smugglers. The cloak-and-dagger midnight getaway. Millions of dollars at play. Betrayal and murder. Smugglers threatening Puig. *Lancheros* shot to death on the side of the road. And if Despaigne was to be believed, it was a story of great legal value for Gonzalez.

Avelino Gonzalez, himself a former Cuban defector, is the plaintiffs' attorney in two ongoing civil lawsuits: the first, filed in July 2013, against Yasiel Puig, and a similar, earlier one against the fireballing Reds' relief pitcher Aroldis Chapman. Both contain explosive claims. The suit against Puig alleges that the slugger, while still in Cuba, had accused a man of offering to help smuggle him off the island. The man claimed to be innocent. But he went to prison and, according to the lawsuit, was mistreated there to the point of torture. He is seeking damages in U.S. courts to the tune of $12 million. The suit against Chapman claims the pitcher conspired with the Cuban government to shanghai an innocent man. That one, as originally filed, seeks damages of $18 million. The suits contend that Chapman and Puig hoped to establish the appearance of loyalty to the government, freeing them to plan their own defections.

Despaigne had come to Gonzalez, in part, out of desperation. He had lived since he arrived in the U.S. in the Miami suburbs

of Sweetwater and Hialeah, where almost every Cuban migrant to the U.S. first winds up. Late last year, Despaigne lost his job with a construction contractor, and for the moment his only consistent income comes from the boxing lessons he gives to kids at a local gym—$60 per month, per student. Six-foot-four and 240 pounds, he looks the part of the heavyweight he once was, despite the nascent appearance over his belt of a retired athlete's paunch.

By 2011, Despaigne had decided he wanted to leave Cuba for the United States, in part because the government's boxing authorities booted him out of the national athletic system, an injustice, he says, motivated by the fact that his uncle—the notable middleweight Yordanis Despaigne—had defected to the U.S. in 2009. But it wasn't until he received a phone call from Pacheco in the spring of 2011 that he truly began to plot an escape. Pacheco, born June 24, 1984, who had known Despaigne since childhood and had fled Cuba on an improvised raft, was calling from Miami. He promised the boxer $150,000 and a Hialeah house bought and paid for if Despaigne could persuade Puig to make another defection attempt. Despaigne recalls the sales pitch: "Puig's going to sign for millions of dollars. There's going to be money for everybody." (According to a source close to Pacheco, Pacheco maintains that he promised nothing and that it was Despaigne who initiated the whole thing—that the boxer called Pacheco in Miami for help in financing both Puig's and Despaigne's escape.) Regardless, over the course of a year, Pacheco wired more than $25,000 in total, which Despaigne passed along to Puig and his family in thousand-dollar chunks. Eventually, the boxer prevailed in persuading Puig to leave. But within a year of arriving in Miami, Despaigne had received only $70,000—less than half the money Pacheco had promised him, and no house. It was around that time that a frustrated Despaigne became aware, through local news coverage, of the lawsuit against Puig. He sensed an opportunity. Of his decision to approach Gonzalez, he says, "At first I was going to leave this alone, but promises were made to me." He'd also begun to receive death threats, including one at gunpoint in Hialeah: "I have a little girl, and I can't be getting threats like that." A Cuban lawyer might be able to offer protection in a way that seemed safer, to a recent Cuban migrant, than dialing up a police station out of the blue. Jilted and afraid—seeking vengeance as well as security—he paid

his first visit to Avelino Gonzalez in early September and began unspooling his florid tale.

The details of the narrative Despaigne relayed to Gonzalez would ultimately become the contents of a signed affidavit dated December 6, 2013—part of an amended complaint filed this January by Gonzalez in the ongoing case of *Miguel Angel Corbacho Daudinot v. Yasiel Puig Valdes.*

A story has emerged from Despaigne's affidavit, the lawsuit, and its proceedings. It spawned a five-month investigation by *ESPN The Magazine* that included analysis of an array of legal documents and interviews with more than 80 people: Cuban baseball players in the U.S. both retired and active, talent scouts, sports agents, former MLB and players' union executives, federal law enforcement personnel, former Cuban government officials, former Cuban and American spies, Miami lawyers who have represented and are representing alleged smugglers who were and are the targets of criminal investigations, and—to use a quantitative phrase of deliberate vagueness—a number of smugglers themselves, who agreed to be interviewed under conditions of anonymity motivated by obvious fears. (Puig, through his agent and the Dodgers, declined to comment for this story on numerous occasions. On April 16, however, a statement was released via his agent saying that Puig will have "no comment on the subject" and that he is "only focused on being a productive teammate.") It also involved a series of in-person conversations with Yunior Despaigne held at the office of Avelino Gonzalez and at Despaigne's home with the assistance of a translator. (In many hours of interviews with Yunior Despaigne over the course of many weeks, his story never changed. However, discrepancies were later discovered between what he said in those interviews and a handful of details that appear in his affidavit. Avelino Gonzalez attributes these errors to oversimplifications made in an attempt to condense a highly complicated series of events. He says an amended affidavit is forthcoming.)

The Magazine's investigation ultimately unearthed information regarding the inner workings of the complex smuggling operations that specialize in the extraction of baseball players from Cuba. For the narrative of Yasiel Puig's defection, however, Despaigne remains a rare and singular witness.

3. La Bolsa Negra de Béisbol

Some 36 hours after leaving Cuba, they reached their destination: a white-sand-and-resort-rimmed island off Cancún, about 400 miles as the crow flies from the mouth of the Bay of Pigs, known as Isla Mujeres. It was another grueling, near-sleepless journey wrought with anxiety. To stay awake, Despaigne says, the *lancheros* snorted lines of cocaine. Despaigne is not ashamed to admit that he did too. (Puig, according to Despaigne, did not partake.) There were delays. Halfway into the passage, in the middle of the Caribbean, they ran out of gas. The lead *lanchero*, a burly thug known as Tomasito, had to radio a colleague on Isla Mujeres who brought a 50-foot yacht to come refuel them, but not before the group spent a fretful night adrift at sea on the dead-in-the-water cigarette boat, pitching, rolling, and, at one point in the wee hours, coming hairraisingly close to getting plowed under by a passing containership. Then, within some miles of Isla Mujeres, they had to fake-fish for several hours, waiting for nightfall before entering port, the better to evade the Mexican naval patrols that had, in the past, nabbed Tomasito's boats.

The *lancheros* escorted the group to a small, tumbledown boardinghouse blocks from the beach. It had at least 10 rooms, Despaigne recalls, each one full of recently arrived Cuban migrants—no vacancies. The place was apparently under the control of Tomasito, aka Tomas Valez Valdivia, born in Cuba in either 1971 or 1974 (the record is unclear). With his thick neck and near unibrow, Tomasito had a face made for a mug shot. In 2005, he was arrested in Florida on charges of grand larceny (theft of a conveyance) as well as aggravated assault of a police officer with a weapon. For some reason, he was allowed to post bail. He fled immediately south of the border, where he set up shop in Cancún.

The boss of a thriving alien-smuggling operation, Tomasito and his crew ferried defectors from the coasts of Cuba to either Isla Mujeres or Cancún, under prior arrangement with the migrants' relatives in the United States, chiefly South Florida. Once those families had paid—for years, the going rate for a garden-variety smuggle of a regular Cuban civilian has been $10,000 a head—Tomasito's crew would transport the migrants to the Mexico-Texas border, usually at Matamoros or Nuevo Laredo. There, the Cubans

would take advantage of the 1995 revision to the Cuban Adjustment Act, which essentially makes it possible for Cubans to seek asylum in the U.S., no questions asked, as long as they can prove they're Cubans and as long as they enter the U.S. on dry ground, as opposed to crossing into U.S. territory at sea—the so-called wet-foot, dry-foot policy. If for some reason payment wasn't forthcoming, the *lancheros* would either hold the migrants until their families made good or kick them out onto the streets, where Mexican authorities would likely catch them and deport them back to Cuba. All over Isla Mujeres, in shoddy hotels and nondescript private homes on backstreets never visited by the island's endless streams of hard-partying American and European tourists, Tomasito and several other rival *lanchero* groups secreted away their smuggled Cubans for weeks and sometimes months at a time. At the Isla Mujeres apartment, Despaigne recalls talking to a young mother with several children. She was crying. She'd been trapped there for perhaps a month; her husband, so far, hadn't been able to come up with the money.

The *lanchero* rings could handle the sunk costs of an occasional nonpaying customer. Their boats regularly carried 25 people each trip—a quarter of a million dollars per haul, two or three times a month. Yasiel Puig, of course, was not your garden-variety smuggle. That Tomasito and four of his chief associates were on the cigarette boat at all—normally, they had pilots in their employ to handle that kind of dangerous work—suggested how valuable they felt this commodity was. One of those associates, Yandrys Leon, aka Leo, had just a few months earlier been indicted in the U.S. for allegedly extorting the Cuban migrants he'd smuggled to Cancún. Within South Florida's tight-knit Cuban-émigré community there are probably tens of thousands of people who have been brought out of Cuba by Cancún-based *lancheros*. Through that grapevine, Raul Pacheco managed to contact Tomasito and hire him to conduct Puig's extraction. The price: $250,000.

At the Isla Mujeres apartment, Despaigne and Puig surreptitiously communicated, via Skype, with Pacheco in Miami. He told them something worrisome: he didn't yet have the funds to pay Tomasito. Rest assured, though, he was working on it. In the meantime, guards kept watch over the four. No one was allowed to leave the boardinghouse's premises unchaperoned. Escape, everyone agreed, was out of the question. They had no Mexican

pesos. Nor, of course, did they have visitors' visas, or even their passports—only their Cuban ID cards. If caught by Mexican authorities, they'd be put on a plane for Cuba and likely prison. Days passed. Still no money from Pacheco. They swam in the hotel's small courtyard pool; they watched Mexican soap operas; they ate takeout. The atmosphere became increasingly tense. "Don't play with me," Despaigne recalls Tomasito saying at one point. "I'm the one who took you out of Cuba. You guys have to follow through just like I followed through."

That Yasiel Puig—who can now be seen in paparazzi photographs, his arms around the shoulders of the likes of Jay Z—departed Cuba in a clandestine operation that involved a 50-kilometer swampland trek and a cigarette boat piloted by Zeta-affiliated gangsters speaks to a certain root absurdity in the ways of man.

Puig would have had no reason to embark on his strange odyssey were it not for the adversarial relationship between Cuba and the United States, still nurtured by both nations 25 years after the collapse of communism nearly everywhere else on the planet. The United States' trade embargo against Cuba, established by the Eisenhower administration in 1960, a year after Fidel Castro took power, makes it illegal for American entities to do business with Cuban nationals, or hire them, unless those Cubans have first defected and, in effect, renounced their citizenship to that dangerous enemy state 90 miles from Key West. The Cuban government, meanwhile, last year eased restrictions by allowing its baseball players to sign with overseas professional leagues in countries like Mexico and Japan. But because of the embargo, its players are still banned from playing the game for those depraved American capitalist-imperialists just to the north—unless, of course, they defect. To this day, the senescent Castro regime considers even the expression of the desire to do so an act of ideological treason.

To take advantage of the arbitrage opportunity created by the opposing policies of the two nations, a robust underworld industry has developed over the last decade. It is, essentially, a baseball-player black market—*bolsa negra* in Cuban slang, which translates literally as "black bag." Puig's experience, in that regard, is hardly unique. To traffic in this rarefied kind of human, the best smugglers have so perfected the art of circumventing the laws of the two adversarial nations that they've made themselves into millionaires.

Since 2009, the market value for the most talented Cuban players has exploded. That's when Aroldis Chapman, a shutdown relief pitcher with a supra-100-mile-per-hour fastball, departed the Cuban national team at a tournament in the Netherlands, quickly became a resident of the obscure European microstate of Andorra, and months later signed with the Cincinnati Reds for $30 million. In October 2013, the slugger Jose Abreu, lately of Cuba, but then suddenly a resident of Haiti (or the Dominican Republic, depending on what news source you read), set the current record: $68 million, courtesy of the Chicago White Sox. Both took advantage of rules collectively bargained between Major League Baseball and the players' union that allow baseball-playing residents of any country other than the U.S., Canada, or Puerto Rico to become free agents, rather than enter the draft. As such, Puig and Abreu were able to instruct their representatives to conduct an auction, multiple bidders ballooning their price effectively without limit.

While not every Cuban player in the U.S. is the product of a smuggling ring, the bull market for their talent has inspired the leading tycoons in *la bolsa negra de béisbol,* themselves native Cubans, to handle the entire process of defection. Over the years, according to those we spoke to within and around such smuggling rings, they and their attendant personnel have developed a highly specialized expertise, encompassing marine navigation, boat handling, bribery, forgery, money laundering, the immigration policies of multiple nations, and the ins and outs of MLB's collective bargaining agreement. Through a network of contacts in Cuba, they approach and recruit baseball players, enticing them to defect with cash payments and, of course, promises of Major League fame and fortune. The smugglers hire the *lancheros.* They act as fixers; they're in charge of the speedy obtainment of residency papers in a third country, often through bribery or forgery—time is money. They bankroll the care and feeding of the players as they work out for scouts in those third countries. Sometimes they even keep experienced trainers on their staffs. Because all of these costs come up front, the smugglers must occasionally finance their operations by raising money from "investors," in effect hawking equity in the players' future earnings, or by "selling" players to a third party. And they maintain relationships with the U.S. sports agents who can negotiate big-money deals with MLB franchises. For this suite of hard-to-come-by services, the smugglers want be-

tween 20 percent and 30 percent of the top-line value of a player's first professional contract.

That kind of revenue stream has interested a whole lot of colorful people in the underworlds of several countries: Mexico, the Dominican Republic, and, of course, Miami, USA. In Cancún, long the seat of smuggling rings that specialize in bringing regular civilians out of Cuba as well as ballplayers, turf wars have been waged over the business. Players have been stolen at gunpoint from one group by the next, hits taken out, rivals driven by and strafed, bullet-ridden corpses left lying in the streets.

Among the many colorful people drawn to the smuggling of Cuban baseball players was a group of Miami-based partners, all Cuban-born men, who had built an alien-trafficking ring with deep connections in Cancún. The ringleader of the group was a blond man in his early forties, born in the town of Güines, due south of Havana near the coast. Because of the many sensitivities regarding a story that involves both cartel-associated smuggling rings and ongoing federal investigations, we will call him El Rubio. Through their many Cancún connections, El Rubio and his partners came to learn of a young, healthy, five-tool prospect—hits for average, hits for power, runs fast, has a live arm, plays the field, 1.9 meters tall, more than 100 kilos of muscle—who'd just arrived on Isla Mujeres in the hands of an occasional colleague of theirs, nicknamed Tomasito. Yasiel Puig, it was obvious, represented the score of a lifetime. El Rubio and his partners—at that point unaware that Pacheco in a sense had "dibs" on Puig and was still trying to find the money to pay the *lancheros*—phoned Tomasito in Cancún, according to a person familiar with the Rubio group. Breaking with their typical methods (they preferred to source their own players in Cuba), they struck a deal to buy Puig for $250,000.

Enter Jaime Torres, a former Chicago tax attorney who has become known as something like the Scott Boras of Cuban defector baseball agents. One of the first Cuban players Torres represented was Jose Contreras, he of the $32 million contract with the Yankees in 2002. Torres has since represented so many Cuban defectors that Fidel Castro himself once denounced him as a kind of baseball-agent *agent provocateur.* For Yasiel Balaguert in 2011, Torres negotiated a $400,000 minor league contract with the Chicago Cubs. For left-handed pitcher Gerardo Concepcion, in March 2012, he

brokered a $6 million deal—also, as it happens, with the Chicago Cubs. Torres has also represented Miguel Alfredo Gonzalez (Philadelphia Phillies, $12 million), Dariel Alvarez (Baltimore Orioles, $800,000), and Aledmys Diaz (St. Louis Cardinals, $8 million), to name a few.

According to Torres himself in interviews with the media on the subject of his Cuban clients, he has a simple ground rule: he will never sully his name by stooping to work with smugglers. Indeed, there is no proof that Torres does anything other than what any good agent does: strive to obtain as large an MLB contract as possible for his clients. It remains an open question, however, how Torres learns of these opportunities.

4. The Stealing of Puig

In late April, according to multiple sources, Jaime Torres arrived on Isla Mujeres. He had come to an agreement with Yasiel Puig to represent him as an agent. Around the same time, just like that, the Rubio group in Miami received a call from Tomasito: He was reneging. He was raising the price. Now he wanted $400,000. Maybe he realized that he'd lowballed himself. Maybe he realized that if Jaime Torres were involved—the guy who represented the likes of Jose Contreras and the Cuban Missile Alexei Ramirez—Puig too must be the real deal. In Miami, the partners understood that Tomasito had all the leverage. If they didn't want to lose out on their epic score, they had no choice but to agree to whatever price he demanded. Time was also running short. Through the grapevine, they'd heard that Tomasito was shopping Puig elsewhere. One rumor suggested that a mysterious group of Dominicans had flown to Cancún to meet with Puig on Isla Mujeres. The problem, however, was that even though the Rubio group would receive 20 percent of Puig's eventual contract, no one in the group outside El Rubio himself had hundreds of thousands of dollars in cash lying around. And El Rubio was not willing to go all-in with his own cash. They would have to scare it up from somewhere within Miami's Cuban community. El Rubio and company nonetheless agreed to Tomasito's increased price. The *lanchero* wanted about 25 percent up front, the rest on delivery.

It was then that El Rubio hatched an audacious plan—a caper.

In the plan's first stage, El Rubio made use of an unlikely emissary in Pacheco, whose own options for keeping Puig to himself were rapidly expiring, and who could now stay in the game by teaming up with this group of buyers. Acting under instructions from El Rubio, Pacheco told Tomasito that the 25 percent up-front fee he required would soon be ready; they were merely waiting for a check to clear. (According to a person close to Pacheco, Pacheco confirms the details of El Rubio's scheme but denies his involvement, saying he met El Rubio for the first time only after it was executed.) This bought them time. El Rubio used the delay to contact a Cuban expatriate in Mexico, a man with connections in the Cancún police department. He had a shaved head, thick arms, and a burly stomach. El Rubio called him El Comando de Cancún. One day over Skype—which they made sure to use when Tomasito wasn't around—Pacheco told Puig and Despaigne to expect a knock on their door in the middle of the night at their Isla Mujeres room. If the four didn't want to die at the hands of Tomasito, they ought to be prepared to leave.

Sometime after one in the morning, the knock came. Two men dressed in burglar black stood silently at the door. Somehow, there were no guards that night. Despaigne is at a loss to say why. Regardless, Tomasito had chosen an inopportune moment to relax his grip on his captives. Following the two men in black, Despaigne, Puig, his girlfriend, and the *padrino* crept out of the hotel and down a few dark streets and into a marina and onto a waiting boat that ferried them across the water to Cancún. No violence, no Tomasito, no Leo, no guards. The heist had worked. But the Rubio group had also just ripped off a criminal gang whose highly lucrative underworld ventures required the sanction of Los Zetas. They had now motivated some darkly uncompromising individuals. In plotting the heist, they hadn't really even discussed the dangers; they were just that obvious. But so too were the rewards, and they'd come to an unstated consensus: for a chance to get Yasiel Puig, they were willing to risk their lives.

From the windows of their rooms in the high-rise hotel, Puig and his fellow defectors could see the jumbo jets come lumbering down out of the sky on approach to the Mexico City International Airport. Despite the fact that none of the four had passports or visas, they had flown to Mexico City on a commercial flight. El Co-

mando had somehow facilitated the trip, likely through bribery. It was part of a package of services, including the wee-hours snatching of Puig, that El Comando provided, price tag: $180,000. In addition to El Comando's fee, the Rubio group's costs included the two rooms at the airport hotel, future travel costs, and, of course, security, one person close to the Rubio group says. Two and sometimes three large armed men, Despaigne recalls, accompanied the four at all times—not to prevent Puig and the rest from leaving but to protect them against some kind of reprisal from the inevitably now-livid Tomasito.

Capital was also needed for another important expenditure. Before any American company can hire a Cuban national, an obscure sub-bureau of the U.S. Treasury Department called the Office of Foreign Assets Control, or OFAC, must give its blessing. The process was fairly straightforward: become a permanent resident of another country and present the resulting paperwork—two separate documents—to your prospective employer. If the employer approves the paperwork, voilà, you're unblocked: OFAC would rubber-stamp the employer's decision. (Interestingly, as of late 2012, all Cuban defectors must now submit their paperwork directly to OFAC.) To become a permanent resident of Mexico, according to Mexican law, applicants must be able to prove that they have been temporary residents for four years (or two years if legally married to a Mexican spouse), have family connections, or apply on humanitarian grounds. Regardless, it's a lengthy process. According to a source close to the Rubio group, Puig arrived in Mexico around Memorial Day. He became a resident, all his documents real and in order and ready for perusal by Major League Baseball, less than 15 days later. The bribe cost about $20,000.

At a restaurant in the airport hotel sometime later, Despaigne ate dinner with Yasiel Puig and El Rubio. They ordered plates of lobster, a rare treat for the newly defected Cubans. In Cuba, it is against the law to fish for the crustacean; all specimens alive in Cuban waters are reserved by the government for the kinds of restaurants far out of reach for the average Cuban citizen. Gorging on claw meat, Despaigne listened to the conversation between Puig and El Rubio. Negotiations had already grown hot and heavy with a handful of major league teams. The day El Rubio had arrived in Mexico City (around the same time as Jaime Torres), he'd had a suit and tie ready for Puig to wear in face-to-face meetings with

team representatives. For four days in mid-June, Los Angeles Dodgers scouts Mike Brito, Logan White, and Paul Fryer had watched Puig take batting practice at a Mexico City ballpark. Also there, according to Brito's recollection, were his counterparts from at least four other teams: the Cubs, White Sox, Braves, and Yankees. Torres wouldn't let Puig run or throw during these showcase sessions—he didn't want to risk injuring the prospect, who'd fallen out of peak physical condition since he'd been kicked off the national team—so the scouts watched in silence as Puig snapped his hips and launched balls with diverse arcs—line drives, majestic soarers—into the empty outfield bleachers, like Roy Hobbs in that scene from *The Natural.* "Every day he made a show over there in [that] stadium," Brito recalls.

Now, during dinner at the hotel, El Rubio received a call on his cell phone. He spoke English into the phone. After he hung up, he said that the person on the line had been a representative of a major league franchise. Despaigne recalls El Rubio mentioning the names of several teams he'd been personally communicating with, but only the Phillies and the Dodgers have stuck in his memory. (Mike Brito says he neither met with nor spoke over the phone to anyone in Mexico City other than Jaime Torres and Yasiel Puig.) Various abstractly gigantic sums were bandied about by El Rubio during the dinner: maybe $32 million, maybe $38 million. "Listen, don't worry, I'm taking care of this," El Rubio told Puig over the lobster, according to Despaigne. "They're going to get crazy over you."

On June 28, word hit the U.S. media: Puig and the Dodgers had struck a deal. "We signed for $42 million!" one of the Rubio partners said when breaking the news to another. "We're out of poverty," said the other. They had their major league score: $8.4 million divided among the partners, payable upon Puig's receiving his signing bonus.

It would take some time before Puig would leave Mexico City for good. When he did, El Rubio arranged for him to enter the United States in the same way as any regular Cuban migrant on the Isla Mujeres route. Puig had no passport; it was in the possession of the Cuban government. So instead of trying to secure a U.S. entrance visa as a Mexican resident who had become so through bribery, instead of spending who knows how long attempting to extract a Cuban passport for Puig from a Cuban government likely

unenthusiastic about granting such a document, instead of forging a passport and risking a felony arrest for Puig at an American airport, the Rubio group had him do something much simpler: he would walk across the international bridge spanning the Rio Bravo/Rio Grande between Reynosa, Mexico, and Hidalgo, Texas, enter the Immigration and Customs patrol station on the U.S. side, and, with only his Cuban national ID card to prove his citizenship, declare for asylum under the Cuban Adjustment Act of 1966, paroled into the country—no American laws apparently broken, no act of smuggling, it would seem, at all.

5. *Everybody Knows, Nobody Cares*

Though the specifics and logistics are not common knowledge, the notion that ballplayers are brought out of Cuba by clandestine means is as open a secret as there is in sports. In the words of Mike Brito, the legendary Dodgers scout, born in Cuba in 1934, he of the perpetual Panama hat and pencil-thin Mambo-King mustache, who played a key role in landing Puig for L.A.: "How he got from Cuba I don't care. I don't wanna find out, either. I never ask any Cuban player that. And even if I knew, I wouldn't tell you. Only thing we care about is when a guy is in a territory where we can sign him. Sign players and keep my mouth shut. The less you talk, the less you get in trouble."

Unsurprisingly, most Cuban players now in the U.S. prefer not to discuss the subject publicly. Their reluctance is easy to understand. They don't want to get family and friends—who may very well be attempting to escape the island at any moment—in trouble with the Cuban government. (The Cuban government, every Cuban émigré says, scours the American media for information on Cubans in America.) They don't want to destroy the chances of other ballplayers—or friends and relatives—making it out by saying too much about the smuggling networks and how they operate. They fear reprisals from the smugglers. The result of all this is a kind of *omertà*. When Cuban players in the U.S. do break their silence, it's mostly with vagueness or outright subterfuge.

For years, Orlando "El Duque" Hernandez, now a kind of elder statesman of the Cuban ballplayer-defector fraternity, allowed any number of fictions to propagate about his escape in 1997, though

they all had the same basic plotline: that he'd fled the island on his own by shoving off on some form of improvised raft. In fact, as is fairly well known by now, he worked with Miami-based *lancheros* to get off the island. Even today, despite the fact that the real story has mostly come out, El Duque would not elaborate to me on how he escaped; he's saving the tale, he says, for his memoirs.

If Cuban ballplayers are reluctant to discuss all this, U.S. law enforcement seems more committed to its end of the business. Two separate federal criminal investigations into two separate (and sometimes competitive) alleged smuggling rings are now under way, one led by the FBI, the other by the Department of Homeland Security's Immigration and Customs Enforcement agency, or ICE. The FBI probe has already resulted in the indictments of several people who, the government contends, brought both regular civilians out of Cuba, charging $10,000 a head, as well as baseball players out of Cuba, charging quite a bit more: 30 percent of their eventual MLB contracts. The second investigation, the one led by ICE, has yet to result in charges. According to people familiar with that probe, it has been ongoing since at least last summer, and its targets include El Rubio and his partners. Raul Pacheco has lawyered up. Puig himself has been interviewed. In fact, only one baseball-player-smuggling case has ever been successfully prosecuted in U.S. courts. In 2007, Ben Daniel, a former federal prosecutor and a specialist in alien trafficking, won a five-year conviction against a Cuban-American agent who had paid smugglers to extract a handful of players. "Everybody in the world knows this is going on, but apparently, nobody cares," Daniel says.

It seems, after all, a victimless crime. If the rates charged by the smugglers appear extortionate, consider the risks they're running in driving boats right up to the coast of Cuba in order to snatch highly prized talent from an authoritarian regime. To some in Miami, the smugglers and the agents who work with them are heroes of the Cuban counterrevolution. What are the smugglers doing, after all, but liberating human potential from an unjust Communist state so that it might find its true value on the free and open market? In certain quarters in Miami, the smugglers are viewed almost as political activists—anti-Castro, pro-freedom—and each player they help defect as another score against a despised regime. "The embargo has created this whole absurd situation," Daniel says. "There are all these silly rules in place that make it too tempt-

ing not to circumvent. Basically, the value of Yasiel Puig outweighs the Cuban embargo. He trumps the embargo. He's bigger than life, and he trumps it all."

Almost as soon as they'd all arrived in the U.S., the threats started to come. A phone call to Yunior Despaigne's mother in Cuba. A call to Yunior Despaigne's new American cell phone with the Miami area code. Calls to Pacheco and to El Rubio and his partners—so many calls that El Rubio was forced to change his number. Calls even, according to Despaigne, to Yasiel Puig. The messages left had a common theme: "What you did is not a joke. Give us our money or we're going to kill you." Tomasito wanted to be made square. And so, too, by extension, did Tomasito's underworld tax man, Los Zetas.

Yasiel Puig sat in the passenger seat, Despaigne in the back, El Rubio driving. The car was a Maserati. It was late in the summer of 2012. They'd arranged this in-car meeting to discuss the escalating threats from Tomasito and his crew. Despaigne recalls El Rubio, hands on the wheel as the car blazed across western Miami, saying something close to "Don't worry about these people. We're not going to pay them."

One night in early October 2012, the body of Yandrys Leon, aka Leo, one of Tomasito's key *lanchero* associates, principal helmsman of the cigarette boat that brought Puig and the others out of Cuba, was found facedown on the side of a road in a fashionable Cancún neighborhood. He'd been shot to death. El Rubio directed Puig and Despaigne and his smuggling partners to the local Cancún news coverage of the murder.

Within a few months, though, the threats began anew. During Dodgers spring training camp in 2013, according to a source close to Raul Pacheco, at least one man representing Tomasito's ring showed up in Arizona, found the rookie's hotel room, knocked on his door, and told Yasiel Puig the boss wanted his money.

By this point, too, Despaigne was harried. Starting in June, following Puig's fast-track promotion to the Dodgers, as his Ruthian exploits were making him more famous by the day, Miami's robust Spanish-language, Cuban-émigré-focused media somehow discovered the identity of one Yunior Despaigne, who had accompanied Puig on his defection, and began hounding him. Meanwhile, Pacheco, then living in Puig's Miami house and serving as a kind of

all-around gofer and confidant for the Dodger, refused to make good on what Despaigne says he was promised as compensation. It was around this time that a car wildly honking its horn pulled right up to Despaigne's rear bumper one day as he was driving home from work. Both cars pulled over. Both drivers opened their doors. Both strode toward the other with dark intent. This was not an uncommon scene in Hialeah: machismo on the road.

"What's your problem?" Despaigne yelled, steeling himself for a fight.

"The problem here is me," the other man said, and he pulled an automatic handgun from his waistband, jammed the piece into Despaigne's left side, and backed Despaigne against his car. "Don't be a *guapo*. Tell Puig to pay. Because if he doesn't, all of you are going to die." The man had a Cuban accent.

Despaigne managed to get a few words in: "I'm not the millionaire. The millionaire is Yasiel Puig." And: "I'm not Puig's padre. I can't force him to pay. I can't grab him by the neck."

"For the well-being of you and for everyone, speak to Puig," the gunman said before heading back to his car. "Then everything will turn out *con paz y tranquilidad*"—with peace and tranquility. Despaigne swears that's what the man said.

6. "This Abogadito in Miami"

By the time Despaigne finished his story, Avelino Gonzalez knew that it could help his cause. In addition to providing important details regarding Puig's previous attempts to defect, the cinematic tale of the ballplayer's escape—moving among Raul Pacheco, Tomasito, and the Rubio group—allowed Gonzalez to make a case for who Puig's real smugglers were. Real smugglers, the story suggested, are a sophisticated lot—not just guys like his clients, who had the misfortune to stumble into one of the country's Kafkaesque holes.

If Danilo Curbelo Garcia, the client he was representing in the Aroldis Chapman case, was unfortunate, then he was unfortunate to an absurd degree. A U.S. permanent resident who ran an animal farm near Okeechobee, Florida, Curbelo had gone missing while on a trip to Cuba to visit family in July 2008. Like almost all Cuban men, Curbelo was a baseball fan, and while in Cuba, a

friend had offered to introduce him to an acquaintance: Aroldis Chapman. According to the complaint, the two men then chanced on the pitcher in the Cuban municipality of Frank País, near Chapman's hometown. Chapman was riding his bike down a road. The men pulled over. Curbelo asked Chapman, half-jokingly, when he planned to leave the island. This was a dangerous idea to articulate to strangers in Cuba, most of all, perhaps, to a star baseball player. His friend told Curbelo to pipe down but not before Chapman replied, according to the complaint, that he'd learned his lesson after his foiled escape earlier in the year; he wouldn't be making any such attempts again. The exchange lasted for only a few minutes. Within a day, Curbelo was under arrest on charges of human trafficking. (Chapman, according to Cuban court documents, relayed a different version of events, saying that Curbelo came to him with a specific plan to defect.)

Six months later, in custody the whole time, he was standing trial. According to the complaint filed by Gonzalez, the prosecution's direct evidence consisted entirely of Chapman's testimony and that of his father. The trial lasted half a day. He was sentenced to a decade in prison. Curbelo spent the first four in a maximum-security prison called Las Mangas, notorious for its cholera outbreaks and hunger strikes, and another year at a kind of *Bridge on the River Kwai* work camp two hours from the closest city and reachable only by dirt roads, where the inmates were forced to erect their own prison.

When Curbelo's wife, Maylen, came to Gonzalez's law office in May 2011 to seek representation, the lawyer was far from intimidated by the prospect of battling with the Cuban Communist machine. From the moment he graduated from the University of Miami law school in 1995 — after defecting from Cuba in 1991 when he was 25 years old — Gonzalez has made himself into a tiny yet irritating barb in the side of the Cuban government. When members of an anti-Castro organization based in Miami were shot down in 1996 by the Cuban military while looking for refugee boats, Gonzalez was brought in as an expert when the families of the dead sued the Cuban government in U.S. court. When an Olympic-level kayaker defected from Cuba to the U.S. and wanted to participate with the American team in the Sydney Games in 2000, Gonzalez played a key role in persuading the International Olympic Committee to disregard the opposition of the Cubans. Soon after that

case unfolded, Gonzalez heard from a Cuban friend who held a position in the government about a recent meeting of elite regime officials. "So who's this *abogadito* in Miami anyway?" one person at the meeting is said to have asked. *Abogadito* translates as "little lawyer." That person was Fidel Castro.

All the attorneys Maylen approached had turned her away. It was unclear how, in a United States court, a Cuban could sue another Cuban over an incident that occurred in Cuba. But in Gonzalez she found the *abogadito* for the job, one familiar with an obscure law: the Alien Tort Statute, or ATS. It entered the books in 1789, and it appeared to give U.S. civil courts jurisdiction over cases where a non-U.S. citizen might want to seek redress for a tort issue, even if the abuse occurred in another country. Gonzalez knew, as well, that the ATS had a more recent offspring, the Torture Victim Protection Act, signed into law in 1992, and designed to provide an avenue of justice for the families of people tortured or killed by authoritarian governments overseas.

At its core, the complaint that Gonzalez ultimately filed contends that Chapman made a deal with Cuban officials in 2008 after a failed escape attempt, for which he was suspended from the national team: by becoming a productive government informant, Chapman could prove his loyalty, earn his way back into the good graces of the regime, and eventually return to the squad's A-list travel roster. With the government thus off his back, he could then plan his next actual defection attempt. The complaint's bottom line: Chapman, in order to grease the skids of his eventual escape, conspired with the Cuban government to frame an innocent man.

When the complaint hit the public domain in May 2012, it received instant coverage by the Miami Spanish-language media. In fairly short order, Gonzalez began receiving phone calls from people with stories similar in substance to that of Danilo Curbelo. One of those calls came from the family of Miguel Angel Corbacho Daudinot, a Cuban citizen who split his time between the island and the Dominican Republic. While in Cuba with his wife and child, he had the bad luck, according to the story he later told Gonzalez, of agreeing to drive the son-in-law of an old friend to Cienfuegos for an important errand. The son-in-law's errand, it turned out, was to meet Yasiel Puig. Corbacho was sentenced in Cuba to seven years in prison in 2010 on charges of attempted

human trafficking. So was the son-in-law, who, according to the complaint, actually was trying to recruit Puig to defect—much like Yunior Despaigne would, a year later, begin to do. His family presented to Gonzalez a report from the Unidad de Delitos Contra la Seguridad Del Estado, a unit of the country's largest domestic spy agency. It is, essentially, Cuba's secret police. Obtained by Corbacho's Cuban lawyers and provided by his family to Gonzalez, the report included a photograph of a young man pointing at a mug shot among other mug shots on a page—apparently picking Corbacho out of a photo lineup. The identity of the young accuser in the photograph is difficult to discern, but the police report contains a helpful caption: *"Obsérvese al testigo Yasiel Puig Valdes . . ."*

Despaigne's story—later compressed into an affidavit affixed to an amended complaint in the suit against Puig—was also valuable because it included details that, if true, seemed to suggest that Yasiel Puig had become something of a serial informant for Cuban state security. According to Despaigne's affidavit, as far back as 2009, Puig, then just 18 years old, had denounced two other people for approaching him with smuggling-defection plans. Those two people were with Puig when, together, they made a failed *lanchero* escape attempt earlier in the same year. All were caught by Cuban police. Despaigne's affidavit also claims he had conversations with Puig during which they discussed several meetings Puig had with a certain high Cuban official named Higinio Velez. Velez was then and remains today the national director of Cuban baseball. In Despaigne's telling, Puig described to him an offer that Velez had made during these meetings. Though Puig had been kicked off the national team as punishment for that 2009 defection attempt, he could nonetheless "prove his loyalty and clean his name if he worked with the state to expose persons who were stealing Cuban athletes through trafficking," according to Despaigne's affidavit. About two years later, in 2011, Puig traveled with the national team to the World Port Tournament in Holland, where he reportedly made another defection attempt, resulting in another team suspension. Further meetings with Velez, Despaigne says, led to further denunciations.

To win either case, Gonzalez faces many challenges. He needs to sway judge and jury that his clients were indeed innocent of the charges they were accused of and that they weren't actually seeking to earn a bit of coin (like Despaigne himself had) by striving to

recruit Puig and Chapman to defect on behalf of some smuggling group. Moreover, he needs to show that the players basically aided and abetted the Cuban government in committing "violations of international law—that is, torture." Gonzalez will get his chance to pass these hurdles in the Chapman case; it goes to trial on November 17. In the Puig case, the judge is still deliberating on a motion to dismiss.

Cuban officials have a term for any baseball player they suspect of wanting to flee Cuba and play ball for the capitalists who operate the U.S. major leagues: *cabeza sucia,* "dirty head." It is, of course, an ideological term, used to describe how a player's fealty to the Revolution has troublingly deteriorated, has grown impure. But there are remedies. Official Cuba has another phrase: *limpiarse,* "to clean oneself."

Domestic espionage in Cuba is as institutionalized as any country in the world, webbed inextricably into the everyday life of the island. It is both centralized and grassroots. Posted in every village, town, neighborhood, and sometimes city block is, for example, a branch office of something called the Committees for the Defense of the Revolution, or CDR. Its membership—a figure reckoned to be in the hundreds of thousands—is tasked with keeping watch on its neighbors and reporting back suspicious behavior to the Cuban state security apparatus. Every Cuban in Miami seems to have a story of local betrayal. A man fed up by rolling blackouts shouts from his window a profanity-laced invective directed at the Castros, and he winds up the next day in an interrogation room. A black-market purchase of a pound of beef, thought to be transacted discreetly, results in jail time. In aggregate, these sorts of Iron Curtain experiences have grown less frequent in Cuba over the years, but they still occur.

It doesn't take much of a leap to imagine that this highly evolved intelligence apparatus takes a special interest in the country's baseball talent and that some portion of its expertise is directed toward keeping that talent on the island. In the course of reporting this story, I spoke to four former Cuban government officials—three of whom worked for domestic and foreign intelligence agencies, and the fourth as the director for INDER, the governing body of sports in Cuba. All themselves defected to the U.S. by various means (some of which are still classified) between

1987 and 2007; their views are therefore dated. But their claims depict a culture of *chivato*—old Cuban slang for a snitch, a rat— that appears to have existed within Cuban baseball for decades. "Do Cuban athletes sometimes have to do things for counterintelligence? Yes, they do. Yes, from the very beginning," said Juan Antonio Rodriguez Menier, one of the highest-ranking Cuban spies ever to defect, in 1987. Multiple counterintelligence agents were, at any given time, assigned to spy on the national baseball team and cultivate collaborators within it, says Gregorio Miguel Calleiro, a high-ranking officer at INDER in the 1970s, '80s, and early '90s. A former major in Cuba's intelligence division named Roberto Hernandez Del Llano, who once trained for two years in Moscow with the KGB, defected from Cuba in 2007. In a signed statement to Avelino Gonzalez, he made an explosive claim: "Most members of the national baseball team that travel abroad are informants for the government." Several Cuban defectors now playing in major league farm systems affirmed to me that state security makes an active effort to turn players. "Some accept, and some don't," said Henry Urrutia of the Baltimore Orioles, who defected in 2010.

The list of those who declined to be interviewed for this article is both unsurprising and yet illuminating. Through the Dodgers, Yasiel Puig turned down requests to be interviewed for this article. The Dodgers front office also declined to comment. Jaime Torres, when contacted in late February, told me: "I have no interest whatsoever in talking to you." (In early March, Puig fired Torres as his agent and took up with Wasserman Media Group.) El Rubio could not be located. According to one source in January, word on the street in Miami was that he'd been kidnapped, probably by representatives of Tomasito. He told me El Rubio had been held for ransom and released after making some large payment to his captors. Perhaps coincidentally, the house El Rubio bought for $1 million in North Miami in 2013 was put on the market; it sold in January. Officials at Major League Baseball declined to comment, other than to issue a statement that stated that the league and its clubs "have individuals and resources in place to provide appropriate security" and "cannot comment on such measures that have been taken without potentially compromising those efforts." The Cincinnati Reds apparently chose not to bring an interview request to Aroldis Chapman's attention at all. "That won't be nec-

essary," said Rob Butcher, a Reds spokesman, in an email. "He is not available to speak to you." The Cuban government did not respond to repeated requests for comment.

7. *Stories Within Stories*

Around Thanksgiving last year, Yunior Despaigne received a call from his mother in Cuba. She had bad news. Despaigne's brother, Eduardo Soriano, was in jail. He stood accused of human trafficking.

Naturally, it was a complicated story; it couldn't be other than a complicated story. When I asked Despaigne for some kind of proof that his brother had in fact been arrested and charged, he first gave me the phone number of Soriano's lawyer in Cuba. Later, through a Miami Cuban friend who'd traveled to the island and back, Despaigne was able to obtain the Cuban government's indictment, dated February 11, 2014, which laid out the charges against his brother. In its legalistic Spanish, it read, in part, ". . . the individuals not present, Yasiel Puig Valdes and Raul Pacheco Hernandez, who are living abroad . . . conceived of a plot to extract from Cuba . . . Cuban ballplayers, taking advantage of the relationships that Puig Valdes, when he was a player in Cuba, had established and maintained with some of his teammates, whom he would convince to leave the country . . ." The Cuban government, in other words, has accused Yasiel Puig of human trafficking. (*The Magazine* has not found evidence supporting the Cuban government's accusations; it is possible that the Cuban government might be lashing out at a high-profile defector.)

The Despaigne affidavit given in the Corbacho suit makes a more pointed accusation against Puig. Having become aware of Despaigne's involvement in the suit, Puig is stated to have deliberately "targeted" Despaigne's family, allegedly sending money to Soriano for delivery to a baseball player in Cienfuegos named Noelvis Entenza. The affidavit makes no mention of what, if anything, Soriano knew about the purposes of the money. Unaware of the "trap" that was being laid, Soriano took the money to Entenza, upon Puig's urging. Several days later, the Cuban police pounded on the door of Soriano's house.

Complexity upon complexity. Stories within stories. Despaigne

also states in the affidavit that his brother was being charged with inducing a second player to defect: the starting shortstop on the Cuban national team, Erisbel Arruebarrena. (Curiously, when the February indictment was later released, Soriano was accused of recruiting only Entenza, not Arruebarrena.)

In his motion to dismiss the Corbacho suit, Puig characterizes the allegations in it as "incendiary and false."

As of this writing, Eduardo Soriano remains in prison, awaiting trial. Cuba's prosecutors are seeking eight years. Soriano is 20 years old. Erisbel Arruebarrena, meanwhile—who was smuggled by *lancheros* to Haiti, who became a Haitian permanent resident within weeks, who was described in one U.S. media report shortly after he surfaced in Haiti as having a "quick transfer and a plus-plus arm with accuracy," whose agent Bart Hernandez negotiated with at least three competing major league franchises—signed with the Los Angeles Dodgers in late February. His contract is worth $25 million.

DAN WETZEL

Peyton Manning Leaves Crushing Super Bowl Loss with Reputation Intact

FROM YAHOO! SPORTS

EAST RUTHERFORD, N.J. — This was after Peyton Manning approached his offensive line on the opening snap of the Super Bowl, trying to scream a change in cadence only to have the din of MetLife Stadium make his voice mute. "No one could hear me," he said. Soon, the unexpectedly snapped ball was zipping by his ear en route to a safety for Seattle, the quickest score in Super Bowl history.

This was after Manning threw two interceptions, including a crushing 69-yard pick-six, after he missed reads and overthrew open receivers, after he'd been pushed out of his comfort zone by a brilliant, brutish Seahawks defense. "An excellent defense," he said.

This was after he trudged off the field, the scoreboard above reading "Seattle 43, Denver 8," one of the worst and certainly most painful losses of his long career. "It's not an easy pill to swallow," he said.

This was after Manning dressed quickly in a silent, emotionless, beaten-down Broncos locker room, after his dad Archie and brother Cooper waited outside. "That's football. It's why I hate football," Archie said with gallows humor.

This was after Peyton received a compassionate pat on the back from NFL commissioner Roger Goodell, after he huddled with his

wife Ashley and a couple friends, after he received a couple of supportive words from John Elway.

This was after he walked slowly, hands in the pockets of his blue suit, headed down toward the interview area, escorted by police. After a reporter from a Mexican TV station tripped over his luggage—pulled by a Broncos employee tailing the quarterback—and wiped out on the floor in a failed, ill-advised interview chase.

This was after he arrived to find a throng of cameras and microphones 15 deep around podium number two, after he gave praise to the Seahawks, took blame himself—and even handled, without losing his cool, a question about whether he'd been "embarrassed" out there.

"It's not embarrassing at all," Manning said. "I would not use that word. There's a bunch of professional football players in that Denver locker room who put in a lot of hard work to play in that game."

This was after all of that, after the developments and aftermath of a night Peyton Manning—the great Peyton Manning—had been so profoundly ordinary and the Denver offense with its 37.9 points per game in the regular season, the 55 touchdown passes, was nearly shut out. After the Broncos' dream season, the one Manning came back from neck surgery to engineer, collapsed in spectacular fashion.

It was then that Manning, walking down a hallway back toward the locker room, still surrounded by cops, still followed by a guy dragging his bag, still trying to just find some peace and quiet and to begin the mourning process that comes from losing the big game in a big way.

It was then that Peyton Manning heard the very respectful voice of Steve Lopez, a beer vendor from the Bronx.

"Mr. Manning, could I please get an autograph?" the 25-year-old asked.

Manning's head turned and looked Lopez in the eye. These were the opposite ends of the NFL food chain—megastar multimillionaire and a guy hawking Bud Lights in the stands. The wave of the crowd was pushing Manning forward, but he locked in on Lopez.

"Not now," Manning said, "but when I come back this way I will."

Look, everyone has heard the stories of Peyton Manning being

a good guy, a regular guy, or at least as good and regular as you can be when you are this rich and famous and successful. Everyone's read and heard the saccharine tributes to him, so much so that it's become trendy to root against him in a way, to celebrate his comeuppance, to laugh at the way his face contorts in certain ways when he's frustrated.

Someone asked that "embarrassed" question with a hint of enjoyment, after all.

Everyone understands, or should understand, that so many NFL players are humble and appreciative and respectful as Manning is—that he is one of many.

At some point, though, at some level, what really matters about a man is how he treats people who hold no leverage over him, let alone how he treats those people in moments of tumult when it would be quite understandable if he just ignored the request.

How many times through the years had Peyton Manning signed for people, stopped for photos for people, been gracious to people. Now? Here? In the harried moments after this painful and thorough loss, after a chance at a championship was lost and might never come again, in the cramped walkways of a football stadium—not some charity meet-and-greet—isn't he allowed to be, well, selfishly human?

Manning didn't think so. He didn't ignore Steve Lopez. He didn't ignore, later after he did return from that locker room, others who made the same request. Here was Cheyenne Wiseman, asking if he could sign a T-shirt. Here was Michael Weisman of Philadelphia, looking for an autograph for his 10-year-old son, Alex.

After everything that happened, Peyton Manning kept stopping in the MetLife hallway and honoring requests for his time, no matter how fresh the wound, no matter how pronounced the pressure, no matter how desperately he just wanted to get on the bus, assume his customary place up front, and get the hell out of Jersey.

"The respect he always has for the fans, that's why I like him," Lopez said. "That's why I asked, that's his reputation. I like the way he keeps his emotions out of the public."

No, he isn't the only player who would've told Steve Lopez to wait. He isn't the only player who would sign. He isn't the only one who knows how great he has it, even when things aren't so great.

Yet after this game of all games, Peyton Manning was somehow no different than before.

"You know, he's got the reputation for being a class act," Weisman said. "That's him. On a night like this [to sign], I mean, I appreciate it. I know. I understand. That's Peyton Manning."

That was Peyton Manning, even on the worst of nights.

Contributors' Notes

Notable Sports Writing of 2014

Contributors' Notes

JOEL ANDERSON is a senior national reporter with BuzzFeed News. He covers race, sports, and American culture. Previously, Anderson worked for the *Tampa Bay Times,* the *Atlanta Journal-Constitution,* the Associated Press, the *Shreveport Times,* and the *Fort Worth Star-Telegram.* He graduated from Texas Christian University, where he was a member of the football team for three years and editor of the campus newspaper. He now lives in Washington, D.C.

KATIE BAKER, a Seattle native, is a graduate of Columbia University (BA '02) and the Columbia Journalism School (MS '05, MA '06). She started her career as "Periscope" editor for *Newsweek International* and is currently the managing editor of The Daily Beast, a national online news site.

CHRIS BALLARD is a senior writer at *Sports Illustrated,* where he has worked since 2000. He is the author of four books, including *The Art of a Beautiful Game* and *One Shot at Forever.* A graduate of Pomona College and Columbia University Graduate School of Journalism, he lives in Berkeley, California, with his wife and two daughters. This is his fourth appearance in *The Best American Sports Writing.*

RICK BASS is the author of 31 books of fiction and nonfiction. In January 2016, Little, Brown will publish *For a Little While: New and Selected Stories.* His work has also been anthologized in *The Best American Short Stories, The Best American Travel Writing, The Best American Spiritual Writing,* and *The Best American Science and Nature Writing.* He lives in northwest Montana's Yaak Valley, where he is a board member of the Yaak Valley Forest Council.

CHRISTOPHER BEAM is a writer living in Beijing. His work has appeared in *The New Yorker, The New Republic, GQ, Bloomberg Businessweek, ESPN The*

Magazine, and *New York.* Previously, he was a political reporter for *Slate* in Washington, D.C.

BURKHARD BILGER is a staff writer for *The New Yorker.* In 2000, his book of essays, *Noodling for Flatheads: Moonshine, Monster Catfish, and Other Southern Comforts,* was a finalist for the PEN/Martha Albrand Award.

FLINDER BOYD is a California native and freelance writer. As a professional basketball player, he lived in France, Spain, the United Kingdom, Slovakia, and Greece during a 10-year career. He holds degrees from Dartmouth College and Queen Mary, University of London, and now resides in New York and London.

JEREMY COLLINS's essays have appeared in the *Georgia Review,* the *Sycamore Review,* the *Chattahoochee Review,* and SB Nation, among other periodicals. His work has received a Pushcart Prize, the Wabash Award for Nonfiction (selected by Mary Karr), and the Lamar York Prize for Nonfiction. He holds an MFA in creative writing from the University of New Mexico and has taught writing at the University of Tennessee, the University of Louisville, and Indiana University Southeast. Collins lives in Colorado with his wife, the artist Alice Stone Collins, and their two daughters, Rose and Grace, and teaches at the Early College of Arvada, outside of Denver.

SCOTT EDEN is a contributing writer for *ESPN The Magazine* and the author of *Touchdown Jesus.* "No One Walks Off the Island" was a finalist for a 2015 National Magazine Award in reporting. His work has also appeared in *Bloomberg, Popular Mechanics,* the *Wall Street Journal,* and *The Believer* magazine. Eden lives in New York City.

TIM GRAHAM covered the NHL for seven seasons with the *Buffalo News* before switching to NFL reporting for the *Palm Beach Post* in 2007 and ESPN in 2008. He returned to the *News* five years ago. The Baldwin-Wallace College alum is a two-time president of the Boxing Writers Association of America.

GREG HANLON's work has appeared in SB Nation, *Sports Illustrated,* the *New York Times, Slate,* the *New York Observer,* and *Capital New York.* His story for SB Nation Longform, "The Many Crimes of Mel Hall," was a finalist for the 2014 Livingston Award for national reporting for journalists under 35. He lives in New Jersey.

CHRIS JONES is a writer-at-large for *Esquire* and a senior writer for *ESPN The Magazine.* He has won two National Magazine Awards for his feature writing and two National Headliner Awards for his columns. This is his fifth appearance in *The Best American Sports Writing.*

ARIEL LEVY joined *The New Yorker* as a staff writer in 2008. Levy received the National Magazine Award for Essays and Criticism for her piece "Thanksgiving in Mongolia." She is currently expanding the essay into a book. Levy teaches at the Fine Arts Work Center in Provincetown, Massachusetts, every summer and was a Visiting Critic at the American Academy in Rome in 2012. She is the author of *Female Chauvinist Pigs.*

ELIZABETH MERRILL is a senior writer for ESPN.com. She previously wrote for the *Kansas City Star* and the *Omaha World-Herald.*

DAN O'SULLIVAN is a freelance writer whose work has been featured by Deadspin, Salon, Gawker, American Circus, Vice Sports, and Et Tu, Mr. Destructo? This is his first appearance in *The Best American Sports Writing.* He lives in Chicago.

BRIAN PHILLIPS is a staff writer at Grantland.

TOMMY TOMLINSON is a contributing writer for *ESPN The Magazine* and ESPN.com. This is his second appearance in *The Best American Sports Writing.* He lives in Charlotte, North Carolina, with his wife, Alix Felsing, and their old yellow Lab, Fred.

WELLS TOWER's work has appeared in *GQ,* the *Washington Post Magazine, Harper's, Outside,* and many other publications. He is a graduate of Wesleyan University and Columbia University.

DON VAN NATTA JR. is a senior writer for *ESPN The Magazine* and ESPN.com. He joined ESPN in January 2012 after 16 years as a *New York Times* correspondent based in Washington, London, Miami, and New York. Previously, he worked for eight years at the *Miami Herald.* A member of three Pulitzer Prize–winning teams, Van Natta is the author of *First Off the Tee* and the coauthor of *Her Way,* both *New York Times* bestsellers, and *Wonder Girl.* He lives in Miami with his wife, Lizette Alvarez, who is a *Times* correspondent, and their two daughters. This is his second appearance in *The Best American Sports Writing.*

DAN WETZEL is the national columnist for Yahoo! Sports and a *New York Times* bestselling author of six books, including *Death to the BCS* and *Sole Influence.* He is a graduate of the University of Massachusetts.

A native of Anchorage, Alaska, SETH WICKERSHAM is a senior writer at *ESPN The Magazine,* where he has worked since graduating from the University of Missouri in 2000. He lives in Connecticut with his wife, Alison Overholt, and their daughter, Maddie. One of Seth's favorite moments in 2014 was visiting Y. A. Tittle months after the story was published. Tittle remembered him.

Notable Sports Writing of 2014

SELECTED BY GLENN STOUT

THE BEST AMERICAN SERIES®

FIRST, BEST, AND BEST-SELLING

The Best American series is the premier annual showcase for the country's finest short fiction and nonfiction. Each volume's series editor selects notable works from hundreds of periodicals. A special guest editor, a leading writer in the field, then chooses the best twenty or so pieces to publish. This unique system has made the Best American series the most respected—and most popular—of its kind.

Look for these best-selling titles in the Best American series:

The Best American Comics

The Best American Essays

The Best American Infographics

The Best American Mystery Stories

The Best American Nonrequired Reading

The Best American Science and Nature Writing

The Best American Science Fiction and Fantasy

The Best American Short Stories

The Best American Sports Writing

The Best American Travel Writing

Available in print and e-book wherever books are sold.
Visit our website: *www.hmhco.com/popular-reading/general-interest-books/by-category/best-american*